ART AND TRADITION
IN A TIME
OF UPRISINGS

————————————

ART AND TRADITION IN A TIME OF UPRISINGS

GABRIEL LEVINE

The MIT Press
Cambridge, Massachusetts
London, England

This book was set in Arnhem Pro by The MIT Press. Printed and bound in the United States of America.

Library of Congress Cataloging-in-Publication Data

Names: Levine, Gabriel, 1975- author.
Title: Art and Tradition in a Time of Uprisings / Gabriel Levine.
Description: Cambridge, MA : The MIT Press, 2020. | Includes
 bibliographical references and index.
Identifiers: LCCN 2019017907 | ISBN 9780262043564 (hardcover : alk. paper)
Subjects: LCSH: Arts—Experimental methods. | Manners and customs
 in art. | Art and social action—North America. | Group work in art—
 North America.
Classification: LCC NX502 .L48 2020 | DDC 702.8—dc23 LC record available
 at https://lccn.loc.gov/2019017907

10 9 8 7 6 5 4 3 2 1

CONTENTS

LIST OF ILLUSTRATIONS

INTRODUCTION

Practices of Freedom
Collective Embodied Practice
Scenes of Encounter

PRACTICES OF FREEDOM

On a blazing summer day in the city of Toronto—from the Kanien'kehá:ka word *tkaronto*, "where there are trees in the water"— a motley procession of children and adults winds its way down a paved road through a sun-bleached river valley. Rouge Park, a new urban national park that follows the Rouge River through forests and marshlands down to Lake Ontario, has been closed to car traffic for the day, setting the scene for *Freedom Tours*, a project by artists Cheryl L'Hirondelle and Camille Turner. Kids from the inner suburbs wave flags hand-printed with local flora and fauna in primary colors, each marked with a number sign, as if tweeting the creaturely world: hashtag-turtle, hashtag-eagle, hashtag-bumblebee, hashtag-strawberry. Groups of young marchers grasp multicolored handmade banners, "River of Life Freedom Flags" honoring the land and its sustenance. The summer of 2017 marks the 150th birthday of the Canadian state, which is why L'Hirondelle and Turner, in an irreverent gesture, have sewn upside-down Canadian flags onto their white aprons. I join the procession with my excited two-year-old, who runs ahead of me brandishing his little strawberry flag down the narrow road. Participants take turns at a megaphone, improvising songs dedicated to Mother Earth. We stop periodically, and the kids are invited to speak to the land, to tell Mother Earth their hopes and fears for the future. Eyes meet, smiles and words are exchanged. The sun beats down on our little parade.

We're not making epochal change here—no grand policy is being shifted, and the only spectators watching are the birds, frogs, and squirrels, along with other critters who escape our notice. But I feel an infectious lightness and joy as we walk through this valley in the middle of the city's sprawl, taking up space and singing to the trees and grasses. A national park, a cordoned-off colonial

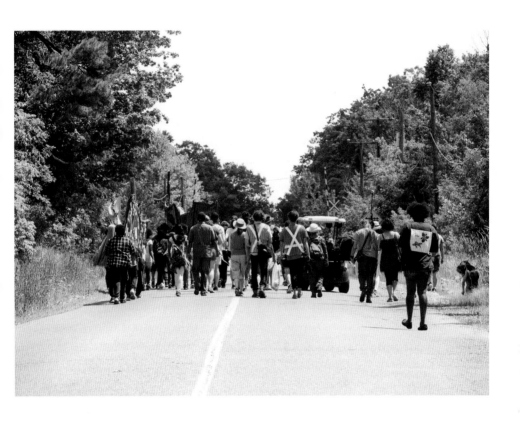

FIGURE 0.1

Freedom Tours (2017), procession
through Rouge Park, Toronto,
by Cheryl L'Hirondelle and Camille Turner
(photo by Jalani Morgan)

space, is being reclaimed by collective vernacular practice. The "freedom tour" that these artists have concocted is a temporary event, not a permanent transformation. But it could be described as a "practice of freedom," a collective bodily engagement in an alternative way of being in the world.[1] Led by Indigenous and African diasporic artists, this particular practice of freedom includes Native and non-Native people, newcomers and descendants of migrants and settlers, all called upon to become caretakers of the land. Aided by simple and repeatable technologies—megaphones, prints, songs, banners—the shared practice of walking puts us in a different embodied relationship to each other and the land we move through. When my tired kid climbs into the stroller for a nap, I turn around and retrace our steps, past hydro lines, train tracks, and pipelines carrying diluted bitumen from the Alberta tar sands, running through the valley's dried-out marshes. As we reenter the city with its traffic and noise, my body is filled with the reverberations of this walk, echoes that are still with me as I write these lines.

In this book, I've sought out other moments of collective reclaiming—what I call "radical vernaculars"—and tried to convey their rooted yet experimental engagement with supposedly outmoded cultural practices. Vernaculars, in a sense I develop from the common use of the word to describe everyday speech, are collective ways of doing, making, and thinking that are not sanctioned by "official" cultural institutions. They tend to be improvisational, rough, and opportunistic, gathering the materials and techniques at hand and combining them in new relations. The experiments with vernacular practice that I examine can be highly skilled or deliberately clunky; they can engage with sophisticated media technologies or with the simplest of discarded materials. My argument in this book is that experimenting with vernacular practices—especially ones that are considered to be elements of

"traditional" culture—can offer powerful resources for reshaping shared ways of being in the world. These practices move through a world that is profoundly damaged, both ecologically and socially.[2] In a time when lived experience is increasingly mediated through corporate platforms, when natural-cultural ecologies worldwide are under attack by extractive industries, and when masses of souls are at work creating value for the billionaire class, these small-scale modes of collective practice can seem puny and insignificant. Yet their power, while limited, is real. As I argue in this book, collective projects that experiment with what have been called "traditional" practices can help dislodge their participants from colonial and capitalist regimes of time and property. Their experimental practices of freedom can produce new modes of shared subjectivity, new aesthetic and political forms, and new horizons of collective action. This potency depends, however, on their ability to confront the hurt of history: to engage with and transform the ongoing legacies of settler capitalism that make "tradition" mean markedly different things across colonial and racial lines.

This book about radical vernaculars, collective practice, and experimental aesthetics is the result of an individual trajectory. My understanding of what it means to reclaim discarded or suppressed traditions has been shaped by what might be called an apprenticeship in the old arts, alongside a growing awareness of my participation in settler regimes of time and property. Growing up in an intellectual Ashkenazi Jewish family in Toronto (in self-imposed "exile" from New York), I participated without much self-reflection in the settler modes of belonging encouraged by the Canadian state and educational institutions. Later, as a young musician and theater student living in Montreal, I gravitated toward alternative modes of collective art-making, founding and participating in a number of independent bands and theater collectives. One pole of my existence at that time was the burgeoning experimental

scene gathered around Montreal's Constellation Records, with its shadowy aesthetic, anticapitalist principles, and commitment to sustaining an experimental community of musical practitioners. The other pole, which opened up a new world of collective art and practice for me, was Vermont's Bread and Puppet Theater, which I joined as an apprentice and then a company member in the late 1990s for the last two years of the epic outdoor event *Our Domestic Resurrection Circus*. During my time working with this theater company, I experienced how collective art-making could open up a different way of being in the world: one based on shared food production, cooking and eating and dishwashing, and singing and music-making, as much as on theatrical or artistic creation. Bread and Puppet's philosophy of "cheap art"—which seeks to reclaim art-making for everyday practice, rather than leave it to a rarefied sphere of galleries and museums—has stayed with me since I left the company. I carried this spirit into the collectives that I founded with collaborators in Montreal: the experimental Yiddish musical group Black Ox Orkestar and the puppet theater company Le Petit Théâtre de l'Absolu (The Little Theater of the Absolute), along with more recent groups and projects. Although these collectives splintered under the pressure of competing personalities and the exigencies of making a living, I have held on to the subversive energy that they found in reclaiming so-called traditional or vernacular practices.

If one anchor of this book is my shared artistic history of experiments with "tradition," another is a growing sense of how these experiments have been shaped by regimes of time and property in the North American settler colony. The projects that I have founded or participated in—whether experimenting with the cast-off vernaculars of my Jewish heritage, reclaiming histories of collective political struggle, or exploring more personal roots and branches—have all occurred within a specifically settler-colonial

temporal, cultural, and legal-political framework. As I explore in the next chapter, this is a framework in which time is progressive and future-oriented, and in which the property-owning, self-possessed individual is the basic unit of sociocultural life.[3] I have worked, with the help of others, to resist these settler-capitalist regimes of time and property, which have caused ecological and human damage. My shared projects have worked to reclaim suppressed or abandoned pasts, while opening toward collective modes of practice that undo the self-possession of the acquisitive individual. But given my position as a white settler subject, these struggles have been elective, not essential. Settler-capitalist regimes of time and property, as I will explore in this book, have quite different effects on Indigenous and racialized subjects who are positioned in specific ways as the "others" of white settler modernity. "Reclaiming" means different things in different social locations, for different times and different peoples, with different stakes. My own efforts at reclaiming have been driven by an aesthetic and political commitment to a more just and equitable world, rather than by a necessity for collective cultural, political, and bodily continuance in a total climate of white supremacy, genocide, and lived oppression.

Rather than recounting my own work, this book spirals outward. Crossing political and disciplinary borders, it moves from performance projects close to my Jewish background and artistic apprenticeship, to music and audiovisual work that participates in the current Indigenous resurgence while addressing a settler public, to everyday life practices that experiment with "tradition" beyond the strictly human sphere. In this introduction and the next chapter, I make a case for the potency and importance of collective experiments with the vernacular, and trace their divergence in North American settler colonies along lines of Indigeneity and race. In the remaining chapters, I work through a series of case studies of aesthetic experiments with so-called traditional

practices. Each belongs to a distinct social location and aesthetic and performative mode, while producing collective forms of life that resist, undo, or reimagine settler-capitalist time and property. New York City's Purim Ball or Purim Extravaganza (chapter 2) is a yearly party featuring live music and folk spectacle, a carnivalesque event that gathers some of that city's queer, leftist, and Yiddishist strands. The music of Ottawa-based Indigenous DJ collective A Tribe Called Red (chapter 3) combines the sounds of pow wow drum groups with the rhythms of global bass; their live shows add video montages of appropriated colonial imagery, creating a decolonizing audiovisual experience. And the twenty-first-century revival of do-it-yourself home fermentation (chapter 4), compellingly articulated in the writing of Sandor Katz, draws on a wide range of traditional culinary practices, fostering a new ecological subculture of human-microbe collaborations.

When these very different projects are brought into constellation, common figures and fault lines begin to emerge. Each of these experiments works to expand sociality and embodied practice beyond the property lines of colonial-capitalist modernity: across ethnic and religious barriers, between Indigenous and non-Indigenous people, beyond the self-possessed settler subject, and even beyond the bounds of the human species. Each is based in early twenty-first-century North American settler colonies (the United States and Canada), which gives them specific, contrasting relationships to questions of belonging, Indigeneity, race, and property. Each has strongly playful qualities, which can sometimes defuse the seriousness of politicized art. Their different forms of expression—a festival, a dance party, a meal—are performances that engage their participants in direct, bodily ways; they are mixed forms that are not easily housed in generic or disciplinary containers, including those of "art." They draw on varying strategies of translating "tradition," which I have distinguished in the

chapter titles: "Profaning," "Remixing," and "Fermenting." Each of these strategies, whose boundaries are not ironclad, works to unsettle static discourses of "tradition" and translate past practices into new collective and creative life—even as they are constrained in varying ways by the settler-capitalist frameworks that they struggle within or against.

My investigation of these projects also belongs to a particular historical moment: largely the years between 2011 and 2013. The years following the financial collapse of 2008 were marked by the resurgence of grassroots political movements against neoliberal austerity, economic inequality, colonial dispossession, and ecological exploitation. Globally, the "movements of the squares," from European and Latin American *indignados* to North African revolutionaries, suggested an experimental reinvention of politics, a reemergence of a spirit of contestation that struggled to find durable political form. In North America, the more impressive of these mobilizations—the Indigenous resurgence of the Idle No More movement, the student-led street protests in Québec, the liberated territories of the Occupy encampments—also reactivated traditions of vernacular political struggle that had seemed to lie dormant. These movements shared a faith in bottom-up, collective vernacular practices that were often translations of suppressed traditions—from the pots and pans of the student protests, to the round dances of Idle No More, to Occupy's carnivalesque protest against finance capitalism and its attempted reinvention of everyday life.[4] Some of the projects I take up in this book have direct ties to these movements; others are less obviously related. But whatever their links to political action, the aesthetic projects I examine are in their own ways practices of freedom, experimental techniques of shared becoming whose consequences are still uncertain.

In some respects, global historical events have overtaken the often fragile and small-scale experiments that I put forward here.

Politically and ecologically, the earth lurches from crisis to crisis, with the current turn to a mediatized authoritarian populism postponing any reckoning with accelerating damage to the land and its inhabitants. The melancholy of some strands of the political left since at least the fall of state communism in 1989, which I address in this book's conclusion, has been shaken but not dispelled by thirty years of varied social movements, spontaneous uprisings, and aborted revolutions. Looking over the past three decades of political experimentation, some intellectuals on the left condemn any recourse to the small-scale and the intimate as "folk politics," arguing that such strategies are in no way commensurate to the scale of the challenges faced by our species and our planet.[5] They are partly right. What I am proposing in this book is not a structural solution to the ravages of global capitalism and the trauma of ongoing colonial legacies. Instead of folk politics, which suggests a constrained political horizon, I analyze specific experiments at the level of vernacular embodied practice. These are shared techniques that encourage their practitioners, as the philosopher Isabelle Stengers argues, to "think, imagine, and resist."[6] These practices of freedom might be as simple as joining a parade for Mother Earth through a grassy valley in the middle of the city, surrounded by buzzing insects and electrical lines, waving animal-printed flags and singing songs into a megaphone. Or they might involve more elaborate forms of gathering, more sophisticated technologies, and more complex arrangements of humans and nonhumans. Across colonial lines, in a world deeply damaged by capitalism's profit-seeking drive, how can souls find the courage to think, imagine, and resist when they have been captured in countless ways? This book offers a number of possible answers to this question.

What is at stake in the experimental reclaiming of lapsed or suppressed traditions? How do these divergent practices intervene

in their historical and political contexts—in this case, the ecologically and socially damaged world of North American settler capitalism? Answering these questions requires a careful examination of essential terms and concepts—from tradition and dispossession to "practice" itself—and an understanding of the fields of force in which they operate. This introduction and the subsequent chapter follow the line of thought by which I have gathered these diverse projects together, and build a theoretical vocabulary that will help illuminate their specific, contrasting reclamations of vernacular practice. I want to suggest that, in these and other cases, experiments with tradition are not only aesthetically compelling. They can also be politically potent, helping people to work through complex histories of colonization, shame, and abandonment, while moving across colonial and capitalist divisions to open up spaces of collective imagination, capacity, and power.

COLLECTIVE EMBODIED PRACTICE

In discussing these collective projects of reclaiming, I have chosen the word "practice" in order to highlight their repetitive, processual, participatory, embodied, transformative, and unfinished qualities. "Practice" is a term that is at once ubiquitous and obscure, self-evident and mysterious. In contemporary parlance, many individuals seem to have "a practice," a turn of phrase that implies a set of professional or personal activities pursued in a delimited and repeated fashion with improvement as a goal. In the field of contemporary art, where this trend is particularly acute, artists speak of "my practice," while critics and scholars write about "contemporary practice," "practice-based research," and "social practice." The connotation of "professional practice" among artists, recalling the name-plated offices of doctors, lawyers, or therapists, is no

accident: it reflects the increasing professionalization of art education, with the rise of MFA and "practice-based" PhD degrees. In art and in life, the injunction to practice is pointedly neoliberal, invoking entrepreneurial and individualized subjects who must constantly improve or better themselves: burnishing their CVs, sculpting their bodies, managing their time, and building their brands.[7] Here, I want to reclaim "practice" from its neoliberal, professionalized, and individualized appropriations. Practice can be acquisitive, top-down, and directed toward self-improvement. It can also be bottom-up and open to collective modes of becoming. This latter version of practice is what I advance in this book.

In current thinking about art and aesthetics, "practice" has two intertwined meanings, both of which are important to my argument. The first, harking back to the term's roots in the Greek *prattein* (to do), captures a shift from the artwork as a fabricated object to an understanding of art as doing, action, or process. Over the past century, artworks that hang in galleries have been increasingly joined or displaced by art practices that change form, elicit human and extrahuman agencies, and enter the social field, sometimes leaving the frame of "art" entirely. At its limit, this kind of "art as practice" rejects the professionalism of the art world, with its requirement that every gesture be recuperated in an exhibitable form. This suspicion of professionalism and wariness of capture is shared to varying degrees by the projects that I discuss in this book, which sometimes position themselves at the borders of art—and sometimes in different fields of practice entirely—while emphasizing processual becoming over commodifiable work.

The second meaning of "practice," less often emphasized in art theory but crucial to my project here, is *the formation of subjects through embodied repetition.* "Practice," in this sense, describes the deliberate or unconscious repetition sequences that shape neuropathways and bodily dispositions. As the various thinkers of what

has been called the "practice turn" in contemporary theory have argued, humans are creatures of practice: our intimate and social selves, along with our bodies themselves, are shaped through ritualized forms of repetition.[8] These forms of repetition are both unconscious and conscious; in fact, the conscious and unconscious dimensions of practice are necessarily intertwined. Walking, swimming, and other "techniques of the body" might be consciously learned, but they soon become second nature, part of an individual's unconscious bodily comportment and then difficult to undo or alter.[9] This has led some theorists to emphasize a tacit and socially determined "logic of practice," as in Pierre Bourdieu's concept of *habitus*, the embodied patterns that articulate social distinctions, including those of gender and class.[10] Yet if practice is socially determined, with bodily and social *habitus* assimilated from childhood and endlessly repeated, it can also become a kind of deliberate research oriented toward experimentation in embodied technique.[11] We may be shaped by already-existing forms of repetition: this is the social "field," to use Bourdieu's term, on which the various games of practice are played. But certain practical experiments also have the ability to alter the embodied being of the players, change the constitution of the field, and even rewrite the rules of the game itself.

Within this play, beyond its social articulation and individual elaboration, the game of practice is worked out primarily at the level of the collective. The philosopher Isabelle Stengers describes "practices" in the sense of collectively defined ways of engaging and shaping social-material realities—the practices of scientists, for example, or computer programmers, carpenters, hunters, or teachers.[12] Each "practice" in this collective sense has its own consistency and depth of knowledge, which cannot be thought of as wholly individual. One learns how to hunt by apprenticing with experienced hunters, or to play an instrument by learning from skilled teachers and peers, or to do biology by working in

laboratories or in the field. But Stengers argues that the knowledge created by each of these practices cannot be dissolved into a general social knowledge that is immediately translatable between practices. Nor should it be used to state capital-T Truths that would render the truths fostered by other practices irrelevant. Each practice, in Stengers's view, has found ways to foster its own efficacy, and must encounter, influence, and contest the knowledge of other practices in a kind of "diplomacy." Stengers's proposed "ecology of practices"—in which the practices of experimental scientists might find a way to exist alongside the practices of neopagan witches, as I discuss below—offers a way to understand "practice" on a collective level, influenced but not fully explained by individual self-shaping and social determination.

Thinking about an "ecology of practices" also allows for an expansive understanding of the relationship between embodied practice and technology. All practices, from the most obviously embodied (such as dance or martial arts) to the least evidently body-focused (such as mathematics or law) weave together a certain arrangement of technique, technology, and embodiment. Embodiment, as the performance theorist Ben Spatz argues in *What a Body Can Do*, should not be seen as strictly body-focused, or as implying a separation between body and mind. "Thought and language," Spatz writes, "are fully embodied processes"; embodiment, in a usage that builds on the work of seventeenth-century philosopher Spinoza, moves from the physical into "a wider territory: everything a body can do."[13] This includes the body's engagement with the world through technique (the accrued, discovered, and transmitted knowledge of embodied practices) and technology (embodied practice's material extensions and engagements). Rather than view embodied technique and technology as opposed, we could instead examine each practice's embodied engagement with technology, from the chalkboard writing or screen projection

of mathematical equations to the repair of complex or simple machinery, or (to use examples from this book) the building of festive spectacles out of cardboard and papier-mâché, the creation of audiovisual performances using samplers and software, and the fermenting of vegetables in crocks. This specificity of technology and embodied technique would then open up an understanding of the particular style of each practice—how it experiments by working with the "relative reliability" of embodied material existence.[14] For the practices that I examine in this book, that style takes the form of various vernaculars, which, despite their crucial differences, all operate "from below" through collectively determined modes of practice.

The figure of "an ecology of practices" also helps illuminate the relationships between collective embodied practice, subject formation, and affect. Affect is a slippery concept—variously defined as, in Spinoza's terms, "the capacity to affect and be affected" or as a dimension of bodily sensations and feelings operating below the level of signification.[15] In either case, as Spatz notes, the concept does not adequately account for the "deliberate and effortful labor" of embodied practitioners, or their conscious experimental research.[16] This does not mean that the concept of affect should be dismissed as irrelevant to collective embodied practice. "Affect" can more generously be understood as a current that flows through embodied practices, pulsing inside their various arrangements of technology and technique. When subjects are created and transformed through forms of repetition, they are accompanied and marked by affects. These include the powerful affects that inhere in the lived experiences of gender, sexuality, class, coloniality, and race, as well as the collective energies fostered by the practices of team sports, music, games, or dance. In my own artistic practice, the affective dimension is what fosters my desire to rehearse, to practice. Working on a theater project with a group, performing

with a band, or singing harmonies in a rehearsal, I find energies that resist signification, a pulse of collective becoming—a shared vibration—that is not fully articulable in the register of technique or knowledge. This is not to suggest that technique is subsidiary or to suggest that performance is somehow "magical."[17] Without technique, rehearsal, and practical know-how, there can be no magic. Rather, a practiced arrangement of embodied technique and technologies encourages a flow of shared affects. Affects accompany embodied practice every step of the way—calling practitioners into being, motivating and shaping their practices, and remaining in anticipatory memory for a future emergence.

In this book, I focus on embodied practices that foreground their collective dimension by experimentally translating suppressed or abandoned vernaculars. As I will argue, these collective experiments have a certain political urgency. Stengers maintains that the attachments fostered by specific practices—attachments woven out of collective knowledge and shared affect—can allow practitioners to "get a hold" (*faire prise*) on the slippery surface of the contemporary reality of neoliberal capitalism.[18] In a context of generalized precarity, white supremacy, mediatized consumerism, and settler-colonial "possessive individualism," collective embodied practices can offer powerful resources for struggle and resilience. This phenomenon manifests itself in different ways among different groups and communities of practice in early twenty-first-century colonial-capitalist societies. It is central to the theorists and practitioners of the current Indigenous resurgence, who emphasize the continued practice of collective lifeways that settler legal systems, land grabs, and regimes of property have attempted to disrupt. Michi Saagiig Nishnaabeg writer and artist Leanne Betasamosake Simpson, writing in *How We Have Always Done*, describes how contact with Elders allowed her to understand "Indigenous resurgence as a *set of practices* through which the regeneration

and reestablishment of Indigenous nations could be achieved."[19] An emphasis on explicitly collective embodied practice is also crucial to what Fred Moten and Stefano Harney call "the under-commons," which is a collection of practices that reject privatized and professionalized educational institutions in order to create a space in which collective "Black Study" can flourish.[20] These and other writers and thinkers know that without persistent embod-ied practice, "otherwise" ways of being and doing are swallowed up by the dominant social field.[21] As this book will show, there are other ways of practicing, and other collectives to practice with. If embodied practices of freedom are to effectively struggle against a context of individualized precarity and settler-capitalist time and property, they must be both persistent and collective.

Theater, music, and other genres of group performance are evidently collective forms of practice. They require a loosening of the individual ego and an openness to the undoing of the self. This is especially true when these practices are freed from profession-alized hierarchies and pursued by a horizontally organized collec-tive, whether this be a musical group, a performance company, or a collaborative project. As I have experienced, these groups can be volatile, difficult, and short-lived. They often collapse under the weight of their participants' desires for individual recognition, de-sires that are magnified by the day-to-day challenges of egalitarian organizing in a neoliberal settler-colonial context. Working in a collective can be exhausting and frustrating—time and money are short, not everyone pulls their weight, and your most cherished ideas can be met with rejection or an indifferent shrug. But when such collectives work, they create a particular kind of power, what the composer and scholar George Lewis calls "a power stronger than itself."[22] This is a book about collective embodied practice, but also about specific collectives of practitioners who come to-gether to make performances of various kinds—festive gatherings,

concerts, theatrical experiments, or shared meals. Through these modes of gathering, they propose new rituals of repetition, new practices of embodied subjectivation, that foster a shared power.

SCENES OF ENCOUNTER

The projects and movements I engage with and theorize in this book are part of a long history of experiments in the vernacular arts, which extends well beyond twenty-first-century settler-colonial North America. This history is far too complex, and too intertwined with the dispossessions of colonial modernity, for me to offer a synopsis or comparative survey here. Instead, in this book I focus on scenes of ambiguous *encounter*: between practitioners and their traditions following or in the midst of a surpassing disaster; between artists or intellectuals and vernacular or "folk" practices; and between practices that are considered to belong to different spheres of activity, different time periods, and different social orders. Each chapter tells a story of a given project or movement, and its strategies of reclaiming within what the next chapter will name "the discontinuum of tradition." Within this discontinuum, across the lines of class, Indigeneity, race, and generational belonging, strange meetings take place. And as even a brief glance at the history of these experimental encounters shows, they can be marked by alliance and appropriation, desire and misunderstanding, creative (mis)translation and radical revisionism.

Two historical figures are particularly prominent in these scenes of encounter, and to the practices of reclaiming that I examine in this book: *the collector* and *the collective*. Collectors set out to gather and retranslate the fragments scattered by the decomposition of tradition, often looking for inspiration to those whom the poet Lorine Niedecker called, with perfect ambiguity, "the folk

from whom all poetry flows / and dreadfully much else."[23] Collectors can be found mingling with singers and storytellers, seated at a fire or on a porch, at sea, in taverns, prison yards, work camps, shantytowns, libraries, and secondhand shops. In North America and Europe, the collecting of vernacular arts has often been preservationist, academic, antiquarian, and conservative. But some innovative collectors have been more interested in translating the pieces they gather into experimental forms. A very incomplete list of these experimental collectors would have to include William Morris's socialist craft revivalism; composers such as Bartok and Komitas who adapted peasant music from the margins of empire; W. E. B. Du Bois as he collaged transcripts of "sorrow songs" into *The Souls of Black Folk*; Zora Neale Hurston, who trained as an ethnographer and visited Bahamian work camps to learn dances that would be montaged into theatrical spectacles; the painter/filmmaker/collector Harry Smith, whose alchemical and eccentric *Anthology of American Folk Music* tipped a whole culture toward vibrant anachronism; and the architects Bernard Rudofsky and Christopher Alexander, whose collections of vernacular architecture inspired new ways of collective building and living.[24] Many artists and intellectuals associated with movements for subaltern revival and Indigenous resurgence have practiced forms of experimental collecting. Against the sealed collections of the colonial museum, they retell stories, learn languages, and reclaim everyday life practices, in the service of a creative flourishing in the present. These diverse collectors, working in the wake of capitalist and colonial dispossessions, do not simply identify, label, archive, and exhibit. Instead, their collections are experiments that seek to retranslate "tradition" into new creative life.

If the collector is the one who gathers, collectives are the ones who gather. Collectors have long accompanied the ongoing dispossessions of capitalism and colonialism, gathering scattered pieces

of "tradition" left by the wayside. The figure of the collective emerges more sporadically, perhaps reaching its peak in a moment when experiments with vernacular arts were widespread, fertile, and contradictory: the (long) global 1960s.[25] Decolonization movements have been marked by numerous collectives that put forward experimental versions of tradition, from earlier journals such as *Tropiques* and *Présence Africaine* (founded in colonial Martinique and Senegal), to the many artistic, literary, musical, and theatrical collectives of the Black Arts movement.[26] In Europe, among the various collectives of the postwar avant-garde, the situationists—especially Raoul Vaneigcm and Asger Jorn—looked to the vernacular as a source of opposition to spectacular capitalism, emphasizing collective and everyday aesthetic practices like the gift, the festival, and the ornament.[27] A range of North American and European experimental theater companies (the Bread and Puppet Theater, the San Francisco Mime Troupe, El Teatro Campesino, Welfare State International, Dario Fo's revival of the *giullare*) energetically reinvented vernacular and popular forms, extending the popular interests of prewar collaborations such as those of Brecht and Weill, but without a strict attachment to the proletarian masses.[28] This development resonated with global experiments in vernacular arts, from the Japanese "ritual school" of performance collectives to musical groups and movements that blended pop, rock, and psychedelia with vernacular and avant-garde influences, notably in politically charged "Third World" contexts, as in Brazil's Tropicália movement.[29] In this period, artistic experiments with vernacular practice also spilled over into daily life, sometimes taking the form of collectives, communes, and intentional communities. A few of these still survive, including the Farm in Tennessee, site of the 1970s feminist revival of midwifery.[30] Even after decades of political and cultural retrenchment, the radical vernacular collectives of these years suggest that experiments

with vernacular arts can open toward a practical mode of life, beyond any purely aesthetic or commodified frame.

One compelling and still-enduring musical collective born in that era was the Chicago-based Association for the Advancement of Creative Musicians (AACM). Founded in 1965, the AACM gathered together Chicago's Black, working-class musical experimentalists, including Muhal Richard Abrams, Phil Cohran, the Art Ensemble of Chicago, and many other composers, musicians, and groups. The AACM grew out of a desire to provide mutual support and infrastructure for its composer members, who had no access to academic resources or public funding, and whose work was not welcome in commercial jazz venues. Composer, scholar, and trombonist George Lewis, a member and the author of the "autobiography" of the collective, writes of the AACM's "mobility of practice," its willingness to go "beyond the purview of genre or method."[31] This creative approach treated tradition not as a museum piece but as a temporally open field of possibility (as in the Art Ensemble's slogan, "Great Black Music, Ancient to the Future"). What Lewis calls the AACM's "boxing with tradition" reinvented and reactivated a shared vernacular past, helping the collective to build an emergent power: "a power stronger than itself."[32] This power still runs through intergenerational networks of musicians and composers, including associated artists such as Nicole Mitchell and Matana Roberts.[33] It makes the AACM a touchstone throughout this book for my understanding of vernacular experimentation.

Art and Tradition in a Time of Uprisings does not include a chapter on Black radical vernaculars, despite the richness and power of Black experiments with tradition, and despite the centrality of anti-blackness to the ongoing history of colonial modernity (as Sylvia Wynter and others have shown).[34] This book does not seek to provide a complete portrait; rather, it is the result of a particular artistic, political, and intellectual itinerary. As a project that

moves outward from my identity and practice, it focuses at length on Jewish, Indigenous, and settler experiments with "tradition." Yet an ongoing dialogue with Black experimentalists informs my work here. Theorists and historians of "the Black radical tradition," along with experiments in Black aesthetic practice, have deeply shaped my thinking about what it means to reclaim suppressed or abandoned vernaculars.[35] Many contemporary Black theorists and artists, including bell hooks and Fred Moten, have emphasized how collective vernacular practice can create and sustain shared forms of life in the midst of white supremacy's ongoing social damage.[36] "We have to defend our ways in persistent practice of them," Moten and Harney write, in reference to the Black Lives Matter protests following the death of Michael Brown. "It's not about taking the streets; it's about how, and about what, we should take to the streets."[37] In the book, I dialogue with Black radical theorists and artists about the *how* and the *what*—how and what to practice collectively—while focusing at length on the potentialities and contradictions of Jewish, Indigenous, and settler projects of reclaiming.

Turning to the divided territories of the contemporary settler colony, the landscape of practical experiments with the vernacular is fluid and difficult to map. For the past several decades among mostly settler subjects, there has been an experimental revival of vernacular arts and crafts—from knitting to pickling—at the level of daily life. Yet, as I discuss in chapter 4 ("Fermenting"), even the more radical of these revival movements are politically and aesthetically ambiguous—lacking an imaginary of scale, imbricated in regimes of authorship, commodification, copyright, and property, sometimes perpetuating white settler ideologies, and threatening to collapse into innocuous lifestyle adjustments. Contemporary "enterprise culture" takes the impulse to experiment with tradition and shunts it into heavily commodified forms, often trapping its

"mobility of practice" in the property of a bounded group.[38] "Instant traditions" circulate via the Internet, encouraged by corporate interests, as in the 2013 phenomenon of the "Harlem Shake."[39] The Internet's universal digital archive has been described as promoting a generalized "retromania": present innovation is sacrificed in favor of digging up the past, in "a free-for-all of asset-stripping that ranges all over the globe and all across the span of human history."[40] This free-for-all is uneasily regulated by discourses of cultural appropriation, which stress the imbalances of power and instances of racial theft that persist across the production and circulation of images, sounds, and memes. At the same time, new forms of media have encouraged new vernaculars—including the contemporary explosion of amateur music-making ushered in by the accessibility of home recording and social networks. Contemporary radical vernacular collectives can flourish within this landscape, such as the cross-border collective Black Constellation (see figure 0.2), who work with old and new media to produce music, graphic work, installations, videos, and textiles that offer wildly experimental and decolonial translations of tradition.

In the realm of contemporary art, participatory "social practice" and "the social turn" have emerged since the 1990s as another ambiguous scene of encounter, or "short voyage to the land of the people."[41] Their historical and current incarnations tend to draw on everyday and vernacular practices: gardening and street parades, to take just two common examples.[42] Contemporary participatory art projects are sometimes banal, and their emphasis on practice sometimes comes at the expense of an attention to aesthetic shaping. Yet certain projects, such as those mounted by the Chicago collective Temporary Services (see figure 0.3), use a keen aesthetic intelligence to curate and reshape "the inventiveness of the everyday, the commonplace, and the nondescript multitude."[43] Indeed, Temporary Services and their related project

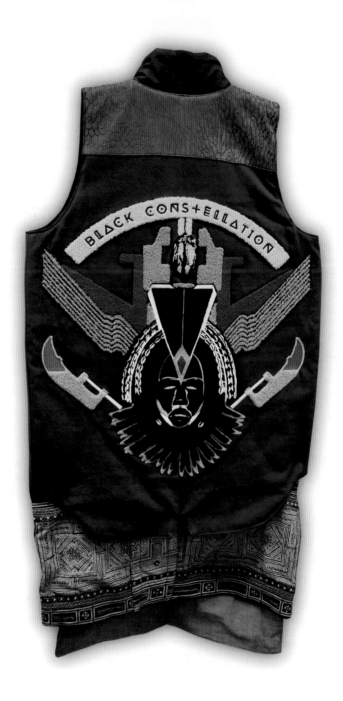

FIGURE 0.2

Nep Sidhu, *Black Constellation Gang Vest* (2013)

SIGNS BY DEN
1708 7506 W 134th Pl
 Cedr Lk IN----------
SIGNS BY DESIGN
1610 13866 S Cicero Av Orchwd-
5455 **Mobile Sign Systems**
 Palos Hils----------
7446 SIGNS BY DON
 12998 Oakdale Pl
 Cedr Lk IN----------
9386 SIGNS BY DUSTY & WILL
 16601 Halstd Harvy----------
SIGNS BY FRY
1761 513 S Brookwood Tr
 McHnry----------
SIGNS BY JOHN
4248 1251 N Skokie Bl Lk Bluf----
SIGNS BY LIZA
5517 27W199 W Bauer Rd
 Naprvl----------

TEMPORARY SERVICES

Re-Used
Interview

The following interview appeared several years ago in a book with other interviews assessing the current state of art. The book presented a wide range of positions on this topic.

Temporary Services manipulated the original text. We took out all references to authors, individuals, places and historical situations. We removed academic conceits, name-dropping and obscure reference points. We updated this text to make it more accessible. We make no claims to authorship of this work. In order to reach certain audiences, the text needs to be presented in this manner. We are certain that receiving permission to re-use and re-publish this text would be impossible. This booklet is therefore provided free of charge.

The interview presents many strong ideas. It puts forth ideas about reforming art education. It emphasizes the importance of teaching artists to become aware of the effects their work can have in a broader social context. It encourages people to understand that art can make a great social impact on the world. It acknowledges that being a successful artist is about more than fame and money.

This booklet is one of many free services provided to you by Temporary Services.

ser-vice (sur'vis) *n*
Abbr. serv., svc
1. Employment in duties or work for another 2. Work done for others as an occupation of a business 3. A facility providing the public with the use of something 4. An act of assistance or benefit to another or others; a favor
-service *tr. v.* -iced, ic-ing, -ices 1. To make fit for use; adjust, repair or maintain 2. To provide services to
-service *adj.*
Offering services to the public in response to need or demand
Usage Note
In the sense "to supply goods and services to" serve is the most frequent or only choice.

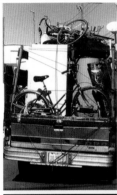

DESIGNATED
DRIVERS
organized by Temporary Services

PUBLISHING 'ZINES
FOR PRISONERS

AN INTERVIEW WITH ANTHONY RAYSON

ABANDONED
SIGNS

By Temporary Services

100 ACTIONS
for Chicago Torture Justice

Lucky Pierre

REVOLUTION
AS AN ETERNAL
DREAM:

the Exemplary Failure
of the Madame Binh Graphics Collective
by Mary Patten

MOBILE PHENOMENA
compiled by Temporary Services

PUBLIC PHENOMENA
by Temporary Services

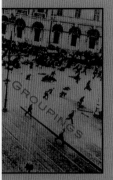

FIGURE 0.3

Selected publications by Temporary
Services (1999–2018)

Public Collectors present a promising fusion of *collector* and *collective*. They gather vernacular creations into exhibits and publications, such as *Prisoners' Inventions*, while working collaboratively through egalitarian structures to find aesthetically potent frameworks of presentation.[44]

Other contemporary art collectives share this experimental interest in the vernacular as both source material and mode of operation. The suggestively titled Abandoned Practices Institute, run out of the School of the Art Institute of Chicago by former members of the Goat Island theater collective, turns forgotten and outmoded vernacular practices into a resource for art and performance pedagogy. Drawing on a collectively created archive of "abandoned practice cards," they work through a series of formal prompts, directives, and constraints to attempt to undo art students' tendency toward self-critique, self-possession, and enclosure. The Abandoned Practices Institute does not share the radical orientation of the projects that I discuss in this book; it is interested in playing with, rather than reclaiming, forgotten or suppressed vernaculars. In its primarily aesthetic interest in lapsed traditions, the Institute risks a certain formalism and abstraction from the hurt of history, a danger that is prevalent in white settler regimes of time. But its inventive "mode of gathering" shows how a certain collective magic can arise, even within the bounds of educational and art institutions.[45]

The experiments that I examine are not situated primarily in the institutions of the self-identified "art world." Rather, they are experiments in activist spectacle, popular music, and practices of everyday life. All of them wind their way through the landscape of contemporary enterprise culture. To varying degrees, they accept the terms of survival—commodification, professionalization, institutionalization—while sometimes clinging to a more precarious marginality. All have a collective dimension in both process

FIGURE 0.4

—————

ANYTIME (2012), installation by Ioana
Gheorghiu at the Abandoned Practices
Institute (photo by Daviel Shy)

and performance. More specifically, each project grows out of an explicitly defined collective structure. The horizontality of these collectives aligns with the vernacular practices they draw upon or reinvent. Vernacular practice, as I will explore in the next chapter, tends to operate on the horizontal rather than the vertical plane, giving it an affinity with egalitarian structures and processes. This is not to suggest that these limited projects are scalable into larger political structures—that their "folk practice" should be taken for the ultimate horizon of some "folk politics."[46] Rather, the horizontal production and collective dimension of these projects offer an experience of equality, capacity, and shared power. With all their incommensurable differences, ambiguities, and limitations, they manage to open affective spaces that productively estrange their participants from the networked controls of neoliberal capitalism and the possessive enclosures of settler colonialism, opening up the possibility of repairing a damaged world. If only for a short time and in a partial way, they invoke a "power stronger than itself": the power of collectively determined embodied practice.

Each of the projects I discuss in this book also involves a certain kind of collecting. This includes the collecting of diverse vernacular scraps, along with fragments of Jewish liturgy and ritual, in the creation of the Purim Extravaganza (chapter 2); pow wow songs in the music of A Tribe Called Red, and images of "the Indian" in the videos of Bear Witness (chapter 3); and numerous recipes and techniques in the practice texts of the fermentation revival (chapter 4). These examples should demonstrate that collecting is not always a top-down affair. In fact, vernacular practice can itself be understood as a kind of collecting, "assembling together everything and everyone needed for an event."[47] Even this book, with its assembling of divergent case studies, is a collection, if an idiosyncratic one. I have gathered together projects based on my social context and individual itinerary, my aesthetic and political

engagements, and the points of contact and fault lines that I see running through them. I chose them not because of their shared content, but because of their related approaches—their experimental, collective, and participatory translations of "tradition."

The types of projects that I discuss—festivals, dance parties, and shared meals—are thoroughly participatory in their form. They are not "social practice" or participatory art, but rather experiential performances that require participation if they are to exist at all. Would-be researchers of these experiences cannot take on the dispassionate perspective of the critic or aim for the elevated position of the fly on the wall. They have no choice but to position themselves at ground level, "in the thick of things."[48] In the chapters that follow, my writing works from a place of practical and aesthetic entanglement, a site marked by affective and bodily engagement—whether that has meant working and performing in the Purim Ball, attending concerts by A Tribe Called Red, or experimenting with home fermentation practices. Yet I also make sense of this engagement by way of extended theoretical investigation and critical self-reflexivity. This approach has been inspired by Indigenous theory and methodologies, by recent work in "practice as research," and by the "radical research" of certain strands of performance studies scholarship.[49] The need for reflection on one's own situatedness is most obvious when it comes to research involving Indigenous peoples in settler societies, which requires a reflexive and critical self-positioning by settler subjects, as in chapter 3, "Remixing."[50] I carry this reflexivity into the other chapters, which raise equally complex issues of whiteness, religious affiliation, appropriation, political efficacy, and participatory engagement. In each chapter, I alternate between more distanced and more imbricated positions, setting up a dialogue between reflection and action, and shifting between narrative and theoretical modes. Throughout, I attempt to translate the experiential texture

of collective performances into text, while sticking close to the "how" and the "what" of practice.

In this book, I use the present participle or gerund (words ending in "-ing") to emphasize modes of practice—reclaiming, musicking, commoning, translating, repairing, experimenting—instead of things or substances. I also use the gerund to title the chapters on individual projects and movements, identifying a key practice, figurative or literal, for each one: "Profaning," "Remixing," and "Fermenting." The open, immediate, repetitive, and ongoing quality of the present participle form is well suited to a study of collective practices, especially ones that invite bodily participation.[51] By emphasizing the present participle, I also mean to convey something of the unfinished and continuing quality of the projects I discuss. All of these projects are still (at the time of writing) developing, altering and reiterating themselves. This book catches each of them at a moment in time, during a particular iteration, but it does not offer definitive summations. As experiments in the art of collective practice, they are not likely to reach a final form or attain unassailable conclusions. Rather, they are provisional examples to follow or abandon, engagements with the vernacular in experimental form.

In these and other projects, experimentally reclaiming collective vernacular practice can be a contradictory, ambiguous, and conflictual process. "Boxing with tradition" is how George Lewis describes the radical musical experiments of the AACM. For me, "boxing" is too much of a winner-take-all, punch-to-the-head proposition: I prefer "wrestling" to describe what is a playful as well as an antagonistic relationship. These experiments grope along amid conflicts and confusions, errors and misunderstandings, requiring a good sense of humor and a necessary embrace of failure. Yet as I describe in my next theoretical chapter, and in the chapters about specific projects and movements that follow, they

can also be surprisingly efficacious. Experiments with tradition, especially in an open, participatory, and playful mode, can work across regimes of property, temporality, and self-enclosure. They can illuminate new figures of collective life, and offer pathways for repairing a damaged world. Such radical vernacular experiments require more than a critical-intellectual appreciation. They also call for joining in that difficult and playful wrestling, by participating in their collective practices of undoing and reclaiming.

1 RECLAIMING

EXPERIMENTS WITH
TRADITION IN
THE SETTLER COLONY

───────────────────

The Discontinuum of Tradition
Vernacular Musicking and Commoning
Settler Time and Property
Strategies of Translation
Experimental Arts

back
in the Beginning
repeating those stories
like a drop
pooling
in fountains of time
linoleum waves
in circles of ancestors ...

—FROM NIIGAANWEWIDAM JAMES SINCLAIR, "DANCING IN A MALL"[1]

In the winter of 2012 to 2013, the sound of drums and singing voices echoed through the interiors of North American shopping malls—from the Cornwall Centre in Regina, Saskatchewan, to the Mall of America in Bloomington, Indiana. This "Round Dance Revolution" was a notable part of Idle No More, an activist movement spurred by a call to action: to reclaim the sovereignty of Indigenous nations, to protest legislation that aimed to dismantle historic treaty rights, and to reverse a long history of cultural suppression and systemic violence, especially against Indigenous women. On December 30, 2012, in Toronto's Eaton Centre—a vast arcade surmounted by a vaulted glass roof—hundreds of dancers, Native and non-Native, circled and sang around a bubbling fountain. They moved with joined hands to the steady rhythm of unison drumming, winding their way between escalators and boutiques advertising post-Christmas sales. Crowds watched from the upper levels as a phantasmagoria of consumption turned into something different: a resurgence of collective ceremony and a reinvention of "traditional" practice inside a temple of capitalist enclosure. That winter, I would join round dances held in other public spaces, but this time I watched

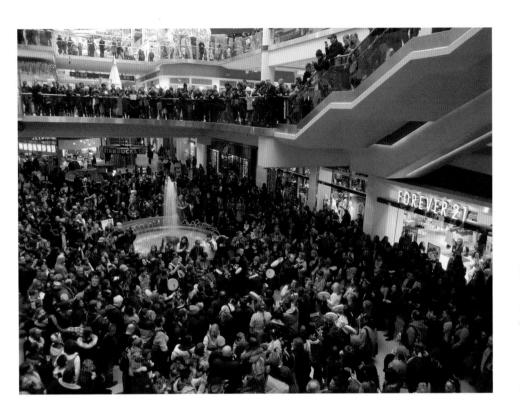

from a different vantage point: a live stream via a Facebook post, the same platform that served to gather this resurgent "flash mob." The camera moved across the crowd, lighting on some familiar faces. In grainy images and saturated sound, the video carried the energy of that gathering, distributing its collective joy and emergent power into far-flung corners of the connected world. The invitation to join in the dance was, I felt at that moment, irresistible.

Idle No More's round dances, as they spread across North America that winter, were double acts of reclaiming. They reclaimed privatized and commodified urban space as Indigenous space, and simultaneously reclaimed "tradition"—often misunderstood as static and bound to the past—as vital, adaptable, and potent. The round dance was an activist tactic that matched its historical moment: enabled by social networks and communication technologies, an Indigenous cultural practice that had persisted through decades of colonial suppression could translate into a new kind of embodied and participatory performance, open to all those living in the settler state. Ripples from these round dances, along with more familiar activist forms—marches, blockades, hunger strikes—spread through independent, social, and mass media. The round dances were brief; like many public performances, they gathered and receded in a short span of time. But as their participants held hands and danced and sang, learning new melodies or remembering old ones, a new collective figure flickered into life. Symbols of colonial and capitalist power were left intact—there were no broken statues or smashed shop windows—but the force of those symbols momentarily evaporated, clearing a space to envisage decolonial and nonexploitative futures. If these round dances were acts of Indigenous reclaiming, they were also acts of political and cultural imagination that wove together layers of past, present, and future into a collective practice that was both old and new.

In what follows, I reckon with the ambiguities of a temporally fluid reclaiming of tradition, in the context of North American neoliberal capitalism and settler colonialism. Each of the projects that I consider in the subsequent chapters is also an experiment in reinventing "traditional" practices for present and future use. While these experiments split along racial and settler-colonial lines, they also have certain formal and contextual similarities. Within a force field caused by capitalist and settler-colonial dispossession, they reclaim and reactivate materials from a supposedly frozen past. They enable vibrant, transitory, embodied experiences that leave affective traces in their participants. And in temporally loosening regimes of time and property, they illuminate new figures of collective practice, figures that trouble the settled categories of aesthetic and political thought.

In the chapters devoted to these individual projects, I reckon with the specificity of their social locations, identities, and communities of practice, theorizing immanently along with them. "Profaning," for example, works through queer theory and Jewish mysticism; "Remixing" takes up Indigenous and Afrofuturist texts; and "Fermenting" engages with ecological theory and science studies. I pilfer from a range of theorists in vernacular style, cutting and mixing pragmatically as the need arises. Certain thematic currents run through all of these discussions: the poisoned dialectic of tradition and modernity, the powers of vernacular practice, the dispossessions of colonialism, the act of translation, and the processes of experimentation. In this theoretical chapter, "Reclaiming," I aim to sound the depths of those currents, as they pool in "fountains of time." In so doing, I engage with a range of perspectives, including Indigenous theory, radical history and political economy, and the work of the German-Jewish critic Walter Benjamin and those influenced by his writing. Benjamin's acute sensitivity to the catastrophic damage of European modernity,

as well as his eccentric reclaiming of Jewish mystical traditions, make him a key thinker for my project here. His essays, letters, and fragments from the 1920s and 1930s resonate for me now, in another "moment of danger."[2] Throughout this book, I argue for a strong relationship between embodied collective practice and what I call, after Benjamin, "the discontinuum of tradition"—the striated and uneven medium, marked by discontinuity and dispossession, through which shared ways of being and doing are translated.[3]

THE DISCONTINUUM OF TRADITION

Collective practice, as I have discussed in my introduction, powerfully shapes embodied subjectivity through forms of repetition. But how are collective practices transmitted over time, especially outside of formal institutions? "Tradition" is a highly contested term, but one way it can be understood is as a way of naming the repeated transmission of collective practices and embodied techniques. Derived from the Latin *tradere* (to hand over or deliver), it is most meaningfully used to identify and establish lineages of intergenerational practice. Tradition does not require a static content or an anchor in a distant past: family or group traditions, for example, can be of quite recent vintage and are altered with each new iteration. What establishes a tradition is its designation as such, along with its accrued history of translation (a term which I will explore later in this chapter), rather than any specific content that is transmitted. Rather than reifying tradition as unchanging and having fixed boundaries, it should be understood as a creative practice of interpretation, a form of retrospective reinvention.[4] It is a way of linking the practices of the dead and the living, elders and youth, ancestors and descendants. Crucially, tradition has a

collective dimension: it declares that a current practice is an echo or a revision of a shared way of doing or making. Despite its appropriation as such by self-described modernizers and traditionalists, tradition need not be conservative. For artists, thinkers, and activists, linking oneself to the collective practice of preceding generations can offer profound resources for struggle and creative work in the present. This is the sense in which "tradition" is taken up in Walter Benjamin's phrase "the tradition of the oppressed," or in Cedric Robinson's writings on "the black radical tradition," which he defines as an "accretion, over generations, of collective intelligence gathered from struggle."[5] Such understandings of tradition place the speaker in a flexible, retrospective lineage, which they are in turn altering with their contributions. And they suggest that political and aesthetic creativity is heightened, not reduced, by a formative affiliation with past collective practice.

Yet this more expansive and active meaning has been colored by tradition's role as the privileged "other" of modernity. "Tradition" has, since the eighteenth century, come to describe cultures and peoples that are static, bounded, and unfree, as distinguished from the rational and creative autonomy of Enlightenment subjects. Enlightenment rationality, with its universalist and progressive drive, has tended to define itself in contrast to "age-old" tradition, which it associates with the rural, the local, the particular, the constrained, and the unreflective.[6] The opposition between Enlightenment freedom and traditional constraint is foundational to the discourse of modernity, which values autonomy above all else. By enacting a "performative break" with tradition, Elizabeth Povinelli writes, the discourse of modernity made a constitutive split between two kinds of subjects.[7] On the one side is the autonomous and sovereign individual, the *parvenu* or self-made man, who establishes his freedom through a rejection of traditional constraints (the gendered language is appropriate here).

On the other is the grid of social determinations, the binding traditionalism to which modernity's others—Indigenous and colonized peoples, peasants, workers, women—have been subjected. These categories are discursive constructions: as Bruno Latour and others have argued, we have never been modern, and tradition has never been "traditional."[8] Nevertheless, the discursive split between the autonomous subjects of modernity and the fettered subjects of tradition has had powerful, and ongoing, effects. The split between autonomous "moderns" and static "traditional" peoples has served to justify operations of dispossession, enclosure, and colonial rule. And it has encouraged the recuperation of tradition in the pacified forms of heritage and folklore—forms that still shape the contemporary understanding of collective vernacular practice.

Enlightenment modernizers began by dismissing the customs and practices of the "traditional" peoples whom they dispossessed or uprooted—including the peasant classes in their own countries—as superstition and irrational error. But perhaps in a recoiling from (or disavowal of) the violence of dispossession, a more charitable way of understanding tradition soon came to the fore. Nineteenth-century discourses of heritage and folklore sought to preserve collective practices that had been suppressed or discarded in the rush to modernize. In Europe, tradition was associated with the vanishing rural world of peasant life, the traces of which existed only in the "mutilated" form of superstitions and stories. The key shift was the recuperation of these "survivals," which previous modernizers had sought to eliminate, as elements that should be valued and preserved—indeed, as the cornerstone of a revitalized national culture.[9] The discipline of folklore took as its subject what Enlightenment rationality had described as shameful backwardness and error, the attachments and practices that capitalist modernization had supposedly left

behind. Folklorists began to sift through the wreckage of modernity for scraps of lost tradition worthy of preservation. As Barbara Kirshenblatt-Gimblett notes, shame and error became the subject of scholarship: "What one was too ashamed to do, one could study, collect, and display."[10] Those elements that folklore pulled from the waste pile of modernity could then be exhibited and enjoyed as heritage.

Ironically, the exhibition of repudiated cultural forms as heritage can be another way of nullifying those same forms as living practices. The "heritage operation" (as Kirshenblatt-Gimblett calls it), in its classic modernizing form, tends to seal embodied practices off from their collective use, turning them into museum pieces. When tethered to the discourse of modernity, heritage domesticates, mummifies, enshrines, and pacifies. In a fragment of *The Arcades Project*, Walter Benjamin remarks on the dangers of this style of heritage operation, and how the danger might be countered. He writes:

> What are phenomena rescued from? Not only, and in the main, from the discredit and neglect into which they have fallen, but from the catastrophe represented very often by a certain strain in their dissemination, their "enshrinement as heritage."—They are saved through the exhibition of the fissure within them.—There is a tradition that is catastrophe.[11]

As Benjamin feared, tradition's "enshrinement as heritage" has become the dominant institutional mode of relating to collective embodied practices of the past. If the discourse of modernity first established itself by splitting with tradition, it soon moved to recuperate that remainder in frozen and neutralized form. Now, ironically, "the possession of heritage" has become "a mark

of modernity," and heritage productions and performances are replicated around the globe.[12] The "tradition that is catastrophe," for Benjamin, is the sealing up of what he elsewhere calls "the discontinuum of tradition," the temporal and spatial medium full of historical gaps and ruptures through which collective practices are transmitted.[13] To rescue tradition from its enshrinement as heritage requires a more radical approach, which focuses on this discontinuum—marked by the breaks and wounds of history—rather than a seamless whole. The projects and movements I examine in this book seek to highlight the fissures within collective practices left behind by colonial and capitalist dispossessions, illuminating the discontinuum of tradition.

If heritage represents one "tradition that is catastrophe," sealed off from the discontinuous movement of collective history, then "the folk" is surely another. "The folk," folklore's object of study, is another eighteenth-century European invention: it imagines an organic and holistic community living outside of urban centers, culturally and technologically isolated and still carrying on the "old ways."[14] "The quest for the folk" became the project of generations of modern intellectuals, who sought to recuperate "folk traditions" as a salve for the fragmentations of commercial urban life.[15] As part of a myth of a lost organic community, the recuperation of tradition in the substantive form of "the folk" has had oppressive and even devastating effects. The idea of the lost folk community—as in the *Volksgemeinschaft*, often coded as racially pure—that could be recovered within the modern nation-state went on to inspire a succession of antimodernist movements. It expressed itself in the "invented traditions"—perhaps more accurately called reified national traditions—of modern state pageantry, iconography, and rituals.[16] And it took on a deadly new life in the twentieth century, in the fascist unification of a "people" with its pure, "organic," premodern essence. In contemporary

liberal states, the fantasy of the organic folk community seemed for many years to have been disentangled from a violent fusion with national belonging. But the reemergence of nativist, neofascist, and white supremacist movements in twenty-first-century Europe and North America suggests that this all-too-literal catastrophe, which long seemed unthinkable, is being repeated in updated, technologically enabled forms.[17]

Less blatant versions of a "tradition that is catastrophe," often blending elements of "heritage" and "the folk," are omnipresent in a world that is at once globalized, connected, and fragmented. State discourses of multiculturalism, which tend to treat "communities" as organic and undifferentiated units, carry forward the fantasy of the bounded folk community, not at the level of the nation-state but at the level of the diasporic group. The fantasy of pure and traditional origins survives in certain subaltern peoples' rhetoric of uplift, which can slide into the pastoral imagination of a "pre-modern idyll."[18] Enduring structures of gender inequality and enforced normativity are often justified by an appeal to tradition; after all, what could be more "traditional" than male domination? Under contemporary regimes of intellectual property, "tradition" is increasingly recuperated through the legal incorporation of identity and the commodification of cultural products and practices. Faced with these commodifying forces, some ethnic and Indigenous groups have been driven to become "entrepreneurial subjects" selling their brand and defending their identities through "lawfare."[19] Markets for "traditional" art and crafts encourage rhetorical claims of authenticity; "intangible cultural heritage" is shored up via UNESCO designation and state support; museums worldwide preserve objects designed for collective use in glass cases and storage vaults. All of these appropriations of tradition, despite their appeals to a well-defined, often "pre-modern" past, are modern to the core.

They take place on a playing field where the rules are set by discourses of modernity.

Part of my project in this book is to continue to undo "the sterile opposition of tradition and modernity," as Paul Gilroy calls it, and to contribute to reclaiming a more expansive and active understanding of "tradition"—a term which some critics would understandably like to abandon.[20] Perhaps unsurprisingly, given their lineage as "conscripts of modernity," writers in the Black radical tradition offer some of the most incisive reclaimings of "tradition."[21] Rather than viewing tradition as the discarded or recuperated other of modernity, Gilroy, echoing the poet Amiri Baraka, describes tradition as "the living memory of the changing same."[22] For Gilroy, retracing tradition's living memory means looking deep into the fissure: in the case of his much-debated book *The Black Atlantic*, into the colonial processes of dispossession and enslavement that have transformed much of Africa and its diasporas. It means viewing history, with all its violence, as the medium where living and embodied memory is transmitted between generations, where the changing same unwinds itself. What matters is not a chasing after lost mythical origins, but a reclamation of tradition in all its awful history, its profane impurity. Indeed, for Gilroy, this worldly history is not where tradition is forever erased, but where it is "secreted and condensed into ever more potent forms."[23] This commitment to a fissured and brutal history as a creative medium for experimentation also runs through the poet and scholar Fred Moten's aptly titled *In the Break: The Aesthetics of the Black Radical Tradition*. "In the break"—and, in Christina Sharpe's evocative phrase, "in the wake"—can be a site where traditions are potently reimagined and transformed.[24]

In its more radical forms, *reclaiming* works to undo the damaging opposition of tradition and modernity, to reject the embalmed appropriation of tradition as heritage, and to experiment in the

breaks and wounds of history. As a style of collective practice, this radical reclaiming makes creative links within the discontinuum of tradition. Its retrospective reinvention foregrounds temporal fissures and translations, allowing tradition's "changing same" to transform into new meanings, new practices, and new vernaculars.

VERNACULAR MUSICKING AND COMMONING

When the apologists of capitalism and colonialism described the practices of the peoples they uprooted as "traditional," they were identifying and hoping to neutralize forms of collective embodied practice that linked people with the land and with their past. These practices were not necessarily sanctioned by official institutions: many of them tended to be bottom-up, flexible, and rooted in intimate networks of human and extrahuman relations. A general term for these grounded collective practices might be "vernacular." If "tradition" can be wielded by cultural elites to achieve consensus about the past, "vernacular" has more of an oppositional class connotation, suggesting collective practices that have been devalued or suppressed. It shares this connotation with the related terms "vulgar," "popular," and "common," which all carry a subaltern charge.[25] Derived from the Latin *verna*, the word for the houseborn slaves of ancient Rome, "vernacular" often refers to languages spoken by localized communities, as opposed to "cosmopolitan" tongues such as Latin or Sanskrit.[26] This is a mobile dialectic: a local idiom like English can turn into a world-conquering cosmopolitan language, while still possessing countless vernacular variants. As with "tradition," "vernacular" should be understood not as a substantive noun, but as a set of moving practices: not as a thing that people are, but as things that people do. Vernaculars are collective embodied practices that operate

FIGURES 1.2 AND 1.3

The discontinuum of tradition:
scores by Matana Roberts (2010)

from below. They begin from local attachments, use materials that are readily available, and proceed without the permission of authoritative institutions.

Vernaculars can be recognized by their bottom-up style of practice, rather than by their mode of transmission. Like "tradition," they have been most often associated with oral rather than written culture, but this attribution is itself an echo of the modernity/tradition split. To take up performance scholar Diana Taylor's language, vernaculars are often transmitted through a "repertoire" of embodied technique: gestures, vocal inflections, foodways, dances, songs, and stories. But they also pass through "archives" of material traces and technological supports, including written language, material culture, audiovisual recordings, recipes, images, and graphic representations—even the breeding of plants and animals, and traces left on the land.[27] Indeed, many vernaculars (including the projects I take up in this book) freely blend archival and repertorial forms of transmission, rendering this distinction rather blurry. As they move through archives and repertoires, two spheres of activity offer useful examples of vernacular practice's bottom-up approach. Looking at collective music-making, or "musicking," can help evoke vernacular styles, textures, and logics; while examining modes of creating and sustaining common life, or "commoning," can reveal the political stakes of reclaiming lapsed or suppressed vernaculars.

The opportunistic and grounded style of vernacular practice is evident in the sphere of music-making, providing insights that can be extended to other practices. As Julian Henriques argues in his study of dancehall crews in Kingston, Jamaica, vernacular music-making requires large doses of what the Greeks called *mētis*, or "practical intelligence."[28] Among dancehall crews, *mētis* allows MCs, selectors, and audio engineers to engage in skilled performances without necessarily specifying the rules by which those

performances are governed. This is "the logic of practice"—a formulation that should be applied to all practices, not only those of "unofficial culture" or subaltern groups.[29] Playing or listening to music, like any practice, is a collective matter: from hip-hop MCs to orchestral musicians to playlist-sharers, music is created and given meaning by formal or informal communities of practice. Vernacular music-making in particular is marked by its lack of explicit codification and formalization. Unlike, say, Western classical music, which works through notation and systems of practice that have come to be established and transmitted by official institutions, the music of Jamaican sound systems is created, judged, and experienced through unofficial and informal criteria—"vibes"—that are worked out in recording studios and street parties rather than in conservatories and concert halls. This is not to suggest a hierarchy of musical worth or ability; nor is it to overlook the tacit knowledge and complex forms of apprenticeship that characterize the training of both classical musicians and dancehall crews. Rather, social hierarchies inflect these different collective practices, giving them their particular modes of logic, methods, styles, and flavors. The opportunism, *bricolage* (mixing of available elements), and abundant multiplicity of vernacular practice are made necessary by its subordinate status: you have to work with the materials that are there.

A closer analysis of this style of music-making helps to reveal what Henriques calls the "subaltern creativity" of vernacular practice. Henriques's term for the logic of sound system crews is "sound practice," with the word "sound" serving in a double sense: both sonic and "correct." Music and sound-making should, in any context, be understood as practices, things that people do: "musicking," as Christopher Small calls it, or "sounding," in Henriques's formulation.[30] The fact that Henriques is studying "a contemporary vernacular culture—the 'vibes' of all night dancehall sessions

on the streets of downtown Kingston"—does not mean that this sonic culture is any less sophisticated, skilled, or rule-governed than "official" culture.[31] Instead, the "sound practice" of these sessions demonstrates a vernacular logic. As Henriques writes,

> The crew's performance techniques assemble a comprehensive range of embodied knowledge, tacit understanding, common sense, folk wisdom, ritual and many other ways of knowing, with which the crew "make sense" of what they do as and by doing it. The logic of sound practice is invariably multiple, as with the practice of musicking—assembling together everything and everyone needed for an event.[32]

Henriques's summary can serve as a capsule definition of vernacular practice, which tends to be situated, multiple, opportunistic, and evidently collective and embodied, and often works from a subaltern position. It proceeds by "assembling together everything and everyone needed for an event"—an approach shared by the diverse aesthetic experiments that I examine in this book.

A primary attraction of vernacular musicking is its ability to transcend the barriers that can be erected around the "traditional," "folk," or "vernacular" community. Sonic affects are carried more through vibration than signification: while linguistic vernaculars tend to mark out semantic and social boundaries, musical vernaculars can function more easily as sites of encounter. Music spills over the legal and symbolic borders of property, culture, and social group. Musical styles and rhythms are easily absorbed and reconfigured across communities of practice, as in the polyglot musical cultures of port cities, from Salonika to New Orleans to Salvador da Bahia, or in the contemporary Internet-based exchanges and appropriations between multiple musical vernaculars. Music is one of the more copious cultural forms: linked to the "abundant

style" of what Marcus Boon calls "folk practice," it "precipitates collective joy [or sorrow], is eminently portable, and resists being turned into a thing or property—which is why folk cultures love it so much."[33] This is not to suggest that vernacular musicking is utopian; vernacular music is subject to intense commodification and battles over property rights and can be appropriated by dominant groups. But as a vernacular practice—as something people do with the materials they have—these styles of musicking carry a certain promise of abundance, experimentation, and encounter.[34]

While musicking allows shared joy and sorrow to flow across symbolic and legal borders, vernacular practices of *commoning* engage more directly with the creation and sustaining of shared forms of life. Embodied practices of commoning are modes of setting up, maintaining, regulating, and defending common lands and lifeways for the purposes of collective mobility and survival. If the vernacular has a political radicality, it can best be seen in these diverse customary practices of establishing collective relationships to the land and the means of subsistence. Liberal economists tend to analyze "the commons" as a *thing*, a pool of common resources which members of a group negotiate to share. But as the historian Peter Linebaugh has argued, it is more fruitful to turn this noun into a verb: to think not of the commons but of collective practices of *commoning*.[35] Vernacular practices of commoning are ways of articulating human and ecological collectivities, and of reining in the power of rulers. As practices of shared subsistence, they are embedded in a particular ecology and a labor process, "in a particular praxis of field, upland, forest, marsh, coast."[36] They can vary widely—from practices like the harvesting of wild rice by the Anishinaabeg peoples of the Great Lakes, to the reliance on common forests, fields, and waterways by subsistence farmers worldwide. Generally, these practices are independent of the restrictions and temporalities of states and their laws. When

practiced in a bottom-up fashion, by people who live close to the land, they are ways of setting up a relational web of what Leanne Betasamosake Simpson, referring to Indigenous practices, calls "grounded normativity," encouraging human and extrahuman flourishing.[37]

In its broadest definition, "commoning" can be understood as a set of collective practices that work to create and sustain common life. This work extends from questions of subsistence and relation to the land, to the creation and maintenance of shared forms of culture, language, and knowledge. Vernacular practices of commoning are historic, to be sure—they regulate forms of collective existence and struggle which enslavement and serfdom, the enclosures of capital, and the armies of colonization have attempted to destroy or suppress. Yet they continue to operate around the globe: as practices of sustaining the land and all its inhabitants, as practices of shared production (from community gardens to the free software movement), and as practices of sociability, including the sharing of food and drink. The verb "commoning" reminds us that "the common" is an active force that is constantly produced and reproduced. A "baseline communism" of reciprocal relationships can even be argued to subtend all social life, including those in capitalist economies, providing the raw material for variable economic structures and cultural forms.[38] Commoning, as a form of collective vernacular practice, can thus be understood as "the creation of new forms of sociality, as new collective practices of living, working, thinking, feeling and imagining that act against the contemporary capitalist forms of producing and consuming (variously enclosing) the common wealth."[39]

The vernacular web of commoning is precisely what must be torn apart for enclosure to take place. Enclosure is necessary for the "primitive" or "original" accumulation of capital, the history of which, as Marx famously wrote, is written "in letters of blood

and fire."[40] Its object is the privatization of the land, and the production of workers who have nothing to sell but their labor power. This process requires the transformation of vernacular affects and practices, as well as the uprooting of subsistence communities. As contemporary theorists have noted, "accumulation by dispossession" does not belong to the "pre-history" of capitalism.[41] Rather, it is constantly reproduced around the globe, in the service of extractive industries and what Silvia Federici calls capital's "lust for labour."[42] In the 1980s, Federici, Linebaugh, and the other members of the Midnight Notes Collective were among the most acute observers of "the new enclosures" caused by the global drive for cheap resources and cheap and compliant labor, a process supported by nation-states and international financial institutions such as the IMF. Enclosure, they write, attempts "to eliminate any 'traditional,' 'organic' or institutionalized relation between proletarians themselves and the powers of the earth or of their past."[43] Both old and new enclosures seek to block the ability of commoners to form an embodied practical relationship with the land or with their own history. Enclosure tries to tear up the intricate root work of vernacular practice that offers a base from which to struggle and resist.

The methods of the new enclosures, which continue to operate globally, are similar to the old ones: severing people from the means of subsistence, seizing land for debt, and encouraging mobile and migrant labor. Enclosures seek to uproot people from collective vernacular practices of commoning and subsistence: what could be called the "practical vernacular economy."[44] Federici and her colleagues in the Midnight Notes Collective refuse to see the destruction of the commons as ultimately progressive, as Marx (mostly) did.[45] Rather, they risk anachronism in allying themselves with struggles to defend the commons, including contemporary movements of Indigenous peoples.[46] In their essay "The New

Enclosures," the members of the Midnight Notes Collective also propose a new "jubilee"—joining their voices to an often-repeated call for freedom and the forgiveness of debt. In the face of intensifying enclosures in the seventeenth and eighteenth centuries, the biblical call for jubilee echoed around the Atlantic world; it meant "the abolition of slavery, the cancellation of debt and a return of all land to the common."[47] The language of jubilee might seem utopian, overly religious, and archaic. But as the Midnight Notes Collective proclaims, defending their reclaiming of this radical vernacular tradition: "It is time at midnight for other words and spells in the magic struggle of classes."[48]

It has now been nearly thirty years since the collective wrote these lines. The clock is still striking midnight: the commons of the air, sea, and earth are subjected to ever more intense expropriation and despoliation; workers everywhere are still ground down by debt; masses of people are forced to leave the land for growing urban slums. Words like "commons," "enclosures," and "jubilee" may seem to belong in another epoch. But if these well-worn words have a little magic left in them, it is because of their roots in collective, vernacular practice. Indeed, even in the midst of the enclosures of capital, practices of commoning are far from anachronistic; they are everywhere. "Reciprocity, sense of self, willingness to argue, long memory, collective celebration, and mutual aid are traits of the commoner," Linebaugh writes.[49] These traits are always available to be reactivated—in practices of music-making, shared sociability, protest, or care for the land and its inhabitants. In their various ways, the aesthetic experiments that I examine in this book are new translations of that practical heritage. They may or may not struggle directly against the new enclosures. But in the simple sharing of a song, a round dance, or a sourdough starter, a vernacular spirit of commoning flickers, ready to be retranslated, renewed, and reclaimed.

SETTLER TIME AND PROPERTY

In a political-cultural economy organized around novelty and forced obsolescence, practices that are called "traditional" are often described as *anachronisms*. They are seen as "survivals," lingering belatedly in a time and place in which they have no business. Anachronistic collective practices are out of step with the current of the times, outmoded and obsolete. They are ways of making, thinking, and acting that are supposed to have been either superseded by technological advances, revealed as superstition by scientific progress, or rendered moot by societal change. At best, they may survive in the form of heritage performances or artisanal craft practices. At worst, they are dismissed, abandoned, or suppressed. Yet the very categorization of these collective embodied practices as anachronistic gives them a subversive charge. As the groups and movements discussed in this book demonstrate, there is a political and aesthetic energy in taking up vernacular practices consigned to the past and translating them into new experimental forms. This is especially the case in settler-colonial societies, with their particular regimes of time and property—regimes that these radical vernacular experiments attempt to suspend or undo.

These settler regimes of time and property work differently for different groups living within them, dividing along lines of race and Indigeneity. As I have argued above, the subject of Enlightenment modernity is predicated on an autonomy that breaks with the supposedly binding nature of tradition. In settler colonies, this break has mapped neatly onto the division between settler and Native. The settler was "master of himself, and proprietor of his own person," in John Locke's famous words; this autonomy and self-possession gave the settler the sense that he had the right to dispossess the native, who was seen as hopelessly enmeshed in customary bonds.[50] Discourses of self-possession are particularly

potent in white settler colonies such as the United States, Australia, and Canada, with their fantasies of pioneers in a hostile wilderness and self-made men who are able to start from scratch. These discourses of autonomy are matched by those that consign Native people to an unchanging "traditional" past, pushing them either to assimilate to a future-driven settler modernity or to become what Elizabeth Povinelli calls "melancholic subjects of tradition."[51] As I examine in more depth in chapter 3, the demand that Indigenous peoples authentically perform their "traditions" becomes yet another mechanism of dispossession in liberal settler colonies. Indeed, in Canada and Australia, this demand is written into law.[52]

Settler-colonial societies have been especially virulent in their categorization of the collective practices of Indigenous peoples as anachronistic, belonging to a "traditional" past, because this categorization has been part of an effort to separate Indigenous peoples from their land base. Through state-driven strategies, from reservation systems to boarding schools to forced adoptions, settlers attempted to sunder the thick intergenerational web of collective embodied practice—including language, subsistence, ceremony, lifeways, and performance forms such as music and dance—that linked First Peoples to the land. By declaring Indigenous collective practices to be anachronisms and either suppressing them or consigning them to the realm of static "tradition," they hoped to legitimize and facilitate the dispossession, assimilation, and eventual elimination of land-based peoples. This process is ongoing: in settler-colonial societies, "invasion is a structure, not an event."[53] Settlers come to stay, laying claim to the land by virtue of their labor. "Lives are lived," the Mohawk theorist Audra Simpson writes, "within an ongoing violence over territory."[54] As she points out, "the condition of Indigeneity in North America is to have survived this acquisitive and genocidal

process and thus to have called up the failure of the project it-self."[55] The fact that Indigenous peoples have persisted in the face of attempted elimination testifies to the limitations of the settler-colonial project, and to the power of Native resolve and creativity. But even if the project of elimination has failed, it has irrevocably shaped the lives and practices of settlers, migrants, and Indigenous people living on this land.

Settler-colonial regimes of time and property continue to warp all those living under their sway. The staking out of property by settlers—the expropriation of land for resource extraction, agricultural production, public enjoyment, or private leisure—is supported by a temporal schema that forces the land's First Peoples to choose between a vanishing past or the progressive futurity of settler modernity. Settler subjects, meanwhile, are offered a future of autonomy, but the cost is that their collective vernacular inheritance can be expressed only in an inert form. This is a "discursive vise," as Povinelli calls it, which insists that "indigenous groups be culturally frozen and alternative groups be culturally stillborn."[56] It produces subjects cut off from their collective past, from the powers of the earth, and from each other. Neoliberal social forms heighten this pressure, throwing uprooted subjects into the maelstrom of competition, dislocation, precarity, and entrepreneurial selfhood. It should be no surprise, then, that neofascisms have emerged promising to reanchor deracinated, predominantly white subjects in a fantastical vernacular community. "Tradition," as the discarded other of modernity, is always in danger of returning in this catastrophic form.

Radical vernaculars, as I theorize them here, do not promise a return to the authentic *radix*, the root, as if it had never been disturbed. Rather, they embrace an experimental process of rerooting (or rerouting) into the soil of collective practice, honoring its complex and entangled forms of life. From different social locations

and with different stakes, they resist settler-colonial regimes of time and property—regimes set up for the purposes of capital accumulation, resource extraction, and social stratification. Against these regimes of time, they experiment with the powers of anachronism, finding energy in forms of life that have been suppressed or abandoned. And against these regimes of property, they propose forms of what might be called *depropriation*—practices of opening up beyond the self-possessed individual and meeting other beings in a space of encounter.[57] They do this work in different ways, and from different social locations. The non-Indigenous projects I explore are focused on undoing the discourses of autonomy that cause "alternative groups," as Povinelli writes, to be "culturally stillborn." Their acts of reclaiming are an effort to undo the self-possession of the Enlightenment subject, by opening their participants up to radical forms of history and alterity. By contrast, the Indigenous projects that I engage with in chapter 3 move with a "radical resurgence" that is oriented, in Leanne Betasamosake Simpson's phrase, toward reclaiming "the fluidity of our traditions," not "the rigidity of colonialism."[58] The artists, writers, and activists of this resurgence movement struggle to undo the regimes of time and property that either treat Indigenous peoples as "culturally frozen," bound to static tradition, or force them to assimilate into a modernity that is designed to eliminate them. They reject the separation of "culture" from other forms of practice, especially those connected to the land. Instead, they emphasize a creative and fluid reclaiming of long-devalued and suppressed Indigenous collective practice.

By addressing these projects in the same book, I do not mean to suggest that they are commensurable—structurally equivalent or exchangeable. There are fundamental differences in the lived experience of settler colonialism between Indigenous and non-Indigenous peoples. These experiences are further stratified by

race, gender, sexuality, and class, and by individual itineraries. Inside this stratified social field, there are numerous histories and projects that would be productive to explore. My work here is not intended to be synoptic or comparative; I do not want to smooth over incommensurable experiences.[59] Instead, I am interested in the productive tension that emerges from thinking through specific experiments with collective practice across settler-colonial divides. The theoretical frameworks I develop here are an attempt to bring out points of contact and fault lines that might otherwise be obscured. In contrasting ways, these Indigenous and non-Indigenous projects work to undo the double bind of modernity and tradition, so pronounced and poisonous in settler colonies, and to unwork regimes of self-possession and enclosure. Central to each of their collective experiments is what might be called an act of *translation*, a movement that carries "tradition" across profound gulfs of historical discontinuity.

STRATEGIES OF TRANSLATION

The need to translate tradition through a discontinuum, across temporal breaks and fissures, can perhaps be most effectively conveyed by a story. In a recent foreword, the Cree-Métis writer Maria Campbell describes the difficulty of reclaiming Indigenous traditions in the wake of the dispossessions of colonialism. Campbell tells the story of her "first old man teacher," Peter O'Chiese, who impressed on her the need to gather the pieces of a fragmented culture from whatever sources were available, including the writings of colonial ethnographers. As she tells it:

> One day, to illustrate why it was important to do this, he picked up a jigsaw puzzle my children and I had just

completed. He lifted it high and dropped it. Pieces flew all over the room. "That's what happened to *wahkotowin* and to all our stuff," he said. "Our kinships, our lives, and our teachings are all over the place. Those anthropologists and people who came to our elders to get stories and knowledge recorded everything and took it away. Our old people talked to them because they knew it was the only way they could save it. Maybe it is not complete, maybe pieces are missing, but if you know the language and some of the stories, then you have a big piece."[60]

O'Chiese's breaking of the puzzle, in Campbell's telling, reveals the experience of colonialism to be one of profound and violent fragmentation.[61] His suggestion—to sift through the archive left by a violent history for pieces that can be reassembled—is a compelling one. Even more striking is the image of the jigsaw puzzle. A jigsaw puzzle is itself a fabrication, a set of fragmented pieces that are cut to fit together snugly. Snugly, but not seamlessly: even in its completed state, a jigsaw puzzle is not a seamless whole. In fact, its seams—its fissures—are what give it value: they are the visible record of the work of its assembly. What is undone in the shattering of a jigsaw puzzle is not the image it depicts (which is in any case visible on the box); rather, what is lost is the painstaking work that went into fitting the pieces together. It is no accident that in the case of the puzzle shattered by O'Chiese, that work was done by Campbell along with her children. In the realm of collective vernacular practice, this embodied work of assembly and fabrication, as it takes place across generations, could be called "tradition."

Campbell and O'Chiese's image of the shattered puzzle of tradition recalls numerous images in the work of Walter Benjamin, a writer acutely attuned to historical uprooting and the disruptions

of intergenerational continuity. One image in particular suggests that translation might be a useful metaphor to describe the work of reclaiming the scattered fragments of past practices. In "The Task of the Translator," Benjamin compares the work of literary translation to painstakingly gluing together the pieces of a broken vessel. In order to reassemble a shattered vase or bowl, he writes, the pieces "need not be like one another." They do not need to be similarly shaped; instead, their broken edges need to fit together in a greater whole. Translation, in his view, functions in this way. Rather than slavishly imitating the literal "sense" of the original text, he writes, a translation "must lovingly and in detail incorporate the original's way of meaning." In this process of incorporation, both the original and the translation become "recognizable as fragments of a greater language, just as fragments are part of a vessel." For Benjamin, there is no "authentic" original that is translated. Rather, original and translation are both suspended in a larger discontinuum, connected across a constitutive gap by their "way of meaning."[62]

Perhaps I can take the risk here of translating Benjamin's discussion from the literary realm to the translation of intergenerational collective practice, or "tradition." A tradition's "way of meaning" might be something like its "changing same"—the essenceless continuity that is secreted and condensed in forms of collective practice as they move through history. "Lovingly and in detail"—or ambivalently and carelessly, or irreverently and playfully—translations of a tradition incorporate and transform that changing same. Unlike in literary translation, and despite the protestations of "traditionalists" everywhere, there is not even a contested original to return to. Every translation of tradition is a translation of a previous translation, in a process that tends to emphasize a style of practice—a "way of meaning"—over its specific content. It is this "way of meaning" that is most easily

identified in a given vernacular idiom: in the cadence of a phrase, the movement of a dance step, the style of a joke, or the cooking of a dish. A tradition is a kind of citation of a citation, a translation of a translation—and yet one that is instantly recognizable to its practitioners. My own devout, shtetl-dwelling Jewish ancestors may have lived lives utterly different from mine, but something of their style of practice is carried over to me in the present. I feel it in my propensity to argue over ideas and definitions, in my styles of music-making and cooking, and in my orientation to books and learning. In a new language, in a new territory, I reach for these fragments of collective vernacular practice and retranslate their "way of meaning."

Tradition, as the transmission of collective embodied practice across generations, is always a matter of translation: in each generation, shared practices must be adapted into new contexts, which requires their translation into more or less recognizable forms. But this process of translation is especially pronounced where historical discontinuity has become dramatic, where the assembled fragments of the past have been broken, scattered, and lost. "Tradition" is always marked by gaps and fissures; the puzzle or vessel of tradition, as Campbell and Benjamin remind us, is already an assemblage of pieces. Yet certain forms of discontinuity are particularly violent and profound: colonial dispossessions and capitalist enclosures, the genocide and enslavement of peoples, as well as secularization, war, occupation, migration, and the transformations of urban life. The storm of history can scatter tradition's fragmentary assemblage and disperse its pieces more profoundly and irrevocably. Peter O'Chiese articulates this painful experience, standing over the broken puzzle: "That's what happened to *wahkotowin* and to all our stuff," he says, using the Cree word that conveys the reciprocal relations of all living things. "Our kinships, our lives, and our teachings are all over the place."

Such profound dislocations and disruptions can cause what the critic Jalal Toufic, referring to the decades-long Lebanese Civil War, calls "the withdrawal of tradition after a surpassing disaster."[63] A surpassing disaster is a traumatic event after which "tradition" as such becomes unrecognizable and unusable. After the expulsion or uprooting of a people, after genocide or years of relentless war, even the ceremonies, practices, books, and artworks that have not been destroyed can no longer be accessed in their previous state of received intergenerational wisdom and cultural inheritance. Benjamin, in a letter written in 1938, describes this condition of withdrawal in a striking phrase as "a sickening of tradition."[64] Here Franz Kafka's writing is exemplary for Benjamin in revealing the decay of traditional "wisdom," or knowledge handed down from generation to generation. In Benjamin's view, the religious tales and knowledge assembled by generations of Jews now lie in pieces, unable to be patched into a consistent whole. Tradition has decomposed into fragments: in Kafka's writing, "there is no longer any talk of wisdom. Only the products of its decomposition are left." Benjamin argues that some of Kafka's contemporaries came to terms with this decomposition by "clinging to truth, or what they believed to be truth, and, heavyhearted or not, renouncing its transmissibility." But Kafka's approach to the withdrawal or "sickening" of tradition was radically different. "Kafka's genius," Benjamin writes, "lay in the fact that he tried something altogether new: he gave up truth so that he could hold on to its transmissibility."[65] Transmissibility is Benjamin's highest value: not the truth of the fragment itself, but the fragment's ability to reveal the larger vessel, which is revealed only through translation. When confronted with the decomposition of tradition, what matters is not the "sense" or "truth" of each broken fragment, but the ability to transmit and translate "ways of meaning" across gulfs of discontinuity. Benjamin suggests that acts of translation can

give new life to tradition, conveying it in a state that is, in Judith Butler's words, "both ruined and vibrant."[66]

In her 2012 book *Parting Ways*, Butler formulates the relationship between tradition, discontinuity, and translation in a particularly incisive manner, as she considers the problem of "deriving a set of ethical principles" from traditions of Jewish thought. These traditions, she argues, cannot simply be accepted wholesale. Of particular interest to her are "those acts of translation where the past must effectively break apart in order to be introduced into the future." In her argument, a translation of tradition can proceed only through a necessary self-departure, which involves a "breaking apart, or scattering."[67] Of course, as she notes, "tradition is itself established through departing from itself, again and again."[68] But translation across a gulf of discontinuity has a qualitatively different character: "A certain chasm provides the occasion for a tradition to reemerge as new. … Some continuity is broken, which means that the past is not 'applied' to the present nor does it emerge intact after its various travels. What proves vibrant in the present is the partial ruin of what formerly was."[69]

For Butler, an effective translation must break apart tradition's seeming continuity, what Benjamin calls its "consistency of truth."[70] In so doing, she writes, translation makes available new resources for the present: "The destructive and illuminative dimensions of translation become whatever still is active, whatever sparks still."[71] Butler's "sparks" derive from Kabbalistic mysticism, which sees myriad sparks of divine emanation scattered throughout the profane world (see chapter 2). In this book, I also follow the sparks that are struck by translations of tradition across historical gaps and fissures, as they fly through the profane realm of collective vernacular practice. Across incommensurable experiences, in the breaks of history, these projects as I understand them do not attempt to reinstate a tradition "as it really was." Rather, they draw

on the destructive and illuminative powers of translation, creating new experiments in the art of collective practice.

EXPERIMENTAL ARTS

Reclaiming lapsed or suppressed traditions—gathering and reassembling the pieces of a scattered puzzle—does not necessarily lead to cultural-political innovation, especially in the midst of cataclysmic social change. In "On National Culture," written in 1959 at the height of the anticolonial struggle in Algeria, the Martinique-born psychiatrist and theorist Frantz Fanon excoriates artists and intellectuals who were chasing after the scattered fragments of a precolonial past. Their "burning, desperate return to anything," he writes, led them to revive tradition as a degraded "inventory of particularisms."[72] The vernacular forms that they sought to reclaim were, according to Fanon, only a "veneer"; this frozen and reified surface did not reflect the "more fundamental substance beset with radical changes," a social totality undergoing the convulsions of decolonization. "Instead of seeking out this substance," Fanon writes,

> the intellectual lets himself be mesmerized by these mummified fragments which, now consolidated, signify, on the contrary, negation, obsolescence, and fabrication. ... Seeking to stick to tradition or reviving neglected traditions is not only going against history, but against one's people. When a people support an armed or even political struggle against a merciless colonialism, tradition changes meaning.[73]

In the context of a life-and-death struggle, Fanon argues, intellectuals cannot let themselves be pulled toward an imaginary past. There lies only "the detritus of social thought, external appearances, relics,

and knowledge frozen in time"; those who would linger there "can do little more than compare coins and sarcophagi."[74] Only by joining the popular struggle against colonialism can intellectuals hope to do more than chase after "mummified fragments." In shared anticolonial struggle, on the other hand, tradition comes alive: "the congealed, petrified forms loosen up." In the throes of revolution, Fanon claims, "tradition changes meaning," becoming an ebullient and flexible creation.[75]

Reclaiming "traditional" modes of collective embodied practice for the purposes of aesthetic production or cultural revival was, in Fanon's view and at that conjuncture, a distraction from the revolutionary struggle for decolonization. Fanon's position is complicated by contemporary Indigenous theorists such as Glen Coulthard, who argue that artistic and cultural expression are part of holistic ways of being, doing, and making rooted in nationhood and the land base.[76] Indeed, the very separation of "culture" from "politics" can be understood as a colonial artefact. For Indigenous and non-Indigenous people in settler colonies, although in sharply contrasting ways, "traditional" forms of practice have been cordoned off into the cultural sphere, neutralized and separated from collective modes of existence—whether as heritage, craft, lifestyle, or high art. Yet, as grassroots social movements continually demonstrate, aesthetic practice is a crucial part of any struggle for radical change. For example, the 2016 protests against the Dakota Access Pipeline at Standing Rock reservation were given symbolic expression by artists of the Onaman Collective, based in Ontario, whose bold single-color prints of water protectors retranslated traditional Anishinaabeg imagery. These images, screen-printed and digitally reproduced, helped to carry the collective spirit and urgency of the Indigenous-led protests far beyond their site. The production of these images was not "traditionalist," in the sense of chasing after mummified fragments of a vanishing past. But in

a deeper engagement with traditional forms than that proposed by Fanon, "tradition changes meaning" through the reworking of images rooted in collective practice. Notably, the graphic work of the collective (by artists Christi Belcourt and Isaac Murdoch; see figures 1.4 and 1.5) is only one aspect of their mission, which is focused on the transmission of Anishinaabeg land-based knowledge, language, and culture across generations, through language camps and other gatherings.[77] The experimental activity of the Onaman Collective finds energy by rerouting and rerouting their collective past, connecting it with embodied struggle in the present moment.

This kind of collective practice sits uneasily within the bounds of "art" as it has been framed by aesthetic discourses and art institutions. Such radical vernacular projects do not neglect the aesthetic dimension: they intervene in the bodily sensorium, the *aisthesis*, altering their participants' sensual and intellectual experience of the world. They are examples of "aesthetic action," to use Métis artist and writer David Garneau's phrase, producing vibrant images, sounds, and performances, which can take shape as forms of art-making.[78] Yet the radicality of these projects is to move outside the frame of art toward the expanded mobility of collective practice. "Art," in this usage, means less the production of self-contained artworks, and more a practiced way of doing, as in "the art of cooking" or "the art of archery." The artists, collectives, and movements that I discuss in this book tend to reject the colonial culture/politics binary, which would place art into a kind of gated community or "ecological reserve," making it vulnerable to appropriation by elites and capture by market forces.[79] Rather, they experiment with collective embodied practices of reclaiming, repairing, and remaking in a damaged world, practices which may or may not take a recognizable artistic form.

The projects and movements of reclaiming addressed in this book have, above all, an experimental quality. Rather than chase

WATER

IS LIFE

ART BY CHRISTI BELCOURT

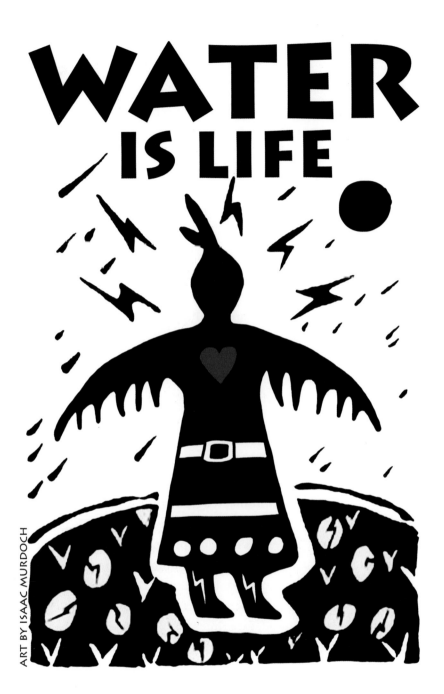

FIGURES 1.4 AND 1.5

Water protector banners by the
Onaman Collective (2016), artwork by
Christi Belcourt and Isaac Murdoch

after mummified fragments of tradition, they work experimentally to translate suppressed or abandoned practices into new forms of life. Philosopher Isabelle Stengers has written in this fashion of the experiments of neopagan witches, the North American feminist groups who have melded a reclaimed spiritual tradition with practices of nonviolent direct action. Indeed, the concept of "reclaiming" is strongly associated with their networks and collectives, for example in the writings of the activist witch Starhawk.[80] As Stengers and the activist Philippe Pignarre write in their book *Capitalist Sorcery: Breaking the Spell*, witches do not claim to be the inheritors of an authentic tradition, which would express itself in socially acceptable forms of spirituality. Rather, they are focused on the "rediscovery/reinvention of old resources," adapting suppressed vernacular practices in experimental fashion to meet the needs of the present.[81] For Stengers and Pignarre, "What makes people uncomfortable, what is difficult to accept is that witches are pragmatic, radically pragmatic: truly experimental technicians, experimenting with effects and consequences."[82] Their experimental techniques are cooked up collectively: what the witches call "magic" is a shared art or craft that embraces a common vulnerability. This art is communicated through "recipes," pragmatic accounts of the efficacy of collective experiments, rather than through doctrinal instruction. Such practical techniques, like other radical vernacular translations of suppressed traditions, are open to accusations of anachronism. But as the witches' role in helping to shut down the 1999 meeting of the World Trade Organization in Seattle showed, experimenting with old resources can create new collective recipes that are highly efficacious.[83]

In a moment of capitalist and colonial dominance marked by authoritarianism and xenophobia, the "rediscovery/reinvention of old resources" can offer experimental recipes for resisting pressing dangers. "Capitalist sorcery," in Stengers and Pignarre's

provocative phrase, names the threat of "capture" by a social system designed to turn its subjects into "minions" in thrall to the imperatives of competition and consumption. They use the anachronistic term "sorcery" to describe "the risks linked, in popular parlance, to the word 'soul': to sell your soul, to be soulless, to have your soul eaten or sucked out, or captured."[84] The vulnerability of the "soul" to capture is similarly analyzed in the work of Franco "Bifo" Berardi. Berardi writes that the present organization of political economy—which could be termed "semiocapitalism" or cognitive capitalism—demands more than just compliance at the workplace. It requires that the "soul" be put to work at all times, in waking and dreaming, producing value through affective engagement in the circuits of capital.[85] Wresting the soul back from its capture by these forms of sorcery, with all their seductions and miseries, is no easy task. As Bifo argues, it requires moving into forms of collective practice beyond the silos of culture, politics, and healing—especially in their predominant forms of consumer culture, representational politics, and self-help. Instead, we need to discover "a new form of activity that must take the place of art, of politics and of therapy, and that must mix these three different forms into a process of reactivating sensibility, so that humankind may become capable of recognizing itself again." In his view, practices of art-making, writing, and performing can provide a "cartography of the emerging new sensibility."[86] And as I argue throughout this book, these experimental forms of activity, in their rediscovery/reinvention of old resources, may be ancient as well as new.

Experiments in the art of collective practice tend not to produce conclusive evidence or final statements. Rather, they put forward "radical prototypes," as art historian Judith Rodenbeck calls them: "figures on a horizon of possibilities."[87] These radical prototypes may ally themselves with political movements, whether

anticapitalist or anticolonial—as in the work of the Onaman Collective or the activism of neopagan witches. This type of alliance is found in the Purim Ball, discussed in chapter 2, which is sponsored by the organization Jews for Racial and Economic Justice, and which turns its activist commitments into festive spectacle. The Indigenous DJ collective A Tribe Called Red is also highly politically engaged, as I recount in chapter 3, and its music (along with that of other artists) often played during the Idle No More movement that began in 2012. Alternately, retranslations of the vernacular may have more metaphorical and micro-level political connotations—as in the fermentation practices that I analyze in chapter 4. With their diverse origins and commitments, all of these projects and movements are connected by an experimental quality, an ability to try out new combinations and recipes in the collective vernacular arts. *Experimenting*—an ongoing and unfinished process—is what allows these projects to at least temporarily undo settler-colonial regimes of time and property, and to shake off the spell of capitalist sorcery. This experimenting is often playful, embracing the possibility of failure with good humor and patience. When faced with a "surpassing disaster," a profound break in the continuity of intergenerational transmission, such playful experiments have few illusions about their immediate efficacy. They acknowledge some degree of failure as inevitable: the vessel or puzzle of the past will never be fully restored. But even in failure, experiments in the art of collective practice produce vibrant prototypes that call for further experiments, further translations. In the course of these experiments, souls can find recipes and techniques that help them to heal and to act in a damaged world. Against various forms of capture, they try out recipes for spell-breaking, and play with experimental practices of freedom. It is to certain of these practical experiments that I now turn.

2 PROFANING

QUEER MESSIANISM
AND JEWISH
FESTIVE POLITICS

———————————————

Purim's Borders
The Order of the Profane
Queer Yiddishkeit
Sparks in the Laboratory
Bodies in Trouble
It Only Has to Last One Night
A Party in Heaven
After the Carnival

Between glittering party and agit-prop spectacle, between intoxicated ritual and queer masquerade, New York's Purim Ball (or Purim Extravaganza) has become a political-carnival institution since its beginnings in 2002. Organized and staged by a group of theater artists, activists, performers, and musicians that calls itself the Aftselakhis Spectacle Committee, for most of its history the event has taken place each year over one long night in early spring.[1] It's a tricked-up and queered-out version of the Jewish holiday, which commemorates the biblical story of Esther: a tale of subterfuge, dressing up, mockery of the powerful, and escape from pressing danger. Traditionally, in Jewish communities both observant and secular, Purim is marked by a reading of the scroll of Esther, also called the Megillah—a reading often half drowned out by jeers and shouts, in contrast to the usual ritual decorum. The holiday also has a long history of practices that feature carnival inversions and transgressions: cross-dressing, masquerades, reversals of hierarchy, feasting, drinking, parodies of sacred texts, and ribald folk plays or *Purimshpils*. The Aftselakhis collective takes its inspiration from these folk plays, which have been performed in Ashkenazi Jewish communities since the fifteenth century, and are often seen as the beginnings of Yiddish theater.[2] This particular Purimshpil is a retelling and a *midrash* or commentary on the story of Esther, adapted to meet the political urgencies of the metropolis—with its non-status workers, marked inequality, cops and homeless, racialized inhabitants, and straining and inadequate healthcare system. For a certain artist-activist milieu, it's also an occasion for one of the more transporting parties of the year, featuring bands and DJs with affinities to the project. The Purim project is, by its own admission, at once "very ancient yet totally contemporary," a self-conscious translation or queering of a longstanding Jewish tradition.[3]

FIGURE 2.1

Scene from the Purimshpil
Parthenogenesis: The Next Generation
(2014), photo by Erik McGregor

The project, which describes itself as "NYC's diasporist, queer, abolitionist, feminist, antifascist, trans, & very maximalist Purimshpil," grows out of a nexus of overlapping scenes, groups, and organizations.[4] It is sponsored by the community organization Jews for Racial and Economic Justice (JFREJ), and by the Arbeiter Ring (Yiddish Workmen's Circle), who until 2010 hosted the party at their Manhattan building. The event is part of a larger context of Jewish performance committed to diasporism and social justice, overlapping with the Yiddish cultural revival underway in North America since the 1970s. That revival movement is markedly queer, to adopt an expanded sense of the term, in its commitment to a historically abjected language and culture. It is also more literally queer, with its large cohort of LGBTQ artists, whose disembedding from mainstream culture might incline them to experiment with nonnormative alliances and intergenerational forms of kinship.[5] The Purimshpil's embrace of transgressive drag, pop culture camp, and fabulousness can be traced through a New York queer theatrical lineage, via the work of Charles Ludlam's Theater of the Ridiculous and other performance artists.[6] The younger DIY queer scene, meanwhile, comes with its own performative codes and code-breaking strategies.

The Purim project draws its "cheap art" methodology and some of its spectacle-making techniques from the tradition of radical puppetry propagated since the 1960s by Vermont's Bread and Puppet Theater. The New York collective Great Small Works, which grew out of post–Bread and Puppet activist object-theater and shares members and studio space with the Purim project, might be the most crucial ingredient in this mixture. Each year's play is created in partnership with allies from non-Jewish activist, labor, and cultural organizations; some of these, like the largely Caribbean and Latina women of Domestic Workers United (DWU), bring their own carnival skills and traditions to the party. All of

these somewhat heterogeneous elements are tied together and set loose by the work of the central Aftselakhis collective. Even though the event sometimes seems like it might collapse under the weight of its various political and aesthetic commitments, the collective strives for a kind of buoyancy, the bounce and glitter that hopes to make the righteousness feel effervescent. Its members weave text, music, and visual spectacle into a carnival whole, an "extraordinary temporary creative art" that aims to be both transient and transporting.[7]

My own entrée into the project came through the world of puppetry. I had met Aftselakhis artistic director and Great Small Works member Jenny Romaine while working with the Bread and Puppet Theater in the late 1990s, and we stayed in touch as friends and occasional collaborators. For years, Romaine worked as an archivist at the YIVO Institute for Jewish Research, which preserved a trove of documents of prewar Jewish culture after the German occupation of Vilna in 1941. Romaine's advocacy of Yiddish in language, music, and culture influenced my own musical experiments with collective vernacular practices, bringing me closer to the world that my grandparents and great-grandparents had abandoned in their drive to assimilate to North American culture. Meanwhile, the political object-theater of Great Small Works served as the model for Le Petit Théâtre de l'Absolu, the puppet theater company I cofounded in Montreal. For nearly a decade, Jenny had been forwarding me the invitations to the Purim project, and had told me wild stories about the vernacular collisions that she and her colleagues were concocting. In 2011, as I was beginning the research for this book, this invitation offered an enticing opportunity. I knew that I would be able to join the Purim Ball not just as a researcher and guest, but as a full participant: to help with the building and rehearsal of the spectacle, and to perform in the final Purimshpil. I would enter into the thick of a collective

experiment with tradition, and try to make sense of it from both inside and outside.

The 2012 Purimshpil—which I joined two weeks before the show as a participant researcher—was focused on the fragility of the body and the politics of care, themes rooted in both personal experience and political commitment. Adrienne Cooper, the beloved singer who mentored a generation of Yiddish-cultural workers and who cofounded the Purim project, had passed away in December after having been diagnosed with cancer only a few months earlier. Her death, and the recent death of other close friends of the collective, gave the work process a sadness that sometimes seeped through the bright joy of the festival. The event took place amidst what is generally seen as a crisis of care in the United States, with its private, for-profit healthcare system that systematically excludes the working poor and non-status people, as well as those with HIV and other chronic illnesses. The body, in the form of bodies in the street, was also front and center that winter in New York, where Occupy Wall Street had added a new uprising to the emerging global "movement of the squares." The invitation announced a Purim Ball dedicated to "the body: its fragility, its care, its resilience, its bounce."[8] The event called its participants back to the interdependence of bodies, their common vulnerability, their need to give and receive care, and their capacity for resistance (and dancing) in a damaged world. In a political season of Lent, under the sign of neoliberal austerity, the party aspired to carnival abundance—the fragility of bodies but also their collective ability to rebound, their regenerative erotic and political bounce. It did this by retranslating Jewish folk and ritual traditions, but also by omnivorously poaching other sources: vernaculars like New Orleans sissy bounce and Korean sauna culture, or high and popular culture figures from Pina Bausch to Whitney Houston. Sometimes schlocky, occasionally

FIGURE 2.2

Cover art for the program for the 2012
Purim Ball, artwork by Ethan Heitner

didactic, and purposefully amateurish, the 2012 Shpil neverthe-less enacted a vision of common vulnerability, resourcefulness, and abundance in a social world of privatized inequality, excess, and privation.

To do justice to this event requires working through a few of its constitutive threads. The first half of this chapter begins with the Jewish tradition of Purim, exploring some of the holiday's festive peculiarities and rituals. I examine the contradictions of this hol-iday, shared by other carnivals and festivals, which both weaken and sometimes violently shore up ritual separations. Building on the concepts of the profane and the act of profanation, which I adapt from Walter Benjamin and Giorgio Agamben, I consider the strategy of "profaning" ritual separations, and the links between Purim and messianic traditions. I then turn to the New York Pu-rimshpil in the context of the Yiddish revival, looking at this re-vival movement as a diasporic, queer, and anachronistic profaning of tradition. In the second half of the chapter, I shift into a narra-tive mode, and turn to the texture of the event itself: its history, its preparation, its composition, and its celebration. In the making of words, worlds, and objects, from workaday preparations to shared festivity, the Purimshpil offers an avenue for what historian and Aftselakhis member Rachel Mattson calls "queer political desire." As Mattson describes it, this desire does not aim at inclusion in the existing social, racial, ecological, and sexual order of things. Rather, it seeks to transform embodied relationships through the collective practice of radical equality, to open a space where mar-ginalized bodies can thrive, and to redefine the meaning of polit-ical work.[9] The event's aspiration to what Mattson calls "a form of world-making" gives it a utopian shimmer, recalling Bakhtin's description of carnival as the "bodily participation in the poten-tiality of another world."[10] Yet this utopian longing is held in ten-sion with a more prosaic desire to transform the here and now by

effecting concrete political change and by placing bodies into new modes of alliance. At this party, queer anachronisms and remixed traditions aim to pry open the solidity of a damaged present. The goal is not to escape into a utopian elsewhere, but to work on this world: to profane the social separations of gender, economy, race, and religion; to repair and reinvent a shared reality; and to make that reality more collective, funky, and festive. To this end, the Purim project seizes on political possibilities that are latent in the stories and practices of the holiday itself.

PURIM'S BORDERS

Of all the books of the Old Testament, the book of Esther distinguishes itself as the only one where the name of God is never mentioned. It is also the only biblical story to take place entirely in diaspora, outside the Holy Land. The exilic and profane qualities of the story spill over into the holiday itself, which commemorates the deliverance of the Jews of Persia from King Ahasuerus and his plotting vizier Haman, through the subterfuge of Esther and her relative Mordechai. The story of Esther has been called a fairy tale, honoring human cunning and reversals of fortune, not divine miracles.[11] Its origins remain unclear, though scholars generally see it as growing out of Near Eastern sources—the names Esther and Mordechai are clear cognates of the Babylonian gods Ishtar and Marduk, and many Purim traditions echo Babylonian and Persian springtide festivals, with their "kings for a day" and rituals of death and rebirth that celebrate spring's victory over winter. Over its long history, the tale did what fairy tales do, gathering popular stories in vernacular fashion into a syncretic whole. And the holiday soaked up festive customs from peoples among whom diaspora Jews came to reside. So the "Purim rabbi," who parodies

the seriousness of the community's religious leader, may have been an adaptation of the Italian Carnival Pope; cross-dressing, animal costumes, gambling, and status inversion echo Roman festivals; the burning of Haman in effigy finds parallels in Near Eastern and European traditions; and Purimshpils probably grow out of medieval Christian folk plays.[12] This osmosis of tales and rites, along with the story's not obviously religious character, are likely why the book of Esther was only included in official scripture after much debate and rabbinical skepticism, perhaps to justify the existing popular celebration of Purim.[13]

The holiday itself is marked by a blurring of the border between sacred and profane, and a general loosening of the strict separations that otherwise characterize Jewish ritual life. Such ritual separations are not unique to Judaism. Many religions are built on a central division between sacred and profane, a division which is constantly reinforced by ritual practices that bind together the community of believers.[14] Yet Judaism is notable for its especially firm insistence on strict borders and separations. Diaspora Jews were (and in some cases still are), as the book of Esther puts it, a "people scattered and dispersed among the other peoples ... whose laws are different from those of any other people and who do not obey the king's laws" (3:8).[15] They maintained cohesion through a kind of "punctilious observance," supported by the tendency of Jewish tradition "to classify, divide, distinguish, and keep categories apart."[16] In this tradition the ultimate distinction is the separation of Jew from gentile, a separation that is carefully maintained by a wide range of practices from circumcision to burial rites. But ritual also separates men from women, adults from children, clean from unclean, and virtuous from sinful. The traditional morning prayers, including the punctilious ritual of strapping on the *tefillin* or phylacteries, give thanks to God "who did not make me a gentile"—or a woman. Most Jewish

holidays share the scrupulousness and exclusivity of these intimate ritual performances, and strict rules govern the handling and reading of the holy scriptures.

In this context, the instructions contained in the *Tractate Megillah*, the Talmudic prescriptions for the reading of the Scroll of Esther, are notable for their laxness. The scroll can be damaged, illegible words can be filled in from memory, and one can read the scroll standing, sitting, or even half asleep; most remarkably, both men and women (and even minors, according to some rabbis) are permitted to read from the scroll. A recurrent term in the *Tractate* is *yasa*, meaning "he has fulfilled his duty"; as Harold Fisch puts it, in the case of Purim, "a minimum performance is always sufficient."[17] This loosening of ritual punctiliousness in the reading of the scroll extends into the carnivalesque customs of Purim festivity. The reading of the scroll is accompanied by noise, shouting, and jeers at each mention of the name of Haman. The holiday has a physical quality, a playful *communitas* encouraged by feasting, drinking, and dancing, which tends to loosen ritual separations if not dissolve them.[18] Wearing masks, cross-dressing, and dressing up in gentile costume is encouraged. Much has been made of the holiday's official invocation to drunkenness: "Raba said: It is the duty of a man to mellow himself [with wine] on Purim until he cannot tell the difference between 'cursed be Haman' and 'blessed be Mordechai.'"[19] The word *mishte* (feasting) appears twenty times in the book of Esther, as many occurrences as in the rest of the Bible put together.[20] A drunken blurring of distinctions is complemented by a series of status inversions, where the low becomes high and the high becomes low. A central phrase in the book of Esther is *venahafokh hu* ("and it was reversed," or "the opposite happened"), and this theme of reversals of fortune shows up in all the carnivalesque inversions, parodies, and degradations that Purim has absorbed in its vernacular, diasporic itinerary.

This festive inversion, which might seem subversive, is open to the same accusations of conservativism as other carnival forms. Like many other carnivals, Purim is "licensed"—it takes place within a larger symbolic structure, in which the temporary transgression of norms by no means implies their overturning.[21] Fisch notes that Purim's one-day binge is more a "symbolic carnival" than a real one; it lacks the duration and immersion that helps Christian (and Afrodiasporic) carnival create a world in itself.[22] (This may be less true for the New York Purimshpilers, festive performers and spectacle-makers, as I argue below.) The holiday's brief jumbling of ritual separations tends to reinforce them in the long run: as in many liminal performances, "by temporarily 'playing' the extraordinary, the ordinary is strengthened."[23] During the holiday, the core separations of Jewish ritual between clean and unclean are never really challenged. Like many other carnivals, the Purim tradition is ambiguous: it plays with ritual divisions for a short while, but at the same time shores them up even more strongly.

Nowhere is this truer than in the holiday's treatment of the separation between Jew and gentile. Dressing up for a day in gentile costume is a mockery that only reinforces group cohesion, as does the entire ritual performance that memorializes Jewish triumph over gentile hostility. In fact, as a holiday celebrating group survival, Purim may be vulnerable to even more serious charges. The reversal of fortune in the book of Esther—where Haman's edict calling for the extermination of the Jews is turned back on its author—includes the description of a wholesale slaughter of Jewish enemies, not only Haman but also his ten sons and some 75,500 other Persians. Elliott Horowitz has powerfully argued that Purim, a holiday celebrating Jewish diasporic survival, is a blend of "reckless hostility and joyful festivity."[24] Its ritual hostility is directed toward "Amalek," the enemy Other to whom Haman is genealogically

linked. Historically Purim has been the occasion for symbolic anti-Christian violence—and in recent history for real anti-Arab violence. In 1994, the Israeli settler Baruch Goldstein opened fire on worshippers at the Ibrahimi Mosque, or Tomb of the Patriarchs, in Hebron, killing twenty-nine Palestinians and injuring a hundred more. Goldstein purposefully committed his massacre on the first day of Purim. He has since become a hero and martyr for a portion of the settler movement, and at least one rabbi has suggested setting up a "local Purim" in his honor.[25] Carnival and violence have often been intimately related, a fact that Bakhtin underplayed in his utopian description.[26] Goldstein's massacre is only the most glaring case of Purim providing a license for xenophobia and hate. But such brutal appropriations of tradition threaten to overwhelm any saving power the holiday might have. To paraphrase Benjamin: in this particular moment of danger, can anything in this festive tradition be redeemed?

THE ORDER OF THE PROFANE

Reclaiming the festive tradition of Purim would first require confronting and undoing its tendencies toward separation and violence, as demonstrated by Goldstein and his ilk. This violence operates through what the philosopher Giorgio Agamben, in his essay "In Praise of Profanation," terms "sacred" separations.[27] It is aimed primarily at hardening the divisions between the ritual group and its despised other, and in turning those divisions into exclusionary territorial boundaries. In Agamben's view, this violence is latent in the principal forms of contemporary social organization: the territorial nation-state and capitalist social relations. States and capital secularize and generalize the ritual separations of religion, transposing them into worldly political life.

Nation-states divide groups of humans from each other, by way of walls, gates, documents, borders, and weapons. And the "ritualized" separations of consumer capitalism divide objects from their use, through property law, mediatized spectacle, and the commodity form.[28] While Agamben's analysis does not extend to colonial, racial, and gender regimes, these too are marked by scrupulous and repeated "ritual" separations.[29] Violence lurks behind these "sacred" separations of inside from outside, pure from impure, with settler-colonial sacrificial violence (such as Goldstein's) as only the most blatant example. If practices of reclaiming are to find political force, they must move in precisely the opposite direction—toward undermining these strict separations by what Agamben terms "profanation."

To profane, according to Agamben, is to lift the power of separations, whether they manifest in sacred or secular form. In his view, "religion" is less a matter of belief than one of "scrupulous separation" (*relegere*), and thus what is opposed to religion is not unbelief but a kind of practiced "negligence" when faced with those separations. As he writes, "negligence" is "a behaviour that is free and 'distracted' (that is to say, free from the *religio* of norms) before things and their use, before forms of separation and their meaning. To profane means to open the possibility of a special form of negligence, which ignores separation or, rather, puts it to a particular use."[30] To describe this "special form of negligence," Agamben uses the term "play." Play, he claims, is the exemplary practice of profanation, of negligence in the face of sacred thresholds. It restores sacred things to the sphere of collective human use, the realm of the common. In his words, "play frees and distracts humanity from the sphere of the sacred, without simply abolishing it."[31] Agamben's description resonates with carnival holidays such as Purim, which indeed play with sacred separations without abolishing them. He also alerts

us to the power of collective practices of "negligence," which have the potential to undo the separations of sacred violence, rework the *"religio* of norms," and return sacralized traditions to festive use.

Purim's playful laxness, its masquerade and feasting, are evidently profane qualities. Yet the term "profane" should not suggest that the holiday is entirely divorced from any relationship to the divine. Messianic traditions of Jewish thought, in particular, have long held Purim in high esteem. Rabbis going back to Maimonides have stated that Purim happiness, the happiness of festive negligence, explicitly prefigures the happiness of the messianic era. Some early commentaries claim that even after the coming of the Messiah, when all other holidays have become obsolete, Purim will still be celebrated.[32] Purim is a minor festival in the Jewish calendar with little religious significance and even without any clear connection to the divine; but for this messianic tradition, it is the one holiday that will still be marked in the days of fulfillment.

In his brief and complex "Theologico-Political Fragment," Walter Benjamin examines precisely this link between messianism and profane happiness, using language that resonates with the aims and strategies of the Purim project.[33] Here, Benjamin argues powerfully against any "theocratic" interpretation of the messianic strain in the Jewish tradition. His vision of messianic fulfillment is directly opposed to territorial or political messianism, which attempts to build a Kingdom of God in the secular realm. Benjamin sees no direct link between the theological idea of the messianic era and what he calls the "order of the profane," which must be set up in this world. He insists that "the order of the profane cannot be built up on the idea of the Divine Kingdom, and theocracy has no political, but only a religious meaning." Worldly, political life should not submit to the rule of religious

structures of thought and action. (Benjamin gives credit to Ernst Bloch's *Spirit of Utopia* for repudiating "with utmost vehemence the political significance of theocracy.") Instead, he argues that "the order of the profane should be erected on the idea of happiness." For Benjamin, happiness is embodied and this-worldly, not anticipated in the world to come; it is only meaningful based on our past and present collective experience. Indeed, Benjamin claims that messianism is not a political category but an individual one, and it is marked by sadness, not happiness: "the immediate Messianic intensity of the heart, of the inner man in isolation, passes through misfortune, as suffering."

Yet the separation between profane happiness and messianic fulfillment is not absolute, in Benjamin's view. He sees a strange, inverse relationship between the "order of the profane" and "messianic intensity," which work in opposite directions yet complement each other. This inverse relation of forces, combined with an emphasis on worldly happiness, might recall the "redemption through sin" famously proposed by heretical Jewish messianic figures like Sabbatai Zevi. But for Benjamin, "happiness" is less a libidinous breaking of religious commandments, and more a practiced pursuit of transience in a damaged world. As he puts it, in a dense passage:

> For in happiness all that is earthly seeks its downfall, and only in good fortune is its downfall destined to find it. ... To the spiritual *restitutio in integrum*, which introduces immortality, corresponds a worldly restitution that leads to the eternity of downfall, and the rhythm of this eternally transient worldly existence, transient in its totality, in its spatial but also in its temporal totality, the rhythm of Messianic nature, is happiness. For nature is Messianic by reason of its eternal and total passing away.

For Benjamin, transience and passing away are the basic characteristics of all embodied worldly existence. "Downfall" is a rhythm that pulses through space and time in all of nature, including human life. Paradoxically, though, by its very downward movement, worldly transience opens up a messianic horizon. The *restitutio in integrum*—the belief that all being will be restored after the coming of the Messiah—corresponds to a temporary, mortal restitution that is constantly passing away. And while nature is temporal and transient, even "eternally transient," moving to a rhythm of downfall and decay, Benjamin argues that this downward rhythm nonetheless is profane happiness itself. At the risk of oversimplification, one could say that messianic happiness lies not in a longing for fulfillment in some earthly or heavenly paradise, but in a recognition of the transient pulse by which we and all other beings move.

In Benjamin's view, embracing this rhythm of passing away is an urgent political task. The entropic "rhythm of Messianic nature" must be embraced in its worldliness, not warded off through dreams of establishing a spiritual or terrestrial paradise. He concludes: "To strive after such passing, even for those stages of man that are nature, is the task of world politics, whose method must be called nihilism." The fragment ends here, leaving the definition of this nihilism open. One scholar has argued that Benjamin's "nihilism" indicates a "retreat from worldly participation" in favor of "an abstract and categorical realm of messianic reflection."[34] But such a retreat seems inconsistent with the fragment's political imperatives. Rather than a retreat from worldly participation, "nihilism" could instead be seen as a negative politics, related to the "negligence" and "distraction" that Agamben portrays as essential to the act of profanation. Nihilism, here, would imply an anarchistic refusal of structures of "natural" domination—especially those structures, religious or secular, that transpose theological

categories into the political realm. Instead of trying to establish a messianic kingdom on earth, for which the militarized nation-state is one secular stand-in, collective practice must work on the order of the profane, with its fragile and pleasure-seeking bodies, its sickness and need for care, its flux, damage, decay, and becoming. This transient "order of the profane," inhabited by precarious bodies, is the realm where the Aftselakhis collective goes to work.

Benjamin's profane messianism in the "Fragment" echoes that of Isaac Luria and the sixteenth-century Kabbalists, as filtered through the research of Benjamin's friend Gershom Scholem. Scholem argued that with the practice of *tikkun ha-olam*, the mending of the world, the Kabbalah left a place for collective human activity to work toward the coming of the Messiah. Each human act of goodness works to restore the damaged and fragmented world to its original state of wholeness. Yet, at the same time, this preparation happens only indirectly: only the Messiah himself can perform the final gathering of the divine sparks that will announce the era of fulfillment.[35] "Nihilism" and *tikkun ha-olam* may at first seem like contrasting concepts, but in this reading they are both committed to this-worldly ethical practice, rejecting any pretensions to political theocracy, whether in religious or secular form. The most common translation of *tikkun* is "redemption"—which should be understood as a "worldly restitution" (as Benjamin puts it), an event that takes place at a collective level, "on the stage of history and within the community."[36] Another frequent translation is "repair." *Tikkun*, in this view, is a profane redemption, requiring collective ethico-political practice in the present. As part of "the order of the profane," the work of redemption does not announce the messianic kingdom, but rather is "a decisive category of its quietest approach."[37]

If the tradition of Purim is to be more than a drunken and sometimes chauvinistic celebration of Jewish survival, it must be

reclaimed from politico-theocratic appropriation by way of its profane qualities. These qualities are latent in the texture of the holiday, in its loosening of ritual separations and its emphasis on bodily participation, on play, on feasting, drinking, and dancing. Purim exhales a form of happiness that is entirely this-worldly. As I have noted, the book of Esther is a kind of fairy tale, which Benjamin (in his essay "The Storyteller") claims is a worldly and profaning form: "The fairy tale tells us of the earliest agreements that mankind made to shake off the nightmare which myth had placed upon its chest." Fairy tales are devices for "disenchantment" (*Entzauberung*, "spell-breaking"), full of "liberating magic."[38] As the book of Esther likes to repeat: "the opposite happened." The happiness of this liberation from the weight of myth shows itself in the carnivalesque practices of Purim, in its laxity and air of negligence, its call for intoxication, its loosening of "the *religio* of norms." If this bodily experience of a world to come is to have any political force in the present, the holiday's profane qualities need to be remembered, reclaimed, and pushed further than the rabbis ever intended. Purim's loosening of sacred separations must be extended beyond the ritual community, and the myths of race and nation must be definitively shaken off. Only then will playful disenchantment meet messianic fulfillment—even for just one night.

QUEER YIDDISHKEIT

Beyond their role in the messianic tradition, the book of Esther and the holiday of Purim have become a rich source of feminist and queer readings, which have proliferated in recent years. The biblical story features not one but two proto-feminist heroines. First there is the king's wife Vashti, who refuses her husband's

command to dance naked at a royal banquet. Then there is Esther herself, who wins a beauty contest to replace Vashti, gains the king's confidence, and eventually reveals her Jewish origins in order to save her people. The book also features the story of the palace eunuchs plotting to kill the king, marginal figures who have become queer heroes in contemporary Purim plays. On top of these narrative elements, the Purim custom of cross-dressing makes the holiday available for gender-queer appropriations. Since the early 2000s, Purim has increasingly been appropriated by queer Jewish artists in North America for events such as the 2003 "Suck My Treyf Gender" party in Philadelphia, in addition to New York's radical Purimshpils. These queer Purims use the holiday as a way to undermine what Ezra Nepon (aka performance artist Killer Sideburns) calls the "false separations" that structure not only Jewish ritual but heteronormative society in general.[39]

A shared emphasis on anachronism and the abject, as well as on innovative intergenerational linkages, can give insight into the overlap between queer cultures and the post-1970s Yiddish revival. The overlap is immediately apparent on both sociological and aesthetic levels. As Aftselakhis member Rosza Daniel Lang/Levitsky asks, seeking to explain the prominence of LGBTQ artists in the North American revival of Yiddish culture: "Who's in this weird relationship to tradition? Why is the 'klezmer revival' so damn queer? Who's in the structural relationship that makes it such an easy thing to do to the tradition (and to not-the-tradition)?"[40] Lang/Levitsky implies that for gay, lesbian, and transgender subjects, tradition and its transmission are always in question. The overlap between queer cultures and the Yiddish revival is in part, indeed, a "structural relationship," a consequence of being shifted out of conventional kinship structures and lines of descent. Necessarily at a distance from heteronormative social

reproduction, queer subjects are in a good position to mess with existing traditions or invent new ones. The "klezmer revival" is one of these impressively reinvented, hybridized, and messed-with traditions—and even the most casual observer would notice that it is markedly queer.[41]

Beyond this explanation, which Lang/Levitsky admits is somewhat "deterministic," there are elective affinities between queer and Yiddish collective practices. Both queer and Yiddish cultures have developed at a distance from the state and dominant-cultural institutions. Yiddish is a diasporic language that has never had state institutions to support it, and thus was treated as a dialect, a motley fusion of existing tongues—initially of medieval German and Hebrew-inflected Aramaic, then absorbing elements of Russian, Polish, and others.[42] As the self-conscious reclaiming of a language that has, outside of Hasidic communities, passed out of daily speech, the Yiddish revival is what Jeffrey Shandler calls "postvernacular." It tends to privilege the affective qualities of the language over its meaning, often straddling the modes of heritage and camp.[43] Like certain forms of "queer time," the Yiddish revival is defiantly anachronistic, reclaiming a damaged culture cast by the wayside.[44] Sidestepping Oedipal conflicts, it creates innovative affective links between generations: between children and grandparents, or between youngsters and elders from different families and parts of the world. (As Romaine says of the Yiddish revival: "What's queer is also people who are supposed to be cool wanting to talk to their grandparents.") This cultural transmission takes place across intergenerational lines of communication severed by both European genocide and North American assimilation, leaving room for retranslation and reinvention. The Yiddish revival has also created its own institutions, both visible (such as Klez-Kamp, KlezKanada, and the YIVO summer language program)

and invisible, "intimate publics" where that abjected culture can be experimented and played with.[45] And in North America, these institutions are rooted in the metropolises that offer a home to both queer counterpublics and large Jewish diasporas: Toronto, Montreal, Philadelphia, San Francisco, New York.[46]

If the Yiddish revival is a queering of tradition, it is also the reclamation of a profane tradition, the revival of a profaning tongue. The ritual (and sexual) separations between sacred and profane that mark Jewish religious life also extend to the linguistic realm. Hebrew—historically the language of prayer, scripture, and rabbinical correspondence—was from the second century CE until the late nineteenth century a sacred language that was read and written by a male elite. Yiddish, by contrast, is a profaning language par excellence: it is an Ashkenazi Jewish vernacular that was elaborated for the purpose of worldly communication, moved freely across secular and sacred matters, and was spoken as a first language by both men and women. In the Ashkenazi diaspora, the two languages intertwined in a hierarchical, gendered "internal bilingualism," with Hebrew coded as masculine and Yiddish as feminine.[47] The worldly nature of Yiddish, its engagement with the transient as well as the eternal, is perhaps what allowed it to flourish in the nineteenth and early twentieth centuries as a medium for impressive literary and political experimentation. Paradoxically, in a way that Benjamin would no doubt appreciate, this abjected language came to be a rich repository for everyday speech, theater and art song, literal profanity (its collection of curses is exceptional), spiritual yearnings, and political action. As a profane vernacular, Yiddish is negligent before sacred and secular thresholds: it jumbles the mystical and the mundane, borrowing omnivorously from (as well as seeping into) the languages and cultures that it encounters. According to Régine Robin, who draws on Bakhtin's concepts, there is a polyphonic "multivoicedness" to

Yiddish; she argues that the language tends toward the carnivalesque, with a preference for inversions, degradations, and profaning laughter.[48]

The Yiddish revival taps into this profane heritage, a heritage nearly obliterated by the genocide of the Holocaust, but also weakened by assimilation in North America and by cultural suppression both in the Soviet Union and the state of Israel.[49] In Purimshpil artistic director Jenny Romaine's words, "part of what we're trying to do is have a queer relationship to a language that was genocided and assimilated and Zionized out of existence. Part of our queer political desire is to use Yiddish."[50] The readaptation of Hebrew into a spoken language by the nineteenth-century Hebraist movement is instructive in this regard. Among Zionist intellectuals and settlers in Palestine, Yiddish, the profane vernacular of the Ashkenazi Jewish world, was pushed aside as a shameful hybrid (ironically, German was considered more seriously as a possible national language for the future state).[51] Yiddish culture was also linked with pan-national socialist movements such as the Eastern European Jewish Labour Bund, an internationalism that did not fit with a certain nineteenth-century vision of the racially based nation-state.[52] Along with its literary history, Yiddish's history of internationalism is ripe for revival. The queer political desire to use Yiddish is anachronistic here as well, a refusal to abide by the "straight time" of progress, which consigns that literary and political history to the dustbin of history or at best to academic study.[53] Today, the revival seems to offer a (perhaps utopian) chance to *reclaim* what has been cast aside: a pan-national, diasporic Jewish culture, which lived at a distance from both state and religious authorities.[54]

In its most radical and open forms, the queer political desire to use Yiddish is profane in a directly political sense. It opposes national, racial, and linguistic purity, the fear of contamination

that ritualistically seals off the borders of states, communities, and forms of speech. Romaine describes the "desire for huge inclusiveness" that animates the Purim project, a desire that plays across the borders between religious and secular, and between Jew and non-Jew. This inclusiveness embraces the condition of diaspora, not as a tragic exile, but as a resource or power.[55] The condition of diaspora implies an irremediable plurality, a constitutive coexistence that cannot be wished away by exclusionary territorial or racial claims. This plurality, which Hannah Arendt has argued is inherent to human action and relationality, is betrayed by any state that declares itself the exclusive property of one nation or people.[56]

Indeed, one could see the creation of an exclusively Jewish state in Palestine and the repurposing of Hebrew as an exclusive national language as both enacting versions of a "secular sacred." The theocratic politics of exclusionary nationalism, Jewish or otherwise, construct a series of linguistic and political separations: between acceptable and shameful, pure and impure, speech and noise, racial insiders and outsiders, citizens and noncitizens, self and other. The concrete walls, machine gun turrets, exclusive roads, and checkpoints are only the most glaring examples of the drive to seal off Israel's political and symbolic borders. Far from this state-supported *"religio* of norms," the Yiddish revival has tended toward profanation and play, a celebration of worldly flux, and an inclusive and hybridizing diasporism. No wonder, then, that the "queer time" of the Yiddish revival has found Purim, with its carnivalesque profanations, to be an especially fruitful holiday, ripe for reclamation.

SPARKS IN THE LABORATORY

The Aftselakhis Collective's Purimshpil can trace its roots back through at least a hundred years of left-wing Jewish performance projects—from turn-of-the-century Bundist workers' Passover seders to political Yiddish theater in the early twentieth century, to more recent cultural experimentation in the wake of the 1970s revival movement. But, as historian and Aftselakhis member Rachel Mattson notes, the years 1999 to 2001 were especially important in the crystallization of this project as a politicized, diasporic Jewish performance. Those two years saw several events of historical significance: the shutdown of the 1999 WTO ministerial meeting in Seattle by a coalition of radical movements, as well as many similar (if less successful) actions around the world; the beginning of the second Palestinian intifada in 2000, provoked by Israel's continued occupation of the West Bank and Gaza; the terrorist attacks of September 11, 2001; and the subsequent U.S. militarized reaction, including wars abroad and domestic repression authorized by the USA PATRIOT act.[57] The epochal events of these two years have helped shape the Purim project, both in its content and perhaps its very existence (the first of these Purim parties took place in 2002). The influence of Seattle and the global justice movement gives the event a kind of radical hope; the increasing militarism of Israel has renewed the project's commitment to diaspora; while the "war on terror" and the heightened American security state have encouraged it to engage directly in combating Islamophobia and extrajudicial detention, and in supporting the rights of racialized and non-status people.

As a queer, diasporic, Yiddishist activist puppet theater event, the Purimshpil can be seen as the fusing of several strands already intertwined in the cultural weave of New York City. One of these strands is the experimental object-theater collective Great Small

Works, perhaps the most innovative group to grow out of the Bread and Puppet Theater; as mentioned, Purimshpil director Jenny Romaine is also a member of that collective, and the Great Small Works studio hosts the workshop for the Purimshpil production.[58] In the late 1990s, Great Small Works put on a shorter Purimshpil in support of Charras El Barrio, a Lower East Side theater and cultural center that was eventually evicted as part of that neighborhood's gentrification. Following this, Romaine and Adrienne Cooper, the late Yiddish singer and cultural worker who has been called the "patron saint" of this event, joined the Boston-based Puppeteers Collective to stage several Purimshpils in Port Washington, Long Island, answering a request to "enhance the ritual life of this community."[59] In 2002, the pair decided to move the project to New York City. Cooper's job at the Arbeiter Ring helped create an institutional connection that would support the project for many years. That year's "Giant Purim Ball Against the Death Penalty" featured rhyming verse, figures taken from traditional Jewish paper cuts (Mordechai as a wolf, Esther as a tree), and music by punk-influenced Yiddish group the Klezmatics.

Over the following years, the event became increasingly carnivalesque and increasingly queer. This progression was pushed along by the 2003 "Suck My Treyf Gender" Purim party in Philadelphia. Organized as a benefit for Jews Against the Occupation (JATO) and Palestinian solidarity groups, the Philadelphia party wed a series of carnivalesque cabaret acts, including a wrestling match between Kosher and Treyf, with a diasporic and queer political stance. At the event, organizers distributed a leaflet titled "The Politics of the Party," which made explicit a certain parodic undermining of structures of ritual separation, what could be called a queer metaphysics of the profane:

On Purim, we are religiously obligated to get so shit-faced [drunk] we can't tell the difference between "blessed" Haman and "cursed" Mordechai. Binaries, dichotomies, opposites are emphasized, exaggerated and celebrated. We masquerade as Good vs. Evil, Male vs. Female, Oppressed vs. Oppressor, but the goal is not to reinforce these dichotomies, but to realize that they are false separations, that there is a beautiful space between all opposites, and that is the space where we live as happy, healthy beings. It is in between the extremes, somewhere between "male" and "female," healing our experiences of oppression while checking ourselves on the power we have to oppress others, that we walk Hashem's path.[60]

The "beautiful space between all opposites," where "we live as happy, healthy human beings," is something like the "order of the profane" described by Benjamin, an embrace of worldly transience that paradoxically is happiness itself. At this 2002 Purim party, walking a divine path meant undoing the "*religio* of norms" that props up the regimes of both gender and nation-states. This resulted in a mixture of the political and the carnivalesque, a Purim cabaret that hoped to be at once ritually meaningful and wildly sacrilegious.

From 2003 until the present, the New York Purimshpil has continued this profaning tradition. Members of the Philly crew, including organizer Ezra Nepon/Killer Sideburns and host/ess Rosza Daniel Lang/Levitsky, formed a "Suck My Treyf Gender Posse" to anchor the New York party in 2003. That year also marked the beginning of the Purimshpil's collaboration with the organization Jews for Racial and Economic Justice (JFREJ), which still sponsors the project.[61] Each year the Aftselakhis collective reinterprets the Megillah, the story of Esther, to create an original play for

the night. The theme and content varies each year, influenced by the campaign work of JFREJ, the pressing political concerns of the moment, collaborations with other groups, and whatever fortuitous material pops up in the process. The core collective is joined by a few dozen volunteers, including members of activist groups like Domestic Workers United (DWU) and Picture the Homeless. Titles of past Purimshpils point to the commitments of the project: The No Borders Non-Stop Purim (2004); Rehearsal for the Downfall of Shoeshine: An Immigrant Justice Purim (2005); Purim without Papers (2006); Roti & Homentaschn: The Palace Workers Revolt! (2007, the first collaboration with DWU); Lower East Shushan: A Purim of Vacant Lots (2008); 28 Condos Later: A Zombie Purim (2009); Choose Your Own Purim (2010); You Better Work: A Very Precarious Purim (2011); Your Hamentashen Are Killing Me! (2012); I See What You're Doing: Purim, Puppets, Politsey (2013); The Spawn of Estherlu Present Parthenogenesis: The Next Generation (2014); Your Roots Are Showing: An Underground Purim Botanical (2015); It's in the Water: A Porous Purim (2016); Jews with Thorns (2017); and Purim Unleashed: An Oracular Heist (2018).

When members of the Aftselakhis collective describe their favorite moments through these years of spectacle-making, they tend to tell stories of encounter—of sparks flying between this collective and other groups, between secular and sacred, between genres and styles, and between their work and global political events. Romaine describes a spontaneous cultural mashup in the studio, which grew out of a longer collaborative process:

> A peak moment: Rebel Diaz, this hip-hop group, walked into the rehearsal, and we were singing something. And they said, "What do you want us to do?" And I said, "Just freestyle over this, *right now*." It was some Purim traditional awesome thing that we were playing the shit out of. ... And

FIGURES 2.3 AND 2.4

Posters from past Purimshpils
(2006, 2009), artwork by Sally Heron

I was thinking, okay, this is why I do this project, this is it. Cause they're these amazing organizers from the Bronx. ... It was this moment where we were coming together as artists very strongly from our cultural places.

For Romaine, coming from a "distinctly Jewish place" allows the collective to meet other groups coming from their own distinct cultural positions. In her words, "culture is power." Cultural specificity—the siting of the project within a vernacular, even a discontinuous and queered one—allows the process to exist as "an interesting lab," a place for experimental collective practice. The studio becomes "a laboratory for investigating theoretical ideas

FIGURES 2.5 AND 2.6

Posters from past Purimshpils
(2016, 2018), artwork by Abigail
Miller and Al Benkin

and then staging them." In the studio, sparks fly between ideas and their realization, as traditions are translated across cultural, religious, and generational divides.

The collective members also describe the sparks that fly between religious and political commitments as key to the power of this event. For the group, Adrienne Cooper was the "priestess" of that encounter between religion and politics, comfortable at the place of friction between the two. Importantly, the Purimshpil has made an effort to reach out to New York's Hasidic community, which has its own carnivalesque Purim tradition, despite the religious, political, and gender-political differences between the two communities.[62] Apparently, Hasidic Jews regularly attend the party, and are often the last to leave. Avi Fox-Rosen, a

longtime musical director of the Shpil, comes from an orthodox religious background, and his repertoire reaches deep into Hasidic *nigunim*, wordless melodies that make a mystical connection with the divine, while blending those melodies with rock guitar or electro-pop beats. This hybridizing of divine and worldly elements extends into Fox-Rosen's ambivalent embrace of the repertoire of traditional Ashkenazi Purim songs, which he "grew up singing." For Fox-Rosen, despite "problematic" lyrics celebrating the victory of the Jews, their exclusive connection to God, and the defeat of their enemies, these songs "kick ass." As he writes in an essay printed in the 2012 program, they encourage a vibrational and embodied encounter: "The melodies make me wanna dance, and put my hands on my fellow singer, and twirl with you in a sweaty circle." Fox-Rosen argues that we can sing these songs, dance, and lose ourselves, without condoning their literal meaning (it surely helps that the words are in Hebrew, which most of the partygoers would not understand). Here, the friction between religion and politics leads not to an abandonment of the tradition, but to an embrace of its ecstatic elements, profaned of any theocratic pretensions.[63]

The sparks between religion and politics can also fly from another kind of meeting, between the allegorical "mythic frame" of the story and world political events. Collective member Abigail Miller describes the work process and performance of early 2011, which took place during the Egyptian Revolution (and "Arab Spring"), while the collective was getting ready to stage an allegorical battle between Winter and Spring:

Last year, the battle between Winter and Spring happened at a moment that was incredibly politically and emotionally important. The energy of the crowd felt really palpable. . . . Maybe this is what it means to go into the studio and listen to [the radio program] *Democracy Now!* while you

paint for a couple of weeks. Like this is not accidental—it actually is about this long winter ending.

Miller is describing a kind of translation, in which allegorical figures like Winter and Spring can condense and give shape to the emotional experience of individuals and communities. The Purim story (the Megillah) remains the same each year, but its mythic figures can vibrate with different content, depending on the telling of the tale and the context in which it is told. Some of this resonance is intentional, the result of the collective's interpretation and artistic visioning, and some of it is just chance. In 2011, the story's reversals of fortune resonated with uprisings taking place halfway across the world, in Tahrir Square and throughout the Middle East. In 2012, the resonance was more domestic—with bodies made vulnerable by precarious labor and the U.S. healthcare system, and with the protesters recently evicted from New York's Zuccotti Park.

BODIES IN TROUBLE

The process by which the collective comes up with its adaptation of the Purim story varies each year, as does the way it works with other groups. The choice of themes and partner organizations is partly determined by the campaign work of JFREJ, the project's sponsor: as Romaine puts it, the ten-plus years of this project represent a series of "experiments in how to meld campaign work into ritual and crazy queer spectacle."[64] The 2007 Shpil was a full-scale collaboration with the cultural committee of Domestic Workers United (DWU), which describes itself as "an organization of Caribbean, Latina and African nannies, housekeepers and elderly caregivers in New York, organizing for power, respect, fair labor

standards and to help build a movement to end exploitation and oppression for all."[65] This relationship continued through the following years, with members of DWU both performing in the Shpil and serving Caribbean food at the party, with proceeds going toward its campaigns. In 2008, the collective worked with GOLES, a Lower East Side activist organization, and used the Purim story along with verbatim text from residents to retell the radical history of that neighborhood. For the collective, each year's campaign work gives a formal discipline to the spectacle-making that follows. Aftselakhis members describe the process of creating a show from an activist campaign as strangely liberating: here, the demands of politics provide what Romaine calls the "formal principles" that allow a moment of art to take shape. As Fox-Rosen says, "It actually simplifies the show-creation, having these kinds of demands." For the artists, "the more demands, the better."

The 2012 Shpil was no exception. That year, the project supported and drew inspiration from the activist work of Caring Across Generations (CAG), a DWU-affiliated campaign that brings together domestic workers and employers in what it describes as an effort to create jobs, improve wages and labor protections, and open up paths to citizenship for non-status workers. The work of CAG and DWU focused the attention of the collective on the politics of care and bodily vulnerability, a set of themes already present in their personal and political lives. In the work that followed, the political and the intimate were tightly intertwined. The eventual theme of the 2012 event—"The body: its fragility, its resilience, its bounce"—allowed a space for the collective to mourn the loss of Adrienne Cooper, and to articulate the experience of caring for her and for other sick loved ones. It also drew inspiration from diverse political sources, including the disability justice movement and the bodily disobedience of the Occupy protesters.

These and other themes were brought together at a meeting on Martin Luther King Day (January 16), at which the collective gathered in the Great Small Works studio with volunteers and campaign organizers to cook up a "soup of ideas" for the 2012 Purim Ball.[66] Again, the studio became a laboratory in which sparks could fly between secular and sacred, culture and politics. The day's events featured presentations by organizers from CAG and the HIV Prevention Justice Alliance (HIV-PJA), as well as a lesson in festive simcha dancing by Jill Gellerman, a Hasidic expert. Collective members Josh Waletzky, Jenny Romaine, and Zachary Wager-Scholl taught, respectively, a Yiddish lullaby, a traditional Purim song in Ladino (a Sephardic Jewish vernacular), and the basic body techniques of New Orleans sissy bounce. As at nearly all the meetings and gatherings of this group, political education and vernacular art forms were mixed together in another set of experiments, with unpredictable results.

At the January 16 gathering, the themes of care, vulnerability, and the body were present in both verbal discussion and physical movement. Julie Davids of HIV-PJA took the occasion of Dr. King's birthday to remind the group of the power of civil disobedience, which uses human fragility to provoke the risk of crackdown and violence, while offering a counterprovocation of empathy and care. Rather than focus on rights and reforms, Davids proposed a "queer liberation model," in which queer activists, like those of the disability justice movement, can offer innovative strategies of resilience. She also described the "trap of self-care," which she termed a kind of "neo-colonialism"—the idea that "if I get sick, it's my fault." Instead, Davids suggested that large-scale goals, including healthcare reform, can be rooted in marginalized groups' strategies of collective resilience. This message was anchored in embodied practice through Wager-Scholl's lesson in the theory and practice of sissy bounce—a Southern Black working-class queer

dance form that he described as "centered in the core of the body, the hips and stomach region ... celebrating a community of resilience and resistance." Wager-Scholl, a volunteer dancer with New Orleans bounce artist Big Freedia when she comes to town, told the group that sissy bounce shows create a "beautiful energy exchange between artist and audience."[67] The group discussed the politics of paying homage to this Black working-class art form, opening a conversation about artistic and cultural appropriation that would recur over the course of the work process. The core collective—mostly white Jews of Ashkenazi heritage—is committed to antiracism in its artistic and political process, but also ready to draw, in vernacular fashion, from any elements of culture that fit the mix. This tension between irreverence and righteousness can produce awkward and sometimes painful contradictions, as I describe below. For the moment, the volunteer group was encouraged to shake their asses in the air, to enjoy this "very nonjudgmental dance," and to pay attention to "what you feel coming through your body."

In locating the body as a site of both vulnerability and resistance, the collective was drawing on multiple traditions of activist practice and theory in North America and beyond. Holding the meeting on Martin Luther King Day honored lineages of Black struggle that foreground the vulnerability of raced bodies to violence in a white supremacist society.[68] The link between mourning, bodily vulnerability, and collective resistance is also well established in queer activism and thought, expressed in writings from Douglas Crimp's "Mourning and Militancy" to Butler's *Precarious Life*, in which she ties bodily vulnerability to the powers of mourning. There Butler argues that grief is "a mode of dispossession" that reveals "the fundamental sociality of embodied life, the ways in which we are, from the start and by virtue of being a bodily being, already given over, beyond ourselves,

implicated in lives that are not our own."[69] For Butler, mourning reminds us of a fundamental "dependency"—the way that we are "exposed" to one another in our very formation. Yet this condition of exposure is often foreclosed and denied. Crimp's famous essay on the AIDS epidemic describes what happens when mourning is thwarted—whether through inadequate healthcare and social welfare systems, or social prohibitions and their "ruthless interference with our bereavement."[70] Crimp argues that within the gay community in the 1980s this inability to grieve in public sometimes resulted in a "moralizing self-abasement," including the purging of "'fringe' gay groups"—"drag queens, radical fairies, pederasts, bull dykes, and other assorted scum."[71] Clearly, the Purim Ball is one of many queer projects that reject this moralizing self-abasement, and instead embrace "the fundamental sociality of embodied life," celebrating all bodies in their constitutive, if unequal, vulnerability.[72]

These traditions of thought and activism were a constant presence in the collective's creation of the 2012 Purimshpil. Making a Purim play about the body—its fragility, its resilience, and its bounce—was a way to mourn friends and comrades, to act in solidarity with the gendered and racialized "intimate labor" of domestic workers, and to support the "bodies in alliance" of the Occupy movement.[73] This was not a new approach for this highly politicized group of activists and artists. As Mattson notes in her 2010 essay on the Purim party, "the event articulates the political desire for all work to be valued equally and for all kinds of bodies to be able to exist unhampered and to thrive—not just well-behaved, middle class gay and lesbian bodies, but also flamboyant bodies, transgender bodies, undocumented bodies, homeless bodies."[74] A marginal space—a queer netherworld, perhaps a kind of "temporary autonomous zone"—the Purim party is also a space where the norms that regulate bodies and public spaces can be loosened

or even remade.[75] For Mattson, this space creates a zone of experimentation for "non-normative political desires"; these desires are not about encouraging tolerance for alternative lifestyles and sexualities, but about real "transformations in relationships between people and political work." With its mixture of movement politics and the politics of movement, the January 16 meeting hoped to initiate this kind of transformation, which would continue through the process of creating the show and during the night itself.

The party's themes of bodily vulnerability, care, and resilience also resonate with the carnivalesque holiday of Purim, and with Benjamin's messianic location of happiness in earthly damage and transience. Carnival holidays celebrate degradation and renewal, death and rebirth, winter and spring; Bakhtin argues that carnival laughter has this double quality, connected with natural processes of decay and regeneration, even with the very flux of temporal becoming. Such holidays, like our fragile bodies, exist in the "order of the profane," which as Benjamin reminds us pulses with a rhythm of downfall, a rhythm in which lies its very happiness. Bodies get sick and die, but they can also heal, care for each other, and act together. They exist in the flux of time, subject to the "eternity of downfall, and the rhythm of this eternally transient worldly existence." Yet in their very transience, as they are pulled into "the rhythm of messianic nature," they are capable of action. Bodies might be subject to what Elizabeth Freeman has called "temporal drag,"[76] but they also are capable of temporal bounce. Bodies dance, rebound, dress up, rise up, move around in time, and move together in the world. They can act on their desires, political, queer, or otherwise. Drag and bounce: these might be two different modes of queer time, two directions of anachronistic temporal flux. But they are also forms of vernacular adornment and dance, and at this party, both are on full display.

IT ONLY HAS TO LAST ONE NIGHT

When I arrive in the Great Small Works studio in DUMBO in February 2012, two weeks before the show, the carnival is already starting.[77] Volunteers are scattered around the space in small groups; they work at long tables or tucked between storage shelves, sewing costumes and building puppets and scenery. Two members of the Occupy Wall Street Puppetry Guild, Alma Sheppard-Matsuo and Joe Therrien, are on hand, putting in long volunteer days, their energy still buzzing from months of round-the-clock activity (the previous fall, during the occupation of Zuccotti Park, Great Small Works had opened their studio up to this group of radical puppeteers). My first night in the studio, following Jenny's minimal instructions, I help Alma sculpt a mountain made of green burlap glued over a stapled cardboard armature. The mountain will apparently feature in the Purimshpil's climax, but for the moment we aren't told much more than that. We work barefoot on the concrete floor, fabric dripping everywhere, our hands sticky with white glue. A crew led by Rosza Daniel is sewing costumes: a dozen lab coats with grotesque trails of hair dangling from the pockets. A few wigs make the rounds, and I become George Washington for a couple of hours. Music pumps from the stereo: bhangra, Peaches, electric gamelan, house, anything to keep us moving. Abigail Miller tries on one of her creations: the Venus Flytrap of Self-Care, an awkward lump of mask and fabric; she bops happily around the room. There are wheels of cheap brie from Zabar's, and wine and whiskey for later in the evening. While the mountain dries, Jenny and I make clouds to surround it—fake snow tied into bundles with fishing line, festooned with glittery bits of Mylar, and glitter-sprinkled bubble wrap stapled into bundles. I stumble out of there sometime after 9 pm, splattered with paint and glue, while the crew works on, the music still going strong.

The construction is slipshod and ramshackle, sometimes ridiculously so, and goes at a crazy pace. Day after day, Jenny repeats the carnival refrain: "It only has to last one night!" The materials we use are scavenged and cheap—cardboard, recycled fabric, scraps from art supply warehouses, house paint, whatever is lying around the studio. We are trying to be cheap and quick and splendid, patching together the "extraordinary temporary creative art" that will create a world for us and the audience and then vanish the next morning. As in much puppet theater construction, cardboard is the base material for the scenic forms: it's lightweight, readily available, easily manipulated, easy to paint, and impermanent—it tends to degrade over time. Much of this stuff we are making will get thrown out the day after the party. The cheapness and transience of the materials suits the mirage-like nature of the show. The spectacle is ephemeral, temporary—like us human beings, whom the Greeks called *ephemeroi*, the temporary ones.

As the days count down, we work quickly, moving from task to task. After the mountain, our next job is to make a giant scrim that will divide the front of the stage from an elaborate set hidden upstage. We start from a bundle of semitransparent pale-blue fabric that we'll paint with text and imagery inspired by traditional Jewish paper cuts—lions, birds, scrolls, tablets, Hebrew and Yiddish script, vines and flowers. Alma sketches out a design on acetate. We hang the scrim on the wall, project Alma's design onto it and outline it in chalk. Again, speed is everything. We lay the scrim down across a long sixteen-foot table, filling in our chalk and Sharpie outlines with black acrylic, moving in sections, letting the rest fall in bundles to the side. Luckily, the porous fabric dries quickly. Next to us, Joe is patiently stitching wire through a giant Golem made of black netting, bending the wire to sculpt its torso, legs, arms, and head. A little girl and her babysitter paint animals from cardboard stencils, brushing in bright pink, yellow,

red, and copper—they'll be festive paper cutouts adorning our blue-gray painted scrim. Tucked into different corners of the studio or spilling out into the hallway, small groups and solo helpers go about their tasks.

Our mode of production is typical of this type of carnival work: a core crew of directors and designers assigns set tasks to shifting groups of volunteers, who have more or less leeway to invent and play with their own ideas. To the women from the cultural committee of DWU who arrive for rehearsal later that week, bringing their own carnival knowledge, the studio is an instantly legible space: "Oh," an activist from Trinidad exclaims, "this is a mas' camp!" She's right: this space has much in common with styles of carnival production across the Caribbean and its diaspora. The mas' camp, a site for making masquerade band costumes and floats, extends the carnival spirit into the making of objects, putting into practice what the curator Claire Tancons calls "the potential for carnival to function as a production system."[78] Here, in its activist puppet theater version, the mas' camp assembles bodies into provisional and flexible arrangements, under loose and reversible hierarchies. The process is adaptable and fluid. But this is not the fluidity of neoliberal capitalism, which forces bodies to conform to externally imposed arrangements for the accumulation of profit. Instead, this mas' camp turns the work process itself into an object of play, a way to see what "bodies in alliance" can do together. The borders between volunteers, directors, and designers are porous: no good idea is turned away, and committed volunteers have whole spheres of autonomy in design and construction, as in the key contributions of Alma and Joe, the Occupy Wall Street puppeteers, to designing and building the scrim and the Golem.

Of course, unlike in Caribbean carnival mas' camps, where crews often turn out costumes on commission, almost no one here

is getting paid. Even the core crew receives only a bare stipend, and the budget for the project is quite small. Money collected at the door and the bar will go toward reimbursing costs—materials, rental of space and vehicles, a few honoraria—and toward future projects. The party is not a benefit: the idea is to gather momentum for activist campaigns, not to fundraise. The larger money economy is kept at a distance; relations among the core crew of directors and designers and the volunteers are governed by mutual aid, not by exchange. This positions the whole process at a distance from the "restricted economy," the world of day jobs and making a living, and closer to the realm of "general economy," of gift-giving and expenditure without reserve—a utopian positioning which is perhaps both a strength and weakness for the project.[79]

The emphasis on speed, play, and the carnival spirit extends from production into rehearsals, which happen every couple of days in the studio in the weeks before the Shpil is performed, and which are quick, sketchy, and fun. "Rehearsal" is the way the show gets made, and we plunge right in.[80] Avi Fox-Rosen leads us in songs that we'll use in the show—Ashkenazi Purim songs, wordless *nigunim*, and a version of "Body Language" by Queen. Choreographer J. Dellecave teaches us some simple and playful movement exercises to get us loosened up. In trios, we compose little shifting, goofy tableaus. There are a series of puppet tryouts: the Venus Flytrap, the Golem, the Topsy-Turvy Dress worn by two performers playing Esther. Then Jenny takes over, a whirlwind of manic energy. She is working on a scene with multiple Esthers and our green burlap mountain, which turns out to be a version of Mount Sinai. In a set piece inspired by the writing of disability-justice advocate Eli Clare, the Esthers will furiously tear down Mount Sinai—while two other performers, also playing Mordechai and Esther, sing a rewritten version of Whitney Houston's "Greatest Love of All."[81]

Jenny, who is both in and outside the scene, whips the Esthers into a frenzy. In a move lifted from the choreography of Pina Bausch, they attack the scenery, writhing and pressing their bodies against the mountain. "Now *that's* carnivalesque," she laughs. Later, she jokes: "Some people take three years to make a show—we make one in about three minutes!" We end the rehearsal working on a key moment of the first act: an endless slow march to a dirgelike *nign*, walking in groups, singing the wordless tune together, hands on each other's shoulders, eyes downcast. Avi plays his electrified, freaked-out backing track on the stereo, while we sing and march together—slow-moving bodies in alliance.

During the rehearsal process, it's hard not to notice the vernacular omnivorousness of the show's design and direction, its poaching and assimilation of heterogeneous elements. Like other theater-makers in the queer tradition stretching from the Theater of the Ridiculous to Jennifer Miller's Circus Amok, these artists don't hesitate to pull from any cultural source, high or low, sacred or profane. The collective tends to incorporate into the show whatever is in the air around it—elements from "our vernacular—our life lived."[82] So the theme of the body leads to discussions about bathing cultures, and then to painted banners of images of water pipes, naked bathers, and curling script, all pulled from the mysterious fifteenth-century Voynich manuscript, written by an unknown Northern Italian author in an undecipherable code.[83] Subsequent visits to the mineral-lined pavilions of Spa Castle, a Korean sauna complex in Queens, result in an elaborate set piece—a series of brightly painted cardboard domes which lift to reveal naked bathers, writhing and singing "Body Language." This isn't about exoticism: as Romaine points out, "Spa Castle is another thing that's in our world—people from our world go to Spa Castle." Indeed, Spa Castle's geode saunas and the world of the Purimshpil seem to belong to a similar fairground universe.

As Romaine recalls, "I went to Spa Castle, and I was like, this is carny as hell. ... What I was attracted to was that it was so gimmicky, and it's so much about pleasure, and that's what we want. We want to create what I would call a carny environment, a 'World of Wonders.'"

If there's a method to this omnivorous poaching, it's something like a thirst for copying and montage, which is common to both avant-garde and vernacular practices.[84] Anything is fair game: Whitney, Pina and Freedia, Taiwanese street art, bogus-mystical Renaissance manuscripts, Jewish songs, and Korean sauna culture. Although the frame is a Jewish holiday, the ritual elements exist in a profane world of wonders where anything that works is welcome. The collective often repeats the motto that "good art is the fortuitous meeting of an umbrella and a sewing machine on an operating table."[85] The operating table is the studio, and these surgeons are ready to suture in any heterogeneous cultural object—the more "carny" the better. This is not a random assembly: as the collective stresses, the whole piece must be legible in formal terms. Music, color, theme, story, and politics tie the show together—while leaving space for absurd elements, including a bikini-clad Yeti in the middle of an array of naked bathers.

If the atmosphere in the studio is often carnivalesque, full of music, food, and fooling around, the meetings about the script are a more serious business. Questions of the politics of appropriation, especially of Black culture, arise among these politicized, mostly white, often highly educated artists. What does it mean to embrace a vernacular or "folk" practice of *bricolage* in a racist society where the appropriation of Black creativity has long fueled the culture industry? The question comes up around the use of Whitney Houston's "Greatest Love of All," which in the show is transmuted into a campy duet about the politics of self-care and movement-building. A program note tries to forestall the inevitable critique:

"As anti-racist Jews, we want to acknowledge and celebrate the song and the legend in this year's purimshpil and are committed to being against cultural appropriation where white people appropriate culture of communities of color without giving credit where credit is due. All credit is due to Whitney Houston."[86] The group's activist commitments, as laid out in this note and throughout the event, hope to serve as a kind of cover for its carnival methodologies. No one is getting famous or making real money from the project, so perhaps there is a certain latitude around these issues. But it is a fine line. Pure freewheeling appropriation might cross the line into disrespect, or even minstrelsy. On the other hand, excessive caution or righteousness risks spoiling the party.

A similar tension arises between the collective's desire to make a fun and fast-paced show, and the need to work with a defined political content and process. Purim is going to be a long night, with bands interspersed between the three acts of the play, each of which should only run around twenty minutes. Cuts to the script become necessary—as much as a quarter of it will have to go. At these meetings, Rachel Mattson is the script captain, responding to the input of a dozen artists and activists, some of whom are more interested in political clarity than in anarchic "carny" moments. Some tasteless jokes are cut, deemed likely to offend. In the discussion, there is confusion about some of the play's allegorical elements: Who is the Golem that (in this mashed-up version of the story) Haman creates? Is it capitalism? Our own fears? Or the faceless and profit-seeking bureaucracy that stands between relations of care? The discussion feels intense, intimate, and a little strained (as Jenny tells me later, "you really got under the hood"). But some of the jokes also get better after their political modification. And much of what eventually gets cut is the didactic material explaining that year's campaign work, which tends to bog down the rapid pace of the show.

On March 1, a few days before the night of the event, we move into the venue where the party will be held: the first floor of a warehouse building and artists' space called Industry City in Sunset Park, at that time still an industrial, mostly immigrant area of South Brooklyn. The space is massive and open—a rough concrete floor, metal pillars, and white-painted walls. Teams of volunteers load in bags and boxes of sets, puppets, tools, lights, and sound equipment. Preparations are made to build a ramp over a short flight of stairs, making the space accessible. I volunteer for the lighting crew, and spend the next few days precariously balanced on a ladder, running power cables around heating and water pipes on the ceiling, trying to get everything plugged into the right fuses. Terra, a lighting designer donating her days to the project, hops from ladder to ladder like a reckless lumberjack, wrenches hanging from her overalls. Others decorate the space, hang the scrim, install the sets, set up the bar, make signage, and organize rows of costumes backstage. In between, we make time for last-minute rehearsals and planning meetings.

Again, speed is more important than perfection or durability. Back in DUMBO at a rehearsal for the Rude Mechanical Orchestra (RMO), Jason Hicks, the technical director for the Purim party, calls out for volunteers with sound and lighting skills: "We're going to have a wild curtain, insane light setup. ... It's the most jerry-rigged pile of shit you've ever seen." Many members from the Purim crew are also musicians or dancers with the RMO, a sixty-odd-piece anarchist brass band whose yearly set is one of the highlights of the party. A trumpet player calls out for band members' participation in this "weirdo hippie art insanity thing." For the brass band, it's one of the more anticipated gigs of the year, a time to come together and let loose: "Everyone you know is performing that night. Be on time and look good. Okay? It's Purim. If you can't get laid on Purim ..." She explains to the uninitiated,

"It's the Jewish Mardi Gras, more or less. Dress in that style." Intoxication is encouraged: "bring your flasks, et cetera." She concludes, emphasizing the community of outcasts gathered by this event: "Like I said, every weirdo you love is involved in this show." All that's left to do is to bake the *hamantashn*, pick up the drinks, and get everyone together in the same space. After months of meetings and weeks of intense work in the studio, it's time for these bodies in alliance to assemble, and to make some profane noise together.

A PARTY IN HEAVEN

In the studio, we've been preparing the theatrical part of the evening, the Purimshpil. But the play is only one element of the night: the party also features other small shows, bands, DJs, decoration, and feasting. The audience gets in on the act, dressing up in and out of drag, dancing, making out, drinking, and generally taking over the space. As Avi Fox-Rosen points out, this expanded, participatory environment helps ground the politics of the Shpil in embodied practice: "The presentation of the theatre is broken up; it's in the context of a party. ... People take what they can take, then dance it off. It's a more holistic experience—you're not just sitting absorbing; you're embodying, you're in your body." There are virtual elements to the party, too, which extend its life before and after the event. The organizers send out an invitation through email and Facebook to various contacts, via JFREJ, Great Small Works, and their personal lists. The invitation contains an explanation of the collective's approach to the holiday, details about the theme of this year's show, and an exhortation to dress up and come with a carnival spirit. After the party, photos are posted and shared online; the semipublic images (and the commentary on them) work

to consolidate and shape the memories of both performers and audience. Yet these photos, like many images of this kind of event, struggle to capture the embodied experience of the party, which is multisensory and kinaesthetic. The event is a collective physical immersion in a common space and time, a shared, durational experience of pleasure. This bodily experience is notoriously hard to capture through the camera lens.

Which doesn't stop us from trying. A few cameras and cell phones flash backstage before the show, while performers are getting dressed up and made up. Friends pose in their masquerade drag, silver sparkles on their cheeks; tables are piled with drinks, dollar-store makeup, lipstick, eyeliner, and sequined jewelry (see figure 2.7). Everyone is getting gussied up, trying to look fabulous; there's plenty of glitter and exposed skin. The ladies from DWU are dressed in imposing red and black armor. I brought along a cream silk dress, but by itself it's too subdued for the occasion. I get some help from a couple of friends: a black-and-gold sparkly scarf, a flower made of silver pipe cleaners for my hair, and white, gold, and glitter makeup for my face and lips. I feel freer with this stuff on, more open, ready to perform, ready to dance. The pleasure of masquerade, which involves hiding oneself, is paradoxically about openness. As Sara Ahmed writes of such collective "queer pleasures": "Pleasures open bodies to worlds through an opening up of the body to others."[87] These pleasures are the flipside of our common and unequal vulnerability, a shared world of profane happiness to which we can open up through transient pleasure and play.

The audience is coming in, eventually numbering around four hundred, some older folks and many young ones—they pay a sliding scale of $12 to $20 at the door, with "no one turned away for lack of cash or costume."[88] There are early small shows in the chillout room, including a dialogue between two scantily clad and very

FIGURE 2.7

A makeup table at the 2012 Purim Ball
(photo by Louise Finer)

fleshy lovers, who face each other in profile with hand-painted signs ("ARE YOU POURING ON THE POUNDS?," "PORTIONS HAVE GROWN") covering their heads. They recount how their abundant bodies often draw public attention; here, they join the carny "world of wonders" that this event embraces in all its carnal multiplicity. Back in the main space, a Brooklyn punk quartet called Daddy is wrapping up their set. There are some general introductions, and then members of the collective take the floor to pay tribute to Adrienne Cooper. Josh Waletzky sings a Yiddish song, plaintive and wavering. A filmmaker in his sixties, Josh is a fluent Yiddish speaker who joined the project after Adrienne passed away; his job is to contribute his linguistic and cultural knowledge of Yiddishkeit to the mix. After he's done, Jenny Romaine and Rosza Daniel enter dressed in their narrators' outfits—bundles of green tulle at waist, head, and shoulders, hats with delicate veils, bare skin, gold and black leggings, and high heels. They tell the audience about Adrienne's founding of the project, and lead everyone in a version of the song "Baleboste," which as Jenny tells them "is a word that can mean 'landlady,' but it also means 'chief woman in charge'—the chief sensual woman in charge, which is how we understood Adrienne Cooper." Everyone in the audience learns the song; as Jenny points out, this is "classic Cooper—each one teach one." In gold and green regalia, Rosza Daniel offers a libation, pouring slivovitz in a long line on the concrete floor: "All I can say is, we love the hell out of you, Adrienne." She was a den mother, sister, mentor, and comrade to this ragged, elective family of revivalists, and her generous spirit hovers over these events.

Now that we've honored the ancestors, the show can begin. The narrators open with an introduction, repeated with variations from year to year, that lays out the stakes of the evening, its invocations of carnival, its embrace of misunderstanding, and its

blurring of sacred and profane. To excited cheers, Jenny reminds the audience that

> this is carnival. Everything is upside-down. We're trying to get to the mystical place of perfect misunderstanding and inversion. The more we don't understand, the more dyslexic we feel, the more supercharged and renewed we become. So do not struggle with the show, do not say, "I didn't understand that, what does that mean?" Simply let your confusion entertain you.

Then it's Rosza Daniel's turn to describe the collective's and volunteers' sometimes vexed relationship to Judaism, in a bit of tortured prose which both describes and performs a blurring of distinctions: "a coalition of people made this show—religious and secular, formerly religious and formerly secular, both the secular and the unsecular, neither the secular nor the nonsecular, and the ones who can neither confirm or deny their secularism or nonsecularism."

After the holy waters have been thoroughly muddied, Jenny reminds the audience about the holiday's invitation to drunkenness, which extends this zone of nondifferentiation: "This is a holiday where you're supposed to get so smashed, so hammered, so *verblunget*, that you can't tell the difference between your enemy and your BFF." Since we already know that "there are many paths to holy disorder, many routes to the place of perfect misunderstanding,"[89] we can achieve that drunken blurring with or without chemical help. As Jenny proclaims to the audience, "We have a lot of people who can't or don't drink, or don't like to use drugs in that way. And we don't want anyone to miss out. So we are going to fuck you up exquisitely—by way of good old-fashioned showmanship." The crowd whoops; the staging of the Megillah can proceed.

This year's take on the story of Esther, we are told, is set in the town of Shushan, Arizona—a state with an aging population and many immigrants and non-status workers, prefiguring the demographics of the United States. In this version, Esther is HIV-positive, a firm believer in self-care (lots of yoga and Vitamin D), while Mordechai is an ACT-UP activist fighting for collective solutions to the healthcare crisis. Meanwhile, Haman leads a cabal of pharmaceutical executives fond of synchronized dance routines, who are looking to jack up prices at the expense of people's lives. The villainous Haman, played in high camp style by Zachary Wagar-Scholl in a gold-lamé-lined blazer, invites the white-coated pharma guys to his bunker to show them a Golem, "this mystical weird robot that I built in my spare time." There is thunder and lightning, an electro version of Queen's "Body Language" turned into "Money Language," and the Golem comes alive, spouting broken fragments of postvernacular Yiddish.[90] The tall black mesh puppet, complete with the Yiddish word *EMES* (truth) on its forehead, imitates some of Haman's dance moves, then with a sigh of "*tate*" (daddy) offers its creator a beating three-dimensional cardboard heart.

The Golem is an allegorical abstraction, a hulking figure invoking the faceless, corporate bureaucracy that stands between sick people, their loved ones, and the people who care for them. Eventually, this specter is unmasked: at the climax of the third act, Esther tries to get some answers from the Golem, who plays the role of an automated telephone operator. The Golem responds in a robotic voice: "We of the government/insurance industry alliance are happy to help you. ... If you want to talk to a shmuck, say 'shmuck.' If you want to talk to a heartless robot, say 'heartless robot.'" Esther demands free healthcare for all who need it—and the Golem refuses, on the grounds that humanity has (or is) "a preexisting condition." As the robot declares, "You're humans! You

can't expect insurance companies to cover humans—humans are fragile, their bodies deteriorate over time." In our very condition of damage and transience, our "eternity of downfall" as Benjamin terms it, the politics of care finds its feet. Esther realizes that the Golem is not only a "schmucky corporation," but also "a phony": she tears the first letter from the *EMES* on its forehead, changing the word "truth" into *MES*, Yiddish for "death" or "corpse." "This is a mess!" she cries. *Venahafokh hu,* "the opposite happens": the Golem collapses in a heap of fabric, and Esther herself is transformed. Instead of disavowing her own fragility through "double doses of Echinacea ... and yoga at Third Root," she embraces a common bodily vulnerability as a resource for political action. In the process, she turns from a self-obsessed self-carer into a brave activist fighting to transform an unjust and exploitative healthcare system.

Of course, this deliberately clunky morality play happens via a series of campy and ridiculous scenes—including the detourned duet version of "Greatest Love of All" ("I decided long ago / Never to climb that mountain solo; / If I fail, if I succeed, / At least I live accountably"), delivered karaoke-style while multiple gyrating Esthers tear down Mount Sinai. That number brings down the house because the ground has already been prepared through a more sober breaking of the spectacle. At the beginning of the second act, the party comes to a halt, so that six activists and domestic workers allied with Caring Across Generations can share their "care stories." One by one, they tell the audience about their friends' illnesses, their own illness, and their care for others. Members of DWU describe their long and hard-fought movement seeking to gain fair labor standards and paths to citizenship. Collective member Anna Jacobs talks about her own struggle living with "late-stage chronic neurological Lyme disease," for which her insurer cut off funding after thirty days of treatment. As she says, her own

experience drove home "how grave the situation is in terms of a lack of care, institutionally and structurally, in our society." She is lucky: "I had a lot of support from family—and family goes way beyond blood in this situation." Her own description of her financial, physical, and emotional difficulties is somehow made more forceful—and carnivalized—by her appearance in the next act as a diminutive king in butch drag, moaning to his new wife, "Oh, Esther, won't you touch my golden scepter one more time!" Through carnivalesque humor, vulnerability becomes power—and once again, the line between serious politics and carny spectacle is elided, to the benefit of both.

The back-and-forth between spectacle and political campaign work is helped by a performance style that embraces all levels of amateurism, while leaving room for talent to shine through. The casting for the show is quite offhand for such a big project: there are no auditions, and volunteers offer themselves to play roles as a kind of "service." I lend my own rusty acting talents to a few scenes, taking on the bit part of the palace vizier, Haman's assistant. Otherwise, aside from a few minor puppetry jobs, I watch from the sidelines. Some scenes have great energy and others fall flat; some performers ham it up with panache, while others struggle to get out their lines. The two scenes with DWU are somewhat awkward in performance (which is unfortunate, after some very spirited rehearsals). During the show, performers speak into a pair of wireless microphones that need to be passed from hand to hand; the women from DWU never got the chance to practice with the mics, and many of their lines get lost. Nobody is particularly fazed by this: in Fox-Rosen's words, "this is one night of great intentions and great ideas and beautiful execution." *Yasa*, as the *Tractate Megillah* likes to say: "it is sufficient." The collective does what it can with often very limited rehearsal time. In fact, the varying quality of the performances, and the good-natured amateurish

feeling to the whole event, helps open up the play to the audience: it's part of what Romaine calls "the gifting of the spectacle." This is not a polished show to be admired from the other side of the proscenium; the audience is right in the middle of things, and could very well be in the show themselves. Plus, the women from DWU are wearing impressive costumes, black and red and silver cardboard armor, shields, greaves, swords, and helmets, as they suit up to fight the Golem. They look fierce—and they know that "the Golem has weaknesses, his fear, his arrogance, of what we are and what we're capable of." "He needs to keep us subservient," they say. "He's afraid of being confronted and us looking him in the eye." Even if the crowd can't quite hear the words, they look at these decked-out carnival warriors and they get the message.

The spectacle elements tie the show together: the ochre color palette of the "Arizona" set, the lovingly sewn lab coats, the brightly painted Spa Castle domes scattered around the audience. In the first act these cardboard domes lift to reveal several dozen singing naked bathers (and the Yeti in a bikini); their sexy come-on number is followed by the slow march of the workers and maidens to the palace. They move through the crowd in groups of ten or so, hands on each other's shoulders, swaying from side to side, singing the wordless Hasidic melody, while Fox-Rosen's band plays some screeching electro-doom accompaniment. As I watch this scene from the audience, I wonder where the power of this moment comes from. Is it its mixing of the carnival and the funereal, the ridiculous and the totally serious? Bathers become a procession of mourners, or maybe protesters, soberly and slowly shuffling to the seat of power. The parade also exemplifies the mixing of heterogeneous vernacular elements in the performance, Jewish and non-Jewish—another profaning of the holiday beyond its ritual borders. This crowd may be singing a Hasidic melody, but they are an image and enactment of "the people"—"the 99 percent," in

the language of the moment. More than any of the show's allegorical, didactic elements, scenes like this affirm the power of this carnivalesque restaging and remixing of tradition.

That sense of power—both vernacular practice as power and the power of bodies in alliance—is brought home by the bands that punctuate the evening. At the end of the first act, the sixty-strong Rude Mechanical Orchestra enters from the hallway at the very back of the space (they are a little late, and their cue has to be repeated a half-dozen times). Part of the wave of anarchist-leaning brass bands that has sprung up around North America in the new millennium, they play a raucous, nonvirtuosic mix of cumbia, klezmer, funk, Hindi wedding music, top-40 hip hop, and whatever other danceable sounds they can get their hands on. There are tubas, trombones, clarinets, flutes, trumpets, saxophones, plenty of drums, and a contingent of gender-queer dancers; the sound is huge, and the party gets started in earnest (figure 2.8). The band is organized horizontally and makes decisions on the basis of consensus. This lack of hierarchy comes through in performance, which is a goofy and festive swarm of bodies. Their spirited amateurism only adds to the atmosphere of equality that permeates the evening. You, too, could be in this band if you wanted; skill is welcome, but not required. Much of the audience is dancing to the global brass band repertoire, unfazed by the switching between genres. Women from DWU join in on percussion. The band closes with a heavy funk version of the union song "Which Side Are You On," which ends with a chant: "Occupy, shut it down, New York is a people's town." Again, "the people" appears briefly, in a utopian, festive, participatory mode.

It has to be said, though, that "the people" in this band are generally white; so it's notable that the next band, blaKbüshe, is a Black queer R&B crew led by singer Shelley Nicole. Unlike the Rude Mechanical Orchestra, they (along with the DJs and other

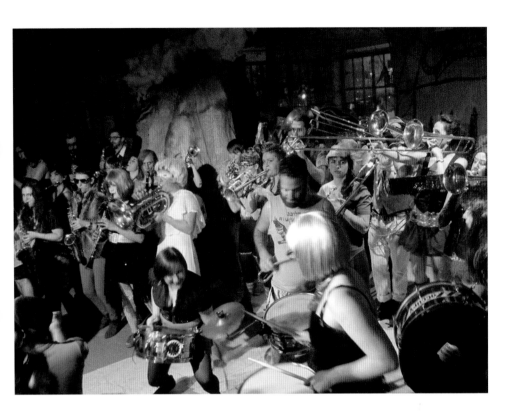

FIGURE 2.8

The Rude Mechanical Orchestra at
the 2012 Purim Ball (photo by John Bell)

bands) are getting paid to perform, and they are a serious, slick, musically adept bunch—no charming amateurism here. The history between Blacks and Jews in Brooklyn is long and complicated, and part of the event's "queer political desire" is for members of these sometimes antagonistic groups to meet here, at this Purim party by the East River. In the event's utopian imaginary, multiple identifications—Blackness, Jewishness, religiousness—are welcomed into the carny pavilion of queerness, and the "queer time" of the evening allows multiple vernacular or postvernacular elements to bounce around into new combinations. This is also the aspiration of the final jam-out that closes the Purimshpil, which mixes music and text from Big Freedia's "Excuse" ("Excuse—I don't mean to be rude," "azz everywhere") with the Yiddish tune "Baleboste," and the Purim song "La'Yehidim." Zachary has given the crowd a bounce lesson, so the audience knows how to "throw your pussy to the back of the wall, like so, while circling your hips." Avi plays his rock guitar, the band lays down a Hasidic electro-disco beat, and much of the crowd dances—a combination of the traditional winding circle dances of Ashkenazi Jews and the sexy balls-of-the-feet moves of New Orleans sissy bounce. In the festivity of the moment, the group's concerns about cultural appropriation and religious exclusivity have been temporarily suspended. The Hebrew lyrics of the song might be celebrating the fact that "the Jews had joy and happiness." But here, happiness has been profaned beyond the ritual community. This happiness presents itself as radically inclusive—it's available to everyone in the room.[91]

The blurriness of ritual borders in this zone of indistinction only heightens as the party slides into its later phases. Many of the performers and guests have taken to heart the rabbi's suggestion to drink "until you can't tell the difference"—words that are repeated, in English and Yiddish, on the doors of the

gender-nonspecific bathrooms. In the spirit of the holiday, and of the party, I've had a few cups of vodka punch as well. As DJ Ripley starts her global-bass-heavy set, the dancefloor is heating up. Some start making out with friends or strangers. The conviviality and overlapping radical politics of the partygoers aim to make intoxication safe, even for those who don't usually indulge. As one member of the core crew recalls a couple of months later:

> I'm not a drinker, and I drank a whole bottle of wine. And I was really sick the next morning. But it was just the best party. ... It was this culmination of a party that ... It's like your dream party. Like, if you partied in heaven, what would it look like? The music was so good, and the people were so fun. It was just a lot of loved ones.

In the moment, I feel some of this elation, as after any big collective production. But the profane character of the holiday, and particularly this queer version of it, suggests to me a more earthbound kind of immanence. As I dance, tipsily, with a lot of loved ones, my critical subjectivity blurs into a sensation of collective becoming. "I" becomes "we," but we—the spectacle-makers and partygoers—are striving for transience, not transcendence. We are in the order of the profane, our fragile and resilient bodies moving to the rhythm of this eternally transient worldly existence, the rhythm of messianic nature. Borders are blurred, and for the moment not redrawn. Time drags and bounces. The rhythm pulses insistently, and we're dancing to it, dancing to the rhythms of uprising and downfall. It is a kind of heaven, brought down to earth in Industry City. But it doesn't last. It's late—the crowd dwindles, and one by one or in small groups we spill out into the cold March morning. Long before the room clears out, I walk alone to the subway, getting ready for the long ride home.

AFTER THE CARNIVAL

After the ecstasy, the laundry. The next day at noon, after too few hours of sleep, I'm back in the space in Industry City, along with the core crew and about a dozen other volunteers, nursing hangovers, tearing down the sets, folding costumes, coiling cables, and packing everything into trucks. The "extraordinary temporary creative art" has come and gone. It's a long day, and the work feels heavy—there's no pre-show adrenaline to propel us. Tempers flare up occasionally. We have plans to cap it off with a visit to the Russian baths in Brooklyn, picking up on the theme of the show, but we're exhausted, and the bathing is postponed.

Two months later, in late May, the collective and core crew gather again for a barbecue and conversation in the backyard of Anna Jacobs's house in Flatbush. This is the first time that this kind of Purim postmortem has taken place, and I travel from Toronto to attend. There are songs, of course, and food. It's a beautiful late spring day. As we go around the circle, the twenty or so Purimshpilers describe what they liked about the event this year, and how it could improve. A few mention that there was a place for sadness in the process, which felt important. There had been a rehearsal shortly after Adrienne's death where the group was discussing another death, that of an older partisan. Josh Waletzky had brought in a Yiddish song; it was a "heavy space," and everyone cried. This sadness made it into the final show in moments like the slow march—as well as the mixing-in of songs and text traditionally associated with Yom Kippur, the Jewish day of atonement. You can feel this sadness hovering in the air, mixed with the pleasure of shared company, as we close the evening with more songs around a fire.

During the meeting, some of the volunteers describe how the space and time of the Purim preparations offered them a

particular kind of freedom. One says that unlike at our regular day jobs, which offer "little space for creativity," in the studio "we could be our whole selves." The queer time and place of the Purimshpil offers the volunteers a space for collective expression, shared joy, sadness, and invention. Another member, LJ, recalls:

> One night ... I just really needed to be creative and get some creative energy out and not think a whole lot. So I went in to paint some of the spa domes, and it was this super gender-queer crew, it was like an all gender-queer crew painting. And Whitney Houston had just died, so we were listening to the Pandora Whitney Houston station, but it was all sorts of music, like Luther Vandross. ... And everyone was singing, and it was really fun.

For the performers and show-makers, queer or otherwise, the weeks of preparation are an extended "time out of time" that offers embodied affects, practices, and relationships not always accessible in their daily lives. These collective practices of shared play, mourning, and pleasure are ways to (in the words of the Purim narrators) become "supercharged and renewed"—able to continue their personal and political struggles with newfound energy. The extended frame of the yearly event, stretching over months of planning and culminating in weeks of creation, building, and rehearsal, allows it to be more than simply a one-weekend fling. Rather, for many returning volunteers, working on the project becomes a repeated practice of freedom, an embodied collective way of being in the world that echoes through their year-round lives.

As LJ makes clear, the studio aimed to be an inclusive space, open to all volunteers, queer and straight, religious and secular

(and various combinations thereof). This inclusiveness in the studio also extends to the audience of the Purimshpil, the ones who receive the collective's "gifting of the spectacle." It's hard to know, as Jenny wonders, "what it's like to receive this art that's given so generously." But she has often heard people at the event say, "'I never feel weird: when I go there I feel like there's nothing weird about me at all.' You hear that quite often. People go there and are like, 'I'll never feel weird about myself again.'" The event tries to create a space where all bodies can thrive, enacting its queer political desire, the "desire for huge inclusiveness." The project's "world of wonders" is all about weirdness—or queerness. In this experimental carnival, differences get multiplied and jumbled, not effaced or hardened. And messianic sparks can fly between these differences, in the lab of the studio and in the air of the party itself.

Importantly, the "desire for huge inclusiveness" extends to bridge religious and secular communities, as well as Jews and non-Jews. Avi describes this project as the "most heterogeneous Jewish place" he has experienced—a place where Jews who don't fit into their often conservative families or communities can flourish. It's open to Hasidim as well as anarchists, cynics as well as mystics. And in a diasporic move, it embraces non-Jewish elements, performers, and audience members. This embrace of supposed opposites is another side of the queer, carnival practice of freedom to which the project aspires. As Jenny explains:

> Part of what I think of the queerness of the project, for me, is more freedom, more liberation, more freedom from what binds. And carnival is where you get the X-ray of civilization, where you see what the binds are. ... Purim is such a time when everything's weird. It's a great opportunity to reach out to people who think you're the opposite from them. A good moment to say, "Hey, Purim, let's freak

out together." And that makes it really exciting. You're go-
ing into the *kavanah*, the intention, of the holiday when
you do that.

You could even say that a queer political desire for radical inclu-
siveness is the *kavanah*, the intention, of this version of Purim.
This crew believes it has found a way to X-ray its society and to
untie what binds, to find the exciting place where the illusion of
opposites collapses and a new translation of tradition is born.

This is not to say that this experiment with tradition is a re
sounding success. Indeed, part of the experience of working with
damaged and abjected cultural material like the Yiddish language
is a constant experience of discontinuity, of never quite achiev-
ing the fullness and richness of the lost culture. As Jenny notes,
the work the collective did with stories from the disability jus-
tice movement felt appropriate: "All this talk about disability, it's
like, oh my god, this language is so disabled!" The collective has
a strange relationship to the lost vernacular world of Yiddishkeit:
it doesn't long for its full retrieval, but it is also not willing to let
it go. Is this a kind of nostalgia? Jenny responds: "I am nostal-
gic, but the approach to the nostalgia is accepting the disconti-
nuity, the failure—that's the hip term, the failure. Saying, yes, I'll
always fail at this." Failure is not just an abstract term: the few
remaining first-generation Yiddish speakers with links to prewar
literary and musical culture are aging. Outside of Hasidic com-
munities, which constrain experiments with tradition within an
inward-looking religiosity, the continuity of the language is not
a given. With Adrienne Cooper's death, this group lost not only
her friendship, but also her deep knowledge and teaching of a
once-flourishing cultural-linguistic-political world. Increasingly,
in this project as elsewhere in the Yiddish revival, postvernacular
elements—affective qualities, suggestions of a blurry heritage or a

campy atmosphere—have taken precedence over a rich tradition of linguistic invention. Failure hurts, and for this profane tongue it may only be a matter of time.

Failure haunts this project in more pedestrian ways as well. The aesthetic success of a given Purimshpil is always tenuous; from the audience's perspective, the collective energy of the performance does not always compensate for its ramshackle and topical qualities. This was my impression the following spring when I returned as an audience member for the night of the 2013 Purim party. The location in Industry City was the same, and most of the collective members and performers had returned. The RMO and Shelley Nicole were back, and so was DJ Ripley. The theme, "I See What You're Doing: Purim, Puppets, Politsey," responded to an increasing awareness and documentation of police violence in the United States (including New York), revelations of mass surveillance, and the activism of the Black Lives Matter movement. The show had its brilliant moments, and I was happy to see so many friends in the same room. But I was no longer on the inside of that magic circle. Inevitably, my experience was more removed, and my judgments more critical. The Shpil seemed a little disjointed and clunky. The party was fun, but Benjaminian reflections about the "rhythm of messianic nature" seemed far away. Evidently, working on a collective project creates a sense of intensity, duration, and solidarity that a one-night party can't match.

Yet the durational experience of working on the Purim project should not be discounted as the privilege of a small group, nor should the event be consigned to the aesthetics of failure. For me and many of the other participants, the experience of building and performing the show was not one of failure, but one of a shared emergent power. It is crucial that the Purim project is created by members of a collective, who then organize many dedicated artists and volunteers. As they explain, this mode of organization and

creation is a direct response to the capitalist organization of labor, which "tells you that you have to be in certain kinds of roles, and that certain people have more value than other people."[92] It is also a response to the commercial art world, which tends to sniff at DIY creation outside of marketable and professionalized channels. Jenny Romaine recalls her early experience starting Great Small Works in the 1990s:

> The commercial art world said you were a piece of shit. ... "Can we be in a theatre?" "No." "Can we do this?" "No." "Is there money?" "No." And so the answer to "no" was, "Oh, then we'll get our own space, and we'll light everything with clip lights, and we'll make our own work, and we'll create our own world." And that's what we did. ... Our group was the way we built power, and also our skills.

This independent, world-building approach required years of dedication and perseverance, and a long process of learning through mistakes—mistakes which continue to be made. But for Romaine, this process created a foundation for collective art-making: "So that by the time I'm reaching this collective, it's my assumption that everybody's reaching for more than they are. That you always understand that you're more than you think you are." The power built during this work might be fragile, relying on clip lights, ramshackle technology, and cheap materials. But it is also a strong power, rooted in bodies in alliance, carnival skills and political intelligence. It is able to gather people together in a queer time and place and bring them beyond themselves, to help them make something weird, old, and new.

For the core collective, the volunteers, and at least some of the audience, the project does indeed make its own world—a world of profane happiness and shared capacity. The disproportion

between the collective labor of the participants and the brevity of
the performance places the event in Benjamin's "order of the pro-
fane," marked by a rhythm of transience. So much work, and all
for one ephemeral moment. And yet, remarkably, the project itself
has endured for nearly two decades. Each year, over the course of
months of discussions, weeks of building and rehearsals, and a
night or two of splendor, these artists have blended remembrance,
redemption, and vernacular invention. With their negligence
before sacred and secular borders, they have worked to profane
tradition beyond the ritual community, animated by a desire for
"huge inclusiveness," even if this desire is not always realized. The
event's queer messianism has given new energy to an ambiguous
holiday and a cast-off language, repeatedly making a translation
of tradition that emerges as "both ruined and vibrant."[93] To use
a mystical metaphor, each year the Purim project gathers sparks
from far and wide, and then scatters them again. Latent in the
silliness, the activist campaign work, and the partying are em-
bers of political desire that ask to be gathered and fanned into
collective practice. And new sparks are sometimes struck as well,
by experiments in the laboratory of the studio and by encounters
during the festive time of the project. The party itself might last
only one night. But those embers continue to flicker throughout
the long life of this event, and those sparks can fly to unknown
places, even after carnival time is over.

3 REMIXING

DECOLONIAL
ELECTRIC BOUNCE

In December of 2012, Ottawa DJ collective A Tribe Called Red released a new track, "The Road." That winter, the Idle No More movement was rising across Turtle Island. Launched by Indigenous women activists, the movement emerged to challenge the Canadian Conservative government's legislative agenda promoting resource extraction at all costs, and the state's ongoing disregard for historic treaty rights and the sovereignty of Indigenous nations. In a few short weeks, #IdleNoMore spread from a social media hashtag to collective embodied uprisings, with blockades, teach-ins, and round dances in shopping malls and city squares, relayed via online videos. Meanwhile, Chief Theresa Spence of the Attawapiskat First Nation had begun a hunger strike, camped on an island in the Ottawa River, demanding a meeting with representatives of the Crown to discuss violations of the treaty relationship.[1] At the time, A Tribe Called Red was working on its second record, what would become *Nation II Nation*. Friends kept asking the group if they had any music to contribute to this most recent surge of Native activism. As video artist and DJ Bear Witness, DJ NDN (Ian Campeau), and DJ Shub (Dan General) told me, Shub had already composed "The Road" in preparation for their next album.[2] Posted on the free web platform Soundcloud—accompanied by a newly iconic, black-and-white photo of flag-bearing protesters raising their fists under a windswept sky (taken at a rally on the Blood Reserve in Stand Off, Alberta)—the track seemed at once historic, contemporary, and prophetic. Within five months, it had garnered upward of 50,000 plays.[3]

I heard the track the day it was released, through headphones while sitting at my laptop. Even through this sedentary form of embodied listening, "The Road" carried a powerful physical and

FIGURE 3.1

A Tribe Called Red, "Guide to Making
Indigenous Music," t-shirt design by Ryan
Red Corn and Ben Brown

affective charge. The song is built around a series of "drops," a convention in electronic dance music derived from Jamaican sound systems.[4] It has become a stock move: the low end (bass and/or drum) drops out, a filter sweeps upward across the sound spectrum emphasizing the treble, and the beat returns with new insistence. In the case of "The Road," the track begins with a pow wow drum marking the downbeats, soon overlaid with a heavy kick-drum sample. The tempo is a quick walking pace of 140 beats per minute. Layers are added and peeled away: a ringing hand drum syncopates the rhythm; a man sings in the high and taut style of the northern pow wow; other members of the drum group Black Bear echo the same high-pitched melody in ragged unison; a digital synthesizer pedals a whole tone in fifths, eventually sketching out minor and major chords. Periodically, the straight on-the-one rhythm breaks, shifting to the syncopated "trap" beats derived from Dirty South hip-hop, with a booming bass drum and skittering hi-hats. The synth ends the track on a reverberating note, a vibrant promise inviting a replay.

In layers of sounds and voices, a "decolonial aesthetic" of "returned and enduring presence" flows from this short, wordless tune.[5] "The Road" breathes what the Anishinaabe poet and critic Gerald Vizenor calls "native survivance": a quality that is "more than just survival, more than endurance or mere response; the stories of survivance are an active presence."[6] In the first winter of Idle No More, that active presence was palpable, even via an online digital sound file vibrating in listeners' ears. The title of the song, along with the quick march of the drums and the repeated, looped singing, suggested Indigenous peoples reclaiming the land, moving to reverse the ongoing dispossessions of the settler state. It recalled a series of walks along roads both real and imagined: activist journeys like The Longest Walk from Alcatraz to Washington, D.C., in 1978 and its many successors, or the walk of Indigenous people

northward to the U.S. border in Leslie Marmon Silko's novel *Alma-nac of the Dead*. It also prefigured the young Cree "Nishiyuu walk-ers" and their 1,600-kilometer journey from James Bay to Ottawa in the winter of 2013. Sounding out from Nation to Nation, "The Road" was a sonic counterpart to the Indigenous "resurgence" moving step by step toward the difficult decolonization of this land.[7]

I listened to "The Road" as a white subject of the settler state, inspired by this movement's creativity and its struggle for justice.[8] I also listened as a musician and a fan of ATCR (as the group is often called), and as a writer investigating experiments with "tra ditional" or vernacular collective practices. In choosing to write about these Indigenous artists experimenting with tradition in settler-colonial North America, I recognized that I would have to move beyond my own musical and cultural frame of reference, in order to approach the problem of "tradition" from the other side of the settler-colonial divide. To do so, I would have to navigate the historically charged terrain of academic research on, with, or by Indigenous peoples.[9] The members of A Tribe Called Red iden-tify both as urban Aboriginal people and as members of First Na-tions: Bear Witness and Dan General are Haudenosaunee, both Cayuga from Six Nations; and Ian Campeau is Anishinaabe Ojibwe from Nipissing First Nation. Given my position as the child of im-migrants living on Anishinaabe and Haudenosaunee land, reck-oning with their creative translations of tradition seemed like an important challenge. I knew that writing about their practice from a critical perspective would run the risk of "blocking out the Aboriginal voice," as Greg Young-Ing warns.[10] But to ignore their Indigenous experimentalism would leave political and aesthetic questions fundamental to this project unexplored.

A Tribe Called Red's musical production demonstrates the persistent power of Indigenous art and performance traditions, which have long been a target of colonial suppression. Since the

nineteenth century, the goal of Canadian colonial policy has been the extinguishing of Indigenous land title and the complete absorption of "Indians" into "the body politic."[11] This policy of coercive assimilation meant breaking the intergenerational links of cultural continuance, carried by the relation to the land and by ceremonial practices, including music and dance. A major plank of this genocidal project was the Residential School system, set up by the federal government and run by churches from the 1880s to the 1990s, which forcibly tore children from their families, land, religion, language, and culture.[12] But in the effort to shatter the links between generations, missionary boarding schools and forced adoptions were not sufficient. Amendments to the Indian Act of 1876 also outlawed ceremonial forms (including the Sun Dance, potlatch, and giveaways) that might tempt children to "regress" from an instilled European individualism to the collective practices of their communities. On the prairies in the first half of the twentieth century, for example, dancing itself was outlawed: Indian agents enforcing the Indian Act on reserves were directed to shut down all "senseless drumming and dancing," which was seen as a distraction from productive agricultural work.[13] Yet, despite this harassment and suppression, forms of Indigenous ceremony and performance endured, linking generations, persisting and adapting to new contexts. This "survivance" includes the music and dance of the intertribal pow wow, which (as I explore below) is itself an experiment within the discontinuum of tradition, a reinvention of suppressed collective practices in the face of ongoing colonial violence.

In adapting the music and culture of the contemporary pow wow, A Tribe Called Red exemplifies the remixing of tradition at the heart of the current Indigenous resurgence. For this most recent movement of artists, writers, and activists, those practices declared to be "traditional"—supposedly destined to disappear

with the passing of each generation of elders—must be reclaimed and reinvented to serve the collective well-being of Native communities. Even more than for their predecessors in the Red Power movement of the 1960s and 1970s, this new generation has little time for a rigid and unchanging vision of "tradition." Anishinaabe writer Leanne Betasamosake Simpson explains that what is necessary is a "returning to ourselves" that reclaims "the fluidity of our traditions" against "the rigidity of colonialism."[14] This "returning" does not aim at reviving an imaginary, lost purity—the colonial fantasy of tradition as belonging to a timeless past. Rather, it understands "tradition" as the collective production, invention, and reinvention of Indigenous practice, the ongoing process of what Tlingit curator Candice Hopkins calls "making things our own."[15] In its music, videos, and live shows, A Tribe Called Red is thoroughly engaged in this tradition of adaptation, remixing, and continuance. The group is part of a wider reimagining of Indigenous history and futurity, a continuous reworking of "traditional" knowledge and practices into a new creative and embodied life.

Unlike the previous chapter, what follows is not an insider account or (auto)ethnographic narrative, although I draw on my embodied participation at the group's concerts in 2012–2013. Instead, I look closely at A Tribe Called Red's music and videos, and especially their live performances, as a remixing of tradition that intervenes in the settler-colonial audiovisual sensorium. Instead of chasing after a frozen past or assimilating to a settler present, the group remixes Native vernacular music—along with Afrodiasporic sounds and mass-cultural images—so that history is set in motion in the body. Their live performances, especially, offer a simultaneity of *haunting* and *vibration*. A Tribe Called Red's montage of sounds, images, and movement works to break up spectral historical fantasies, while their vibratory intensities open up new affective configurations for settler, migrant, and Indigenous subjects.

This is not to say that these concerts are utopian spaces, exempt from "enterprise culture" and the commodifying pressures of the music business. In fact, part of the group's power comes through their opportunistic engagement with mainstream commercial networks of musical production, promotion, and distribution. At their best, their live sets reject utopian discourses in favor of the creation of new embodied forms of aesthetic experience and political encounter.

This chapter begins by dialoguing with Indigenous and settler colonial theory to explore how discourses of tradition are directed toward, and used by, Indigenous peoples in settler states, deepening the analysis begun in chapter 1. Against this background, I look at the work of A Tribe Called Red in the context of Indigenous engagements with contemporary technologies and practices of media production. I connect their music and concerts to the history of the intertribal pow wow, which is already a site of what Vizenor calls "native *transmotion*," a space of remembrance, active presence, and experimentation.[16] I consider the group's innovative blending of the "bounce" of pow wow with the syncopations of "global bass" music, which circulate in digital networks that stretch across the Black Atlantic and the Americas. I then examine the group's video work, which—in Bear Witness's comic-ironic montages of colonial images, projected behind the DJs in concert—presents a decolonizing remix of another kind. Finally, I explore the affective and embodied politics of A Tribe Called Red's live shows. At their monthly Electric Pow Wow club night in Ottawa and on tour, vibrant sounds and haunted images open up an experimental space for both Indigenous and non-Indigenous peoples, offering an opportunity to imagine what a shared, decolonized future might look like. This is a space in which decolonization can be worked through in the body, if not achieved. The nonmetaphorical return of the land to

its First Peoples—the baseline goal of decolonization—remains a work to be accomplished.[17] But on a symbolic level, on an affective level, and on the level of collective practice, A Tribe Called Red is walking on that road.

THE TRADITIONAL THING

Discourses of "tradition," with their suggestion of a lost, authentic, collective past, continue to impress themselves on the experiences of Indigenous peoples in settler colonies. In the opening monologue of his novel *Keeper'n me*, the Anishinaabe writer Richard Wagamese captures the ambiguity of the term, in a characteristically ironic voice. Keeper, the knowledge holder at White Dog reservation, jokes:

> Anishanabe got a good word no one ever argues with, Indyun or not, makes everything right and okay. We say—TRA-DISH-UNN. Heh, heh, heh. Wanna make white people believe what you tell 'em? Say it's TRA-DISH-UNN. Same thing with the young ones round here. You gotta do it, we say, it's TRA-DISH-UNN. Good word that. Makes life easy.[18]

Addressing himself directly to the reader, Keeper reveals how the term "tradition" works to designate past collective practices and obscure them at the same time. "Tradition" is a powerful "structure of feeling," tied up with notions of belonging, sovereignty, and cultural continuity.[19] It can also be a way to shut down internal debate, or to poke fun at settler fantasies. Wagamese's Keeper knows that "tradition," in the settler colony, can be a toxic word used to place Native peoples in a timeless and frozen past. Turning

it into "TRA-DISH-UNN" frees up more ironic and flexible possibilities of self-designation.

Yet this ironic and flexible position can be hard to maintain. As the Anishinaabe/Dakota critic Scott Lyons argues in *X-Marks: Native Signatures of Assent*, discourses of "tradition" are often used to justify a rigid, exclusive, and static Native identity. Since the 1960s, Lyons notes, Indigenous political movements across the continent have been accompanied by a broad cultural revivalism: the restoration and reinvention of Native languages, ceremonies, and everyday life practices. This efflorescence has successfully countered the colonial discourse of "salvage anthropology," which treated Indigenous traditions as constantly vanishing and in need of ethnographic preservation.[20] Nevertheless, a preservationist urge persists, both in and outside Native communities, in the insistence that "tradition" remain a pure, authentic, and uncorrupted *thing*, rather than a dynamic and "kinetic" practice.[21] A reified vision of tradition, Lyons notes, opens the door to "culture cops," new "traditionalists" in Native communities who attempt to enforce colonially inflected, often patriarchal ideas of authenticity. Against this static traditionalism, Lyons argues that the articulation of Indigenous culture requires a shift "from being to doing," from "culture" as a noun to "culturing" as a verb. "Being vanishes," he writes. "Doing keeps on doing."[22] The Anishinaabe language, Lyons notes, emphasizes process-based verbs rather than substantive nouns. Understanding culture as "the practice, not the thing" means treating it as "not timeless but situated and pragmatic, a way to meet needs."[23] It means embracing certain *values*—for example, the Anishinaabe "grandfather teachings" of love, respect, courage, honesty, wisdom, humility, and truth—rather than reviving specific past practices. Such values, Lyons suggests, can be carried across the passage of historical change and adaptation into new forms of collective embodied practice.

Lyons's flexible understanding of Indigenous practice echoes through much contemporary Indigenous thought, including specifically aesthetic and performance-based theorizations of tradition. As he notes, "the policing of traditional knowledge" denies the fluidity of oral traditions, their emphasis on adaptation, their "elasticity and boundlessness."[24] Yet his argument is hampered by an insistence on the split between "tradition" and "modernity," which suggests that certain embodied and land-based practices might need to be abandoned for Native peoples to flourish in the "modern" world. Reproducing the split between tradition and modernity reinforces the Enlightenment understanding of tradition as bounded, static, and unfree, and of modernity as the sphere of individualized freedom and autonomy—and forces a choice between the two. Lyons argues that the "x-mark" on the treaty signifies Native peoples' negotiating a "modern" configuration of sovereignty and nationhood; and once the treaty is signed, there is no going back. What matters is "the possibility of making good x-marks," or achieving the best outcome in all spheres of political-cultural life.[25] Lyons is supportive of certain revival movements, especially the renewed transmission of Native languages. But, ultimately, he is interested in how these "Native signatures of assent" can support the flourishing of contemporary Indigenous peoples, with all their diversity and necessary "impurities."[26]

Lyons's skepticism about the cultural-political effects of reviving suppressed traditions is well-founded. The discursive split between modernity and tradition, as I have argued in chapter 1, is essentially a European colonial operation, reserving cultural autonomy for the colonizers and fixing tradition (in this case, Indigenous practice) as an anachronistic, unchanging "thing." In settler colonies like the United States and Canada, after explicitly genocidal regimes give way to frameworks of multicultural recognition, this "traditional thing," as Elizabeth Povinelli calls it, becomes

both impossible and alluring. Povinelli asserts that in settler colonies the "traditional thing" is a "lost authenticity" just out of reach, the mirage of "a social practice and space which predates the settler state."[27] Settler subjects reach for "the traditional thing" in order to differentiate themselves from imperial identities and to redeem or disavow a tainted, bloody history. To this end, "traditional" Indigenous practices and iconographies are incorporated into the rituals of settler nationhood, as in Olympic opening ceremonies and other national pageants. State-sanctioned Aboriginal culture invites settler subjects to "enjoy their traditions"—or in the form of commodities with an Aboriginal flavor, to "enjoy our product *like* you enjoy their traditions."[28] For Povinelli, this "traditional thing" gives settler national discourses a utopian and fantastical quality. "The nation," she writes, "truly celebrates this actually good, whole, intact, and somewhat terrifying something lying just beyond the torn flesh of present national social life."[29] It is both sublime and evanescent, always in the past, always just out of reach.

If white settler subjects reach anxiously after the "traditional thing" as a way of smoothing out the rough patches of history and of marking their own difference or specialness, Indigenous subjects are oriented toward it by bureaucratic regimes of recognition. Povinelli points out that for Indigenous peoples, the performance of "tradition" has become necessary to "gain access to public sympathy and state resources."[30] In Australia, for example, proof of "traditional ownership" of land requires the demonstration of continuous customary practices, even as those practices are constantly disrupted.[31] The requirement to perform tradition is no less powerful in Canada and the United States, where the bureaucracies of Indian status or tribal affiliation based on blood quantum work to reinscribe divisions between "'real' Indians and others."[32] The injunction to identify with identities and practices

that the state has done its best to destroy is a mode of managing Indigenous peoples, who are pushed to abandon present struggles in favor of chasing after a misty past. Povinelli argues that in "(post)colonial multicultural societies ... hegemonic domination works by inspiring in the indigenous a desire to identify with a lost indeterminate object—to become the melancholic subject of tradition."[33] As she points out, this melancholic identification is doomed to failure. Any existing Indigenous subject inevitably lacks the full presence of authentic "Indigenous tradition."

Ultimately, the mirage-like quality of "the traditional thing" is designed to obscure the very real struggle over land and livelihood at the heart of the settler colony. Encouraging Indigenous peoples to chase after a timeless past (or assimilate to a settler future) is one way to naturalize the theft of their land for "productive" future uses, such as settlement, agriculture, or resource extraction. Consequently, reclaiming Indigenous intergenerational practice as creative and open-ended is a highly political act.[34] Insisting on the fluidity of tradition—and on Native futurity and survivance—is a way to fight against the dispossessions justified by a colonial temporality. "Tradition is not static," note the editors of *Native Studies Keywords*, summarizing the thought of Marcus Briggs-Cloud; "it is the historical accumulation of communications with the land. These traditions may have been severed, but communication can always begin again." Rooted in language, tradition can be understood as "the *practice* of ceremony and of living in right relationship to the land."[35] Again, the crucial move in the decolonizing of "tradition" is the shift from singular thing to collective practice, from "being" to "doing," which allows land-based traditions to move out of the prison of the past. Renewing communication with the land adapts and extends histories of long practice dating from before and after European colonization; this renewed communication will inevitably create new, unexpected cultural-political forms.

Can "tradition," as a keyword or concept, ever be fully wrested away from a colonial melancholy? The debates in Indigenous theory and settler-colonial studies are compelling. Povinelli argues that "tradition" should be abandoned as a critical term, as it serves only to encourage repressive fantasies of an unchanging, precolonial past. Yet many theorists are willing to see "tradition" as a flexible and open-ended mode of defining intergenerational continuity, invention, and production. "Native traditional practice," Anishinaabe scholar Gail Valaskakis argues, need not be a matter of "feathers and fantasy" or an "oppressive reification of the distant past." Rather, "[t]raditionalism is an instrumental code to action knitted into the fabric of everyday life."[36] Kanien'kehá:ka activist and scholar Taiaiake Alfred writes in opposition to static "traditionalism," pointing out that in Indigenous practice, "traditions have always changed."[37] Yet his writing breathes new life into lineages of Native cultural and political work, notably the warrior tradition. Some of these writers look to reclaim lapsed traditions—especially language and ceremony—as a foothold in present struggles for land and cultural continuity. Others stress traditions of invention and adaptation. In the most recent wave of Indigenous theorizations of tradition, authenticity is not the primary concern. What is important is the collective power that allows tradition—as a living *practice*, not a melancholy *thing*—to be produced and determined by Indigenous peoples themselves.

GONE DIGITAL[38]

Contemporary Indigenous music and media art is a site where what can be called the "power of designation" over tradition is being energetically challenged.[39] Native media artists and musicians, including A Tribe Called Red, reject the pastoral colonial

frameworks that would place Indigenous peoples in the past (as in Edward Curtis's "vanishing race") or in a timeless present-as-past (what Johannes Fabian famously called the "denial of coeval-ness").[40] Instead, the members of the group situate their work firmly in a self-defined present. As Ian Campeau (DJ NDN) says, "We're telling people that we're not the stereotypes that you think we are. We're not headdress-wearing, something-from-the-past, brave warrior types; we're just dudes. I'm wearing a Brooklyn Ncts hat and a sweater. I'm not this idea of a brave, I'm not this idea of a mystic, I'm not something from the past that uses stone tools. I'm a fully functioning person today." The same goes for the pow wow drum groups A Tribe Called Red works with, who (as I describe below) are thoroughly engaged with contemporary audiovisual technologies and networks. A Tribe Called Red often needs to remind non-Indigenous interviewers and fans that they aren't sampling archival recordings: "There are full-on successful labels right now that are signing only pow wow music, and signing young drums." All of this work—by DJs, video artists, or singers and drummers—is enmeshed in digital, technologically mediated forms of media production.

The fantasy of the "traditional thing" has special power when it comes to Indigenous peoples' engagement with new technologies. In the colonial imaginary, technologies are linked with regimes of time, marking forms of practice as traditional or modern, authentic or inauthentic. If one of the functions of the "traditional thing" is to encourage Indigenous peoples to chase after a vanished, premodern past, another is to make their present technological engagements seem exotic, surprising, or romantic. Academics are often seduced by the apparent contrast between Indigenous tradition and digital technologies. The anthropologist Kimberley Christen describes the colonial allure of juxtaposing "two seemingly contradictory elements: the past-oriented, romantic notion

of indigenous peoples who are somehow in modernity but not of it, set against the future-oriented, equally romantic notion of new technologies as the signifier of a progressive, fast-paced, global modernity."[41] This approach should be thoroughly rejected. ATCR's project is of interest due to its specific, decolonizing audiovisual configuration—its mixing of Native and Afrodiasporic vernacular sounds with colonial images in a space of embodied encounter—and not due to any romantic juxtaposition of old traditions with new technologies.

The binary opposition between "technology" and "tradition" is at its heart a colonial one, and is rejected by contemporary Indigenous practitioners. These practitioners include, among countless others, media artists such as Skawennati, whose digital experiments over several decades have involved the creation of animated virtual Indigenous worlds (figures 3.2 and 3.3), and composers such as Ziibiwan, whose ambient soundscapes draw inspiration from Anishinaabe roots and personal/historical disruptions. This digital experimentalism continues into new virtual reality platforms, as in the immersive VR project *Biidaaban: First Light* by the Anishinaabe filmmaker Lisa Jackson, which takes participants into a future Toronto that is both ruined and re-Indigenized (see figures 3.4 and 3.5). In an interview, Cree performance and media artist Archer Pechawis is asked: "Do you find there is a resistance to your use of technology as art form from those harbouring a more traditionalist interpretation of art?" Pechawis's response complicates these loaded terms: "what is traditional? using plant-based paints on bone-knife scraped hide to draw images of a buffalo hunt is using technology, and plenty of it. i respect all artists' right to express themselves in whatever medium they choose, whether i like it or not."[42] Similarly, for Buffy Sainte-Marie, whose 1969 album *Illuminations* used analog synthesis to manipulate her voice and guitar, digital technologies are simply another opportunity to

play with sound and image: "To me, a Macintosh is a natural and easy to learn tool, and it belongs in the hands of our bead workers and powwow singers, our linguists, our historians."[43] Progressive and romantic ideologies of technological difference obscure the long engagement of Indigenous peoples with technology, before and after colonization. Whether artists use potter's clay or digital modelling, stone tools or Pro Tools, what matters is their power of designation over tradition and cultural identity—the ability to determine what counts as Indigenous practice.[44]

In the realm of electronic dance music, Indigenous producers like A Tribe Called Red and Mexico's Javier Estrada reclaim that power of designation by rewriting global musical discourses long shaped by curators of European origin. These discourses were for many years split into the romantic binary of "world music" and "world beat," tied to allegories of salvage and futurity. In late twentieth-century Western markets, "world music" curators offered "'truth,' 'tradition,' 'roots,' and 'authenticity,'" treating Indigenous musical practices as endangered and in need of preservation from the forces of modernity. Admirers of "world beat," on the other hand, uncritically celebrated "practices of mixing, syncretic hybridization, blending, fusion, creolization, [and] collaboration across gulfs," with little attention to questions of power and commodification.[45] Still operating today, these discourses share utopian and ahistorical qualities. They also enact, in varying ways, what Eve Tuck and K. Wayne Yang call "settler moves to innocence," disavowing listeners' complicity in ongoing colonial relationships.[46] Such discourses tend to allegorize Indigenous peoples, as Jayna Brown writes, situating them "as representatives of the past and the holders of the future, the transcendent solution to the fracturing politics of race and global inequality. ... [Through 'world music'] the entitled violence of Western imperialism and colonialism could be placed in the past and resolved.

FIGURES 3.2 AND 3.3

Skawennati, "Jingle Dancers Assembled"
(2011) and "Steppin' Out" (2010):
digital images/machinimagraphs
from *TimeTraveller*™, courtesy the
artist and ELLEPHANT

FIGURES 3.4 AND 3.5

VR stills from *Biidaaban: First Light*
(2018) by Lisa Jackson, Mathew
Borrett, Jam3, and the National Film
Board of Canada

Social hierarchies could be euphemistically called 'differences' and, in the space of music, dissolve into a state of utopian unity."[47] By taking control of technologies of production and distribution, Indigenous musicians have been able to engage with these colonial scripts on their own terms: appropriating and remixing them, or tearing them up and writing their own.[48]

Contemporary Indigenous musicians such as the members of A Tribe Called Red—who produce their own tracks, DJ, make videos, and manage their business on digital platforms—are in no sense betraying "traditional" culture; nor are they engaged in a revolutionary, unprecedented blending of past and present. Rather, they should be considered part of a long history of Indigenous technological adaptation and remixing. Tlingit curator Candice Hopkins argues that current Indigenous media work is "a continuation of what aboriginal people have been doing from time immemorial: making things our own."[49] For Cherokee artist and activist Jimmie Durham, adaptability and dynamism have been crucial Indigenous traditions—including the adaptation of colonial technologies such as the horse, and later the skidoo. Durham notes that in the eighteenth and nineteenth centuries, "every object, every material brought in from Europe was taken and transformed with great energy. A rifle in the hands of a soldier was not the same as a rifle that had undergone Duchampian changes in the hands of a defender, which often included changes in the form by the employment of feathers, leather, and beadwork."[50] This tradition of innovation continues in the contemporary proliferation of Indigenous media arts. Indeed, digital technologies extend the processes of copying, reuse, and montage that are already present in both Indigenous and "folk" cultural practice.[51]

While digital technologies allow sounds to be repurposed, copied, and displaced, they also allow those sounds to travel between neighboring or distant nations. In the first Internet boom of the

1990s, Indigenous practitioners were quick to seize on the connective possibilities of collaborative websites, including the gallery/ chat network CyberPowWow, "an Aboriginally determined territory in cyberspace" set up by Skawennati and other artists in 1996.[52] The connectivity enabled by digital networks (and amplified by social media) is both a continuation and a restoration, echoing modes of communication that have long joined Indigenous nations, such as "storytelling, the moccasin telegraph and ancient trade routes."[53] For Bear Witness, the collaborations between A Tribe Called Red and Javier Estrada recall the precolonial sharing of cultural practices such as Three Sisters agriculture (beans, corn, and squash) across the Americas. The current wave of Indigenous electronic music revives these networks of dissemination, using websites and social networks (Soundcloud, Facebook) to connect distant communities broken up by colonial borders. For these artists, digital networks allow the communication of images, voices, and sounds between nations, and between Indigenous nations and others in the settler state. As ATCR told me, their 2013 album *Nation II Nation* should really be called "Nation to Nation to Nation to Nation to Nation ..."

Contemporary digital networks are often described in this kind of utopian language by Indigenous new media practitioners, as they are in the culture at large. While these enthusiastic claims hold some truth, they should be set against a more sober analysis of the current media landscape. Communications networks are spaces of surveillance, deception, monetization, and commodification as well as exchange, and these networks amplify conflicts over intellectual property and cultural sovereignty that are not easily resolved. Discourses of "the digital commons" or "the public domain" can undermine the ability of Indigenous peoples to determine who has access to their knowledge, sounds, and images. Social media sites are as useful to micro-targeting advertisers,

political operatives, and state security agencies as they are to activists and artists. Paeans to the power of "remix culture" in a digital age tend to glide over the corporate-owned infrastructure that enables that cultural remixing.[54] This includes the "physical Internet" of cables and servers, run by providers who profit from the bandwidth costs of streaming and legally or illegally downloading files, as well as the pervasive advertising that makes "free" content highly lucrative. Any analysis of these international digital networks and platforms should follow the money—which is overwhelmingly flowing to tech companies, service providers, and content curators, leaving artists like A Tribe Called Red to make most of their living on the road. Like any other musicians, they must find their way through this contemporary "enterprise culture," supporting themselves with DJ fees and state-funded touring grants, commodifying their music, and selling their brand to the public.

Conscious of these constraints, A Tribe Called Red moves adeptly through a complex new media landscape. They released their first album as a free download on their website, and regularly post new tracks and live mixes to Soundcloud, including their 2012 *Trapline* EP (the title is a pun on the "trap" beats that provide its musical backbone). *Nation II Nation* (2013), like 2016's *We Are the Halluci Nation*, exists as a paid download, via streaming services, and as a physical CD. A collaboration with the Native-owned Tribal Spirit label and its drum groups (as well as with the eclectic label Pirates Blend), *Nation II Nation* is an example of digitally mediated conversation between Indigenous Nations, and between those nations and non-Indigenous subjects. It honors the integrity of the Tribal Spirit drum groups, whose names and Nations are listed in its liner notes: "Black Bear (Atikamekw), Sitting Bear (Ojibway), Northern Voice (Atikamekw), Smoke Trail (Ojibway), Eastern Eagle (Mi'kmaq), Sheldon Sundon (Seneca),

and Chippewa Travelers (Ojibway)." The album continues a dia-logue between different musical traditions of innovation across the colonial divisions that separate Native peoples dispossessed from their land, whether living on reserves or in the "urban dias-poras" of the settler state.[55] During the recording process, A Tribe Called Red remixed tracks for the Tribal Spirit drum groups, in-tended for those groups' forthcoming albums. And to the three DJs' excitement, in the summer of 2013, physical copies of *Nation II Nation* were available for sale on the pow wow trail. This ongo-ing engagement with pow wow music and cultural production is at the heart of A Tribe Called Red's sonic and performative remixing of tradition.

POW WOW'S TRANSMOTION

In April 2013 in downtown Ottawa, partiers are trickling into the Electric Pow Wow, and Bear Witness is warming up the crowd with a set of dancehall. Gently bobbing over his laptop, his denim vest dotted with pins, he eyes the crowd expectantly. Groups of young friends gather around the ratty couches of the appropriately named Babylon nightclub, sitting below airbrush-style murals of martyred rock, soul, and rap artists from Aaliyah to Cobain. The crowd is hard to place: there are lots of young people in baseball caps and streetwear, a few glamorously dressed club-goers, Indige-nous and non-Indigenous people. There are even a few middle-aged non-hipsters. As the line outside lengthens and the dancefloor fills up, Shub and DJ NDN join Bear Witness on the low stage. They start playing more hyped-up electro club tracks, moombahton, and trap music. A camera crew circles the room; Shub on the mic says, "CBC [the Canadian Broadcasting Corporation] is in the house, so don't do anything your mom wouldn't do." It's a warm

spring night, and the energy of the crowd is edgy: many of them seem like undergraduates juiced up after their exams. Bear drops one of his favorite mashups of the moment: the anthemic chorus of Paul Revere and the Raiders' "Indian Reservation" ("Cherokee people! Cherokee tribe! So proud to live, so proud to die!"), montaged with a vocal sample ("this is real hardcore") and a heavy synth-driven bass drop. ATCR foregoes the coolness of some club DJs; they get into their music, whipping up the crowd. When they spin their own tunes, the crowd gets excited and joins in, bouncing and singing along with the chorus of "Electric Pow Wow Drum."

Questions of belonging and appropriation do not disappear in this celebratory setting; there have been controversies about white kids showing up in war paint. But the very existence of such controversies, and their informal resolution through online and in-person debate, points to the Electric Pow Wow as a Native-defined cultural space, not unlike the "traditional" pow wows from which it takes its name. The group often describes how they were surprised by the success of the monthly party in Ottawa, which began in 2008. According to Campeau, friends told them that above all it was "a comfortable space for the Native population in the city," a "really safe space where people can listen to good music and DJs." In addition to being a safe space for urban Native people, the party is a place for gathering, for conversation between Nations, for Indigenous artistic invention, and for reclaiming the power of designation over tradition. Calling the party an Electric Pow Wow is not an offhand gesture: the group sees the event as "a cultural continuance." As Campeau says, "Pow wows are celebrations of songs and food and friends. It's a gathering of people to share songs and dances, and compete in a friendly sort of way. The only place you'd be able to do that in an urban setting would be a club." Like "traditional" or competition pow wows, this urban club night expresses "the ways that Indians render their own

experience into being, how they represent themselves and their people *to each other*."[56]

Indeed, the continuity between pow wows and an urban club night is not particularly far-fetched. "Traditional" pow wows, as collective vernacular practices, are sites of embodied invention and reinvention, in a process of constant change and dialogue. Bear Witness makes this clear:

> I'm a strong believer in the idea that culture and tradition are living, growing and changing things. We learn to understand our past to guide us into the future. I will always remember going to pow wows when I was a kid in the early '80s, right around the time break dancing was getting really big. There were fancy dancers who were adding break dancing moves in with the pow wow steps and things like checkered bandanas to their regalia.[57]

This tradition of creative adaptation—between multiple Indigenous nations, from settler groups, or (as Bear Witness describes) from Afrodiasporic vernacular practice—is part of pow wow's own "cultural continuance." "Pow wow" itself is a European term (supposedly for "medicine man") reappropriated by Native peoples.[58] While pow wow can be traced back to summer tribal gatherings led by medicine societies, it began to take shape in a newly defined way in the early 1800s, starting in the south among the Omaha and Pawnee people, traveling north through the Dakota people and the Plains Cree, and spreading eastward in secrecy. As a form of collective practice, it is intertwined with the suppression of Native ceremony on the Plains in the late nineteenth century. Confronted with the ban on giveaways and ceremonial practices associated with the Sun Dance, Plains nations adopted the pow wow as a more secular means of cultural continuance. Often occurring

alongside white-run exhibitions and stampedes, the modern-day pow wow emerged in the 1940s in a newly visible and popular form. Its music, dance, and cultural practice have only recently been the subject of serious study.[59] Twentieth-century anthropologists tended to regard it as syncretic and inauthentic, a corrupted version of the "traditional thing," unworthy of the salvage operations of ethnography.

The Electric Pow Wow translates into a club setting pow wow's ability to unify through music and dance, its embodied quality, as well as its relation to shared pride, memory, and feeling. What Gail Valaskakis calls the "sweetgrass solidarity of pow wow" is built around dance and song, the vibration of the drum, and the gathering of members of different nations.[60] Pow wow itself can be seen as a remixing of intergenerational practice, a way to activate and reinterpret the historical, spiritual, and ancestral past of Indigenous nations. Pow wow dancers describe each step on the ground as being a prayer to the Creator, and the beat of the drum (the "heartbeat of the nations") as invoking the memory of the ancestors.[61] The pow wow drum is a "mnemonic device" that calls up feeling in the body, creating a sensation of continuance, joy, and unity.[62] Through embodied and shared remembrance, in music, dress, and dance, pow wow becomes a site for the reconstruction of Native collectivity. It is a contested site: contemporary competition pow wows, with their standardized categories and cash prizes, have been criticized for promoting a "pan-Indian" culture that tends to blur the distinctiveness of the songs and dances of each nation.[63] Yet pow wow's images and expressions of unity encourage, in Valaskakis's words, a "feeling of collective identity and shared community." This community does not root itself in the unchanging past or in a settler-defined present: it "is not an expression of nativistic revitalization but an awareness of cultural persistence." As a form of persistence, it

allows for variation and adaptation, for movement in time, for *survivance* and *transmotion*: "In the commonness of ceremony, Native people not only remember the past but also imagine the future."[64]

Pow wow songs can carry these feelings of remembrance, unity, and persistence beyond the context of ceremony and gathering, far from the pow wow trail. As Choctaw musicologist Tara Browner notes, pow wow music has in effect become a specialized genre of popular music—particularly intertribal songs, which are mostly sung in vocables rather than tribal languages. For many participants on the pow wow circuit, Browner writes, "intertribal songs (as well as tribal-specific ones) fill a specific sonic and emotional void, especially when speeding down a rural highway played at full blast on the car stereo. Detached from their original function and meaning, the songs create a kind of portable Indian space, not really an extension of the pow-wow arena but instead an intensification of the self."[65] These songs are transformed by their engagement with media technologies and processes of commodification, as they find their way into diverse modes of embodied practice. In the recording studio and in performance, innovative drum groups like Northern Cree, Eyabay, and Midnite Express experiment with sound and rhythm to create new translations of tradition. Songs flow between nations, due to the heightened intertribal connectivity brought about by both the pow wow trail and the Internet.[66] Videos of performances or studio recordings by Northern Cree can easily top 100,000 views on YouTube. Performance styles are "borrowed" and adapted, and songs recorded with hand-held devices can show up in the repertoire of distant drum groups.[67] A Tribe Called Red draws from this rich sonic universe, importing pow wow music's structure of feeling—its memory, futurity, and affective intensity—into their own club tracks.

DIASPORIC BOUNCE

A Tribe Called Red's most evident musical innovation is to take recordings of pow wow drum groups and collage them into the electronic Afrodiasporic vernaculars of dubstep and global bass, creating what has been called "powwow step." Their remix of Northern Cree's "Red Skin Girl," for example, takes an intertribal song by the popular drum group (sung in vocables and English) and marries it to Afro-British dubstep's abrasive timbres and staggered rhythms. The remix opens with a clavé-syncopated drum, a 3-3-2 beat quite different from pow wow drum groups' straight or swung downbeats. Over this rhythmic base, it layers fragments of singing in interlocking lines, with a high voice swooping up like a siren from a Bomb Squad production. The track then splinters into digital shards of sound and sweeping filters. As the chorus hits, the Northern Cree singers enter in powerful unison over a funky bass drum–snare–hi-hat breakbeat, with accents on the "honor beats" (the heavy downbeats that close each main phrase) of the original song. Even when the track strips itself down to its bare essence in the coda—just singers and drums—its groove carries the memory of the previous verses' heavy syncopations.

Pow wow drum groups already have their own groove or "bounce," also known as "participatory discrepancies"—the rhythmic, melodic, and textural idiosyncrasies that set heads nodding and bodies moving, causing music to be productively "out of tune and out of time."[68] Pow wow's "bounce" could be described in musical terms as "displaced syncopation": singers tend to sing "off the beat," in slight tension with the drum. Drum groups themselves use the term "bounce" to describe the "rhythmic energy" that results from "the tension between the drumbeat and the melody."[69] As singers strike the drum in unison, their sticks literally bounce off the skin. When voices and drum find the right relation,

the right bounce, it "feels as if the melody is floating effortlessly but firmly over the drumbeat."[70] A Tribe Called Red's "powwow step" takes this "displaced syncopation" and allies it with the more evident syncopation of Afrodiasporic rhythms. Pow wow music already bounces; Campeau will sometimes drop a track in unadulterated form as part of his DJ sets. When A Tribe Called Red mashes drum groups' off-the-beat singing with the dense syncopation of trap music, or with the "heartbeat" house tempo and percussion flourishes of moombahton, the rhythmic and melodic energy becomes electric.

This sonic mashup has historical roots in intertwined colonial experiences. While pow wow's remixing of tradition carries forward the histories and memories of Indigenous nations, A Tribe Called Red opens this work up to include the sonic histories and memories of West Africa and its diaspora. Contemporary electronic dance music and DJ culture, it must be emphasized, grow out of Black vernacular sonic practices.[71] From hip hop to reggaeton to baile to kuduro to dancehall, music of African origin is a touchstone for A Tribe Called Red, as it is for other contemporary dance music producers tapping into the "sound of a black planet."[72] These sounds carry a freight of history, dating from before, during, and after the colonization and enslavement of Indigenous Africans—histories of discontinuity and persistence, terror and resilience. In their music, the members of A Tribe Called Red both insert themselves into those histories and rewrite them to decolonize them further, interweaving the pasts and futures of Blackness and Indigeneity. The group tends to take its mixing of sounds and histories for granted: for Bear Witness, listening to and DJing dancehall and hip hop was simply a product of growing up in a certain urban time and place—Toronto, with its large Jamaican and other Caribbean diasporas, in the 1980s and 1990s. Yet the seamlessness of the group's integration of Afrodiasporic

music should not obscure its criticality and power. Echoing out from the internal diaspora of urban Indigenous people, A Tribe Called Red's music becomes an evocative point of intersection: a way for peoples whose lands were stolen, or who were stolen from their lands, to "chant down Babylon" in the midst of the settler state.

By bringing together the Afrodiasporic sounds of global bass with the music of pow wow drum groups, A Tribe Called Red finds another way to reject the false contradiction between the traditional and the contemporary. Here they find common ground with Black electronic musicians/composers and media artists, especially the various practitioners grouped together under the (now rather overused) term "Afrofuturism": artists, writers, and musicians of African origin who also struggle against racist and colonial temporal frameworks, offering a technologized "vision of the future that is purposely inflected with tradition."[73] Afrofuturist discourse has often borrowed its tropes from science fiction; like Indigenous media theory, it offers contrasting approaches to the problem of tradition. Kodwe Eshun's 1998 Afrofuturist manifesto *More Brilliant Than the Sun*, for example, resists the temporal drag of past practices on sonic futurity. "Sonic Futurism doesn't locate you in tradition," Eshun writes; "instead it dislocates you from origins. It uproutes you by introducing a gulf crisis, a perceptual daze rendering today's sonic discontinuum immediately audible."[74] Following Jacques Attali's *Noise*, Eshun is above all interested in the prophetic and anticipatory qualities of Black sonic practices, and critiques the orientation of twentieth-century Afrodiasporic subjects toward projects of recovery. Eshun's future-oriented subjectivity is echoed by contemporary global bass DJs like the aptly named DJ /rupture (aka Jace Clayton), who puts out mixes with titles like *Minesweeper Suite* and *Uproot*. Yet, despite his stage name, /rupture's work is not pure discontinuity, deterritorialization, or

deracination. His mixes—which move quickly between Egyptian shaabi, Mexican cumbia rebejada, abrasive hip hop, and ambient experimentation—are stylistically eclectic but steeped in situated vernacular knowledge. Rather than uprooting, they practice "uprouting," as Eshun terms it, a sonic rewiring that makes the global "changing same" audible and affectively present.[75] Along with other contemporary sonic experiments in the Afrodiasporic tradition, /rupture's mixes vibrate with temporal bounce.

Afrofuturism, like many strands of contemporary Indigenous media art, does not tend to call for a radical break with the past, but rather for remixing the discontinuum of tradition. In his later essay "Further Considerations on Afrofuturism," Eshun offers a more nuanced engagement with tradition and futurity, memory, and anticipation. "The field of Afrofuturism does not seek to deny the tradition of countermemory," Eshun claims. "Rather, it aims to extend that tradition by reorienting the intercultural vectors of Black Atlantic temporality toward the proleptic as much as the retrospective."[76] Echoing Walter Benjamin, he argues that both past and future can be a repository of "temporal complications and anachronistic episodes that disturb the linear time of progress."[77] For Eshun, music—specifically, Black vernacular music—is a privileged site of investigation: "It is difficult to conceive of Afrofuturism without a place for sonic process in its vernacular, speculative, and syncopated modes."[78] Eshun lauds those musicians, from composer/bandleader Sun Ra to techno DJ Derrick May, who specialize in "the articulation of futures within the everyday form of black vernacular expression."[79] Such an articulation is not the sole preserve of African or Black diasporic subjects. It can be seen in the work of musicians like Maga Bo, a white American DJ and producer who lives in Rio de Janeiro, whose 2012 album *Quilombo do Futuro* gathers a musical community of liberated runaways of all stripes, inspired by the history of Brazilian *quilombos* or "maroon

states." And it can be seen in Indigenous sonic artists such as the Colombian-born singer-composer Lido Pimienta and the Inuit vocal experimentalist Tanya Tagaq, both collaborators with A Tribe Called Red, who also weave multiple past and future-oriented vernacular practices into a vibratory force in the present tense.

Beyond the temporal orientation of A Tribe Called Red's work, its compositional techniques of cutting and mixing derive from Black diasporic cultural practice. "Cut 'n' mix" remains the basic strategy of "sonic Afro-modernity," and by extension of many forms of contemporary popular music.[80] As Julian Henriques writes in *Sonic Bodies*, referring to Jamaican dancehall music, cutting and mixing are complementary practices, "*partnered*, to use a Jamaican expression": one divides, the other reunites; one makes a break, the other sutures and smooths out.[81] Certain musical genres that spring from Black vernacular practice, like hip hop, tend to foreground the disjunctive cut; others, like disco or house, glide more smoothly across the sonic mix. Cutting and mixing are "invariably coupled together" as a form of syncopated repetition, a repetition that is a primary feature of African and Afrodiasporic musical practice.[82] But this repetition does not indicate temporal stasis or regression, a quality that Eurocentric critics have historically ascribed to music of African origin.[83] Repetition moves both forward and backward in time, dragging and bouncing by turns: "one side of the cut is the moment of return, going back to the beginning, and regression. On the other side is the moment of renewal, emergence, and progression."[84] Cutting and mixing can be seen as a mode of working with the past, of prying historical material from seemingly settled frameworks and reorienting it toward the emergence of the new. With this in mind, the embodied practice of the DJ can be seen as a kind of sonic history-writing. Cutting and mixing turn the sonic archive into a repertoire (to

use Diana Taylor's terms), opening history to new performative possibilities.[85]

A Tribe Called Red's cutting and mixing ranges across Indigenous and Afrodiasporic pasts, marking their divergences and points of intersection in colonial modernity. One particularly multilayered example of their sonic history-writing is "NDNs From All Directions," a remix of dancehall DJ Super Cat's "Scalp Dem."[86] Opening the track with a loop of high pow wow singing gives Super Cat's toasting, with its Western-themed references to cavalry and Apaches, another historical twist. The Jamaican DJ threatens to send in "Indians from all directions"; as reclaimed by A Tribe Called Red, the threat becomes an affirmation of resurgence. The remix doesn't condemn Super Cat's fantasies of "playing Indian" and avenging himself on his enemies (which in any case are self-conscious fantasies: in the original video for "Scalp Dem," Super Cat falls asleep in front of a sepia-toned Western on TV and dreams himself inside it). Instead, A Tribe Called Red pushes these fantasies front and center. Bear Witness's video for "NDNs" doubles down on the grim humor of this complex history, adding a layer of white ultra-violence in a stuttered loop: an enraged Southerner (Merle Dixon from the zombie drama *The Walking Dead*) brandishes a gun over what might be a beaten body, yelling, "We're gonna have ourselves a little pow wow, huh?" The brief image of the white zombie-survivor condenses and displaces the bad conscience of colonial modernity, acting as a screen for its "ghostly and haunting trouble."[87] Here, the zombie figure is the colonizer, the undead revenant who keeps staggering back, mindlessly cannibalizing Indigenous and Afrodiasporic practices. Super Cat and A Tribe Called Red are uneasy allies in this horror comedy. Full of unsettled energy, driven by a stripped-down dancehall beat, the remix drops into the scratched grooves of history, following

the ambiguous appropriations between peoples persisting in the wake of colonial dispossession.[88]

HAUNTED IMAGES

If A Tribe Called Red's music vibrates with Afrodiasporic and Native survivance, Bear Witness's videos deal with a different kind of temporal survival—the endless, repeated images of "Imaginary Indians" that persist in the colonial visual archive.[89] The video artist selects clips from his extensive collection; using digital editing software, he then loops, color-saturates, distorts, and montages them into new narratives. The videos are often synchronized with the jagged rhythms of A Tribe Called Red's tracks, stuttering along with a dubstep beat or punctuating a bass drop. They are in the tradition of video appropriations from the 1970s and 1980s such as Dara Birnbaum's work, or Gorilla Tapes' "scratch video," in which mass-media video clips are looped repetitively and set to music to satirical effect. They also echo video and musical work from other Indigenous remixers, notably Kanien'kehá:ka artist and theorist Jackson 2bears, in projects like *Ten Little Indians* (2005) and *Iron Tomahawks* (2005–present). As with 2bears's work, when Bear Witness's videos are projected live behind the DJs in performance or shown online, their successively disturbing, eerie, and comical montages critically remix colonial and Indigenous modernity. They record a haunting, and perform a kind of exorcism.

While Bear Witness's clips are drawn from diverse sources, they tend to cluster around the image factory of the Hollywood Western, which for the past century has churned out pictures of alternately savage and noble Indians in relatively static form.[90] Their contradictory quality reflects the undecidability of the "Indian thing," which is "neither bad nor good, neither noble nor

FIGURE 3.6

A Tribe Called Red in
concert in Vancouver (2018),
photo by Timothy Nguyen

bloodthirsty, neither loved nor despised," or rather, which moves erratically between these poles.[91] Settler anxieties work themselves out in narrative and filmic genres like the Western, which oscillate between desire and disavowal in their relation to the Indigenous.[92] These narratives fulfill a dual purpose: "the suppression or effacement of the indigene" and "the concomitant indigenization of the settler."[93] As Rayna Green points out, these genres are hardly innocuous: if "playing Indian" is an obsession in settler colonies, "play Indian roles depend on dead Indians."[94] The removal of the territory's first inhabitants makes room for stories of the Indigenized settler: the cowboy, the backwoodsman, the *gaucho*, the Mountie, the voyageur. Settler narratives often involve a peculiar inversion, in which "Indigenous people are seen as entering the settler space (and disturbing an otherwise serene unperturbed circumstance) *after* the beginning of the colonization process."[95] These narratives are a collective version of what Freud called "screen memories"—compromise memory formations marked by dreamlike displacements and condensations—which disavow the founding violence of colonization.[96]

In the settler imaginary, a disavowed colonial violence returns in symptomatic form. Indigenous people become threatening shadows, fleeting specters, or ambivalent ghosts that haunt the present. "Indigenous spectrality," as Emilie Cameron calls it, is a "deadly trope" common to all settler colonies, from Canada to Australia to the United States.[97] Literary critics sometimes mischaracterize stories of Indigenous ghosts haunting the settled landscape as postcolonial. In fact, such stories reinscribe ongoing colonial relations by "writing out" "the bodies and voices of living, politically active Indigenous peoples."[98] Sometimes this "writing out" is quite literal, as in the poetry of Duncan Campbell Scott, who worked as Canada's Deputy Superintendent of Indian Affairs during one of the department's most aggressively assimilative

phases. While traveling to Northern Ontario in 1905 to secure the surrender of Cree and Ojibway lands, Scott wrote a poem called "Indian Place Names," a sort of elegy. The poem begins: "The race has waned and left but tales of ghosts, / That hover in the world like fading smoke / About the lodges." Scott laments the "vaunted prowess" of the Native, which is "Gone like a moose-track in April snow," yet lingers in the "wild names" of rivers, lakes, and city streets.[99] Yet, when he wrote his allegorical ghost story, Scott was engaged in negotiations with "real, live Indians." His spectralizing operation was ultimately unsuccessful: "In spite of Scott's efforts, both poetic and bureaucratic, the Cree and Ojibway clearly did not 'wane,' after all. They were real then and are real today."[100]

In the Indigenous experience of colonization, the haunting trope is inverted. Maria Campbell recounts that elders describe white settlers as "ghosts trying to find their clothes."[101] In the domain of the visible, Jackson 2bears argues that settler subjects produce spectral images of "the Indian" that haunt the present, affectively shaping the lived experience of colonialism.[102] Racist images from more than a century of audiovisual production—ethnographic films, Westerns, advertisements—linger in the electronic archive, on videotape, film reels, DVDs, and now online. Preserved in "the medium of the media," their being is subject to a certain "hauntology," as Derrida terms it, a being that is "neither living nor dead, present nor absent; it spectralizes."[103] These haunted images have had destructive political consequences. Emma LaRocque writes that the repetition of racist images and texts has legitimized processes of dispossession by serving to "degrade," "infantilize and objectify ... Native people and their societies." For settler subjects, these ghostly representations have "become more real in the minds of the public than any *real* Native peoples as human beings."[104] Native people themselves have grown up surrounded by these colonial representations and can internalize them, leading

to a "sense of shame concerning their Indianness."[105] Such images are "survivals," to use the term that art historian Aby Warburg borrowed in the 1920s from colonial anthropology; their "afterlives" echo through "ghostly and symptomatic time."[106] Yet this "colonial debris" has nonetheless elicited a tremendous creative response: for LaRocque, these images are "colonial shadows that have both haunted and inspired our own expression."[107]

While some Native artists and writers have responded to this "denied history of Indigenous erasure and spectacularisation" by laying out a countervision of a vibrant Indigenous culture, others, like Bear Witness, wade deep into the sludge of colonial visual history.[108] His decolonizing work, like that of many other Indigenous artists, operates through reappropriation and humor. The video artist sees his work as a kind of revisionist history-writing. Through his "life project" of working with colonial images, he ultimately aims to depict "Aboriginal history from an Aboriginal perspective."[109] In its inversion, counterappropriation, humor, and exaggeration, Bear Witness's work has much in common with the work of contemporary Indigenous visual artists such as Shelley Niro, Edward Poitras, Terrance Houle, Jim Logan (in *The Classical Aboriginal Series*), and Kent Monkman (in his *Moral Landscapes* and other work).[110] In its reclaiming of debris from settler culture, it resonates with the collage and sculptural work of Native artists such as Carl Beam, Brian Jungen, and Sonny Assu. And in its ambivalent engagement with racist images, Bear Witness's work intersects with works by African American artists: Kara Walker's cutouts and shadow videos, for example, or Spike Lee's film *Bamboozled* (2000). Bear Witness's comic-ironic inversions also recall the work of his father, the celebrated photographer Jeff Thomas. In Thomas's photo *FBI, Bear with Indian Scout* (1998), the young Ehren "Bear" Thomas (a.k.a. Bear Witness) leans casually at the base of Ottawa's notorious Champlain Monument, his arm draped

over the bent leg of the bronze sculpture of a well-muscled Native guide. The young video artist's t-shirt sports an iconic Edward Curtis image of Native American chiefs, superimposed with the text "FBI—Full-Blooded Indians."[111]

A Tribe Called Red's album art and press photography are filled with similar subversions of stereotypes and counterappropriations of colonial imagery. The inside sleeve of *Nation II Nation* features an earlier Jeff Thomas photo of the same "Indian scout" statue, this time looking over the Ottawa valley and Parliament Hill. The CD jacket also reproduces the three DJs' Indian Status Cards, which certify that each of them "is an Indian within the meaning of the *Indian Act*, chapter 27, Statutes of Canada (1985)." Their blank-faced ID photos echo similar mug shots in hip-hop album art, including the welfare card ("Identification Card for Food Coupons and/or Public Assistance") on the cover of Ol' Dirty Bastard's 1995 debut album. These counterappropriation strategies, both humorous and serious, are what Kobena Mercer calls "visual maroonage" after the practices of the maroons, enslaved Africans who escaped from Caribbean and South American plantations and set up their own communities of resistance, joining forces and intermarrying with local Indigenous peoples.[112] These strategies reclaim a power of designation over lives and identities that have long been defined by white settler institutions and racist iconography.

Like Jeff Thomas's photographs of colonial statues and Ol' Dirty Bastard's Photoshopped ID card, Bear Witness's videos are strong examples of what the situationists called *détournement*, the politically creative reappropriation of mass-cultural forms. In his visual montages, haunted images are detourned, turned back, reversed, and cut loose from the web of colonial narratives. Looped to the music of vibrant Afrodiasporic and Native survivance, they can turn an injurious and objectifying gaze back onto their

makers. Some of these painful images even contain an element that can be redeemed. Bear Witness often refers to the character of Billy, the "Indian scout" from the Arnold Schwarzenegger film *Predator*, who the artist says was a "powerful icon" for him when he was growing up. As he recalls, Billy "has all the normal things that come with being the Indian scout: he doesn't speak in full sentences, he spends a lot of time staring off into the bush." But in *Predator*, the character also demonstrates real skill and courage: "As a young man, I looked at that and said, here was a really powerful Native actor in this awesome movie." In videos like ATCR's *Indigenous Power*, Billy is placed alongside clips of the WWF wrestler The Ultimate Warrior, and is played partly for laughs. But he also carries with him powerful affects formed by childhood desires and identifications. Pulled from the narrative matrix of the action film, looped, and made the hero of his own story, Billy can be redeemed from racist stereotypes of the "stoic Indian," becoming a half-ironic, half-sincere icon of a certain Native masculinity.

Such strategies of appropriation and redemption are widespread in found-footage film and video work. Indeed, with their saturated colors and grainy degradations, Bear Witness's blown-out video loops strongly resemble the computer-synthesized images presented by the fictional artist Hayao Yamaneko in Chris Marker's film *Sans Soleil* (1983). Bear Witness's images, like the clips of political demonstrations worked over in Yamaneko's "zone," foreground their mediated quality. The narrator of *Sans Soleil* observes that Yamaneko's images "proclaim themselves to be what they are: images, not the portable and compact form of an already inaccessible reality."[113] Bear Witness's videos proclaim themselves to be images in a similar fashion, though humor is more important to his approach. One could even say that his videos use laughter to break up the compactness of colonial reality, exposing it as a series of spectacular images. Looped and treated

in the "zone" of video editing software, the images Bear Witness pulls from the settler visual archive are revealed as spectral: "digitalized, abstracted, and ghostly in their video form."[114] By dredging up these haunted images and exposing them to laughter, he strips them of their power, symbolically decolonizing them and shaking off their ability to shame. Watching Yamaneko run images of protest through his synthesizer, the narrator of *Sans Soleil* offers a remedy for political and visual inertia: "if the images of the present don't change, then change the images of the past."[115] Bear Witness's video work shares this anachronistic remixing strategy, if in a more irreverent key.

Found-footage films and video remixes often employ a "redemptive aesthetic," assembling "allegories of history" from the image bank of colonial modernity.[116] Yet in Bear Witness's videos, redemption is always ambiguous and uneasy. His tools, like those of other found-footage filmmakers, are juxtaposition and irony. In the artist's montage, some sequences are grindingly racist, while others are more complex, like the shots of the New Zealand All Blacks rugby team dancing the Maori haka "Ka Mate." In his live projections and streaming videos, images rub up against each other: Judy Garland as a dancing Hollywood Indian, African American Mardi Gras Indians in full regalia, the clichéd blue warriors of *Avatar*, Gary Farmer as Nobody in Jim Jarmusch's *Dead Man*, black-and-white ethnographic footage, endless loops of the 1980s sci-fi cartoon *BraveStarr*, and ghostly clips that are less easily identified. The whole forms a montage that is often queasy, sometimes comic, and generally difficult to pin down. Bear Witness's visual remixing changes the signification of these ambivalent images, thus rewriting the historical past that they repeat in spectral form.

Much of the power of Bear Witness's video montage results from the uncanny familiarity of its sources. Film scholar Catherine Russell notes that while "it is always tempting to trace the

sources of images in found-footage films, the effect of the images is precisely due to the unknown status of the sources, which is what provokes the images' radical ambiguity."[117] Russell's observation does not quite apply to the ambiguity of Bear Witness's work, in which the source is sometimes buried and sometimes unnervingly obvious. Through selective cutting, he can take a familiar sequence and render it uncanny. The "Wild West" setting of *Back to the Future 3*, for example, when remixed and projected live behind A Tribe Called Red in performance, becomes a kind of "dream analysis," puncturing the colonial dreamworld of my own settler childhood.[118] In live projections, Bear Witness often loops one particular sequence from *Back to the Future 3*: an anxious Marty McFly, catapulted back to the nineteenth century, guns the motor of his DeLorean, pursued by mounted Indians galloping across the Plains. Marty looks in front of him and into the side mirror, and sees Indians coming "from all directions." When accompanied by such images, A Tribe Called Red's live shows become an unsettling conversation, a remixing of history that is also a working-through. The title of that 1990 film seems appropriate: perhaps the group is suggesting that Indigenous and non-Indigenous people had better go back, and work through these damaging images and damaged histories together, if we are to share any kind of future on this land.

WORKING IT THROUGH

Outside of A Tribe Called Red's performances, Bear Witness's work is often presented in gallery exhibitions, like the groundbreaking *Beat Nation: Art, Hip Hop, and Aboriginal Culture*.[119] His videos are also shown in short-film programs and streamed online. Some of his videos for A Tribe Called Red are specific to those more

contemplative platforms—including *Woodcarver* (2011), which assembles surveillance footage of the fatal police shooting of Seattle totem carver John Williams, superimposed with an over-the-shoulder shot of a long-haired man running toward a setting sun. But the videos work differently in the context of the group's live touring sets, which blend music, dancing, and video into an immersive embodied experience. It is one thing to observe an audiovisual "allegory of history" from the vantage point of a desk chair or the hard bench of a museum; it's quite another to absorb historical ghosts into your body while dancing in a sweaty mass. Live DJs already depend on the contribution of the "performing audience," the dancers who along with the producer and the DJ "form a third side of the triangle of creative activity in electronic dance music."[120] Bear Witness's videos add another relationship to this circuit, in which playing, listening, and dancing are joined by viewing. Other guests at the group's performances—from hoop dancer Rhonda Doxtator, a frequent and important collaborator, to various MCs, DJs, vocalists, and drum groups—build on this basic arrangement of sound, video, and dancing. At A Tribe Called Red's shows, dancers might look at each other or at the DJs, while absorbing the videos half-consciously. They might also pause and concentrate on the flow of images that Bear Witness mixes live from his laptop. Projected behind the DJs, the video loops invite the performing audience to work through ongoing "haunting legacies" while working it out on the dancefloor.[121]

Building on the notions of "screen memories" and "dream analysis," the psychoanalytic concept of "working-through" can help illuminate A Tribe Called Red's decolonizing embodied practice. This requires radically extending these concepts beyond the individual psyche, to the collective or social body. In his essay "Remembering, Repeating, and Working-Through," Freud notes that psychoanalysis aims gradually to replace the patient's "compulsion

to repeat" a symptom with a process of remembering.[122] What Freud calls the "playground" (*Spielraum*) of the transference is the space in which the symptom can be "acted out" safely. Through free association, shards of the patient's unconscious memories enter into this play space; the symptom condenses the "afterlives" of those unconscious memories. Psychoanalysis happens by way of a kind of montage, or even "cut 'n' mix": analyst and patient gather together memory fragments, making them conscious so as to rob them of their compulsive power. In this process, the analyst might give a name to the resistances that cause the patient to repeat rather than to remember. Yet conscious naming is not enough. Rational knowledge of a resistance does not cause it to disappear. As Freud writes, "One must allow the patient time to become more conversant with this resistance with which he has now become acquainted, to *work through* it, to overcome it."[123] This working-through, Freud observes, often occurs during periods of relative stagnation in the analysis, when no apparent progress is being made. But there is movement underneath the surface. "Working-through," according to the psychoanalysts Laplanche and Pontalis, moves beyond "intellectual acceptance" of a resistance that causes a repetition compulsion, to "a conviction based on lived experience."[124] By becoming "more conversant with the resistance," by *practicing* with it in the play space of analysis, the patient might be able to work it through.

Extending these psychoanalytic insights beyond the (colonial, modern) individual to the sphere of collective embodied practice, a parallel emerges with A Tribe Called Red's remixing work. In its videos and performances, the group also moves an intellectual knowledge of psychic and social repetitions—the traumas of colonial history, genocide, and white supremacy—into the realm of lived experience. Bear Witness, in this analogy, acts almost like a decolonial therapist, montaging fragments from the "optical

unconscious" of settler-colonial North America into new narratives.[125] These images are social symptoms, compulsively repeated and acted out. To work through them, for white settler subjects in particular, requires more than an intellectual understanding of these "deadly tropes" that overshadow Indigenous and colonial history. What is needed is a *Spielraum*, a safe space where we can "become more conversant" in our divergent embodied experiences with the resistances that block emergent decolonial futures. A Tribe Called Red's live show offers one of these possible spaces of play. In this relatively protected space, settlers, diasporic peoples, and Indigenous peoples can "work through" traumatic images, shaking them up in the vibratory intensities of the dance floor.[126]

A Tribe Called Red's live set accomplishes this working-through by bringing the repetitions of colonial imagery into the participatory and collective realm of sonic and musical practice. Sound tends to work on the level of participation, sympathetic vibration, and "contagion," rather than on the level of representation.[127] This makes it an appropriate vehicle for working-through, which seeks to bring the representations of thought (or in this case, visual culture) into the body, into lived experience. It is interesting to note that the German word *Durcharbeitung*, translated as "working-through" in Freud's works, is also a musical term: it refers to the "working-out" or development of a musical theme in the sonata form. In the case of dance music especially, we cannot ignore the bodily dimension of this musical working-through. Henriques emphasizes the carnal qualities of working-through via sonic media: "We work *through* something to find out more, or to 'work it out,'" he writes in *Sonic Bodies*. "This can mean 'taking it in,' or letting it 'sink in,' that is, absorbing, assimilating, incorporating, or even ingesting something, so that we become part of it and it becomes part of us. So the passage of working *through* indicates the crossing of a threshold."[128] In the sonic field of A Tribe

Called Red's live shows, we work through the afterlives of colonial images by incorporating them, ingesting them. We bring these survivals into the body, as each one of us moves across the many thresholds of this music's transmotion.

The politics of A Tribe Called Red's party, in Ottawa or on tour, depend on this embodied participation. For Bear Witness, this "echoes the way Aboriginal spirituality works, where it's a holistic thing—it's part of your entire life, it's part of your whole day, it's part of how you get up in the morning, it's part of how you go to sleep at night. The political part of A Tribe Called Red and of the Electric Pow Wow party is a holistic thing; it's all part of the dance party." The videos and music catch us when our guard is down, in a place where we're looking for a good time. Their comic juxtapositions allow us to make our own connections, to take our "own experiences and start to put things together." The politics of these gatherings are indeed "holistic," connected to everyday, embodied, lived experience. But they are also uncanny, haunted by the repetitions of histories that seep into the audiovisual mix.[129] The group's unsettling montage of images and sounds keeps its shows off-balance, with a political urgency unlike much of electronic dance culture. Montage, here, is a way of puncturing the utopian yearning that haunts electronic dance music, which often manifests a "desire for a time that is not in time, a *unity outside history*," with the dancefloor as a utopian space in which history is transcended and conflict is dissolved.[130] Although A Tribe Called Red opens up the possibility of certain embodied alliances, there is nothing utopian about their mashup of Native song and Afrodiasporic music, especially when combined with images dredged up from the colonial image bank. Together, they present an aesthetics of colonial dislocation that is soaked in history.

Still, even given its haunted engagement with colonial images, the group's energetic remixing of sounds and images from

the past and present should not be reduced to an allegory of dis-possession, nor to an act of exorcism. It can be useful to hear "sound as history," and to treat music as a medium that can reg-ister historical experiences of colonization and displacement.[131] But if sound is history, it is also more than history. A Tribe Called Red's sonic and visual montage absorbs and remixes the history of Indigenous peoples—both "a pain that is 400 years old" and the laughter that can help translate that pain into Native *surviv-ance* and *transmotion*.[132] At their shows, as part of the performing audience—and in my case, as a white settler subject I am placed in bodily relation to these sounds and images, a relation that is unsettling and ultimately hopeful. What transpires at these par-ties is neither utopia nor historical allegory, but an experimental space where new relationships—between bodies vibrating to the same bassline—can emerge.

Ultimately, the body is a crucial place to work through resis-tances built up by an ongoing, haunted history. As Brian Massumi writes, affect is fundamentally historical: "The body doesn't just absorb pulses or discrete stimulations; it infolds *contexts*, it in-folds volitions and cognitions that are nothing if not situated."[133] Histories of hurt, guilt, prejudice, illness, and shame are held in the body. In the vibratory intensities of the sound system and the dance floor, some of that can be loosened up, changed into vitality, capacity, a "sense of aliveness."[134] At many of the group's shows, one or more hoop dancers incarnate this transformation in a vi-brant whirl, counterposing Bear Witness's haunted videos with an exuberant and skilled assertion of Indigenous embodied presence (see figure 3.7). But this process necessarily works in different ways for different bodies—diasporic bodies, Native bodies, migrant bod-ies, settler bodies—and for each body in the room. There is an in-commensurability that this experimental space does not attempt to reconcile. A Tribe Called Red's "politics of vibration"[135] plays

across these gaps, acknowledging and bridging them at the same time. At their shows, "the agency distributed around a vibrational encounter"[136] can be felt across incommensurable pasts—in the bass of the sound system, in diasporic rhythms and Native voices. Sometimes, the sound system isn't even necessary: at a June 2013 concert in a Toronto club, the DJs invited the drum group Sitting Bear to open up the set. Dressed in white, seated around their drum in the middle of the dance floor, surrounded by concentric rings of young listeners, the group played a short set of intertribal songs. Their unison beats and high singing bounced harder than any club track, vibrating Indigenous pasts and presents through the flesh, bones, ears, and skin of everyone in that room.

REMIXING RESURGENCE

A Tribe Called Red's remixing of Indigenous and colonial history operates on a symbolic level, and on the level of bodily affect and practice. It could be argued that this remixing fails to address the key decolonizing struggle in settler states: the defense of the land and its return to its First Peoples. Indeed, a certain amount of the group's energy has gone into struggles over Indigenous iconography—from hipsters wearing headdresses to the names of sports teams like the Nepean Redskins—which might appear to be of secondary importance. Yet "symbolic," "affective," and "actual" struggles cannot be neatly distinguished. As Cherokee blogger Adrienne Keene asks, in the context of debates over the appropriation of Native identity in the United States: "How can we expect mainstream support for sovereignty, self-determination, Nation Building, tribally controlled education, health care, and jobs when 90% of Americans only view Native people as one-dimensional stereotypes, situated in the historic past, or even

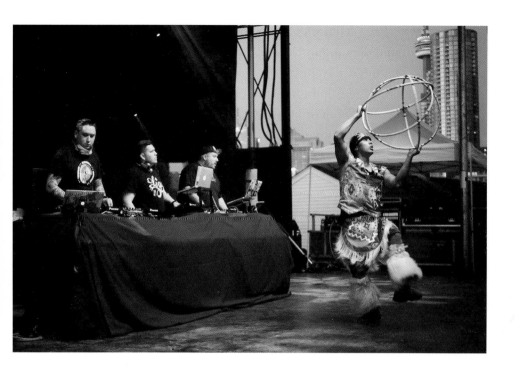

FIGURE 3.7

A Tribe Called Red in concert in Toronto
(2014), photo by Blake Stacey

worse, situated in their imaginations?"[137] Symbolic struggles are struggles over legitimation and hegemony, with a powerful impact on the lived experience of colonization. This lived experience is stored in the body, working itself out in structural patterns of sickness and health, through felt states of capacity and incapacity. Images, sounds, and bodies matter. This is why another generation of Indigenous artists and intellectuals is working hard to reshape the audiovisual and bodily world established by settler colonialism, often addressing all the peoples living on this land.

A Tribe Called Red's populism and popularity allow the group to play an influential role in this regard. In interviews and photographs, they project an urban style and relaxed, joking demeanor, counteracting colonial stereotypes that continue to wound and shame. Their live performances and self-presentation in the media claim the urban present as Indigenous time and space, while welcoming others who would join them in a spirit of hospitality. Utterly accessible, their music draws on all the conventions and many of the clichés of electronic dance music while dipping into related genres such as hip hop, especially in recent collaborations with Yasiin Bey and Narcy. Its "bounce" is irresistible. No one is turned away from the party (free festival shows sponsored by various state institutions make sure of that). The group participates in mainstream structures of musical commodification, state funding, and media publicity, which give them the opportunity to speak broadly to both Indigenous and non-Indigenous youth. This opportunity is extended on tour, in Canada and abroad, where they see their role as "ambassadors," allied with more directly political movements like Idle No More. Although their work mainly takes place in cities, they are as invested in the continuance and reshaping of tradition as land-based Native activists and culture workers. Indeed, their collaborations with pow wow drum groups and performances such as the Rez Tour of 2015 have helped to strengthen the links

between communities that have been kept apart. As Yellowknives Dene scholar Glen Coulthard writes, "whether in reserve settings like Grassy Narrows and Six Nations, or in urban centres like Vancouver and Victoria ... the best of today's Indigenous movements ... are attempting to critically reconstruct and deploy previously disparaged traditions and practices in a manner that consciously seeks to prefigure a lasting alternative to the colonial present."[138] ATCR can certainly be counted among these reconstructive and prefigurative movements; its music has become part of a soundtrack to them, transportable to various settings on reserve and in the urban diaspora.[139]

A temporally fluid remixing of tradition is a thread running through the current Indigenous resurgence. By embracing tradition as "doing" rather than "being," as collective practice rather than a thing, this diverse movement has rejected a static and melancholy "traditionalism" while extending "the historical accumulation of communications with the land."[140] This is especially true for the younger generation in Canada, which, as Ian Campeau points out, is the first to grow up without the violent intergenerational disruption of the Residential School system—even as other forms of dispossession, from predatory child welfare systems to resource extraction, continue to churn on. For Native scholars, artists, and activists, now is a time for "picking up the pieces" of what has been shattered, for "digging up the medicines" to see what they can offer to the present.[141] A Tribe Called Red, with their remixing of Indigenous songs and dance, Afrodiasporic beats, and warped colonial images, are wholly of this cultural-political moment. While they make music and art that is firmly part of the urban present, they are also deeply invested in reworking history and tradition. And while they are engaged in a dialogue with the settler state, they are also part of a larger wave of Indigenous resurgence that looks to the past to move into the future. The

basic tension in their music and art—between vibrant sound and haunted images—makes clear the need to work through the resistances of a complex history so that new, unexpected forms of collective practice can emerge.

In the current resurgence, artists and writers often draw on concepts from Indigenous languages to address this need. I will close this chapter by gesturing toward the crucial role of language in Indigenous thought, which leads me to confront the limits of my own thinking about the translation of tradition. Decontextualization and appropriation are real dangers; Leanne Betasamosake Simpson makes this clear in her discussion of the Nishnaabeg word-concept of *Biskaabiiyang*, which can mean "to look back," or "returning to ourselves." As she writes, "I could only really learn to understand this concept within the web of relationships of my existence."[142] She describes how researchers and scholars from the Seventh Generation Institute have used "Biskaabiiyang" in a similar way as the term "decolonizing"—"to pick up the things we were forced to leave behind, whether they are songs, dances, values, or philosophies, and bring them into existence in the future."[143] Simpson sees no sense in returning to an imagined precolonial past; those songs, dances, values, and philosophies were never static and cannot be treated as such. As she writes, "Within Nishnaabeg theoretical foundations, Biskaabiiyang does not literally mean returning to the past, but rather re-creating the cultural and political flourishment of the past to support the well-being of our contemporary citizens. It means reclaiming the fluidity around our traditions, not the rigidity of colonialism."[144] Biskaabiiyang, as an Elder explained to her, could be defined in terms of "a new emergence." Simpson's discussion of this and other Nishnaabeg stories and philosophies could be understood as a remixing of tradition, a reinterpretation of the ancestral teachings that she has sought out, translated into her own experience, and put into

writing. Her work walks a path of Native-defined reconstruction and prefiguration that avoids the pitfalls of "reconciliation" and other forms of engagement offered by the settler state.[145]

As Simpson makes clear, the Indigenous engagement with tradition, in the context of this "new emergence," means invention and interpretation as much as recovery, moving freely through time as much as going back. This is not simply a matter of cultural renewal: as Simpson argues, and as Indigenous grassroots movements have demonstrated, a fluidity around tradition can translate into more directly political practice. In the Indigenous experience, culture and politics are intimately intertwined, and the colonial suppression of cultural practices has only reinforced this bond. A Tribe Called Red's remixing of tradition melds culture and politics in this "holistic" fashion. In the present musical landscape, their sonic practice can only go so far; they are limited by the constraints of the music business in which they operate, and the pressures of touring for a living. But in December 2012, when they released "The Road," the DJs found themselves in a rare position: able to give affective shape to a political conjuncture, even in a song without words.

Four months later, in April 2013, as I joined the young people lined up outside Babylon to party with A Tribe Called Red, the political enthusiasm of this moment was becoming more tempered. It was clear that struggles over Indigenous land title and resource extraction would only intensify in the coming years, and would require a broader political response than had thus far been assembled. The massive scale of the industrial transformation of this land—transcontinental pipelines carrying bitumen from prairie tar sands, large-scale shipping through the newly ice-free Arctic—would implicate everyone living on Turtle Island, and even everyone on this planet. Faced with dramatic transformations ahead, settler and migrant subjects were joining with Indigenous

movements to slow or halt the dispossessions of the extractive industries, their ecological and human violence. Building these alliances, and ensuring that they were and are true alliances, continues to require a great deal of work. Settler subjects have much to do: we need to work through a haunted present, decolonize our thoughts and practices, and act in solidarity with Indigenous struggles for land and rights. At that moment, in April 2013, the resistance of the Water Protectors and their allies at Standing Rock against the Dakota Access Pipeline was some years away; this next phase of the movement was only just beginning. Yet there was a shimmer of things to come—as the dancefloor filled up at the Electric Pow Wow at Babylon, as "solidarity spring" looked forward to "sovereignty summer,"[146] and as kids in baseball caps bounced and sang along to melodies that vibrated with the promise of a different future.

4 FERMENTING

MICROCULTURAL
EXPERIMENTS AND
THE POLITICS
OF FOLK PRACTICE

Microcultural Revivals
Grassroots Modernism?
DIY Moralism
You Must Change Your Life
Being Entangled
Strange Strangers
This Compost
Recipe: Eat Some Dirt
Nourishing Traditions, Stolen Land
Radical Healing
Political Ferments

MICROCULTURAL REVIVALS

In August 2001, Sandor Ellix Katz, author of the pamphlet and soon-to-be-book *Wild Fermentation*, gave a sauerkraut-making demonstration at the Vermont farm belonging to the Bread and Puppet Theater. On a weathered picnic table behind the farmhouse, Katz roughly chopped napa cabbage, onions, garlic, and carrots, lifted them into a stainless steel bowl, tossed them with salt, squeezed them, and pressed them down into a crock. These steps, he explained, would create conditions hospitable for *lactobacilli*, single-celled microbes living in the crevices of the cabbage, to reproduce and to feed on the vegetable substrate, eventually resulting in a pungent and sour delicacy. Fermentation, Katz told his audience, is nothing more than controlled decay. It works with invisible creatures in the air and soil—what Donna Haraway has called "companion species"—and applies them to the metamorphic transformation of edible things.[1] Not only kraut or kimchi, he emphasized, but many of the substances prized by humans—from intoxicating drinks to regenerating compost—owe their existence to the patient reproduction of these quiet and powerful partners.

Katz's demonstration was part of the aptly named Radical Cheese Festival: an assembly of puppeteers and activists gathered on the Bread and Puppet farm to share shows, stories, and techniques, all oriented toward theatrical and cultural ferment.[2] As a former Bread and Puppet puppeteer then working with my own theater company in Montreal, I was one of these guests. After Katz's talk, we ate samples of kraut atop sourdough rye bread—another product of fermentation—baked by Peter Schumann, founder of Bread and Puppet. Schumann's sourdough starter has been living and reproducing for many decades, and has initiated the rising of countless loaves, baked and served to

XINONA is living in a post-apocalyptic,
dried-out economy devoid of funding for
art, for living, for loving, and for
everything else.

She sits in her spaceship, bobbing on the
waves of Kombucha planet, her home.

She spends a lot of time watching sci-fi
television on her phone.

"Greetings XINONA, We at the Government
AKA Weird Heads have taken an interest
in your work. We know that you're
Indigenous to Kombucha Planet, and we
feel SUPER STRONGLY ABOUT IT. It's so
sad how your people judge each other by
how much Kombucha is in your veins.
Isn't everyone a human after all?

FIGURE 4.1 (this and following two pages)

Stills from the online project *XINONA*
(2017), by Walter Kaheró:ton Scott and the
National Film Board of Canada

As she sinks down into the wet Kombucha
abyss, little pellets form around her.
The pellets are ideas that hit against
her windshield; each idea splatters like
a bug.

The deeper she gets, the less she feels
like she's any one thing anymore. She
becomes less of everything: a gender,
Indigenous to Kombucha planet,
Indigenous to anything, a body, a
brain, a citizen, an artist.

She soon approaches a dark object in the deep. In the sea of Kombucha, she encounters THE MOTHER. The Kombucha Mother that is always there.

audiences worldwide. Like the liquid yogurt at Yonah Schimmel's New York knish shop—soured by a venerable bacterial colony and drunk by generations of Lower East Side radicals—Schumann's sourdough suggests that there might be invisible links between practices of edible, performative, and political fermentation. As I ate the dense bread and tangy kraut at this gathering of radical food-makers, artists, and activists, I wondered if there were more than metaphorical links between the culinary, artistic, and political uprisings that they hoped to foster.

A decade later, as I was beginning to write this book, I knew I wanted to engage more deeply with the renewed interest in home fermentation practices in settler-colonial North America. I was only a casual fermenter, having made the occasional batch of sauerkraut; I lacked the almost messianic fervor of certain "fermentos"—a loose term for the ragged and diverse assortment of practitioners who make up the most recent "microcultural revival." This movement, which began to bubble up in the late 1990s, has been most eloquently articulated by Katz himself, the writer, food activist, and charismatic proselytizer of pickling. In his books *Wild Fermentation*, *The Revolution Will Not Be Microwaved*, and *The Art of Fermentation*, Katz collages multiple culinary traditions into syncretic manuals for home experiment. His watchword is a simple one: "Use what is abundantly available to you, and be bold in your fermentation experimentation!"[3] Across the United States, Canada, and abroad, practitioners have taken up Katz's exhortations to revive these slow and strange ways of making cultured foods, working with microorganisms as silent and powerful partners. I myself owed my tentative efforts at home fermentation to Katz's writings and example. I was especially taken with his experimental passion for vernacular practices that, across cultures and generations, have long existed as collective "ways of doing"—"traditional" culinary techniques that happen to involve

multispecies collaboration. I thought that this microcultural reclaiming deserved the kind of serious consideration usually reserved for more macro-scaled aesthetic and political projects.

Katz and other "cultural revivalists" have overlapping motives, including the struggle for a more sustainable food system, the health benefits of live-culture foods, the importance of these foods to almost all culinary traditions, and their pungent and sour deliciousness. Yet as home fermentation has become newly popular over the past two decades, building on earlier generations of enthusiasts, the making of sauerkraut, pickles, kombucha, and kimchi has come to acquire contradictory political connotations. On the political right, it has been championed by certain health-conscious, localist libertarians, exemplified by the Weston Price Foundation, who see it as one component of a return to more authentically "traditional" foodways. Among liberals and DIY leftists, on the other hand, the renewed interest in fermented foods has sometimes been viewed as one of the more laughable signs of privileged lifestyles and tendencies toward gentrification. Pickles, it seems, are a particularly easy target for ridicule. The TV comedy *Portlandia*, which skewers the narcissism of locavore and DIY movements, opened its second season with a sketch called "We Can Pickle That." A Yelp Wordmap that locates the geographical use of the term "hipster" "can be used to eschew aficionados of pickling, Pabst, pretension, pay-what-you-can, performance art, and pretending to know everyone."[4] Walking through Toronto's gentrifying Kensington Market, I could buy a one-dollar "pickle-on-a-stick" from a new artisanal boutique—and then be greeted with a derisive "Yeah, you're cool" from a passerby.

This mockery is all too easy, and not entirely misplaced. A class analysis and an understanding of scale are often absent from slow food and locavore movements, including some parts of the fermentation revival, which tend to imagine that an unjust and

damaging food system can be transformed by micro-changes in life-style practices. The rhetoric of certain "fermentos"—including the latterly converted food writer Michael Pollan, whose book *Cooked* (2013) contains a lengthy section on fermentation—is not exempt from this fantasy. Their vision fails to take into account the ways in which specialized lifestyle practices are easily accommodated as market niches within larger capitalist structures.[5] From a perspective that focuses on social relations of production and class antagonism, anyone who considers their pickling practice revolutionary is at best a well-intentioned but delusional petit bourgeois. Previous waves of enthusiasm for home yogurt, sauerkraut, and sourdough-making have come and gone, without any large-scale impact on the capitalist organization of food production and consumption.[6] And the more recent embrace of home fermentation by libertarian localists suggests that the politics of fermentation are ambivalent at best.

Pickling is indeed a long way from any collective revolutionary *praxis*. Yet to devotees like Katz, the daily embodied *practice* of gently cultivating bacteria in home fermentation has strong political resonances, and even a certain efficacy. Certain fermentos argue that the experimental revival of these vernacular practices cultivates a resistance to forces of cultural homogenization, expanding notions of the collective beyond the human while allowing traditions to be reshaped and to grow in unexpected directions. Integrating home fermenting into daily routines alters one's relation to "productive" time; sharing recipes and bubbling mason jars within fermentation networks builds resources outside the industrial food system. With the help of bacteria from the air and soil, consumers of dead commodities become producers of living food. This is grassroots "microbiopolitics," as the anthropologist Heather Paxson has termed it, on its smallest scale and at its slowest speed.[7] In an accelerated economy, when most food is produced on a mass scale and consumed in haste,

home fermentation offers a way to scale down and slow down, while opening into wider circles of human and extrahuman relations. Even if such transformations do not alter larger structures of exploitation, they are practical techniques of bodily and spiritual regeneration that might offer ways to build strength, energy, and hope.

Fermentation can also be read as a metaphor for collective activist practice. Katz himself came to lacto-fermentation for health reasons in the 1990s after testing HIV-positive, following an intense engagement with civil disobedience and creative protest as a member of ACT UP. Drawing on this activist impulse, he often invokes the parallel between culinary and social-political ferment. "The word *ferment*," he writes, "along with the words *fervor* and *fervent*, comes from the Latin verb *fervere*, to agitate or boil. Just as fermenting liquids exhibit a bubbling action similar to boiling, so do excited people, filled with passion and unrestrained."[8] He invites experimenters to spread their effervescent cultures through the body politic: "As microorganisms work their transformative magic and you witness the miracles of fermentation, envision yourself as an agent for change, creating agitation, releasing bubbles of transformation into the social order" (see figure 4.2).[9] Katz's rhetoric is infectious, and offers a way to connect daily embodied practice with social change, a connection rejected by some voices on the left that focus on more spectacular mobilizations and transformations.

Do-it-yourself fermentation—which like other forms of "DIY culture" asks participants to pull back from dominant institutions and reclaim collective practices that were once everyday and commonplace—has multiple and conflicting political connotations. It could be considered as a radical vernacular practice for the Anthropocene, a damaged epoch in which the human being has become impossible to separate from the large-scale transformations

FIGURE 4.2

The analogy between fermentation and
collective practice: illustration by
Vahida Ramujkić for the *Microcultures:
A Collaboration with Microorganisms
Project* (2011)

wrought by the capitalist reorganization of nature.[10] As a collabo-
rative performance that involves multiple species, fermentation
rehearses an expansion of the collective beyond the usual defini-
tion of the human, touching on "matters of concern" that are vital
for our shared flourishing in this troubled time.[11] But fermenting
is multivalent: it can also be seen as a practice of self-care, as a
widespread culinary trend, as part of a conservative return to an
imagined "traditional" diet, as a hobby for "creative" workers with
time on their hands, as a way of playing with an imagined Indig-
enous spirituality, and as an avenue for selling value-added food-
stuffs to niche markets. In fact, as I will show, it is often many of
these things at once.

In this chapter, I draw on a wide range of sources—recipes,
theory, poetry, online commentary, my own haphazard ferment-
ing experiences, and especially Katz's writings—to investigate the
human and microbial cultures of the fermentation revival, while
engaging with debates over the aesthetics and politics of everyday
life practices. I begin in the realm of human sociality by posing
the problem of the politics of DIY, looking at arguments for and
against the political value of local, everyday, vernacular practices,
including pickling. This leads me to a more general discussion of
the politics of daily embodied practice, focusing on the writings
of Michel Foucault and Peter Sloterdijk. I then move beyond the
human to the microbiological side of home fermenting, analyzing
it as a set of "post-Pasteurian" practices of hospitality toward the
"strange stranger."[12] I explore the practice of composting—another
kind of fermentation—and its relation to intoxication, digestion,
death, and regeneration. I then argue that fermentation is perhaps
most intriguing as an aesthetico-political practice, tracing connec-
tions between Katz's writing and avant-garde art movements. This
leads me to another critique of the fermentation revival: its rela-
tion to aesthetic holism, the appropriation of Indigenous cultures,

and settler-colonial imaginings, on both the right and the left, of "authentic" tradition. Finally, I follow the politics of fermentation, both practical and metaphorical, to look at recent movements of political contestation and social ferment.

GRASSROOTS MODERNISM?

Left-leaning defenders of DIY are well aware of the gap between the small-scale practices they promote—community gardens, bicycle co-ops, coding collectives, craft circles—and the large-scale global challenges of the early twenty-first century. This discrepancy is the focus of "Grassroots Modernism," a 2011 issue of the *Journal of Aesthetics and Protest*, which tries to strengthen the ties between "the general" and "the specific."[13] In the wake of the Occupy movement's reassertion of the general ("the 99%") in North American politics, the issue's editors attempt to link small-scale practices to broad-based social movements. They write:

> Broadly speaking, movements are successful not because of a unified ideology but because of the common dream we maintain before us. We bat at it as a moving target on the horizon. We attempt to achieve it through making things. We make artwork, situations, events, proposals, laws, procedures, non-profits, broken newspaper boxes, gardens. We write manifestos and statements, songs and barricades. Each act, real, spectacularly real, structural, spectacular, contributes to the institutionalization of forms in the production of social meaning.[14]

For the editors, these specific practices of "making things" can all be gathered up into a "common dream," which perhaps necessarily

remains undefined and difficult to grasp. As they note, there is a "dynamic tension between autonomy and sociality" that underlies the various small-scale projects and practices they discuss.[15] Do-it-yourself practices can easily slip into a virtuous narcissism, aligned with networked forms of power that encourage individualized self-shaping at the expense of social critique.[16] Yet the editors of the *Journal of Aesthetics and Protest* are convinced that diverse acts—from the writing of songs to the building of barricades, from litigation in the courts to the planting of gardens—can join together with other forms of social struggle, creating a sort of popular front of the practices.

In the same issue of the journal, an article by artist Meg Wade, "Grassroots Modernism as Autonomous Ethos and Practice," offers an intriguing political defense of DIY that resonates with the current fermentation revival. Wade acknowledges that the "small actions" of DIY practitioners seem inadequate in the face of "an expansion of state and corporate powers" and the threat of ecological devastation. How can such hands-on vernacular ventures as "bicycle coops and backyard homesteads" even begin to solve "the vast problems described by our grand analyses"? Such practices do not seem large enough. "Nor," she writes, "do they seem new enough, looking very much like the practices that humans have always engaged in throughout the ages."[17] Yet, Wade asserts, these small-scale, anachronistic pursuits have a key role to play—not so much as components of mass movements, but on the spiritual plane: they encourage "a renewal of souls that are crushed, defeated."[18] Drawing on Franco Berardi's notion of the "soul at work" under "semiocapitalism," Wade argues that the kitchen, the garden, or the workshop offer spaces of retreat where "signs are less dense." In an ever-accelerating spectacular economy, these spaces create the possibility of a certain "scaling down and slowing down." The revival of a traditional practice like home fermentation, for

example, allows one to step back from hectic consumer activity: "The instantaneous delivery of goods and entertainment is not the point here; one must wait weeks for the bacteria in a batch of sauerkraut to do their work."[19] The slowness of microbial growth, the patient work with organic matter in garden and kitchen, can be a kind of healing, regenerative activity.

To the slowness of DIY practices, Wade adds the virtues of tinkering and collective experimentation. Her piece, surprisingly, draws on Kant's and Foucault's essays on the Enlightenment to offer a vision of DIY practices as a "way out" of "our state of submission."[20] This is the "modernism" of the essay's title—the critical and creative power to break with an inherited and unjust state of affairs. Paradoxically, Wade's modernism works through a return to the past, by reactivating ways of doing and making that are not particularly new. In contrast to the Enlightenment's supposedly progressive and universal conception of reason, Wade argues that DIY modernism is anchored in the "grassroots," in horizontal forms of knowledge worked out in daily experimental practice. She notes that there is "something decidedly early modern about grassroots modernism. Perhaps it is a return to the experimental mode of early modern natural philosophy, to science as garage experiment rather than as a universalizing, dominating, state-corporate partnership."[21] The philosopher Isabelle Stengers, whose work helped guide our thoughts on practice in this book's introduction, would appreciate Wade's argument that DIY communities build collective confidence and the "capacity to produce, to think, and to want."[22] Yet she would dispute Wade's blanket condemnation of contemporary scientists, who are not necessarily in thrall to forces of domination. For Stengers, too, communities of practice such as experimental science are what enable humans "to think, imagine and resist."[23] This view resonates with what Wade suggests by the phrase "an autonomous ethos and practice": not

the autonomy of the self-governing liberal subject, but the collective autonomy worked out in "the daily practice of transforming our own material conditions"—even, it seems, when that daily practice is as small-scale and slow-paced as the fermenting of vegetables.[24]

Wade's defense of DIY can be seen as broadly anarchist, concerned with building the capacity for anticapitalist collective renewal. Other writers with various relations to left-wing political movements, such as Rebecca Solnit and Michael Pollan, have also praised the slowness and experimental nature of DIY practices, including vernacular practices of fermentation. In a 2013 essay on the transformation of the experience of time in an era of smartphones and social networks, Solnit observes that "some of the young have taken up gardening and knitting and a host of other things that involve working with their hands, making things from scratch, and often doing things the old way." She sees this as "a slow everything movement in need of a manifesto." Like Wade, Solnit is torn between recognizing the pitfalls of DIY and praising its virtues. As she acknowledges, "We won't overthrow corporations by knitting—but understanding the pleasures of knitting or weeding or making pickles might articulate the value of that world outside electronic chatter and distraction, and inside a more stately sense of time."[25] Solnit's "stately sense of time" may be a fantasy, one that every generation seems to long for. Yet as capitalism has repeatedly transformed daily life through time-space compression, with electronic communication as a powerful enabler, it isn't surprising that the experience of time both in and outside of metropolitan centers grows ever more fractured.[26] While Solnit does not go as far as Wade's call for anarchist withdrawal, she agrees that reclaiming anachronistic vernacular practices such as home fermentation might offer a way to take a breath, to gather a collective sense of value, and to build shared resources.

The popular food writer Michael Pollan shares Solnit's sense of the remedial promise of DIY food practices, but with more of a focus on the individual. As he writes in *Cooked: A Natural History of Transformation*, doing it yourself offers "a first-person, physical kind of knowledge that is the precise opposite of abstract or academic."[27] The "abstract" is Pollan's enemy throughout his book: he contrasts the abstracting processes of the global industrial food system with the concrete embodied knowledge gained by, say, learning how to ferment milk into cheese. Pollan offers the kitchen as an antidote to what he describes as the immateriality and anti-sensuality of computer work, including his own writing practice. He doubts that it is "a coincidence that interest in all kinds of DIY pursuits has intensified at the precise historical moment when we find ourselves spending most of our waking hours in front of screens—senseless, or nearly so."[28] In an economy governed by the historyless abstractions of circulating commodities, Pollan views his own DIY fermentation practice as a form of "remembering where things come from." It allows him to memorialize the concrete qualities of food: "To make [beer] yourself once in a while, to handle the barley and inhale the aroma of hops and yeast, becomes, among other things, a form of observance, *a weekend ritual of remembrance*."[29] Pollan is gifted at conveying the texture of his hands-on engagement with cooking from scratch, and his writing on fermentation is scientifically and symbolically astute. Yet, in this passage, his political imagination is limited to lodging a "small but eloquent protest" against industrial agriculture and consumer capitalism through his own experiments in growing, cooking, and fermenting food.[30]

DIY MORALISM

The slide from Wade's "autonomous ethos and practice" through Solnit's "more stately sense of time" to Pollan's "weekend ritual of remembrance" illustrates the dangers of putting too much faith in the micropolitics of DIY. Pollan's weekend ritual is, indeed, a kind of compensation—the reenactment of traditional foodways as a respite from the endless flows of screen-based media and the pressures of the market. It is an expression of what political economist Greg Sharzer doesn't hesitate to call "petit-bourgeois ideology." In his polemic *No Local: Why Small-Scale Alternatives Won't Change the World*, Sharzer argues that the petite bourgeoisie—including what more boosterish thinkers call "the creative class"—is shut out from the antagonistic relation between capital and labor, and finds itself confronting capitalism on the level of everyday consumer choices. Its political proposals thus tend to turn around the ethics of these personal choices—what products to buy, or what things to make oneself. Sharzer argues that DIY movements can at best create niche markets for "ethical" consumption, or small, protected spaces partially sheltered from commodification. Meanwhile, the great wheel of the global economy keeps turning, content to let these scattered experimenters continue their tinkering.

Sharzer is especially critical of anticapitalist localist projects proposed in books like Chris Carlsson's *Nowtopia: How Pirate Programmers, Outlaw Bicyclists, and Vacant Lot Gardeners Are Inventing the Future Today!* For Sharzer, such experimenters enact a debased version of the cooperative proposals of Proudhon, the anarchist thinker whose economic theories were castigated by Marx as naïve, and were already seen as outmoded in the mid-nineteenth century. Sharzer notes that "in the face of oligopolies Proudhon could never have dreamt of in his worst nightmares, [experimenters create] tiny alternatives at the margins."[31] Vacant-lot gardeners,

for example, are not outside the broader capitalist food system. Nor do they pose any threat to it: in fact, they tend to fuel urban gentrification and raise real estate values, effectively pricing themselves out of their own neighborhoods. And to go beyond Sharzer's political-economic critique, which does not extend to questions of land and white settler belonging, they can also be seen as performing a "settler move to innocence" by re-homesteading the land of the colonial city.[32]

In the face of ongoing colonial-capitalist damage, the evident insufficiency of DIY small-scale proposals leads many of their proponents to oscillate between utopian and apocalyptic imaginaries. Perhaps we are changing the world by growing and pickling vegetables or learning how to fix bicycles; if not, these skills will help us to survive the coming catastrophe. For Sharzer, "hidden behind localism's DIY attitude is a deep pessimism; it assumes we can't make large-scale, collective social change."[33] Along with pessimism, Sharzer argues that localism generally tends toward moralism, a belief that individual behavior is the ultimate target and motor of reform. He likens DIY proselytizers to the sandal-wearing socialists derided by George Orwell in *The Road to Wigan Pier*. Like nineteenth-century paternalist reformers, twenty-first-century localists seek to reform the structural inequities of capitalism through moral change at the level of the individual. In Sharzer's estimation, "Hygiene and poetry have been replaced by ethical consumption and Do-It-Yourself, but the high-mindedness of patience and restraint remains."[34] The emphasis on individual behavior deflects attention from structural exploitation and injustices, and drives a wedge between localist activists and the people whose behavior they are trying to alter. Instead of experimenting with micro-alternatives and lifestyle adjustments, Sharzer argues, activists need to unite in class struggle, which ultimately unifies its participants around a common revolutionary goal.

Despite its own anachronisms, including its focus on a narrow conception of the working class as global revolutionary subject, *No Local* offers an important critique of localist and DIY movements. Yet it does not address the gist of Wade's argument for "grassroots modernism"—that DIY practices, including experimental revivals of vernacular knowledge, "offer a renewal for souls that have been crushed, defeated."[35] Indeed, Sharzer admits that his analysis does not touch the affective and embodied dimension of DIY practices, or the know-how and resources they can foster. He professes generosity on this point: "If growing your own vegetables makes you feel better and helps you meet your neighbours, then you should do it. Moreover, participating in a local DIY project can provide the strength and tools for community activism. Inspiration and political imagination are highly personal and subjective things, and no one can predict what inspires a critical understanding of society and how to change it."[36] Despite this seemingly open-minded admission, Sharzer's perspective in this statement (and elsewhere) is teleological. For him, the strength and tools gained from DIY projects are justified by their leading to a broader understanding of the necessity of class struggle, rather than existing as what Agamben calls "means without ends."[37] Ultimately, Sharzer sees these projects as a drain of time and energy that could more profitably be spent building revolutionary alliances—which in his view also offer a more promising route to spiritual renewal.

YOU MUST CHANGE YOUR LIFE

Beyond undermining the value of practices for their own sake, Sharzer also ignores the ability of embodied practice to form and transform individual and collective subjects. In Sharzer's analysis, practice is inevitably subordinated to *praxis*—what, for the Marxist

tradition (to simplify greatly), could be described as transformative revolutionary action informed by theory.[38] Yet daily embodied *practice* is at the heart of Wade's argument: she sees "grassroots modernism" as an ethos and a practice, a "form of life" that must be constantly exercised. It is an example of what Michel Foucault termed an *àskesis*, after that term's use in Stoic philosophy: a mode of self-constitution as an ethical subject through daily embodied exercises.[39] The politics of this kind of *àskesis*, as I suggested in my discussion of DIY culture, are highly ambivalent. Many of the practices proposed by localist or DIY movements, such as Pollan's weekend beer-brewing rituals, seem stuck at the level of compensation through lifestyle adjustments. But others, including Sandor Katz's fermentation experiments, might offer a more radical opening—a way, as Foucault puts it in *The Use of Pleasure*, "to release oneself from oneself" (*se déprendre de soi-même*).[40] The task would then become to find ways to broaden and generalize this release, to link embodied practice with political action, and to work ourselves collectively out of what Wade terms "our state of submission." However, working toward this radical opening would mean undoing the powerful and longstanding connections between embodied practice and individual human self-mastery—a self-mastery that the multispecies entanglement of fermentation gently undermines. This self-mastery has deep roots in (colonial) "modern" subjectivity, as I explored in chapter 1.[41] While the ethics of Foucault's *àskesis* are drawn from Greek and Roman texts, they promote a certain kind of autonomous "proto-modern" subject, one who tears himself or herself away from tradition, custom, and habit in order to live by a higher set of rules. Indeed, the last two volumes of Foucault's *History of Sexuality* emphasize practices of self-mastery and self-control, sexual and otherwise.

The connections between embodied practice and individualized self-mastery are especially notable in philosopher Peter

Sloterdijk's 2009 book *You Must Change Your Life: On Anthropotechnics*, making it a useful foil for my argument here. In this lengthy treatise on the subject of human practice, Sloterdijk embraces Foucault's work on ascetic "practices of the self," expanding it into a grand tour of what he calls "the planet of the practicing."[42] His notion of "anthropotechnics" covers all sorts of practice-based subjectifying work that humans do on themselves, "whether they are farmers, workers, warriors, writers, yogis, athletes, rhetoricians, circus artistes, rhapsodists, scholars, instrumental virtuosos or models"—or, presumably, fermenters.[43] *You Must Change Your Life* is at once a useful philosophical treatment of the "practicing phenomenon" and a dangerously misguided manifesto for collective practice in a damaged world. Published shortly after the 2008 economic crisis, during an era of accelerating ecological devastation, the book stubbornly promotes individualized self-shaping over collective flourishing. In *You Must Change Your Life*, the "you" is singular, and "life" is restricted to the human and the exceptional. For Sloterdijk, embodied practice is not a mode of everyday collective existence; instead, it is radically opposed to both the collective and the everyday, marked by qualities of absolute *verticality* and *separation*.

Sloterdijk makes this argument through two metaphorical oppositions: the base camp and the summit, and the river and the shore. In Sloterdijk's view, Pierre Bourdieu and other theorists of everyday embodied subjectivation are ultimately concerned with what goes on in the "base camps" of humanity. They study the inertial behavior and the games of power and distinction taking place at the foot of the mountain that the acrobats of ascetic practice attempt to climb. Sloterdijk considers Bourdieu's *habitus* to be a useful sociological concept, but he is more interested in conscious *habit*, the disciplined use of repetition to break socially determined, repetitive behavior. He calls this discipline

"turning the power of repetition against repetition."[44] Through repetition, the acrobats of practice exit the base camps of everyday life, with all their banal struggles, in order to make the ascent of "Mount Improbable" (a term Sloterdijk borrows from evolutionary biologist Richard Dawkins). This mountain can be scaled only when "individual people—whether alone or in the company of co-conspirators—begin to catapult themselves out of the habitus communities to which they initially and mostly belong."[45] Outside the base camp the air is clearer, squabbles over distinction fall away, and the peak reveals itself with all of its stark imperatives. But you have to train to climb.

Sloterdijk's other central metaphor is one of separation: practitioners begin by stepping outside the river of life, and observing its currents and swimmers from the shore. The view from the riverbank of everyday swimmers splashing and flailing creates what Sloterdijk calls "shore subjectivity." To avoid getting swept back into the stream, one must adopt a new mode of life. Everyday and habitual "automated programmes" must be broken through repetitive exercise sequences, which separate the practicing from the rest of the human world. Sloterdijk claims that "entering ethical thought means making a difference with one's own existence that no one had previously made. If there were an accompanying speech act, it would be: 'I herewith exit ordinary reality.'"[46] The tricks and ruses of everyday existence, as described by Michel de Certeau and his collaborators in *The Practice of Everyday Life*, are precisely what the acrobats of anthropotechnics reject as they separate themselves from the game of daily affairs.[47] From the vantage point of the shore, such subtle tactical maneuvers look like the vain gestures performed by the drowning.

Sloterdijk's insistence on verticality and separation leads him into some extreme theoretical contortions. He ends his book by suggesting that only "the global catastrophe"—presumably

irreversible ecological damage and collapse—now has the author-
ity to say, "You must change your life!" In the face of the coming
catastrophe, humans must invent a new set of "monastic rules,"
and make the decision "to take on the good habits of shared sur-
vival in daily exercises."[48] Many proponents of "grassroots mod-
ernism" might share this endorsement of common practices of
survival. But Sloterdijk's insistence on vertical and horizontal
separation from the everyday world leaves a gap in his ethical ar-
gument. It is as though only the threat of utter catastrophe can
shock the practicing into reengaging with the everyday life they
have abandoned. Only melting glaciers will lead the mountain-
eers to bother with what goes on in the base camps; only rising
floodwaters will cause the watchers to abandon their perch on
the riverbank. Sloterdijk's late plea for shared survival contradicts
the Nietzschean spirit of his book, which emphasizes the individ-
ual's acrobatic self-mastery rather than collective ethico-political
practice. Indeed, Sloterdijk almost entirely disregards how prac-
tice, as I have argued, is constituted at the level of the collective, in
"communities of practice."[49]

Sloterdijk's emphases on verticality, separation, and mastery do
not extend to DIY fermentation practices, which (as I will show)
tend to be horizontal, imbricated, and unmasterable. Yet Sloter-
dijk's and Foucault's focus on practice as a kind of purposeful
asceticism is helpful in thinking through the politics of these
practices. Like other grassroots modernists, "fermentos" are not
simply engaged in the tactics of everyday consumers, nor are their
experiments reducible to repetitive *habitus* or games of distinc-
tion. Instead, fermenters draw on deliberately anachronistic culi-
nary tactics and techniques, which require a certain discipline and
exist in tension with the broader food system. The paradox is that
these fermentation practices were once customary and habitual.
What was once a vernacular practice or "way of doing" has become

a conscious *àskesis*. The "grassroots modernism" of Sandor Katz and other DIY-ers emerges against a background of loss: lapsed everyday activities (fixing things, fermenting food) are revived as ascetic practices. They are experimental translations made possible by what Benjamin calls "a sickening of tradition."[50]

This transition to fermentation as a form of deliberate *àskesis* has worked itself out in varying ways in North American settler colonies. Home fermentation practices were once fully integrated into the daily life of settlers and migrants to North America; each wave brought its vernacular techniques and living starter cultures (sourdoughs, yogurts, miso spores). Indigenous peoples on Turtle Island, too, have long engaged in fermentation practices for food preparation and preservation, including the Inuit fermentation of fish and other proteins in grass-lined pits. West Africans, enslaved and transported across the middle passage, adapted fermented foods—"stinking fish," fermented grains, salted meats—to New World contexts, expressing "the power of these survivors who used preserved flesh in exile to preserve ancient connections to the land of their ancestors."[51] But in recent settler, migrant, Black, and Indigenous contexts, many fermentation techniques have fallen out of daily use—whether due to colonial suppression, cultural assimilation, antibacterial ideologies, or the general industrialization of the food system. Now, out of the fragments of custom and in the fractured space of the settler colony, experimental fermentation practices are again being reclaimed, invented, and disseminated. This reclamation has encouraged a turn to collective learning and the sharing of practical techniques and ethical models.

Intriguingly, Katz's writings—his fermentation cookbooks, his blog posts, and his book on underground food movements—are generically close to the "practical" texts analyzed by Foucault in his late work on the Stoics. Foucault writes that these Greek and Roman documents were

texts written for the purpose of offering rules, opinions, and advice on how to behave as one should: "practical" texts, which are themselves objects of a "practice" in that they were designed to be read, learned, reflected upon, and tested out, and they were intended to constitute the eventual framework of everyday conduct. These texts thus served as functional devices that would enable individuals to question their own conduct, to watch and give shape to it, and to shape themselves as ethical subjects; in short, their function was "etho-poetic," to transpose a word found in Plutarch.[52]

Katz's books are undoubtedly "etho-poetic": they constantly slip into the imperative voice, calling on readers to become practitioners and to change their everyday embodied lives in small but significant ways. More than collections of culinary recipes, they contain recipes for altering the self and the social world. They outline an ascetic commitment that is both disciplined and full of new bodily sensations and pleasures. They do not invite readers to scale Mount Improbable so as to attain the heights of vertical separation, but they do suggest a critical distance from the networks of capitalist reproduction and colonial expropriation running through the industrial food system. At their core, they understand fermentation as a process of ethical awakening and collective transformation. Importantly, this transformation is not solely a human affair. Katz's version of "You must change your life" does not limit itself to an *anthropo*-technics. Instead, it is rooted in those original agents of change, the microbes that initiate the fermentation of organic matter. As he suggests, "Draw inspiration from the action of bacteria and yeast, and make your life a transformative process."[53] This human-microbial etho-poetics goes a certain way toward undoing settler-modern imaginaries of individual autonomy and self-mastery.

BEING ENTANGLED

In Sandor Katz's books, fermentation becomes a kind of exercise in non-mastery, a straying through fields of nature-culture full of strange little creatures. In his practice, "wild fermentation" means working with the airborne yeasts and bacteria present in all organic matter, creating the right conditions that allow microorganisms to break down a substrate—vegetables, fruits, honey, grains, pulses, sweet tea, meat, or milk—turning it into pickles, wine, bread, miso, dosas, fizzy drinks, sausage, or cheese. Experiments in home fermentation require a high tolerance for the unexpected; while skills may be gained through repetition, mastery is unlikely and not usually desirable. A given ferment will have its own taste, depending on a host of factors—the particular substrate, the ambient temperature, the strain of lactic acid bacteria on the vegetable or in the starter culture, whatever airborne yeasts propagate on the surface of the crock. Inevitably, things will go awry. Katz warns would-be pickling practitioners toward the beginning of *Wild Fermentation*: "If your desire is for perfectly uniform, predictable food, this is the wrong book for you. If you are willing to collaborate with tiny beings with somewhat capricious habits and vast transformative powers, read on." He has a fitting motto: "Our perfection lies in our imperfection."[54]

In fact, the bacteria cultivated and consumed in fermentation practices open up a world of practice that, in its webs of interspecies dependencies, is far removed from the autonomy and self-mastery of human individuals assumed by Foucault's "work of the self upon itself" and Sloterdijk's anthropotechnics. Bacteria are the original "companion species," to use Donna Haraway's language; they are the bearers of primordial "significant otherness."[55] They are inside us and outside us, on our skin and in our guts. It is more accurate to say that they *are* us: over 90 percent of cells in our

bodies are microbial, and these microbial cells together contain over one hundred times as many genes as the human genome.[56] "Microbes participate in our breathing, eating, drinking, and digesting," writes Mrill Ingram in "Fermentation, Rot, and Other Human-Microbial Performances"; we need to appreciate "the infinite fuzziness of any boundary between microbe and human."[57] Microbes are not a nonhuman supplement to humanity, which in any case has its evolutionary origin in single-celled creatures. Rather, "we" are the product of what Karen Barad calls "entanglements," an ongoing process of "intra action" at every level, in which organisms do not precede their relating.[58]

As the biologist Lynn Margulis argues in *Microcosmos*, symbiosis is the origin and driving force of evolution at all levels. Bacteria originally formed the energy-producing mitochondria in animals and chloroplasts in plants. All eukaryotic organisms (plants, animals, fungi) are integrated with a host of prokaryotic bacteria, whose DNA is free-floating, not contained in nuclei. Bacteria are thus genetically fluid and can adapt much more quickly to meet environmental challenges than can their symbionts.[59] Coevolution and companion species are the norm; as Haraway puts it: "Earth's beings are prehensile, opportunistic, ready to yoke unlikely partners into something new, something symbiogenetic."[60] Heather Paxson (mis)quotes Arthur Rimbaud to suggest this interspecies porosity: "The man of the future will be filled with animals."[61] But we have always been those animals, all the way down—as we carry around a trillion or so bacteria in our gastrointestinal tract that break down the food we eat, and as those bacteria use the gut's anaerobic container to survive and thrive. "I is another," as Rimbaud wrote, indeed.[62] Or better, "I is a crowd."

This constitutive entanglement is rejected by the ongoing "War on Bacteria" (as Katz terms it), in which human-bacterial symbiosis is replaced by a managerial effort aimed at containing,

controlling, and eliminating our single-celled companions. Beyond the chemical sterilization of water, the overprescription of antibiotic drugs, and the gratuitous use of antibacterial soaps, the food system is the most heated front of this war on microbes. This assault includes the overwhelming use of antibiotic drugs in livestock: 25 million pounds of antibiotics a year in the United States alone, or eight times the amount of antimicrobials used in human medicine.[63] The vast and complex networks of industrial food processing massively increase the reach and impact of *E. coli*, *Listeria monocytogenes*, and other pathogenic bacteria. Meanwhile, consumers are constantly warned of the dangers of drinking raw milk from small producers, and pregnant women are cautioned about the dangers of eating soft or raw milk cheeses. Paxson describes how this "Pasteurian" biopolitics aims at eliminating the risk of contamination, both microbial and social.[64] It creates germophobic subjects who are encouraged to manage their own behavior to avoid risk. This top-down microbiopolitics clearly does not welcome home experimentation, in nonsterile conditions, with wild bacteria and yeasts.

In *The Art of Fermentation*, Katz quotes a 1979 microbiology textbook that proclaims, "Microorganisms are [our] most numerous servants." For Katz, this statement epitomizes "a worldview of humans as the supreme creation of evolution, with all other life-forms ours to freely exploit."[65] The fermentation revival is not interested in this Pasteurian mastery over the invisible world, and over the world of human-microbial collaboration. Instead of master and servant, exploiter and exploited, parasite and host, Katz and his colleagues prefer the messy, entangled, and sometimes playful relationships of the microbiome. "To view ourselves as masters and microorganisms as servants denies our mutual interdependence," he writes.[66] The DIY practices of the fermentation revival embrace interspecies heteronomy, not autonomy, and

promote practices of intimacy, coexistence, and responsibility toward single-celled "queer critters."[67] The bubbling crock becomes an example of what we can do together when species meet.

STRANGE STRANGERS

The fermentation crock, this homely spot on the planet of the practicing, is far from Sloterdijk's training ground for an all-too-human acrobatics. Rather, it is the container for a set of subtle relational practices, requiring a "mastery of non-mastery" which could be described as a kind of interspecies love.[68] For Donna Haraway, whose love for various canines includes some entangled "agility training," this is not "unconditional love," which she describes as more or less a "neurotic fantasy." Instead, love means "meeting the other in all the fleshly detail of a mortal relationship," and encourages "the permanent search for knowledge of the intimate other."[69] Practices of knowledgeable intimacy, not mastery, are what is necessary among "such organic beings as rice, bees, tulips, and intestinal flora, all of whom make life for humans what it is—and vice versa."[70] Many fermentos share a kind of "biophilia"; their practices soften the borders between species, and the borders inside them as well. Bacteria are our closest and most constant companions, simultaneously self and other. The fermentation revival reinvents ways of working with these intimate strangers, basing its ethical relations on fleshly mortality and intimate co-becoming.

Fermentos often like to theorize their own practice in these entangled terms. Lisa Heldke, a philosophy professor and DIY fermentation enthusiast, relates fermentation practices to other embodied practices that depend on capricious beings and forces. She writes that fermented foods remind her of

the unpredictable interconnections between me and not-me. Other people experience this complex interconnectivity when they garden, or sail, or parent, or perform brain surgery. For me, it is encapsulated in a rubbery mat, stained brown and floating on top of a jar of tea. Yes, the mat is creepy and slightly malevolent. But treat it gently, for you and it are in a subtle, tenuous relationship, the parameters of which you are only beginning to discern.[71]

Heldke's philosophical rhapsody is directed to a kombucha mother, a symbiotic community of bacteria and yeasts (or SCOBY) that ferments sugared tea. Like any companion species, kombucha mothers need to be cared for and fed regularly. Heldke's "subtle, tenuous relationship" with that floating thing perfectly captures the fermentation revival's search for intimate knowledge of the other, and its post-Pasteurian care for human-microbial collectives.

This interspecies love is directed toward what Timothy Morton calls "the strange stranger"—a creative translation of Jacques Derrida's *arrivant*, the one who turns up unexpectedly. The "strange stranger" might be "creepy and slightly malevolent," like a kombucha mother. (Indeed, what could be creepier than calling that brown rubbery thing a "mother"?) It might be floating slimily in a mason jar or hanging out in our intestines. As Morton writes, "strange strangers are right next to us. They are us. Inner space is right here, 'nearer than breathing, closer than hands and feet.'"[72] Morton calls for an intimate acceptance of "uncanny familiarity"—an "erotics of coexistence" that he doesn't hesitate to define as queer. As he writes, "Loving the strange stranger has an excessive, unquantifiable, nonlinear, 'queer' quality."[73] Morton calls for a "queer ecology" with an eroticism that departs from social codes: "To contemplate ecology's unfathomable intimacies is to imagine pleasures that are not heteronormative, not genital,

not geared to ideologies about where the body stops and starts."[74] The erotic ecology of the fermentation revival is certainly a queer one. It embraces the abject: fermentation is essentially controlled rot. It undoes inside-outside boundaries on both physical and metaphysical planes, as it welcomes the strange strangers in our guts and in the soil to the feast.

Considering the "strange stranger" in the form of Derrida's *arrivant*, as Morton does, is appropriate here. Fermentation is traditionally linked to vernacular practices of hospitality, and it can be seen as a practice of hospitality in its own right. The *arrivant* is the one to whom we must offer sustenance, the one who turns up unexpectedly at our door. Among humans, we serve the new arrival prized ferments—bread and wine, nourishing foods, refreshing and intoxicating drinks. Beyond the various customs of hospitality, Derrida argues that there is an ethical law that requires us to offer the *arrivant* an unconditional welcome: "Let us say yes *to who or what turns up*, before any determination, before any identification, whether or not it has to do with a foreigner, an immigrant, an invited guest, or an unexpected visitor, whether or not the new arrival is the citizen of another country, a human, animal, or divine creature, a living or dead thing, male or female."[75] Or a bacterial community: neither male nor female, living in the midst of its wastes, perhaps undead, not exactly "animal," neither human nor divine.[76] Derrida's term *hôte*, which in French means both "host" and "guest," captures the ambivalent queerness of fermentation's hospitality.[77] In fermentation processes, both we and the microbes are *hôtes*, in what Haraway calls an "ontological choreography" of conjoined intimate strangeness.[78] The products of that strange intimacy are then transformed, through controlled decay, into culinary offerings of welcome.

Yet Haraway's image of the ontological dance paints too rosy a picture, both of hospitality and of human-microbial collectives.

"The stranger is a digression that risks corrupting the proximity to self of the proper," Derrida argues, a corruption that is not easy to endure.[79] In his lectures on hospitality, Derrida repeatedly refers to the difficulty of the law of "radical hospitality," which consists in *receiving without invitation*, beyond or before the invitation."[80] This radical receptivity invites a certain violence or violation: one must say yes to precisely that which one does not expect or await or even want. Derrida observes that the arrival of the stranger has something messianic about it; indeed, that there is a messianic "madness" at the core of the concept of hospitality.[81] The violence and madness of the law of absolute hospitality exist in tension with the traditional customs of hospitality, creating an unresolvable contradiction in the act of welcoming the stranger.

Timothy Morton, in adapting the concept of the *arrivant*, pursues Derrida's conception of radical hospitality into ecological thought. Morton argues that welcoming the strange stranger goes beyond "the animal" or even the "non-human" to extend hospitality to "the inhuman," to "the radically strange, dangerous, even 'evil.' For the inhuman is the strangely strange core of the human."[82] Morton would join Sandor Katz and Lynn Margulis in rejecting the imaginary division between "good bacteria" and "bad bacteria"; bacteria are thoroughly mutable and are helpful or harmful to humans only under certain specific conditions. But if we take Morton literally, we should be extending an unconditional invitation to *E. coli* and salmonella, along with more familiar and helpful strange strangers like *L. plantarum* and *S. cerevisiae*, the fermenters of sauerkraut and beer. The unconditional law of hospitality starts to break down when we approach the question of immune systems, toxicity, and infection. The strange stranger might be *really* malevolent, not just a bit slimy. Pasteur's discoveries may have been allied to some sinister biopolitical purposes, but microbial management is not something that most humans

would be willing to give up altogether. Cholera, for example, is not welcome at the table.

It might be more helpful to understand hospitality not only as governed by a law, even a nonabsolute law, but also as a threshold practice, one which moves across borders. Hospitality is only meaningful if it involves actually welcoming strangers—human or otherwise—by giving them shelter and sustenance. Practicing hospitality means that there must be those who welcome and those who are welcomed; it cannot completely dissolve the threshold between inside and outside. Since we are dealing with the world of microbes, the immune system offers a fitting metaphor. As Roberto Esposito writes, "the immune system cannot be reduced to the simple function of rejecting all things foreign. If anything, the immune system must be interpreted as an internal resonance chamber, like the diaphragm through which difference, as such, engages and traverses us."[83] Derrida is right that the stranger corrupts the proximity of the self to the proper. But this corruption can't lead to a total dissolution or immunological collapse; nor can corruption raise a total defense, leading to a kind of hyperimmunity or autoimmune disorder. Instead, the practice of hospitality plays across immunological thresholds and allows a coexistence in difference to emerge.

To adapt Esposito's language, we might say that practices of hospitality, including fermentation practices, are another kind of diaphragm through which difference traverses beings. The practitioners of the fermentation revival play across the borders between human and microbial communities, strengthening immune systems (figuratively and literally) in the process. Their hospitable practices undo philosophies of autonomy and fantasies of mastery without collapsing back into the primordial soup, which contains some rather nasty guests. There is a messianic fervor to their welcome, or even love, of the microscopic *arrivant*. But their

messianism is thoroughly entangled with creaturely life, recalling the messianism of Benjamin's "order of the profane" (see chapter 2). In the order of the profane, happiness lies in "the rhythm of this eternally transient worldly existence," in nature's "eternal and total passing away."[84] Fermentos, too, find happiness in profane rhythms, welcoming the strange stranger while elbow-deep in buckets of transience and decay.

THIS COMPOST

Fermenting is indeed intimate with what Benjamin calls "the eternity of downfall, and the rhythm of this eternally transient worldly existence."[85] It adopts a creaturely materiality, entangled with larger processes of degeneration. As many writers on fermentation point out, microorganisms are not only responsible for the culturing of food and drink by breaking down and reorganizing plant and animal cells into tasty substances. Those strange strangers also work to degrade dead matter into elements that regenerate the soil. As Jacob Lipman writes in *Bacteria in Relation to Country Life* (1908), microorganisms

> are the connecting link between the world of the living and the world of the dead. They are the great scavengers intrusted [*sic*] with restoring to circulation the carbon, nitrogen, hydrogen, sulphur, and other elements held fast in the dead bodies of plants and animals. Without them, dead bodies would accumulate, and the kingdom of the living would be replaced by the kingdom of the dead.[86]

Each teaspoon of soil contains up to one billion bacteria, as well as thousands of protozoa, dozens of nematodes, and several yards

of fungal filaments; under good conditions, those tiny creatures can start turning dead matter into regenerative humus.[87] Katz celebrates this process as an "everyday miracle," in which dead things—fallen leaves, animal excrement, rotting trees and plants, carcasses—provide nutrients that allow the living to flourish.[88]

There is, undoubtedly, something miraculous and even frightening to this transformation. Walt Whitman writes in "This Compost" (from *Leaves of Grass*):

Now I am terrified at the Earth! ...
It grows such sweet things out of such corruptions,

It distils such exquisite winds out of such infused fetor,

It gives such divine materials to men, and accepts such
 leavings from them at last.[89]

There is a terror to death and fertility, the birth of new life from corruption and waste. But this miraculous terror is easy to forget. Whitman marvels at its apparent disappearance: "The summer growth is innocent and disdainful above all those strata of sour dead."[90] Fermentation preserves a hint of that mortal sourness in each crock of sauerkraut, with its slow-motion degeneration of cabbage and salt into exquisite pungency.

Degradation links soil fertility to another power of fermentation: its ability to produce intoxicating alcohol. In alcoholic fermentation, microbially driven processes of decay create powerful substances that can transform consciousness and bodily experience. The intoxicating powers of decaying substances were likely first discovered through the spontaneous fermentation of tree sap and fallen fruit. Humans are not the only creatures to appreciate such rotten delicacies: in *Intoxication*, Ronald K. Siegel describes

elephants, monkeys, and flying foxes gorging themselves silly on decaying, fermented durian in the Malaysian jungle.[91] Yet humans are unique in having reorganized whole swaths of the earth in order to alter their embodied being by ingesting fermented substances. Some archaeologists argue that in the ancient Near East, agricultural settlements emerged primarily to secure a steady supply of grain used for brewing beer.[92]

Intoxicating and pungent drinks often accompany celebrations, rituals, and feasting, honoring the intertwining of life and death. Nearly every culinary tradition, especially those engaged in subsistence agriculture, has its vernacular techniques for fermenting drinks from fruits, milk, honey, grains, and other plants. In *The Physiology of Taste* (1825), the French gastronome Brillat-Savarin notes this near-universality. He writes:

> All men, even the ones we have agreed to call savages, have been so tortured by this thirst for strong liquors, which they are impelled to procure for themselves, that they have been pushed beyond their known capacities to satisfy it. They have soured the milk of their domestic animals; they have extracted the juices of various fruits and roots where they have suspected there might be the elements of fermentation; and wherever men have gathered together they have been armed with strong drinks, which they employed during their feastings, their sacrificial ceremonies, their marriages, their funerals, and in fact whenever anything happened which had for them an air of celebration and solemnity.[93]

Brillat-Savarin's observations still hold true: marriages, funeral rites, and agricultural festivals (springtide, midsummer, and harvest) often honor the links between death and fertility with "strong

liquors." At these events, intoxicating and pungent ferments are often taken into the body to celebrate cycles of growth and degeneration, living and dying. Such ritual structures are invoked by latter-day fermentos, who revive vernacular techniques for the wild fermentation of sugar into alcohol through the work of airborne yeasts. Their "practice texts" abound with reclaimed recipes for "Herbal Elixir Meads" and "Sacred and Herbal Healing Beers."[94] Some fermentos seem to get intoxicated on the earthly, degenerative powers of lactic acid bacteria alone.

A steaming pile of compost, a cup of sour kvass, or a frothing jug of honey mead evidently mix elements of destruction and regeneration. But so does the production of cheese, with its lengthy process of managed rot. The Benedictine Sister Noëlla Marcellino, otherwise known as the Cheese Nun, suggests that cheese should be included in the Eucharist along with bread and wine, those other products of fermentation. "Cheese," she says, "forces you to contemplate death, and confronting our mortality is a necessary part of spiritual growth."[95] Cheese-making has an immediate link with death: it requires not only lactic acid bacteria but rennet, an enzyme traditionally culled from the lining of a cow's stomach. The disgust that some people feel at the smell of a stinky ferment—runny Reblochon or stinky tofu—is traceable to an intelligent wariness of decaying animal bodies, which can carry pathogens. Vernacular practices of fermentation find ways to mediate this wariness and to let death traverse us by incorporating it into the body. They experiment with the regenerative properties of degradation, and play across thresholds between life and death, clean and unclean. Fermentation, as Whitman writes, "distils such exquisite winds out of such infused fetor." Its techniques celebrate the microbial link between generation and decay—even if, until relatively recently, the microbes themselves received little credit.

Folk fermenting techniques all involve some kind of degrada-
tion to the material level, as Mikhail Bakhtin describes in his writ-
ing on the carnivalesque. "Degradation," Bakhtin writes, "means
coming down to earth, the contact with the earth as an element
that swallows up and gives birth at the same time. ... Degradation
digs a bodily grave for a new birth; it has not only a destructive,
negative aspect, but also a regenerating one."[96] Bakhtin felt that
this vision of degradation as both death and regeneration had al-
ready begun to disappear with the scientific revolution and the
Enlightenment. But in the agricultural modernization of the past
century, it has been beaten back on a global scale. The "green
revolution" of the second half of the twentieth century separates
Bakhtin's two aspects of degradation: it temporarily pumps up
soil fertility through nitrogen-based fertilizers, while using Pas-
teurian policies of microbial management to discourage the re-
cycling of animal waste into compost.[97] Fertility is forced on the
soil through chemicals and on animals through hormones; plants
are protected by genetic engineering and pesticide sprays, and an-
imals by antibiotics. Total immunization, against bacterial con-
tamination and other dangers caused by economies of scale, is
the rule. As a result, for industrial agriculture, degradation means
only the pure despoiling of the land. The fermentation revival, by
allying itself with vernacular techniques of promoting soil fertility,
consciously struggles against this one-sided degradation. Its tech-
niques work with our microbial partners in the air and in the dirt,
who are experts at complex processes of decay and regeneration.

The fermentation revival's reclaiming of decay and degrada-
tion extends to what Bakhtin calls "the lower bodily stratum" in the
processes of digestion and excretion. Digestion is another form of
fermentation, the anaerobic work of communities of single-celled
organisms. The consumption of live-culture foods is considered
by both vernacular knowledge and scientific communities to help

with digestion. Lactic acid bacteria adhere to the gastrointestinal wall, strengthening it and promoting digestive health and immune response. For many lovers of fermented foods, the process of digestion becomes eroticized in a truly queer manner. Roland Barthes writes that for Brillat-Savarin, "Food provokes an internal pleasure, interior to the body, enclosed within it, not even beneath the skin, but in that deep, central zone, all the more original for being soft, confused, permeable, which is called in the most general sense, the bowels." Barthes describes how, for the author of *The Physiology of Taste*, "gustative delight is diffuse, extensive to the entire secret lining of the mucous membranes." Although localized in the mouth, it spreads out in a kind of "*cenesthesia*, the total sensation of our internal body."[98] Brillat-Savarin undoubtedly enjoyed feeling a scoop of Brie de Meaux slide down his gastrointestinal tract, and he would surely have thrilled to learn of the role of microorganisms in both its creation and its digestion. These diffuse and secret gustatory pleasures are familiar to the proponents of the fermentation revival, who are often just as concerned with well-being and sensation in that "soft, confused, permeable" zone as they are with strong flavors in the mouth.

Sandor Katz shares a version of Brillat-Savarin's permeable eroticism that includes both digestion and excretion. For Katz, too, "Eating is a full-body experience, involving the nose, the mouth, the hands, the teeth, the tongue, the throat, the vast array of internal sensations relating to digestion, and the renewing pleasure of defecation."[99] To these sensory pleasures he adds a healthy philosophical embrace of decay. "In our contemporary culture," he writes, "we treat shit as unspeakable and flush it away to make it disappear instantly. Personally, I like to talk about shit. When I feel completely reborn by a particularly satisfying movement, I like to share my enthusiasm. If a friend is sick and experiencing changes in shit texture or consistency, I like to hear about that, too.

For me it's about claiming the body and all its functions without shame."[100] This rejection of bodily shame recalls Bakhtin's profaning carnival laughter, which "liberates not only from external censorship but first of all from the great interior censor; it liberates from ... fear of the sacred, of prohibitions, of the past, of power."[101] Reclaiming shit brings humans back to a common carnal vulnerability and baseness. It is also an ecological act. For the vernacular experimenters of the "humanure" movement, feces—the product of human digestive fermentation—can be turned into compost, beginning the cycle of fertility and degradation once more.[102] We can think of Antonin Artaud's proclamation from "The Pursuit of Fecality": "There where it smells of shit / it smells of being."[103] Or as Katz puts it, in a characteristic imperative: "We must face our shit, embrace our bodies, and feel our connection to the earth."[104]

There is something almost mystical to these fermenters' love of earthly corruption and profane bodily processes. Sometimes this mystical tendency turns into full-blown magic, as in the case of Steiner-inspired biodynamic farmers, who draw on a series of alchemical preparations (or "preps") to enhance soil fertility. "For instance," Katz writes, "cow horns are stuffed with fresh manure from lactating cows and buried from fall to spring. For another prep, a stag's bladder is stuffed with yarrow flowers and hung up in a tree over the summer. After its fermentation, a small amount of this prep is added to water and stirred for a full hour."[105] A biodynamic farming manual states that these "preparations bear concentrated forces within them and are used to *organize* the chaotic elements within the compost piles," resulting in "*medicines* for the Earth which draw new forces from the cosmos."[106] Contrasted with this cosmic folk magic is the more subtle mysticism of the tiny world of microbial fermentation. When Sister Noëlla Marcellino looks through her microscope at a cheese culture, she sees "something microcosmic that opens up a world to me, a vision."

She likens this experience to that of Saint Benedict, who "saw the whole world in a ray of light."[107] That microcosmic world, as she is well aware, is nothing but the continual downfall and regeneration of creaturely life. Fermentation harnesses earthly processes of decay: as Whitman puts it, "It grows such sweet things out of such corruptions." Sweet things, sour things, intoxicating things, pungent things—and the fertile earth itself.

RECIPE: EAT SOME DIRT

Fermentation's practiced engagement with earthly transience roots its politics in everyday embodied life. Repeatedly and deliberately facing our shit, embracing our bodies, and feeling our connection to the earth, as Sandor Katz suggests, can bring ecological theory into daily experience. It reminds us that we are beings among other beings, subjected to—and subjectifying ourselves through—earthly forces. Timothy Morton suggests that this kind of shared abasement might be a good place to locate an ecological politics: "Politics in the wake of the ecological thought must begin with the Copernican 'humiliations'—coming closer to the actual dirt beneath our feet, the actuality of Earth."[108] This process is neither elegant nor beautiful: Morton suggests that "we must base ecological action on ethics, not aesthetics."[109] In his view, the collectives we form with other beings can't be predicated on those beings looking or feeling nice, or on their being delicious, for that matter. Yet the fermentation revival shows that ethics and aesthetics are not so easily disentangled. Katz's books are indeed ethical "practice texts" like those explored by Foucault. But they are also *aesthetic* practice texts, in the broad sense of the term. They instruct their readers to experiment with strange forms of sensory experience.

Katz's aesthetic instructions come in the form of another vernacular genre: the recipe. Recipes have historically been a medium of "tradition" as *tradere*—passed down from hand to hand through embodied practice, archived on index cards or scribbled notes, and eventually collected in cookbooks. Those traditions are now scattered and omnipresent, disseminated through various online platforms and accessible at any time to anyone with an Internet connection. Like works in the public domain, they are exempt from copyright, and can be freely copied, distributed, and altered.[110] Katz encourages this kind of bricolage with his own practice texts. He writes that he enjoys consulting recipes, "but then I end up ignoring them, varying the ingredients, using what's around, and learning from my experiments. That's what I like for people to do with my recipes."[111] This encouragement to experiment is especially appropriate for vegetable ferments, for which, unlike the delicate and precise arts of patisserie, proportions are rough and ingredients replaceable. Reflecting this roughness, Katz's own published recipes have grown increasingly spare, becoming more like prompts or directives than detailed instructions. *Wild Fermentation*, published in 2003, contains conventional recipes with proportions and measurements. Nine years later, *The Art of Fermentation* offers more general principles and watchwords: Katz summarizes the section on fermenting vegetables as "Chop, Salt, Pack, Wait."

The recipe's imperative voice suits Katz's inclination to offer practical steps toward reordering the sensible world. Even his book on radical food politics, *The Revolution Will Not Be Microwaved*, includes thematic recipes: for the chapter on edible weeds, Katz suggests a foraged chickweed pesto; for the chapter on "slow food for cultural survival," he proposes "shav," a chilled purée made from lemony sorrel leaves, boiled potatoes, and pickle juice. His success as an ambassador of pickling can be seen in the many

practitioners who have taken up the call to change their lives through the art of fermentation. On Katz's website, www.wildfer mentation.com, other fermentos share the results of their own experiments—posting recipes and photos of complex culturally specific delicacies ("Takuan—the transformation of a radish"), or of home ferments made with whatever ingredients are close at hand ("Adzuki Bean Spritzer"). Users with names like "the fart rocket" start lively discussions tied to their proclivities ("Fermen- tation Obsession Disorder and Old Soft Beets"). The fermentation subculture continues to spread like a creeping bacterial colony, fueled in part by the instructions in Katz's writings, but taking new forms and branching off into alternate fora (and flora). Katz admits there are no step-by-step instructions or easy recipes for social change. But even the sparest of recipes activates the reader to concoct—or at least imagine—a material change in the fabric of the sensible.

Despite plenty of research, proselytizing, and polemic, *Wild Fermentation* and *The Art of Fermentation* contain mostly recipes and instructions for making ferments. But in *The Revolution Will Not Be Microwaved*, Katz moves beyond food preparation instruc- tions into recipes for altering everyday life. One of these recipes puts ecological "humiliations" into directly embodied practice, getting close indeed to the dirt beneath our feet:

RECIPE: EAT SOME DIRT

Try it. Choose a place that seems clean, away from chem- ical waste, lead paint, traffic, and fresh excrement. In a garden, perhaps, or a forest. Taste a little dirt. On its own, or what you find clinging to a fresh carrot or radish or burdock root. It may be gritty, so protect your teeth and don't bite down on it too hard. Savor the flavor. The earth is good for you. Pregnant and lactating women in many

places routinely eat dirt to obtain minerals, a practice known as *geophagy*. And probiotic formulations known as soil-based organisms (SBO) are some of the most expensive nutritional supplements on the market. Don't buy a capsule; taste the earth to get your SBOs. This is another important aspect of eating locally: eating the local soil organisms further integrates us into the web of life of our environment and adapts us to the local microbial ecology. Be here now. Learn to love the flavor of the earth.[112]

"Eat Some Dirt," while not exactly a fermentation recipe, brings together many aspects of the fermentation revival: its emphasis on embodied and experimental vernacular practice, its queer ecologies and pleasures, its orientation beyond the human, and its rejoining of death and fecundity. The practice of geophagy, which Katz links to Indigenous traditions of pregnant women eating dirt, is thoroughly opposed to the antibacterial fanaticism that marks the current microbiopolitical regime. He tells us to "choose a place that seems clean"—not a sanitary or sterilized environment, but a dirty playing field where humans and other organisms can meet. What better way to learn to love these strange strangers than to feel their gritty medium in our mouths? With "Eat Some Dirt," Katz offers more than just a "ritual of remembrance," a lifestyle practice meant to compensate for the abstractions of consumer capitalism. His recipe is a "profanation," a set of instructions for play across the ritual separations—between degradation and fertility, between human and nonhuman—that characterize the industrial food system.[113]

This kind of recipe for sensory profanation can be traced back at least as far as the "instruction pieces" of the early twentieth-century avant-gardes and their post-World War II inheritors, who also sought to transform everyday life through aesthetic exercises.

Peter Bürger argues that the historical avant-gardes' "intention to do away with art as a sphere that is separate from the praxis of life" brought some artists to formulate their work as practice texts, or as recipes. As Bürger writes,

> It is no accident that both [Tristan] Tzara's instructions for the making of a Dadaist poem and [André] Breton's for the writing of automatic texts have the character of recipes. This represents not only a polemical attack on the individual creativity of the artist; the recipe is to be taken quite literally as suggesting a possible activity on the part of the recipient. The automatic texts also should be read as guides to individual production. But such production is not to be understood as artistic production, but as part of a liberating life praxis. This is what is meant by Breton's demand that poetry be practiced (*pratiquer la poésie*).[114]

For these avant-gardists, poetry was a mode of existence to be practiced in everyday life, not a genre reserved for the autonomous realm of art. The recipe or set of instructions, or even certain works of art like automatic texts, became an invitation to readers to reorganize their embodied subjectivity by way of life-altering practice. Bürger argues that this historical project failed in the realm of art, only to be recuperated by art world and literary institutions. But it is alive in the ethico-aesthetic practices of movements like the fermentation revival. In this respect, Katz can be seen as part of a web of avant-garde practitioners—running from the surrealists (including Salvador Dalí's cookbook *Les Dîners de Gala*), to John Cage (a fervent mycologist), Fluxus (as in Allison Knowles's "Make a Salad" from 1964), the situationists, certain conceptualists, and mavericks like Piero Manzoni, who produced ninety cans of his own *Artist's Shit* (1961)—before dispersing into

movements and countercultures that were and are more inter-
ested in transforming life than in making art.[115] The spirit of
Raoul Vaneigem's *The Revolution of Everyday Life* lives on in the
more radical pockets of the DIY world. As Katz writes of various
political food movements, from feral foragers to infusers of plant
medicines, "This is a revolution of the everyday, and it's already
happening."[116] In the case of the fermentation revival, this revolu-
tion of the everyday is happening by way of anachronistic, vernac-
ular experiments—retranslating multiple practices through the
discontinuum of tradition.

The arts of preparing and eating food, which gather together
various beings for a collaborative culinary event, can also be un-
derstood as live performances. As Barbara Kirshenblatt-Gimblett
points out: "An art of the concrete, food, like performance, is alive,
fugitive, and sensory."[117] Fermentation with live cultures is espe-
cially performance-like: humans, ingredients, and bacteria put
on a show together, each iteration singular and ephemeral, to
be consumed and then repeated with a difference. As a set of in-
structions for one of these live events, Katz's "Recipe: Eat Some
Dirt" can be understood as a kind of performance score. If the
ferment or meal is a performance—a time-based, shared sensory
experience—the recipe is a score: "one realizes the recipe, just as
one performs a musical composition (transforms written nota-
tions into sounds)."[118] Recipes and scores are generically similar:
they are both instructions for sensory events that may or may not
be enacted by their readers. While some complex recipes might
mirror the elaborate scores of Western symphonic music, "Eat
Some Dirt" is more along the lines of an "event score" by the likes
of George Brecht, Yoko Ono, Ben Patterson, or Allan Kaprow. Like
certain conceptual works, "Eat Some Dirt" is an aesthetic exper-
iment that can be enacted or imagined, often with similar re-
sults.[119] It seeks to alter our experience and understanding of the

world, and to discover what comes of that change. Yet, while focused on sensation, Katz's proposal goes beyond the dimension of aesthetic or sensory experience. To use Foucault's language, it is an "etho-poetic" invitation to step outside of our daily habits and customary embodied practices. Katz's aesthetic exercise in abasement pushes us to live otherwise in a shared and damaged world.

Given its intertwining of the ethical and the aesthetic, it is no surprise that in recent years the growing, cooking, and eating of food, including ferments, has become a rich medium for artists. The backdrop of their actions is the sensorium of the industrial food system, which has what Susan Buck-Morss calls an "anaesthetic" quality.[120] Brightly lit supermarket shelves hide antibacterial and hyperimmunological practices, the expropriation of Indigenous land, monocropped and pesticide-sprayed fields, factories of animal suffering, and the global immiseration of farmers and farm workers. Food arrives to consumers in sealed packages, free from any visible blemish or trace of dirt; soil-based organisms are best ingested in pill form. In response to this numbed sensorium, numerous contemporary artists have created projects that reinvent more hands-on and sensual forms of sociability and relations to the land. In their work, touch, taste, smell, and commensality (or "eating together") are embodied pathways to share new and old sensations in a desensitized world. Some of these artists have begun to integrate fermentation practices into their work—from Marissa Lee Benedict's algae-nourishing vats of mead to the Microcultures Collective's exercises in public fermentation (including the sonic amplification of fizzy mason jars), and from Eva Bakkeslett's yogurt-making workshops to Claire Pentecost's compost-as-currency (see figures 4.3 and 4.4). Their projects take inspiration from the work of Katz and other cultural revivalists, while moving those cross-species experiments with tradition into an explicitly aesthetic and often politicized discursive field.

Chicago-based Claire Pentecost sees her own composting exhibitions and investigations into soil fertility as vernacular experiments in aesthetic form. For her, as for Katz, such experiments can open onto Sloterdijk's "good habits of shared survival in daily exercises." A vermicomposter, Pentecost works with earthworms, another set of strange strangers who live close to the ground. She writes, in support of what she calls "the public amateur":

> It becomes increasingly clear that no one is going to save us and we have to work together to experiment with new ways of being in the world. For this we have to return knowledge to the realm of the social by producing knowledge collectively. We have to start with "I don't know," and proceed to think across disciplines to propose alternatives to a system founded on violence against life.[121]

As an artist, Pentecost is proposing a kind of "grassroots modernism" with clear links to DIY movements. Even in her orientation to future alternatives, she calls for a "return" to collectivized knowledge, the shared knowledge of vernacular practices. Like Katz, she proposes that we start with our hands (or mouths) in the dirt. Her art projects and his fermentation practice are low-cost endeavors (unlike much recent "bioart"); they may be framed differently, but they open onto similar territory. Ethical knowledge and practical alternatives to economic and ecological violence come through sensory experience. These "ways of sensible being" may not be pretty or nice. They might be framed as art, or they might be part of daily practice. But they start with bringing us down to earth: with the worms in the soil and dirt under our fingernails, or with the gritty taste of minerals and microorganisms in our mouths.

NOURISHING TRADITIONS, STOLEN LAND

The writings of Katz and other fermentation revivalists play across the borders between art and everyday life, seeking to alter everyday embodied practices by making them both more ethical and more aesthetic. In so doing, they tend to enact, in a culinary key, what Terry Eagleton calls "the ideology of the aesthetic": its search for "the ideal unity of a divided reality."[122] In a fragmented, "abstracted," and damaged world, many fermentation revivalists seek wholeness, concreteness, and connection. This striving for wholeness results in a range of political visions—radical, liberal, and conservative. For Michael Pollan in *Cooked*, the fragmentation of capitalist modernity is experienced primarily as an aesthetic problem, which can be tackled on the level of aesthetic practice. Pollan fears that within a generation, "food will have become completely abstracted from its various contexts: from the labor of human hands, from the natural world of plants and animals, from imagination and culture and community." To heal this abstraction, he proposes what is essentially an aesthetic remedy: "My wager in *Cooked* is that the best way to recover the reality of food, to return it to its proper place in our lives, is by attempting to master the physical processes by which it has traditionally been made."[123] This proposal recalls the utopian aesthetics of the romantics: if we can experience wholeness, connection, and freedom in art (or in the practice of making sourdough bread), then we can critique a society (or food system) that lacks these qualities. In this perspective, the experience of the aesthetic is an agent that can begin to transform an "anaesthetic" and unjust social system.

In the case of the fermentation revival and related food movements, aesthetic experience finds its healing agency in folk foodways. This approach can be seen in Katz's work to some extent, but it is more evident in Jessica Prentice's *Full Moon Feast: Food*

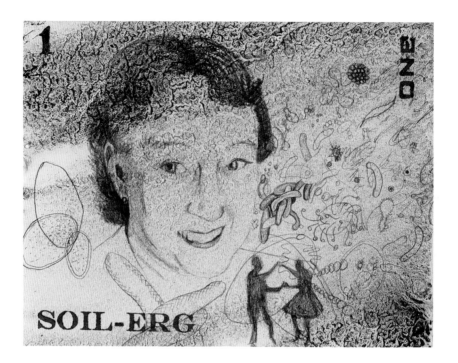

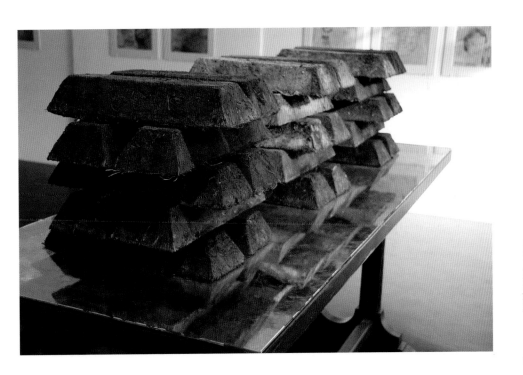

FIGURES 4.3 AND 4.4

Claire Pentecost, banknote of
Lynn Margulis and bars of compost,
from the installation *Soil-Erg*
(dOCUMENTA 13, 2012)

and the Hunger for Connection, which draws on multiple traditions to promote a more holistic relationship to food. *Full Moon Feast* contains many recipes for live ferments, and emphasizes unpasteurized milk and whole ingredients. Prentice divides her book into thirteen seasonal chapters based on the lunar calendar, with names like "Mead Moon," "Wort Moon," and "Moon of Making Fat." In "Sap Moon," she contrasts small-scale maple, palm, sorghum, and cane sugaring with the massive operations that produce contemporary cane sugar, with its history of enslavement, violence and terror, indentured labor, and Indigenous dispossession. "The heart of the difference," she claims, "has to do with wholeness versus fragmentation"—a rather aesthetic complaint.[124] Prentice describes the exploitation of laborers and the ravages of the plantation system, but her real focus is on how capitalism and colonialism have disrupted ancestral foodways. The production of refined white sugar "broke down communities and wiped out traditions," leaving the people who grew sugar with no "ancestral relationship" to the cane or the refined product.[125] To heal this "disconnect from both people and place," Prentice proposes delicious-sounding recipes like "Coconut and Palm Sugar Semifreddi," "Cardamom and Jaggery Rice Pudding," and "Lacto-fermented Tabbouleh." In *Full Moon Feast*, "the hunger for connection" can be sated, and social wounds healed, by an aesthetic reimagining and remixing of multiple culinary traditions.

In settler-colonial North America, the agent of aesthetic healing often comes packaged as "the Indigenous." This is surely the case for Prentice's *Full Moon Feast*, which is deeply engaged with Indigenous traditions and foodways on Turtle Island. Prentice is not a naïve appropriator of native cultures: her book enters into conversation with writers including Jeannette Armstrong of Okanagan First Nation, and begins with a dialogue between two Karuk elders, in Karuk and English on facing pages, describing

the "poison food, world-come-to-an-end-food" that settlers imposed on First Peoples. Nevertheless, in *Full Moon Feast*, Indigenous traditions are what have the power to heal a fragmented food system and bring connection to a disconnected world. As Jayna Brown points out, such utopian discourses position Native peoples "as representatives of the past and the holders of the future, the transcendent solution to the fracturing politics of race and global inequality."[126] Indigenous practices—music or foodways—stand in for Eagleton's "ideal unity of a divided reality." The settler can then assume a colonial aesthetic position, becoming a kind of curator or remixer of global Indigeneity. DJs and producers fly around the world (or surf the Internet) collecting global beats; Prentice flits from Tibet to Mexico, from the Celts to the Quechua, gathering recipes to heal our wounded bodies and souls. The fragmentation imposed by economic processes and encouraged by media technologies allows for syncretic remixes that draw on multiple traditions—whether they celebrate that fragmentation, as in much remix culture, or seek to heal it, as Prentice's *Full Moon Feast* does.

This position, in which the settler becomes the gatherer and curator of Indigenous practices, structures another cookbook that has been highly influential in the fermentation revival: Sally Fallon Morell's *Nourishing Traditions* (1999). Morell heads the Weston Price Foundation (of which Jessica Prentice is a regional director), named after the American dentist Weston A. Price. Price's *Nutrition and Physical Degeneration* (1939) has attained the status of a founding text, a Book of Mormon for some anachronistic food movements, an error-filled heresy for others. "In the 1930s," writes Morell,

Dr. Price traveled the world over to observe population groups untouched by civilization, living entirely on local

foods. ... Dr. Price found fourteen groups—from isolated Irish and Swiss, from Eskimos to Africans—in which almost every member of the tribe or village enjoyed superb health. They were free of chronic disease, dental decay and mental illness; they were strong, sturdy and attractive; and they produced healthy children with ease, generation after generation.[127]

Price compared these people with "members of the same racial group who had become 'civilized' and were living on the products of the industrial revolution—refined grains, canned foods, pasteurized milk and sugar. In these peoples, he found rampant tooth decay, infectious disease, degenerative illness and infertility."[128] Based on these findings, Price's interest in eugenics as a mode of combating "degeneration" shifted to a focus on nutrition. Food, not heredity, was the key to the health of the species. Drawing on evidence that was more anecdotal than experimental, he promoted a diet that drew on Indigenous foodways, made up of whole grains and vegetables, seafood, organ meats, raw milk products, animal fats, and unrefined foods.[129]

Nourishing Traditions takes Price's nutritional antimodernism and folds it into what might be called a "paleoconservative" culinary practice text.[130] The book is filled with recipes, invective against "politically correct nutrition and the diet dictocrats," and citations of scientific papers (often produced by the foundation itself). Many of its recipes involve fermentation with live cultures. Morell writes that "later research" shows "almost universally" that "traditional and nonindustrialized peoples ... allow grains, milk products and often vegetables, fruits and meats to ferment or pickle by a process called lacto-fermentation." Fermentation preserves foods without damaging their nutritional value, and "supplies the intestinal tract with health-promoting lactic acid and

lactic-acid producing bacteria."[131] Morell's cookbook includes a section on fermented vegetables and fruits, from *curtido* ("Latin American Sauerkraut") to papaya chutney. As in Prentice's *Full Moon Feast*, Morell jumps from one nourishing tradition to another, which collectively offer a salve for modern disaffection and disease. Indigenous peoples "the world over" are celebrated for their consumption of animal fats, organ meats, and fermented foods. The cover of *Nourishing Traditions* illustrates a harmonious vision of these global Indigenous foodways: Pacific Islanders, American pioneers, Maasai herdswomen, Arabian camel drivers, and Chinese sages smile from their separate panels in various shades of brown and pink. Drawn in pastel colors, separated by patterned borders, sheep, fish, and other animals are ready to sacrifice themselves to feed this distinct and multiethnic "family of man." Morell herself is photographed smiling knowingly on the back cover, impeccably lipsticked and coiffed, the modern gatherer of this repository of traditional culinary wisdom.

Politically, Morell's cookbook is geared more toward homeschooling libertarians with a nativist bent, and less toward Katz's anarchist experimenters or Prentice's liberals longing for connection. She advocates the union of ancestral wisdom with scientific knowledge in explicitly gendered terms. As she writes, "Technology can be a kind father but only in partnership with his mothering, feminine partner—the nourishing traditions of our ancestors." Morell officiates at the wedding between father science and mother tradition, ushering in a new era of social harmony: "The wise and loving marriage of modern invention with the sustaining, nurturing folk foodways of our ancestors is the partnership that will transform the Twenty-First Century into the Golden Age." The breakdown of this marriage would be catastrophic, turning utopia into dystopia: "divorce hastens the physical degeneration of the human race, cheats mankind [*sic*] of his limitless potential,

destroys his will and condemns him to the role of undercitizen in a totalitarian world order."[132] Here again, folk and Indigenous cultures present a transcendent solution to a fractured social reality—but only if they remain safely bracketed, unmixed, and pure. Morell's call for a "marriage" of traditional wisdom and scientific knowledge is a gendered, heteronormative, colonial version of aesthetic wholeness. Her insistence on the marriage of science and tradition echoes through other contemporary North American food movements—including so-called paleo and primal diets, which cast their anachronistic lines even further back, into the stream of prehistory. All of these movements sift through Indigenous, "ancestral," and nonindustrial foodways in search of holistic well-being and social healing. They rarely acknowledge that this move to Indigenous wholeness takes place on stolen land.[133]

RADICAL HEALING

Sandor Katz's engagement with aesthetic wholeness and Indigenous knowledge is more complex. Like Prentice and Pollan, he proposes vernacular food practices as a remedy for the fragmented and abstracted quality of the colonial-capitalist engagement with daily sustenance. The social division of labor—generalized to a damaging separation between humans, other species, and the land—breeds a longing for connection. As he writes, "The mass disconnection of human beings from the harvesting and cultivation of our own food reflects a broader disconnection from the natural world, our physical environment, the land, wild plants and animals, the cycles of life and death, even our very own bodies. This disconnect is a source of spiritual longing, leaving us searching for reconnection and yearning for meaning."[134] But while the

yearning may be spiritual, Katz's struggle is material and political. *The Revolution Will Not Be Microwaved* discusses commons and enclosures, and engages with Winona LaDuke and the White Earth Land Recovery Project's work to revive the Anishinaabe harvesting of wild rice. Katz is explicit about the need to struggle against the commodification of life, which turns folk modes of sustenance like seed-saving into corporate property. Commodification and colonial-capitalist regimes of property breed abstraction, mystification, and one-sided degradation: "Food in the supermarket is anonymous, detached from its origins, lacking history, nutrient density, and life force. It is food as pure commodity, and we need better food than that."[135] Fermentation is one way to unlock the "life force" in our food. But Katz reminds us that there are other ways, such as acting in solidarity with farmers and migrant workers, and joining in alliances with Indigenous struggles for land.

On the other hand, Katz's position as a compiler of global fermentation traditions gives his cookbooks a certain colonial relation to Indigenous knowledge. This trait is especially notable in *The Art of Fermentation*, which, unlike *Wild Fermentation*, has the ambition to be comprehensive and encyclopedic (its subtitle is "An In-Depth Exploration of Essential Concepts and Processes from Around the World"). Drawing on remarkable archival and field research, and incorporating writing from various practitioners of the contemporary revival movement, *The Art of Fermentation* gathers global modes of daily fermenting practice into a compendium.[136] Katz picks up the fallen flowers of tradition and weaves them into new garlands: he positions both himself and his readers outside specific fermentation traditions, free to combine, invent, and rework them into new forms.[137] This positioning extends to the ritual practices that accompany many traditional ferments. Katz offers a telling description of the brewing of *baälche*, an herbal mead made by the Lacandon people of Chiapas:

Like all traditional fermentation processes, *baälche* production and consumption are practiced with elaborate ritual. The *baälche* makers mark the removal of foam from the active ferment by holding kernels of special sacred symbolic corn in their palms over the *baälche* while moving their hands over it in a clockwise circular motion, and then they similarly bless the utensils and cups used in drinking. Finally, they place the corn kernels with the skimmed-off foam in a plantain leaf with other sacraments, and the *baälche* maker folds the leaf into a package, goes into the forest, and buries it as an offering to the deity of death. Indigenous fermentation practices are thoroughly enmeshed in broader understandings about death, life, and transitions. *Those of us who have no such received tradition have to discover and reinvent those practices and give them meaning as best we can.* In reclaiming fermentation, we can take back more than the mere substance of our food and drink. Through fermentation, we can reconnect ourselves to the broader web of life, in spirit and in essence, as well as the physical plane.[138]

Elsewhere in his writing, Katz roots himself in a particular fermentation lineage—that of Eastern European Jewry, with its brined cucumber pickles and other home ferments.[139] Yet here he seems to ignore this received tradition's daily practice (including repeated blessings over food and drink), implying by omission that his lineage lacks precisely what Indigenous peoples have: a ritual structure that links fermentation to a broader cosmology of life and death. *The Art of Fermentation* invites its readers to dip into that ritual structure, to "discover and reinvent" Indigenous fermentation practices "and give them meaning as best we can." It is hard not to see this spiritual bricolage as a kind of "playing Indian," in

which subjects of settler society, Jews included, search for authenticity or spiritual meaning by taking on the cultural trappings of settler imperialism's dispossessed.[140]

Katz's relationship to Indigenous practices could be connected to the queer community that for many years hosted his fermentation experiments: Short Mountain, a Radical Faerie commune in the hills of Tennessee. The Radical Faerie movement was founded in the late 1970s by gay activist and writer Harry Hay, who drew on the colonial construction of the "berdache" to suggest a link between contemporary (white) gay men and Indigenous two-spirited sexuality. Radical Faeries secured rural spaces as "sanctuaries" where an "indigenous gay nature" could be freed for experimentation.[141] Hay's was one of a number of post-1960s countercultural movements that sought to escape liberal society's demands for self-rule, turning away "from normative Judeo-Christian theologies" and embracing "as antidote, a pan-pagan/indigenous spirituality."[142] Ritual practices like the "heart circle" were loosely adapted from imagined pagan and Indigenous traditions. Radical Faerie culture has been critiqued as "neo-primitivism," a refuge for gay urbanites looking for a temporary escape.[143] But it could more helpfully be understood as a complex operation whereby, as Scott Morgensen writes, "nonnative gay men" find "in rural spaces and in tales of indigeneity a self-acceptance and collective nature that also grants new belonging on settled land."[144] Like other inhabitants of liberal settler colonies, the Radical Faeries are caught in a matrix of discourses of "tradition" and autonomy, which they enact and struggle against in varying ways.

The AIDS epidemic also provides an important background to both Radical Faerie culture and Katz's fermentation practice. Radical Faerie sanctuaries such as Wolf Creek and Short Mountain emerged in the epidemic's early years and exist as permanent memorial sites to Radical Faeries who died of AIDS. The "heart

circle" is a mode of accommodating individual and collective grief, which was blocked by metropolitan heteronormative culture. The move to Indigenous spirituality is tied up with the need for shared spaces of mourning. As Morgensen writes, the sanctuaries "became privileged sites where radical faeries could return to recommit to collective survival and sanctify the memory of lost friends, now imagined as part of the spiritual power of radical faerie lands."[145] Katz's willingness to experiment with Indigenous healing practices is surely grounded in his daily experience with Radical Faeries at Short Mountain, where he lived for nearly two decades, as well as his own experience living with AIDS. His fermentation practice began through a desire to maintain health and vitality without resorting to AZT and other damaging medications. He still credits live-culture foods for maintaining his strength. But after a brush with death, he now takes antiretroviral drugs, and has little patience for purists who fault him for his "fall into pharmaceuticals."[146] He has since left the Short Mountain sanctuary and moved into his own house down the road, complete with a large experimental kitchen. Still, the spirit of the Radical Faerie reimagining of tradition, with all its ambiguities, carries over into his fermentation practice and his writing.

Before moving to Short Mountain, Katz was also an active member of a more explicitly political collective, ACT UP/New York. Based on that experience, he credits collective activism, and not just fermented foods, with healing power. As he notes, "In the AIDS activist group ACT UP that I was part of in the late 1980s, we saw that expressing rage, feeling solidarity, and believing in the possibility of change were all therapeutic cofactors that helped people stay healthy."[147] In a video interview for the ACT UP Oral History Project, Katz (while milking one of Short Mountain's goats) describes the "feeling of incredible devotion" that came from immersing oneself in that activist community. The etho-poetic commitment

that ACT UP encouraged went beyond organized actions, and extended into the life practice or *àskesis* of each individual activist. "I feel each of us sort of became an action waiting to happen, should we stumble upon the right situation," he says.[148] Like the fermentation revival, ACT UP denounced the cult of the expert and promoted the collective redistribution of knowledge. It might seem like a long way from ACT UP's media-savvy actions to raising goats and fermenting radishes on a Tennessee commune, but a similar devotion marks Katz's writing on fermentation and his readiness to experiment and build alliances. Rage, solidarity, and the belief in change still drive his folk practice. Those affects might not show themselves in every crock of kraut. But cumulatively, they offer a path toward radical healing that goes beyond self-care, borrowed spirituality, or even interspecies intimacy—toward an attempt to heal social and ecological wounds through political practice in the world.

POLITICAL FERMENTS

Brine, like tears, like the sea is salt water. Brine, like tears, like the sea, is activated with bubbling, proliferating life by and through the act of its containment. The sea thrives in its vigorous multitudes exactly as it is permitted to rest within and upon the sacred vessel of our home planet earth, as our tears rest within and upon the sacred vessel of our bodies, as this brine within and upon this crock.

—NICKI GREEN, FROM "BLESSING FOR FERMENTATION," WRITTEN FOR QUEER MIKVEH
FOR PRIDE, SAN FRANCISCO, 2017

The move to radical healing through everyday embodied practice can be seen in other "grassroots modernist" movements that

seek to reclaim "tradition" in order to repair bodily, social, and ecological damage. These include the reclaiming of Jewish ritual bathing practices (or *mikveh*) by queer and trans artists and activists, who have traditionally been excluded from such practices. The San Francisco–based Queer Mikveh project and Toronto artist Radiodress experiment with mikveh as a container for bodily and spiritual fermentation, using everyday objects and accessible bathing vessels (from bathtubs to pools and seas) to foster rituals of shared regeneration and transformation.[149] An emphasis on experimental vernacular healing can also be seen in the revival of folk herbalism, which draws on everyday plant "allies," including weeds and so-called invasive species, in its reparative work. For politically oriented herbalists like Dori Midnight, otherwise unwanted plants—mugwort, dandelion, burdock—can help work through colonial histories held in the body, and aid in "healing the land and healing ancestral patterns."[150] Brought over with European colonizers, thriving in the cracks of urban concrete and disturbed industrial landscapes, weeds contain powerful medicine for healing past and ongoing colonial violence. Midnight believes opportunistic weedy plants like mugwort can help address personal and ancestral wounds, especially for "shapeshifters and edgewalkers"—those who are gender nonnormative, sex workers, and activists. Weeds are part of the toolkit of witchcraft—which, as Midnight reminds us, is a practical craft, not a supernatural ability. Plants can be used as needed, along with other everyday magical things: "household objects like spoons and brooms, and cheap objects like rocks and sticks and bowls and pots."[151]

Using whatever is close at hand—bathtubs, household objects, common weeds, the sea—is a key element of what Midnight calls "folk practice." Sandor Katz's watchword is similar: "Use what is abundantly available to you, and be bold in your fermentation experimentation!"[152] As herbal practitioners like to say, "medicine is

everywhere"; you just need to look.[153] Midnight believes that daily work with nearby materials can open up onto political action, and that reviving everyday healing folk practices can have powerful consequences. "There's work for people to do," she says. "Going back into their history, dreaming, or writing, or doing rituals, or eating certain things—daily ways for people to do healing work themselves to free their ancestors, or free the land."[154] None of this poses an imminent threat to capitalist and colonial power structures, or to the ecological devastation that they produce. But such forms of grassroots modernism intimate with weeds, salt water, worms, dirt, human bodies, and other organisms—can ally themselves with broader transformative movements, and lend them a collective healing force.

While the fermentation revival tends to share this perspective, in recent years the politics of fermentation's healing practice have become somewhat "gentrified" or "domesticated," to use Slavoj Žižek's language.[155] Fermentation engages with neighboring beings that are uncannily close at hand, "nearer than breathing, closer than hands and feet": the intimate strangers with whom we share our bodies and our surroundings. But as the fermentation revival has become more mainstream, the inhuman, faceless, or even monstrous dimension of the strange stranger has given way to familiarity. In Katz's own writing over the course of a decade, the balance has shifted subtly from radical and experimental hospitality (*Wild Fermentation*) to deep and comprehensive knowledge (*The Art of Fermentation*). Katz is now, despite his commitment to amateurism, a fermentation expert: he advises chefs such as David Chang of Momofuku on microbial matters, and speaks at food conferences around the world. *The Art of Fermentation* includes "Considerations for Commercial Enterprises," meant to assist those fermentos who have set up their own cottage industries and who hope to establish a niche market for their

products. Berkeley's Cultured Pickle Shop, the most celebrated of these enterprises, avoids industrial homogeneity by producing small-batch ferments in their laboratory-style shop and selling them to local foodies. Their products are exquisite, though it would be a stretch to call them politically subversive. The fermentation revival seems to have ended up gentrifying itself, in addition to acting as a convenient stand-in (or punching bag) for the gentrification of urban neighborhoods. It, too, is subject to what Sarah Schulman, describing the mainstreaming of queer culture in the 1990s, calls "the gentrification of the mind."[156]

Some critics would undoubtedly go further, and argue that even the more radical strands of the fermentation revival are engaged in narcissistic ethico-aesthetic practices that make no universal political demands. Fermenting cabbage in your kitchen is a domestic affair that has no direct impact on the business of capital and the state. This folk practice, if seen as the ultimate horizon, can transpose itself into a "folk politics," an unreflective commitment to the immediate, the local, and the small-scale.[157] In the mid-1990s, Murray Bookchin critiqued a certain "lifestyle anarchism," which pursues individual autonomy through lifestyle adjustments rather than collective freedom through broad-based social movements.[158] Through a class analysis, the fermentos' politics of the everyday could be seen as basically petit-bourgeois. As Bourdieu writes somewhat dismissively, "the new petite bourgeoisie is predisposed to play a vanguard role in the struggles over everything concerned with the art of living, in particular, domestic life and consumption," areas removed from the spaces where politics is conventionally understood to take place.[159] Bourdieu is correct, in a sense. Even if a home fermentation practice is not strictly "consumption," it is concerned with the art of living. And even wild fermentation, if not quite domesticated, is certainly domestic.

However, political critiques of "the domestic" and "domestication" are all too easy, and have strong patriarchal overtones. As many feminist writers and activists have demonstrated, what goes on in private or domestic space is hardly outside the sphere of the political. The domestic is a site of social reproduction, commodification, power relations, and resistance. It is a place where strength is gathered, or where it is lost. Home fermentation is indeed a domestic practice, one that takes place in the home and that is oriented toward the body—even as it extends beyond both of these sites toward wider human and extrahuman collectives. Historically pursued by women, domestic practices of fermentation have been ripe for feminist reclamation, as in Lauren Fournier's *Fermenting Feminism* zine and associated exhibitions.[160] In the form of an ascetics of self-care, fermentation appears to have the same inward-looking tendencies as the Stoic practices theorized by Foucault. But in its embodied experimentation, the fermentation revival is oriented outward, shrugging off the pursuit of individualized self-mastery. As part of fermentation's entangled practice, cultures (from sourdough starters to kombucha mothers) are shared, recipes are translated, and fermented food and drink become the occasion for collective celebration. Little of this activity may take place in conventionally public settings. But feminist and queer theory and practice have long maintained that what happens in domestic or protected spaces—including the various studios, parties, concert venues, and kitchens that I discuss in this book—should not be dismissed as irrelevant to wider political concerns. These contained spaces are sites of embodied collective practice, where techniques and affects can be cultivated and harnessed like so many wild yeasts, microcultures that can then spread out and begin to work on the damaged substrate of the everyday.

The domestic is also a site for expanding the collective beyond the human, a place where species meet. As Donna Haraway

describes it, domestication is not a simple affair but a complex interspecies process of *sympoiesis*, or coevolution and cocreation. "Domestication," she writes, "is an emergent process of cohabiting," a set of opportunistic prehensions between beings in a process that carries historical traces.[161] Even the most domestic of species like the yeast *S. cerevisiae*, perhaps the first species domesticated by humans, is an uncanny neighbor—as are Haraway's dogs, or Katz's goats and *lactobacilli*. Such bearers of "significant otherness" should not be barred from the realm of the political, pushed across the gulf that separates humans from nonpolitical animals or speech from noise.[162] As we move through the Anthropocene together—or rather, through the entangled and damaged epoch that Haraway calls the Chthulucene—we need to build larger experimental collectives that include these neighbors and other strange strangers in "matters of concern."[163] Ultimately, we all share the same home, the same *domus*. What we need is to figure out a way to live in that place together. Fermentation puts this interdependence into practice, experimenting with traditions of multispecies co-becoming that foster shared habits of curiosity, resilience, and hospitality.

Why not begin, as folk practice does, with the domestic—with nearby materials, people, and other organisms—not as an end point, but as a way to work with what resources are there? What matters is that small-scale resistance opens onto common horizons—that intimate practices can be bonded by the "hegemonic glue" of broad-based ethical demands for justice and equality.[164] Perhaps these broad-based demands can gather their formulators into a fighting force, "compact and self-aware" (if not particularly "homogeneous").[165] Again, ACT UP provides a powerful example of this kind of structure. In its heyday, it gathered affinity groups across social boundaries into a focused movement that allowed for anger and joy, intimacy and publicity, a way of living and a way

of fighting back. Such movements puncture fantasies of auton-
omy and self-mastery. They take us out of predefined social roles
and into new forms of shared dependence and collective political
life. And they begin not by separating themselves from the domes-
tic, but by opening it up toward common concerns.

Certain contemporary political theorists argue that politics
has no ontological foundation, that it is instead an interruption
in the order of being.[166] Even less, presumably, would politics
have a biological foundation, as eugenicists and Social Darwinists
(along with other racial supremacists) have claimed. Nonetheless,
the biological fermentation encouraged by microorganisms has
proved an irresistible metaphor for the political ferment that can
spread among humans. Fermentation, in food and politics, is the
slow and patient practice that prepares the ground for more dra-
matic action. Peter Schumann of the Bread and Puppet Theater
used this metaphor in his illustrated broadsheet for the Radical
Cheese Festival, which both Katz and I attended in 2001. In the
broadsheet, Schumann connects his own daily practice of sour-
dough bread-baking to insurrectionary activity. He writes: "The
call for fermentation is prior to the call for uprising because up-
rising needs all the wild yeasts of the moment to be what it is." For
Schumann, the substrate—people or grains—must first be "cor-
rupted" by what he calls "the ecstasy of nature." We need some
kind of outside starter, some ec-static sourdough to break down
our propriety, complacency, and resignation. "Only by the spread
of such corruptions caused by fermentation can uprisings occur,"
Schumann writes.[167] Even given the perfect conditions, people
(and loaves of bread) will rise up only if fermentation has first
done its corrupting work.[168]

Transformations don't just happen miraculously. Fermentation
is a slow process, one that requires patience and persistence. Its
work is often invisible: only a quiet bubbling reveals the complex

degradations that are taking place beneath the surface. In *Wild Fermentation*, Katz contrasts the gentle, slow, and steady change of fermentation with the rapid transformations of fire, which burns quickly and bright. "In the realm of social change," Katz writes,

> fire is the revolutionary moment of upheaval: romantic and longed for, or dreaded and guarded against, depending on your perspective. Fire spreads, destroying whatever lies in its path, and its path is unpredictable. Fermentation is not so dramatic. It bubbles rather than burns, and its transformative mode is gentle and slow. Steady, too. Fermentation is a force that cannot be stopped. It recycles life, renews hope, and goes on and on.[169]

In times of rapid change, it is easy to be transfixed by the fire and miss the slow ferment that precedes it. Sparks now fly around the globe at terrific speed. A vegetable seller sets himself on fire in Tunis, and revolt breaks out across the eastern Mediterranean. What fermenting work—slow, patient, and nearly invisible—allowed those epochal flames to spread so quickly? Given the chaos, suffering, and repression that followed, might gentle but persistent fermentation have proven more transformative and durable than the ravages of fire? These questions may be answered decades from now, if ever. In the meantime, we resume our steady and urgent work, playing between life and death, practicing with what is close at hand, and creating the conditions for that bubbling activity to rise again.

CONCLUSION

PROJECTS
OF UNDOING

In 2011, as I was gathering material for this book, groups of humans began again to reclaim traditions of collective uprising, assembling "bodies in alliance" into local configurations of widespread significance.[1] In multiple places across the globe, confronting varying forms of capital and the state, and with divergent revolutionary, reformist, or reluctant demands, groups experimented with projects of shared survival and political reinvention. Many of these movements engaged in various forms of "folk practice," like the clanging casseroles of *indignados* and student protesters, which reprised the "rough music" of the European medieval *charivari*.[2] Others of the same moment, including Idle No More, drew on Indigenous histories of dispossession, struggle, and continuance. Their participants worked opportunistically in vernacular fashion with whatever was at hand—pots and pans, laptop computers, food, tents, drums, cardboard signs, camera phones, voices—"assembling together everything and everyone needed for an event."[3] Some of these movements were marked by a limited strategic imagination; many were met with severe repression; few have resulted in durable political gains. But their reverberations continue to echo through the contemporary political landscape, even in a moment of reactionary and media-driven authoritarianism. Indeed, their work has transformed the sense of what is politically possible, opening up new practical horizons for collective thought and action. Like the divergent experiments and collectives that I have discussed in the preceding chapters, they were projects that fostered otherwise ways of thinking, imagining, and resisting in a damaged world.

The word "project" is one that I have used deliberately throughout this book to describe certain collective experiments in reclamation and repair. In so doing, I draw on the meanings the term has accrued in artistic and political discourse over the preceding decades. In the field of art, in parallel with "practice,"

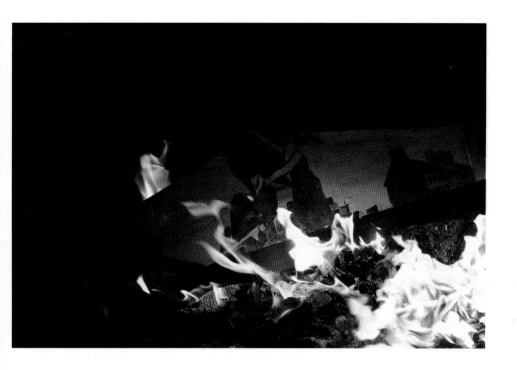

FIGURE 5.1

Burning the archive of Le Petit
Théâtre de l'Absolu (2012), photo
by Antoine Peuchmaurd

the artistic "project" has come to convey a shift from a singular work to an extended process (one that often occurs outside the studio). As the editors of *The Art of the Project* write, the term has come to describe a range of aesthetic activities that move outward from art to life, orient themselves toward the collective, embrace amateur and vernacular forms of knowledge, and pursue "a spirit of open-ended enquiry articulated in formal and existential experimentalism."[4] With their orientation toward the experimental, the vernacular, and the collective, many examples of "the art of the project" parallel the aesthetic projects that I have analyzed in this book. They also share this orientation with a number of recent political movements and projects, including the diverse "movements of the squares."

The term "project"—whether used in the field of art, in politics, or in everyday life—also has a complex semantic relationship to time. A project, as the editors of *The Art of the Project* observe, "may designate something envisaged, something ongoing, or something completed." The word's etymology suggests a prospective, forward-looking anticipation: a "temporal *pro-jection* into an as yet unrealised and open future."[5] This anticipatory and futural orientation suffuses a project's present and past temporalities, too. Used in the present tense, a "project" extends over time toward a definite or indefinite horizon. Even when describing a completed undertaking, the word retains traces of vanished anticipation and processual duration. (Indeed, many artistic projects resist any sense of completion, presenting themselves as still in progress or temporarily suspended.) A "project," like the grammatical present participle, suggests an activity that is open, repetitive, reflexive, ongoing, immediate, and unfinished.[6] More than this: a "project" also carries a certain confidence about the future, implying that an imagined activity will eventually be accomplished, that a dream will be brought to fruition.

The art historian Claire Bishop has remarked that the rise of the term "project" in artistic discourse can be linked to the post-1989 era, following the end of the cold war. As she writes:

> A project in the sense that I am identifying as crucial to art after 1989 aspires to replace the work of art as a finite object with an open-ended, post-studio, research-based, social process, extending over time and mutable in form. Since the 1990s, the project has become an umbrella term for many types of art: collective practice, self-organised activist groups, transdisciplinary research, participatory and socially engaged art, and experimental curating. ... My key point, however, is less to define a new tendency than to note that the word chosen to describe these open-ended artistic activities arrives at a moment when there is a conspicuous lack of what we could call a *social* project—a collective political horizon or goal.[7]

As Bishop observes, the prevalence of "the project" in art emerged out of the disintegration of large-scale twentieth-century social projects. Although she rejects any simplistic relation between artistic and political projects, Bishop suggests that the surge of "project art" after 1989 has been symptomatic of the absence of any "collective political horizon or goal." Certainly "the art of the project" has a longer pedigree: as a "procedural as opposed to substantial approach to art," it is traceable back at least as far as Duchamp.[8] But as a resurgent concept and term of self-designation, the artistic project is contemporaneous with the failure of the twentieth-century communist project—its petrification in repressive, authoritarian, imperial, ecologically ruinous, and genocidal state forms, and its eventual collapse. That catastrophe tarred the language of universal emancipation, and shattered faith in

large-scale social projects. Reckoning with that damaged history remains essential to the future of any collective project that hopes to divert capitalism's exploitative and destructive drive.

Without a universal "collective political horizon" to guide them, the projects that I have examined orient themselves by their own lights, or by the sparks thrown by the activist movements with which they are allied. While these experiments are not, strictly speaking, political projects, their creative translations of tradition have intriguing correspondences with contemporary political movements on the left. Experimenting with tradition has been necessary for a political left, oriented toward social equality and collective emancipation, that is only now emerging from a long process of working through its own damaged history. And new figures on the horizon are necessary to guide a left that, following the "surpassing disasters" of state communism, seemed for some time to have lost its bearings entirely.[9] I want to address the conformist dangers that threaten the experiments with tradition I have analyzed in the preceding chapters—dangers that are similar to those courted by contemporary grassroots activist movements. But first, it is worth taking a closer look at the cloudy and sometimes melancholy landscape in which traditions of left politics must find their way. These traditions of emancipation have experienced a kind of "sickening" of their own, leaving them in a weakened state. Launching a collective aesthetic or political project requires projecting an idea, with confidence, into an open future. This collective ability is what Hannah Arendt calls "the promise of politics": "the spirit of starting an enterprise and, together with others, seeing it through to its conclusion."[10] Yet for some decades, that ability, promise, and spirit seemed to be lacking on the political left, which some critics have portrayed as sunk in a brooding melancholy.

This melancholy is more than just an atmosphere or mood: political theorists have not hesitated to use the psychoanalytic

language of *melancholia* to describe the left's disarray following the catastrophes of the twentieth-century communist project. In 1999, Wendy Brown's "Resisting Left Melancholy" drew on Freud and Benjamin to critique certain Marxist thinkers who clung to antiquated political forms and concepts in the face of epochal change. This old guard, she argued, refused to abandon the well-worn language of communist revolution, often viewing "identity politics" and poststructuralist theory as dangerous enemies. Brown castigated "a Left that has become more attached to its impossibility than to its potential fruitfulness, a Left that is most at home dwelling not in hopefulness but in its own marginality and failure, a Left that is thus caught in a structure of melancholic attachment to a certain strain of its own dead past, whose spirit is ghostly, whose structure of desire is backward looking and punishing."[11] Brown argued that this left needed to let go of melancholy attachments to failed revolutionary theories and projects. It had to turn its gaze away from the past, and abandon its self-punishment, so that new ideas and movements could emerge.

Jodi Dean's "Communist Desire"—a critique of Brown's argument published well over a decade later, in 2013—shifted the diagnosis of melancholy to the postcommunist, activist left. In Dean's view, the melancholics were not the die-hard Marxists, but rather those who had turned away from "the communist horizon" and contented themselves with micro-projects and specific issues and campaigns. Using the psychoanalytic language of Jacques Lacan, she claimed that this activist left had given up on its "communist desire," instead preferring to wallow in melancholic impotence. In her view, "such a left enjoyment comes from its withdrawal from power and responsibility, its sublimation of goals and responsibilities into the branching, fragmented practices of micro-politics, self-care, and issue awareness." It

finds melancholy pleasure in its very lack of a collective project: "Perpetually slighted, harmed, and undone, this left remains stuck in repetition, unable to break out of the circuits of drive in which it is caught, unable because it enjoys."[12] For Dean, the revival of the language of communism in the mid-2000s, at least in academic discourse, was a healthy sign that "the period of guilt is over."[13] The resurgence of communism as an intellectual watchword, especially when set alongside the reemergence of large-scale political action after the 2008 economic crisis, suggested to her that post-communist melancholy was giving way to a new collective political desire oriented to the future.

Who are the melancholics of the sickened left tradition—Brown's old revolutionaries clutching their faded dreams, or Dean's self-absorbed micropolitical activists with no grand social project? Perhaps we can clarify these conflicting diagnoses of political melancholia by drawing an image from a text that directly inspired them both. In "Left-Wing Melancholy," published in 1931, Walter Benjamin used the image of a plundered department store—with bare shelves and no goods for sale—to illustrate the melancholy that had overtaken the "intellectual elite" of his day. The humanist gestures and feelings of that class, Benjamin wrote, "have long since been remaindered. What is left is the empty spaces where, in dusty heart-shaped velvet trays, the feelings—nature and love, enthusiasm and humanity—once rested. Now the hollow forms are absentmindedly caressed."[14] In Europe between the wars, Benjamin saw humanist intellectuals lingering over the empty trays where their cherished liberal values were once displayed. But even worse than their melancholic caressing, in Benjamin's view, was a "know-all irony" that rejoiced in those empty display cases. This irony took failure for success: it "makes a great display of its poverty and turns the yawning emptiness into a celebration." This was Benjamin's

critique of the so-called New Objectivity of his day: it offered the melancholy remnants of political affects—the "traces of former spiritual goods"—as objects for sale on the market, demonstrating a comfortable nihilism that was utterly disconnected from ongoing social struggles.[15]

It is tempting to translate Benjamin's figure of the empty display case of political feelings into the postcommunist era. For the feelings of "nature and love, enthusiasm and humanity," we can substitute revolution, communism, and universal emancipation. In this reading, we can see two kinds of "left wing melancholy" operating in the West since 1989. For many years, the Marxist old guard longingly caressed the empty forms of political struggle, unable to let go of its attachments to a vanished revolutionary project and the feelings that it carried. Meanwhile, a new guard turned that emptiness into a celebration, embracing the shopworn fragments of postmodern culture with a "know-all irony."

With this in mind, Dean's critique of the activist left and its issue-driven micropolitics has a certain justice. Although this left does not operate through irony, its ambivalence toward taking power turns emptiness—the lack of an explicit revolutionary project oriented toward the state—into a kind of celebration. But is it better to claim, as Dean does, that those old revolutionary feelings and values are still present, and that shopworn political forms such as the vanguard party can simply be revived? Should we join her in seeing the empty display cases in communism's department store as once again bursting with goods? As with other "sickened" traditions, the complex and embattled traditions of left politics cannot simply be revived in a zombie-like state. Dean's argument falls prey not so much to left-wing melancholy as to left-wing mania. Rather than caress the empty velvet trays of communist feelings (or ironically celebrate their emptiness), it loudly denies the very fact that they are empty. It refuses to admit that what some intellectuals have called

"the Idea of Communism"—as a prescriptive revolutionary project, if not as a collective *practice*—has long since been remaindered.[16]

The oscillation between left-wing melancholy and mania among what Benjamin called the "left-radical intelligentsia" has been expressed in a variety of texts since the 2008 economic crisis. T. J. Clark's "For a Left with No Future" turns its gaze squarely and melancholically toward a bloody history which cannot be superseded, urging the left to abandon the "modern infantilisation of politics" that comes from "a constant orientation to the future."[17] By contrast, Williams and Srnicek's "#ACCELERATE MANIFESTO for an Accelerationist Politics," the precursor to their 2015 book *Inventing the Future*, argues that the future is precisely what "needs to be constructed." Instead of abandoning a broken future to the ravages of neoliberalism and ecological devastation, the manifesto insists that we need to marshal existing capitalist technologies and forms of knowledge, in order to move "towards a time of collective self-mastery, and the properly alien future that entails and enables."[18] In a similarly future-oriented vein, the collectively written "Xenofeminist Manifesto" (first published in 2014) calls for bodies to find shared techniques and technologies for modifying capitalist, white-supremacist, and hetero-patriarchal forms of "nature," "affirming a future untethered to the repetitions of the present."[19] Despite their conflicting prescriptions, each of these somewhat melancholic and manic texts has something useful to offer. It remains necessary, as Benjamin wrote, to break the spell of the future—to "strip the future of its magic"—and to face the catastrophes and lost promise of the past.[20] Yet it is also crucial to break the spell of the past, which can suck present desires and actions into a compulsive repetition of used-up ideas and forms. A resurgent left must break both of these spells—allowing the present to emerge as a field of possibility, a *Spielraum* or play space for experimenting with future collective projects out of the wreckage of the past.

It would be all too easy to dismiss these various and contradictory texts as yet more writings by left academics with tenuous if any connections to broader social movements. As Benjamin wrote of the left-radical intelligentsia of his day, "Their function is to give rise, politically speaking, not to parties but to cliques; literarily speaking, not to schools but to fashions; economically speaking, not to producers but to agents."[21] Yet one could more charitably see these alternately melancholic and manic texts, with their opposing diagnoses and courses of treatment, as contradictory attempts to work through powerful attachments to a left tradition that has sickened, if not died, following the surpassing disasters of the preceding century. What is to be done when confronted with "a sickening of tradition"? How can traditions of collective political practice be retranslated across gulfs of discontinuity, following their withdrawal after a surpassing disaster? As Benjamin reminds us in his essay on translation, the important thing to salvage is not tradition's "truth" but its "transmissibility," not its definite content but its "way of meaning."[22] Moreover, as I have argued, collective practices can only move across the "discontinuum of tradition" through the fraught process of their translation. Traditions of emancipatory and egalitarian politics are no exception. Despite their opposing prescriptions, all of these authors would agree that if left traditions are to find new life in thought and action, there is an urgent need for them to be retranslated into new, experimental forms.

If we take the psychoanalytic model of mourning and melancholia seriously, the virulence and ambivalence of these various texts should not be surprising. Over the past decades, the political left has been engaged in a kind of mourning work—a slow detaching from the lost object, which in this case could be described as "the classical figure of the politics of emancipation."[23] Freud, in "Mourning and Melancholia," describes mourning as a gradual

and painful process of "dissolution" (*Auflösung*), or a loosening or undoing of bonds. As he writes: "To each individual memory and situation of expectation that shows the libido to be connected to the lost object, reality delivers its verdict that the object no longer exists, and the ego, presented with the question, so to speak, of whether it wishes to share this fate, is persuaded by the sum of narcissistic satisfactions that it derives from being alive to loosen its bonds with the object that has been destroyed."[24] In the face of the loss of a loved person or deeply cherished ideal, a sense of reality and the pleasure of living intervene to save the ego from destruction. But it is first necessary to accept that the loved object will not return. From this perspective, the bonds to what has been destroyed can be loosened, one by one.

Freud represents the work of mourning as a conscious project: a kind of "reality-testing" on the part of the ego, whose narcissistic satisfactions persuade it to let go of the lost object. But as the psychoanalyst and theorist Jean Laplanche argues, in a close reading of "Mourning and Melancholia," mourning is as much an unconscious as a conscious process. Laplanche draws a parallel between Freud's *Lösung*, or the "detachment" of affective bonds, and the Greek *analuein*, "to undo" or "unweave" (from which we get "analysis"). Somewhat counterintuitively, Laplanche reads the tale of Penelope—weaving and unweaving her "resplendent fabric" while waiting for the return of Ulysses—as a story of mourning work. He emphasizes her work's careful, repetitive, embodied, and unconscious qualities: "Penelope does not cut the threads, as in the Freudian theory of mourning; she patiently unpicks them, to be able to compose them again in a different way. Moreover, this work is nocturnal, far from the conscious lucidity with which, Freud claims, the threads are broken one by one." Laplanche sees a parallel, which Freud misses, between Penelope's "unweaving" (*analuein*) and the practice of psychoanalysis. Both are projects of undoing, requiring

embodied forms of repetition: "unweaving so that a new fabric can be woven, disentangling to allow the formation of new knots."[25]

With this image in mind, rather than viewing the postcommunist left as pathologically melancholic, we might more helpfully see it as having been preoccupied with the "unweaving" that is characteristic of mourning. As Laplanche reminds us, the undoing of bonds with the object that has been destroyed is a "nocturnal" process, involving both conscious and unconscious work. It does not mean cutting one's ties with the shattered past, but unweaving those threads and then learning how to weave them into a new fabric. For various thinkers and activists on the political left, this loosening or disentangling of bonds has come with all sorts of ambivalences, false starts, and awkward misfires. It has meant confronting the tangled past, with all its disappointments, horrors, and lost promise. But it has also been a "disentangling to allow the formation of new knots"—a slow opening to hope, to anticipation, and to the emergence of new projects in the world.

The fruits of this patient work can now be seen in the reemergence of coalitional movements in diverse contexts, which have continued since the uprisings of 2011–2012. These include the reappearance of avowedly socialist politics in the Anglosphere, where, for many decades, the word "socialism" could be publicly uttered only as a slur.[26] The Indigenous resurgence of Idle No More, the vital activism of Black Lives Matter: these are not reducible to "left" movements in the sense described above, but they have also emerged out of periods of mourning and rebuilding, following the violent state repression of the Black Power and Red Power movements in the 1970s.[27] These renewed movements, crucially, draw links between racial, patriarchal, and colonial structures of domination and the ravages of neoliberal capitalism. They are rooted in the everyday experiences of dispossession, debt, eviction, racism,

and deportation, but also in embodied collective practices of organizing and struggle, from anti-pipeline protest camps led by Indigenous peoples, to youth-led movements for climate justice, to invigorated political campaigns at the neighborhood level. Faced with ongoing economic exploitation, widening inequality, accelerating planetary damage, the persistence of racist institutions, and a resurgence of neofascism and authoritarianism, people are working across generational, colonial, and class divides to build egalitarian and ecological alternatives and to reverse the capture of the state. As they confront powerful forces with persistent collective practice, they manifest little of the ambivalence that has characterized the left since 1989. While some of this transformation may be due to generational change, the preceding decades of unweaving and reweaving have surely played a role in these experimental retranslations of emancipatory political traditions.

The projects that I have examined in the preceding chapters engage in a similar unweaving of the discontinuous fabric of tradition, a disentangling and formation of new knots. As experiments in collective embodied practice, they are "radical prototypes," "figures on a horizon of possibilities."[28] Each of them offers a distinct configuration of class, sexuality, religion, and race. Notably, the projects are split along settler-colonial lines, with vastly different stakes for settler and Indigenous reclamations of "tradition." Compared to the political traditions I have been discussing, they work with a more modest loom. Rather than sweeping theories or broad social movements, they propose specific experiments with lineages of vernacular embodied practice. Yet they, too, can be understood as "projects of undoing," both in their relation to a tangled past and in their political orientation in the present. Each of these projects unweaves and weaves in its own fashion, and with its own goals. The Purim Ball weaves a new glittery garment out of Jewish vernaculars that have been abandoned and destroyed; in the process, it

attempts to undo (or profane) the ritual separations that make that tradition vulnerable to xenophobic appropriations. A Tribe Called Red takes the intergenerational lines that have been cut by colonial genocide and the suppression of Indigenous culture and plugs them into an electric circuit; the very term "decolonizing," which could describe their music, videos, and live performances, implies an undoing and reweaving of historical bonds. And the fermentation revival's emphasis on degradation and regeneration—along with the encounters it stages between humans and other strange strangers—offers a project of undoing at the level of life and death. As a site for this undoing and reweaving, each of these projects proposes a *Spielraum*, a play space—a studio, a warehouse, a dance club, a kitchen, or a fermentation vessel. At times, in these fragile and protected spaces, mourning can give way to practical experimentation and play. Bonds can be undone and then reformed; matted threads can be disentangled, then woven anew.

In this book, I have tracked this process of undoing and reweaving in several translations of intergenerational collective practice, or "tradition." Translating tradition is a fraught process: it necessarily involves betrayal, and risks various forms of complacency and conformism. Benjamin, in his theses "On the Concept of History," stresses that tradition is always vulnerable to the danger of becoming "a tool of the ruling classes." "In every era," he reminds us, "the attempt must be made anew to wrest tradition away from the conformism that is about to overpower it."[29] This injunction to wrest tradition away from the pressing dangers of conformism—or at least to make the *attempt*, to essay, to experiment—is never satisfied; it returns in every era, at every moment. Indeed, this danger threatens each of the projects that I have examined. In each one,

the process of undoing is partial and incomplete: the urge to experiment can give way to complacency or self-satisfaction. Each of these collective projects courts a different kind of conformism, and each succumbs to this danger on occasion.

In the case of the Purim Ball, the danger is similar to the one that Dean diagnoses in the activist left (with which the Purim project is closely linked): the danger of getting overly comfortable with its own political righteousness. As a space for "queer political desire" and for experimenting with and beyond Jewish traditions, the Purim party is exemplary and fruitful. Yet its links to specific, issue-driven campaigns lend it an educational quality that no amount of carnivalization can disguise. At times, the tension between profane celebration and activist politics is deliberately foregrounded and made comic; at other times it is more uneasy. The Purimshpil tries to hold together ribald jokes and activist campaign work, but when conflict arises, righteousness tends to win the day. More painfully, the Aftselakhis Spectacle Committee sometimes feels forced to take political positions that could damage its own goals. This was the case in March 2014, when the collective cancelled the performance of Shelley Nicole's blaKbüshe shortly before the party, based on that group's upcoming planned appearance at the Michigan Womyn's Music Festival—the object of a long-running boycott due to its rejection of trans women. As the collective notes, this "difficult and painful" decision was the product of much introspection and internal debate.[30] Yet both the now-defunct Michigan festival's anti-trans policy, and the collective's decision to exclude the Black R&B band point to the danger that threatens the activist left in an age of resurgent right-wing populism: a conformism and self-policing that leads to endless internecine struggles. Meanwhile, the real enemy, as Benjamin observes, "has never ceased to be victorious."[31]

A Tribe Called Red's politics are more affective than explicit, allowing their sonic translations of Indigenous resurgence to be transmitted into a variety of settings. The conformism that they face is inherent to the commercial system of popular music in which they operate. Here, the pressures are obvious and inescapable: professional touring musicians need to market themselves, standardize their recordings and live sets, endure endless weeks on the road, and find sources of revenue in the lean digital age. None of this is exceptional, but it might account for the somewhat more formulaic quality of ATCR's music and videos following their first self-titled album, as well as the fact that Bear Witness is (as of this writing) the only remaining original member still in the collective. The group's intense sonic and visual discrepancies have been dialed down, with more emphasis given to positive portrayals of Indigenous identity in both videos and live performances, and less to the manipulation of stereotypes. Perhaps the pressure of being Indigenous "ambassadors" has contributed to this relative smoothing-out of their creative activity. At the same time, the political movement to which they lent their voice has had most of its visible successes in the educational and cultural spheres, as state-supported resource extraction pushes ahead in the face of Indigenous resistance. The group continues to work hard, touring and creating new music, and its professional future is bright—even as collective members come and go. Their 2016 album *We Are the Halluci Nation* goes further into the field of blurring popular genres, with notable collaborations from guest artists including Tanya Tagaq, Lido Pimienta, and Yasiin Bey. It is an exciting and eclectic testament to radical Indigenous experimentalism, and has won many accolades.[32] But that moment in December 2012, when "The Road" gave powerful sonic shape to political feelings and actions, has now passed into memory, and must be relayed and retranslated if it is to live again.

I have discussed at length the dangers courted by the fermentation revival, which are again similar to the ones that Dean identifies: its tendency toward self-care, toward becoming another "practice of the self" that lacks an engagement with broader social movements, and its political ambivalence. For some practitioners, fermenting is one among many grassroots practices of healing and regeneration, offering resources for souls that have been crushed or defeated. It frames everyday embodied life as a site of struggle—a political perspective that should not be dismissed. And its invitation to an encounter with nonhuman "strange strangers" could push it toward becoming a radical practice for the Anthropocene's damaged epoch. But the mainstreaming of fermentation as a health-conscious culinary trend, along with its championing by libertarian traditionalists as part of a restoration of "natural" lifeways, reveals the ambiguities of a politics of everyday vernacular practice. A truly "wild" fermentation needs to open onto a wider and deeper political engagement if it is to live up to the metaphorical promise that Sandor Katz, among other practitioners, identifies. Katz's own writing demonstrates a move from youthful revolutionary enthusiasm to a more tempered, adult perspective: from the proselytizer of *Wild Fermentation* to the researcher of *The Art of Fermentation*. The latter compendium also steps back from explicit political commitments, including the alliance with Indigenous struggles, in favor of a collector's synoptic eye. This might be a helpful shedding of illusions: fermenting vegetables is not going to bring structural political change. But without that radical vision, the fizz of fermentation is bound to evaporate in a series of lifestyle adjustments, unable to put its corrupting energies to work on the substrate of society.

In each of these projects, a danger is that the fissure in what has been handed down from the past will not be preserved—that the discontinuum of tradition will be smoothed out, and that the

discrepant qualities of past collective practices will be lost. Another danger is that the projects of undoing that they initiate will remain constrained. Their translations of tradition run the risk of not going far enough, of remaining caught within their own protected boundaries. Translation, as Judith Butler describes it, is an opening to the "alterity at the core of transmission": it moves outward across incommensurable gulfs. In the ideal case, Butler writes, "the chasm of translation becomes the condition of contact with what is outside me, the vehicle for an ec-static relationality, and the scene where one language meets another and something new happens."[33] This is what Laplanche calls the "anti-autocentric movement of translation," a movement which displaces the subject from its own centrality.[34] The danger, as Laplanche sees it, is that displacements and discrepancies might revert to a more comfortable, self- or group-oriented stability. This is a danger that threatens both psychoanalysis and left politics, as well as the translations of collective vernacular practice that I have worked through in the preceding chapters.

Against complacency, conformism, and self-oriented recentering, we might counterpose what Benjamin called "the destructive character." Sometimes translations need to activate a more radical undoing; sometimes the tangled threads of tradition must be deliberately ripped if they are to be woven anew. Experiments with tradition need to be destructive as well as creative, if they are to do more than preserve the historical treasures that weigh us down. "The destructive character stands in the front line of traditionalists," Benjamin writes. "Some people pass things down to posterity, by making them untouchable and thus conserving them; others pass on situations, by making them practicable and thus liquidating them. The latter are called the destructive."[35] Without a dose of this destruction, traditions cannot become situations that are "practicable," open to practice and available for use. This process

of "liquidation," despite its apparent violence, can be quite play-ful. Indeed, as Winnicott and other psychoanalytic theorists have noted, play often involves an attempt to destroy the object as a way of experimenting with one's capabilities.[36] If mourning is a slow and nocturnal process of unweaving, sometimes it is necessary to playfully tear the threads, to clear a path, to make new space. In Benjamin's words:

> The destructive character sees nothing permanent. But for this very reason he sees ways everywhere. Where others en-counter walls or mountains, there, too, he sees a way. But because he sees a way everywhere, he has to clear things from it everywhere. Not always by brute force; sometimes by the most refined. Because he sees ways everywhere, he always stands at a crossroads. No moment can know what the next will bring. What exists he reduces to rubble—not for the sake of the rubble, but for that of the way leading through it.[37]

The damage of the world continues to pile up, the rubble forming a devastated scene of our collective making. But if a way can be cleared, then the crossroads can reveal itself as a space of experi-ment and play. Sometimes a radical undoing is necessary for sit-uations to be made practicable, and for new collective projects to be formed.

Montreal, a night in April 2012—the spring of student strikes. Four of us have gathered in *le champ des possibles*, the field of possibil-ities, a stretch of waste ground tucked between train tracks, in-dustrial buildings, and the wall of a convent. There's a bottle of

whiskey and a pile of homemade boxes overflowing with painted cardboard sets and figures. This is what's left of Le Petit Théâtre de l'Absolu, the puppet theater company we formed back in the spring of 2001. We build a little mound of paper and sticks, and I strike a match. It doesn't take long for the pile to light; puppetry is an eminently burnable medium. Hoping to avoid a visit from the cops, we try to keep the blaze small. Paint makes the flames glow blue and green at the edges, and a cloud of solvents adds another layer to our intoxication. We burn the characters from our first toy theater show, the one about the Paris Commune. Arthur Rimbaud's young face looks at us dreamily from the flames. A marching crowd of workers, a crumpled sheet of newspaper that for a moment was filled with the wind of history—*au feu*! Generals, guillotines, soldiers, situationists—*au feu*! The proscenium stage itself catches fire. Back to where we started, *in girum imus nocte et consumimur igni*, we go round in the night and are consumed by flames. It's a miniature conflagration with no one to impress but ourselves. We take photos for the archive and sing halting versions of songs from the time of the Commune. Words come back to me slowly, verse by verse. The wind blows smoke and ash in our eyes.

As John Giorno says, "you got to burn to shine." What do you do after the carnival with all the leftover crap? Letting it rot in landfill seems sad—better to bring gifts to be destroyed. Something is released, transmigrated, set free. All that stuff, clogging up our minds and studios and hearts. There's no need to hoard, preserve, museify. We are not going to do these shows again. We each save a little sheaf of papers, a few cardboard figures and battered hand puppets—survivors, *rescapés*. Otherwise, let the past become smoke. Years of work, friendship, love, rivalry, sadness, and camaraderie: old shared stories that need to give way to new ones. We burn it all, down to the last cardboard flat. So many ashes and sparks, gusting about in the high spring wind.

There's no water around to douse the remains, so Benoît relieves himself in the cinders with a satisfying hiss. I make a joke about Gaston Bachelard—"*L'homme, l'eau et le feu.*" We are in elemental territory, a little buzzed, lost in darkness on a patch of ground not yet claimed by condo developers or landscape architects. *Le champ des possibles*, an open space. The field has been cleared. Let's see what happens next.

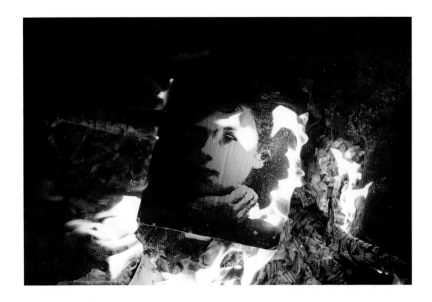

ACKNOWLEDGMENTS

As a book about collective projects and practices, *Art and Tradition in a Time of Uprisings* necessarily owes its existence to many collectives, friends, interlocutors, mentors, and collaborators.

Thank you to the musicians, performance-makers, and artists whom I've had the good fortune to work with and alongside over the years, even in all sorts of trouble—including but not limited to the members of Black Ox Orkestar, Le Petit Théâtre de l'Absolu, Sackville, kith&kin, Constellation Records, the Bread and Puppet Theater, Great Small Works, Clare Dolan and the Museum of Everyday Life, Sean Frey, Michelangelo Iaffaldano, my brother Jesse Levine, Eric Chenaux, Sandro Perri, Sam Shalabi, and Annie Katsura Rollins.

Thanks to the members of the collectives I write about here for opening up their processes to me, and for sending my research in unexpected directions.

This book began as a dissertation in the graduate program in social and political thought at York University, which encouraged experimenting with undisciplined ideas. Thanks to my teachers, including Deborah Britzman, Nergis Canefe, Asher Horowitz and Bonita Lawrence, and to my fellow graduate students, especially

Jonathan Adjemian, Elleni Centime Zeleke, and Fabian Voegeli. Thanks to my dissertation committee members, Ian Balfour and Janine Marchessault, for their careful attention and feedback, and to examiners Richard William Hill and Kirsty Robertson for their astute responses and engagement. The writing of Marcus Boon, my supervisor and now friend and collaborator, inspired me to embark on this project; its shape and substance grew out of our dialogue, and I would never have attempted it without his example and support.

Doctoral and postdoctoral fellowships from the Social Sciences and Humanities Research Council of Canada gave me the time, funding, and latitude to pursue this work.

Thanks to Matthew Goulish, Lin Hixson, Mark Jeffery, and the students of the Abandoned Practices Institute 2012, whose influence has echoed through this book and beyond. The practice, art, and writing of Peter Schumann have been foundational throughout. Rachel Mattson generously shared the Aftselakhis Spectacle Committee's archives. Conversations with Micah Donovan, and Rebekka Hutton were a productive starter for "Fermenting"; Orev Katz (Radiodress) pointed me to the "Blessing for Fermentation." Emelie Chhangur's curation, writing, and dialogue gave me much to reflect on.

Thanks to my co-fellows at the Jackman Humanities Institute at the University of Toronto in 2015–2016, especially Chris Dingwall, Eugenia Kisin, and Elizabeth Parke, and to Mark Sussman and my colleagues at Concordia University in 2016–2017. Thanks to my current colleagues at Glendon College and York University for their ongoing support.

Thank you to Nadine Attewell, Sarah Trimble, and the peer reviewers of an early version of "Remixing," which was published in *TOPIA* 35 (Spring 2016), as part of a special issue on "The Work of Return." Thanks to editor Mike Levine and the two reviewers

of an earlier version of this manuscript at Northwestern University Press for their helpful feedback.

I am grateful to my editor, Victoria Hindley, and to the MIT Press for believing in this project and carrying it to completion. The three reviewers contacted by MIT offered crucial and insightful comments. During various stages of the project, Laurie Milner and Jonathan Adjemian provided generous, invaluable, and repeated editorial assistance. At the Press, Matthew Abbate and Paula Woolley worked on the manuscript with scrupulous care. Thanks to many friends and colleagues, especially Lauren Fournier, Noah Kenneally, and Damian Tarnopolsky, for their encouragement and suggestions along the way.

A special thank you to all of the artists and photographers for allowing me to include their images. Color printing and artists' honoraria were made possible by funding from SSHRC and Glendon College.

My parents, Ellen and Steve Levine, opened up this path, and their intellectual and emotional support helped me as I wandered along it. Bee Pallomina has accompanied me at every step, making sure I didn't waver; thanks to her for her love and patience, and for reminding me how to play. In the middle of this project, Leocadio Elias Levine came along, joyfully, to further open up the field of possibilities.

NOTES

INTRODUCTION

1. Foucault, "Ethics of the Concern for Self"; Simpson, *As We Have Always Done*.
2. I have learned about the possibilities of life in a "damaged world" from recent interdisciplinary work in anthropology, ecology, and science studies, including Haraway, *Staying with the Trouble*; Tsing, *Mushroom at the End of the World*; Tsing et al., *Arts of Living on a Damaged Planet*; and Weston, *Animate Planet*. Others have also written of living in the wake of racial capitalism, coloniality, war, precarity, and other forms of ongoing damage.
3. Rifkin, *Beyond Settler Time*; Povinelli, *Empire of Love*.
4. Sterne, "Quebec's #casseroles"; McMahon, "Round Dance Revolution"; Tancons, "Occupy."
5. Srnicek and Williams, *Inventing the Future*.
6. Stengers, "Diderot's Egg," 15.
7. Phillips, "Educational Aesthetics." I situate the current prevalence of the word "practice" in socioeconomic and aesthetic history in more detail in Boon and Levine, "Promise of Practice."
8. Schatzki, Knorr-Cetina, and Savigny, *Practice Turn*.
9. Mauss, "Techniques of the Body."
10. Bourdieu, *Logic of Practice*.
11. Spatz, *What a Body Can Do*.
12. Stengers, "Introductory Notes."
13. Spatz, *What a Body Can Do*, 11.
14. Ibid., 41ff.
15. Massumi, *Politics of Affect*; Stewart, *Ordinary Affects*.
16. Spatz, *What a Body Can Do*, 4.
17. Ibid., 56.

18. Stengers and Pignarre, *Capitalist Sorcery*.
19. Simpson, *As We Have Always Done*, 16 (emphasis added).
20. Harney and Moten, *Undercommons*.
21. See the discussion of the "otherwise" possibilities of Black vernacular aesthetic practice in Crawley, *Blackpentecostal Breath*.
22. Lewis, *Power Stronger Than Itself*. "A power stronger than itself" was an early slogan of the Association for the Advancement of Creative Musicians (AACM), an organization that I discuss later in this introduction.
23. Niedecker, "In the Great Snowfall before the Bomb," ll. 7–8.
24. Among many other sources, see Linebaugh, introduction to E. P. Thompson, *William Morris*; Weheliye, *Phonographies*; Kraut, *Choreographing the Folk*; Perchuk and Singh, *Harry Smith*; Architekturzentrum Wien, *Lessons from Bernard Rudofsky*; Alexander, Ishikawa, and Silverstein, *Pattern Language*. For a range of perspectives and case studies in the sphere of music, see Bithell and Hill, *Oxford Handbook of Music Revival*.
25. On the global 1960s, see Dubinsky et al., *New World Coming*.
26. Wilder, *Freedom Time*; Collins and Crawford, *New Thoughts*.
27. On this aspect of situationist practice, see Wark, *Beach Beneath the Street*.
28. Brecht, *Peter Schumann's Bread and Puppet Theater*; Bell, "End of Our Domestic Resurrection Circus"; Scuderi, *Dario Fo*.
29. KuroDalaiJee, "Performance Collectives"; Addington, *Sound Commitments*; Milstein, "Revival Currents."
30. Farber, "Building the Counterculture."
31. Lewis, *Power Stronger Than Itself*, xl.
32. Ibid., 504.
33. For an example of these intergenerational networks, see Ewart et al., "Ancient to the Future."
34. Wynter, "On How We Mistook."
35. The phrase "the Black radical tradition" is Cedric Robinson's: see Robinson, *Black Marxism*, and Johnson and Lubin, *Futures of Black Radicalism*.
36. hooks, "Performance Practice as a Site of Opposition" and "Black Vernacular"; Moten, *In the Break*.
37. Harney and Moten, "Michael Brown," 86.
38. On "enterprise culture," see Sholette, *Dark Matter*.
39. Ashton, "Harlem Shake."
40. Reynolds, *Retromania*, 426.
41. Rancière, *Short Voyages*.
42. Uchill, *On Procession*.
43. Sholette, *Dark Matter*, 89.
44. Temporary Services and Angelo, *Prisoners' Inventions*.
45. On "modes of gathering" that put their participants productively "out of equilibrium," see Stengers, "Introductory Notes." I participated in the 2012 Abandoned Practices Institute, taught in Prague by Matthew Goulish, Lin Hixson, and Mark Jeffery.

46. Srnicek and Williams, *Inventing the Future.*
47. Henriques, *Sonic Bodies*, 227.
48. Conquergood, "Performance Studies," 146.
49. Nelson, *Practice as Research*; Conquergood, "Performance Studies."
50. See Tuhiwai Smith, *Decolonizing Methodologies*; Kovach, *Indigenous Methodologies*; Denzin, Lincoln, and Tuhiwai Smith, *Handbook.*
51. Weber, "Future of the Humanities."

CHAPTER 1

1. In Kino-nda-niimi Collective, *The Winter We Danced*, 150.
2. Benjamin, "Theses (On the Concept of History)," *SW4*, 391. (All selections from Benjamin's *Selected Writings* will be cited as *SW* along with the volume number.)
3. Benjamin uses the phrase in notes to "On the Concept of History." See Khatib, "Walter Benjamin."
4. Hobsbawm and Ranger, *Invention of Tradition*; Handler and Linnekin, "Tradition, Genuine or Spurious"; Noyes, "Tradition."
5. Benjamin, "Theses (On the Concept of History)," *SW4*, 391–392; Robinson, *Black Marxism*, xxx.
6. Williams, *Keywords*, 319; Eisenstadt, "Multiple Modernities."
7. Povinelli, *Empire of Love*, 201.
8. Latour, *We Have Never Been Modern*; Noyes, "Tradition."
9. Tylor, *Primitive Culture.*
10. Kirshenblatt-Gimblett, *Destination Culture*, 161.
11. Benjamin, *Arcades Project*, 473.
12. Kirshenblatt-Gimblett, *Destination Culture*, 180.
13. In notes to "On the Concept of History." See Khatib, "Walter Benjamin."
14. Abrahams, *Everyday Life*, 6.
15. McKay, *Quest of the Folk*; Storey, *Inventing Popular Culture.*
16. Hobsbawm and Ranger, *Invention of Tradition.*
17. Fielitz and Thurston, *Post-Digital Cultures of the Far Right.*
18. Gilroy, *Black Atlantic*, 193.
19. Comaroff and Comaroff, *Ethnicity, Inc.*, 128.
20. Gilroy, *Black Atlantic*, 202.
21. Scott, *Conscripts of Modernity.*
22. Gilroy, *Black Atlantic*, 198; Baraka, "Changing Same."
23. Gilroy, *Black Atlantic*, 197.
24. Sharpe, *In the Wake*. As Michelle Wright argues, this does not mean extending a "middle passage epistemology" to all Black subjects, whose relation to history and temporality might be quite different from the conventional narrative of oppression and uplift. Indeed, her call for a nonlinear and nonprogressive temporality has affinities with my argument here. See Wright, *Physics of Blackness.*

25. Abrahams, *Everyday Life*, 12.
26. Pollock, "Cosmopolitan and Vernacular," 596.
27. Taylor, *Archive and the Repertoire*.
28. Henriques, *Sonic Bodies,* 222.
29. Bourdieu, *Logic of Practice*.
30. Small, *Musicking*.
31. Henriques, *Sonic Bodies*, 275.
32. Ibid., 226–227.
33. Boon, *In Praise of Copying*, 65.
34. For a philosophical treatment of vernacular music that does focus on its utopian promise, see Brown, "Buzz and Rumble."
35. Linebaugh, *Magna Carta Manifesto*.
36. Ibid., 45.
37. Simpson, *As We Have Always Done*.
38. Graeber and Rockwell, *Capitalism*.
39. Ruivenkamp and Hilton, introduction, 6–7. See also Hardt and Negri, *Commonwealth*.
40. Marx, *Capital*, 1:875.
41. Harvey, *Brief History of Neoliberalism*.
42. Federici, quoted in Caffentzis, "Future of 'The Commons,'" 34.
43. Midnight Notes Collective, "The New Enclosures," 321.
44. Harris, "How Did Colonialism Dispossess?," 172.
45. A notable exception is found in the drafts of Marx's late letter to Vera Zasulich, on the Russian *mir* (village commune) and other precapitalist communities. See Shanin, *Late Marx*, 95–126.
46. Indigenous peoples' movements contributed to the revival of the language of commons and enclosures in the 1990s—particularly the Zapatista-led protests against the repeal of Article 27 of the Mexican constitution, which guaranteed the *ejido*, or common lands, of each village. See Linebaugh, "Enclosures," 12.
47. Midnight Notes Collective, "The New Enclosures," 333; on jubilee, see also Linebaugh and Rediker, *Many-Headed Hydra*.
48. Midnight Notes Collective, "The New Enclosures," 332.
49. Linebaugh, *Magna Carta Manifesto*, 103.
50. Locke, *Second Treatise*, 27. The gendered language is appropriate here.
51. Povinelli, "Settler Modernity," 23.
52. In section 35 of the Canadian Constitution Act, and in the Australian Native Title Act; see Lawrence, *"Real" Indians*; Povinelli, *Cunning of Recognition*.
53. Wolfe, *Settler Colonialism*, 2.
54. Simpson, "Settlement's Secret," 207.
55. Ibid., 205.
56. Povinelli, *Empire of Love*, 156.
57. Esposito, *Communitas*, 7.
58. Simpson, *Dancing on Our Turtle's Back*, 51.

59. On the incommensurability of colonial experiences, see Tuck and Yang, "Decolonization."

60. Campbell, foreword, xix.

61. Linda Tuhiwai Smith agrees, calling colonialism a "process of systematic fragmentation," reflected "in the disciplinary carve-up of the indigenous world: bones, mummies and skulls to the museums, art work to private collectors, languages to linguistics, 'customs' to anthropologists, beliefs and behaviours to psychologists." Tuhiwai Smith, *Decolonizing Methodologies*, 28.

62. Benjamin, *SW1*, 260.

63. Toufic, *Forthcoming*.

64. Benjamin, "Letter to Gershom Scholem," *SW3*, 322–329.

65. Ibid., 326.

66. Butler, *Parting Ways*, 13.

67. Ibid., 226.

68. Ibid., 8.

69. Ibid., 11.

70. Benjamin, "Letter to Gershom Scholem," *SW3*, 326.

71. Butler, *Parting Ways*, 13.

72. Fanon, "On National Culture," 160.

73. Ibid.

74. Ibid., 161.

75. Ibid., 175, 160.

76. Coulthard, *Red Skin, White Masks*.

77. See "Onaman Collective." Similarly, the Debajehmuhjig Theatre Group, founded in 1984 and based on Manitoulin Island in Ontario, has come to emphasize the collective practice of Anishinaabeg lifeways as much as the creation of theatrical performances. See Freeman, "Theatre."

78. Garneau, "Extra-Rational Aesthetic Action."

79. Rolnik, "Lygia Clark," 57.

80. "Reclaiming"; Salomonsen, *Enchanted Feminism*.

81. Stengers and Pignarre, *Capitalist Sorcery*, 136.

82. Ibid., 138.

83. See Starhawk, "How We Really Shut Down the WTO."

84. Stengers and Pignarre, *Capitalist Sorcery*, 40.

85. Berardi, *Soul at Work*.

86. Berardi, introduction, 11.

87. Rodenbeck, *Radical Prototypes*, 28.

CHAPTER 2

1. The Yiddish expression *aftselakhis* means "in order to provoke anger"—or, more generally, to do things because someone else doesn't want you to; to act out of spite or to exasperate. See Wex, *Born to Kvetch*, 2.

2. Baumgarten, "Purim-Shpil"; Belkin, "Ritual Space."

3. Aftselakhis Spectacle Committee, "Purim Ball," invitation.

4. See the Aftselakhis Spectacle Committee's website.

5. I work with the performative sense of "queer" as a disruption of normative structures of gender, as developed in queer theory since the late 1980s. This performative sense has since been extended to other recuperations of shamed bodies and cultures. On the double queerness of the Yiddish revival, see Shandler, "Queer Yiddishkeit."

6. See Marranca and Dasgupta, *Theatre of the Ridiculous.*

7. On "extraordinary temporary creative art," see Chief Victor Harris, cited in Tancons, "Greatest," 49.

8. Aftselakhis Spectacle Committee, "Purim Ball," invitation.

9. Mattson, "Queer Political Desire." Mattson traces the spirit of this phrase to the performance artist Sharon Hayes.

10. Bakhtin, *Rabelais*, 48.

11. Doniach, *Purim.*

12. Epstein, "Drinking"; Doniach, *Purim.*

13. Berlin, *Esther*, xv–xvi.

14. As Emile Durkheim generalizes, "A religion is a unified system of beliefs and practices relative to sacred things, that is to say, things set apart and forbidden—beliefs and practices which unite into one single moral community called a Church, all those who adhere to them." *Elementary Forms*, 44.

15. As translated in Berlin, *Esther.*

16. Fisch, "Reading and Carnival," 55; Rubenstein, "Purim," 260; see also Douglas, *Purity and Danger.*

17. Fisch, "Reading and Carnival," 62.

18. Even during Purim, religious authorities still do not permit adultery or the eating of nonkosher foods, and in Hasidic synagogues women may only peer over, but not cross, the curtain that divides them from the male worshippers. See Rubenstein, "Purim"; Epstein, "Drinking."

19. Cited in Fisch, "Reading and Carnival," 59.

20. Epstein, "Drinking," 137.

21. See Eagleton, *Walter Benjamin*, 143–156; Stallybrass and White, *Politics and Poetics.*

22. Fisch, "Reading and Carnival," 71.

23. Rubenstein, "Purim," 251.

24. Horowitz, "Rite," 28.

25. Horowitz, *Reckless*, 315.

26. Emerson, *First Hundred Years.*

27. Agamben, "In Praise of Profanation."

28. Here Agamben follows Benjamin's fragment "Capitalism as Religion" and Debord's *Society of the Spectacle.*

29. See Butler, who describes how the borders of gender are ritually policed: "Social constraints, taboos, prohibitions, threats of punishment operate in the *ritualized repetition of norms.*" "Critically Queer," 21 (emphasis added).

30. Agamben, "In Praise of Profanation," 75.

31. Ibid., 76.

32. See *Midrash Mishlei* 9:9, cited in Epstein, "Drinking."

33. Benjamin, "Theologico-Political Fragment." All citations in the following paragraphs are from the translation by Edmund Jephcott in *Reflections*, 312–313.

34. Jacobson, *Metaphysics of the Profane*, 50.

35. Scholem, *On the Kabbalah*, 113–117; Scholem, "Walter Benjamin," 233–234.

36. Scholem, *Messianic Idea*, 1.

37. Benjamin, "Theologico-Political Fragment," 312. Scholem's interpretation of the Lurianic mystical tradition, which Benjamin absorbed, is itself highly secularized, and ignores the more "magical" strands of the Kabbalah. See Idel, *Old Worlds, New Mirrors*.

38. Benjamin, *SW3*, 157–158.

39. Nepon, "Wrestling."

40. Unless otherwise noted, all quotations by Lang/Levitsky, Romaine, Fox-Rosen, and Miller are from a personal interview with those members of the Aftselakhis Spectacle Committee, in Brooklyn, NY, May 22, 2012. Further quotations are taken from the author's audio recording of a Purim Meeting, Brooklyn, NY, May 21, 2012.

41. See Alicia Svigals, who articulates and celebrates this "Queer Yiddishist" movement: "Why We Do This Anyway."

42. Weinreich, *History*; Katz, *Yiddish and Power*. Stateless tongues are often called dialects; as Yiddishist and YIVO founder Max Weinreich liked to quip, "a language is a dialect with an army and a navy." Quoted in Katz, *Words on Fire*, 3.

43. Shandler, "Queer Yiddishkeit," 109.

44. On "queer time," see for example Halberstam, *In a Queer Time and Place*; Dinshaw et al., "Theorizing Queer Temporalities"; Muñoz, *Cruising Utopia*. "Queer time" is a proposition to be enacted, not a necessary consequence of sexual orientation. As Lisa Duggan points out, "homonormativity" is alive and well in the "gay pragmatism" that asks for inclusion in larger normative structures (especially marriage, militarism, and sexual reproduction). Duggan, "The New Homonormativity."

45. On "intimate publics," see Berlant, *Queen*.

46. See Warner, *Publics and Counterpublics*.

47. Weinreich, "Internal Bilingualism"; Seidman, *Marriage Made in Heaven*.

48. Robin, "La litterature yiddish soviétique."

49. Shandler, "Queer Yiddishkeit" and *Adventures*.

50. This is not, of course, to draw any kind of ethical equivalence between these causes of the decline of Yiddish. It is important to note that the communities in which Yiddish is still spoken widely are those of Hasidic Jews, whose insularity ensures the language's continued survival. See Shandler, *Adventures*.

51. The same scorn was manifest among non-Yiddish-speaking Jews in Western and Central Europe. In 1899, the philologist Leo Weiner observed that "there is probably no other language in existence on which so much opprobrium has been heaped" (quoted in Shandler, *Adventures*, 13).
52. Shandler, *Adventures*; Brossat and Klingberg, *Revolutionary Yiddishland*.
53. On "straight time," see Boelstorff, "When Marriage Falls."
54. The danger is that this Yiddishist utopianism will repeat the racialized marginalization of Sephardic and Mizrahi ("Eastern") Jews, which has occurred both in the state of Israel and in the diaspora. See Shohat, "Invention of the Mizrahim"; Kaye/Kantrowitz, *Colors of Jews*.
55. Boyarin and Boyarin, *Powers of Diaspora*.
56. Arendt, *Human Condition*.
57. Mattson, "Rad Jew."
58. See Orenstein, "Thinking Inside the Box," and the Great Small Works website for the company's history.
59. Romaine, interview.
60. Quoted in Nepon, "Wrestling." Hashem is one of the euphemistic Hebrew names for the divine—literally, "the name."
61. The Arbeiter Ring (Yiddish Workmen's Circle) pulled out after 2010, apparently uncomfortable with the event's flamboyantly queer party scene, which included occasional nudity and public making-out. In the opinion of one collective member, "It was homophobia—it's not that people were naked, it's that not the correct people were naked for them." The absence of this Yiddishist institutional anchor created a kind of "fault line" in the project which threatened some of its intergenerational links. In 2013, the Arbeiter Ring renewed its association with the project.
62. Epstein, "Drinking."
63. Fox-Rosen's exegesis is titled "A Word on the Importance of Ritual, or 'Why Do We Sing Songs with Words We Don't Believe?,'" in Aftselakhis Spectacle Committee, "Your Hamentashen" program.
64. From the author's audio recording of a Purim Meeting, Brooklyn, NY, May 21, 2012.
65. Aftselakhis Spectacle Committee, "Your Hamentashen."
66. The proceedings were documented on a video recording by Rachel Mattson, from which I draw this account.
67. Big Freedia's music, videos, and live shows are a brilliantly carnivalesque, queer, radical-vernacular body of work. See the video for "Y'all Get Back Now," among many others.
68. This meeting occurred just weeks before the killing, in South Florida, of unarmed black teenager Trayvon Martin by a white neighborhood watch volunteer, who was later acquitted—an event that would become an impetus for the Black Lives Matter movement.
69. Butler, *Precarious Life*, 26.
70. Crimp, "Mourning and Militancy," 8.

71. Ibid., 13. Crimp is quoting from Kirk and Madsen's notorious *After the Ball*.
72. Bodily vulnerability is unevenly distributed along the axes of race, class, gender, and place. Not everyone is considered equally dispensable. See Razack, *Race, Space, and the Law*.
73. On gendered and racialized domestic work, see Borris and Parreñas, *Intimate Labors*. On "bodies in alliance," see the essay of that title by Judith Butler, who used the phrase in her address to protesters in Zuccotti Park on October 23, 2011.
74. Mattson, "Queer Political Desire," n.p.
75. Bey, *T.A.Z.* See Ken Moffat's essay "Dancing without a Floor," on Toronto artist Will Munro's long-running party Vazaleen, which allowed participants to "relax into the communality of imperfect bodies and porous boundaries rather than the individualizing forces of fastidiously perfected beauty."
76. Freeman, *Time Binds*.
77. DUMBO is Down Under the Manhattan Bridge Overpass, a Brooklyn riverside neighborhood largely owned by a single developer who from the early 2000s rented reduced-cost studio space to artists, encouraging gentrification and a rise in property values. With gentrification complete, these artists have become expendable, and rent reductions are ending; Great Small Works was forced to leave its studio in 2016.
78. Tancons, "Greatest," 52.
79. On restricted and general economies, see Bataille, *Visions*.
80. Describing the long hours, collective labor, and slapdash production techniques of this kind of spectacle-making, Romaine jokes: "There's a word for it, 'collective creation' in the *goyishe* world. We just called it 'rehearsal.' Puppeteers don't do training."
81. See "The Mountain" in Clare, *Exile and Pride*. Clare, who has cerebral palsy, describes an attempted hike up Mt. Adams that ends in retreat. In his view, those who have been marginalized should let go of the compulsion to scale the mountain of compensatory achievement—and instead imagine "the metaphoric mountain, collapsed in volcanic splendor" (12).
82. Romaine, Interview.
83. Clemens, *Voynich Manuscript*.
84. Boon, *In Praise of Copying*.
85. From Lautréamont's *Maldoror*, via the surrealists.
86. Aftselakhis Spectacle Committee, "Your Hamentashen" program.
87. Ahmed, *Cultural Politics of Emotion*, 164.
88. Aftselakhis Spectacle Committee, "Purim Ball," invitation.
89. Ibid.
90. Josh Waletzky's garbled groans in this scene are a perfect example of Shandler's description, in "Queer Yiddishkeit," of Yiddish as a "travesty language." In general, the Purimshpil doesn't so much "straddle the modes of heritage ... and camp" (109) as fuse heritage and camp into a carnivalesque whole.

91. This final number was the source of a rare aesthetic argument inside the collective. Should the medley be played at the bounce tempo, or the tempo of the Jewish songs? While one member described this as a "philosophical difference," the question seemed to be more about what kind of dance party the group wanted to have. In the end, bounce won the day—which didn't hamper any of the dancing.

92. Romaine, interview.

93. Butler, *Parting Ways*, 13.

CHAPTER 3

1. Canada, while politically independent, is still a constitutional monarchy under the British sovereign. Indigenous nations continue to honor and negotiate treaties with representatives of the British Crown.

2. A Tribe Called Red—Ian Campeau, Dan General, and Bear Witness—interview with the author, Ottawa, 2013. All quotations from members of the collective are taken from this interview, unless otherwise noted. Since this interview, the collective has fractured and shifted: Dan General and Ian Campeau left the group in 2014 and 2017 respectively, and the group is currently a duo of Bear Witness and Tim "2oolman" Hill.

3. A Tribe Called Red, "The Road."

4. See Robbie Shakespeare, quoted in Veal, *Dub*, 201.

5. Martineau and Ritskes, "Fugitive Indigeneity," 1.

6. Vizenor, *Fugitive Poses*, 15.

7. See Simpson, *Dancing on Our Turtle's Back*.

8. The core of my research in this chapter is tied to a particular moment, from late 2012 to mid-2013. Even though I wrote parts of it later, the social and political energy of that moment informs my analysis and is an irreducible part of the art and music I describe.

9. Among other sources, see Kovach, *Indigenous Methodologies*; Tuhiwai Smith, *Decolonizing Methodologies*.

10. Quoted in LaRocque, *When the Other Is Me*, 166.

11. Duncan Campbell Scott, cited in Pettipas, *Severing the Ties*, 212.

12. See Truth and Reconciliation Committee of Canada, *Canada's Residential Schools*.

13. Scott, cited in ibid., 160.

14. Simpson, *Dancing on Our Turtle's Back*, 49–52.

15. Hopkins, "Making Things Our Own."

16. Vizenor, *Fugitive Poses*, 15 (emphasis in original).

17. Tuck and Yang, "Decolonization."

18. Wagamese, *Keeper'n Me*, 2–3.

19. Williams, *Marxism,* 132.

20. See Clifford, "Ethnographic Allegory"; Deloria, *Playing Indian*.

21. Teves, Smith, and Raheja, "Tradition," 233.

22. Lyons, *X-Marks,* 60.
23. Ibid., 93.
24. Ibid., 96–97.
25. Ibid., 40.
26. Ibid., 107.
27. Povinelli, "Settler Modernity," 28.
28. Ibid., 30 (emphasis in original).
29. Ibid., 34.
30. Ibid., 22.
31. See Povinelli, *Cunning of Recognition.*
32. Lawrence, *"Real" Indians.*
33. Povinelli, "Settler Modernity," 23.
34. See Ginsburg and Myers, "A History of Aboriginal Futures"; Biddle, *Remote Avant-Garde.*
35. Teves, Smith, and Raheja, "Tradition," 239 (emphasis in original).
36. Valaskakis, *Indian Country,* 10.
37. Alfred, *Wasáse,* 225.
38. The title of this section is borrowed from Christen, "Gone Digital."
39. The phrase "power of designation" is from Cornellier, "'Indian Thing,'" 51. For key readings on Indigenous digital and new media art, see Townsend, Claxton, and Loft, *Transference, Tradition, Technology*; Loft and Swanson, *Coded Territories*; Iglioliorte, Nagam, and Taunton, "Indigenous Art."
40. Fabian, *Time and the Other.*
41. Christen, "Gone Digital," 318.
42. Quoted in Ahasiw Maskegon-Iskwew, "Drumbeats to Drumbytes," in Townsend et al., *Transference,* 212.
43. Quoted in Evans, "Buffy Sainte-Marie."
44. As Faye Ginsburg writes of current Indigenous film and video practice, "The sense of its contemporary novelty is in part the product of the deliberate erasure of indigenous ethnographic subjects as actual or potential participants in their own screen representations in the past century." Ginsburg, "Screen Memories," 39–40.
45. Feld, "From Schizophonia," 265.
46. Tuck and Yang, "Decolonization," 3.
47. Brown, "Buzz and Rumble," 130–131.
48. Jace Clayton (aka DJ /rupture) notes this tendency in Javier Estrada's Aztec-inspired club music: "Estrada's music complicates the narratives of newness or progress that propel global dance music. If there is no newness and everything has already happened then we can jettison related concepts like 'original' or 'old,' and start listening to music in its promiscuous, iterative glory." Clayton, "Aztec Imagery."
49. Hopkins, "Making Things Our Own," 342.
50. Durham, *A Certain Lack of Coherence,* 108. Rayna Green makes a similar point regarding Indigenous peoples' "readaptive use" of European clothing in "The Tribe Called Wannabee."

51. Boon, *In Praise of Copying*.
52. This work has continued in AbTeC (Aboriginal Territories in Cyberspace), a research-creation network founded in 2005 by Skawennati and Jason Lewis. Their many projects include the Skins Workshops, which teach experimental digital media and video game design to on-reserve and urban Indigenous youth.
53. Hopkins, "Making Things Our Own," 343.
54. On "remix culture," see Bourriaud, *Postproduction*; Lessig, *Remix*.
55. On the urban Aboriginal diaspora, see Lawrence, *"Real" Indians*.
56. Simpson, "Paths toward a Mohawk Nation," 126 (emphasis in original).
57. toksala, "Q&A."
58. Valaskakis, *Indian Country*, 162.
59. Pettipas, *Severing the Ties*, 188, 233. Recent work includes Browner, "Acoustic Geography"; Krystal, *Indigenous Dance*; Scales, *Recording Culture*.
60. Valaskakis, *Indian Country*, 160. (Valaskakis draws on Warrior, "Sweetgrass.")
61. Ibid., 155–156.
62. Ibid., 157.
63. See, for example, Russell Means's scathing comments in the epilogue to his autobiography, *Where White Men Fear to Tread*, 538–539.
64. Valaskakis, *Indian Country*, 160.
65. Browner, "Acoustic Geography," 139.
66. Scales, *Recording Culture*, 7.
67. Browner, "Acoustic Geography," 135.
68. Keil, "Participatory Discrepancies," 96.
69. Scales, *Recording Culture*, 81, 104.
70. Ibid., 104.
71. Weheliye, *Phonographies*, 88.
72. Brown, "Buzz and Rumble," 140.
73. Nelson, "Introduction: Future Texts," 8.
74. Eshun, *More Brilliant*, 453.
75. Baraka, "Changing Same."
76. Eshun, "Further Considerations," 289.
77. Ibid., 297.
78. Ibid., 294.
79. Ibid., 293.
80. Hebdige, *Cut 'n' Mix*; Weheliye, *Phonographies*.
81. Henriques, *Sonic Bodies*, 160 (emphasis in original).
82. Ibid.
83. Snead, "Repetition."
84. Henriques, *Sonic Bodies*, 169.
85. Taylor, *Archive and the Repertoire*.
86. The original track is from Super Cat, Junior Cat, Junior Demus, and Nicodemus's Wild West–obsessed *The Good, The Bad, The Ugly & The Crazy* (1994), released on Super Cat's Wild Apache label.

87. Gordon, *Ghostly Matters*, 16.

88. On the "grooves of history," see Weheliye's discussion of Ralph Ellison, Walter Benjamin, W. E. B. Du Bois, and DJing in *Phonographies*, 73–105.

89. Francis, *Imaginary Indian*.

90. Rayna Green traces the Western's generic clichés back to nineteenth-century Wild West Shows, as well as dime novels, the works of James Fenimore Cooper, and "stagey versions" of Longfellow's "Song of Hiawatha." See Green, "Tribe Called Wannabee," 41.

91. Cornellier, "'Indian Thing,'" 56.

92. Goldie, *Fear and Temptation*.

93. Johnston and Lawson, "Settler Colonies," 369.

94. Green, "Tribe Called Wannabee," 49.

95. Veracini, "Settler Collective," 371.

96. Ibid.

97. Cameron, "Indigenous Spectrality," 390.

98. Ibid., 388.

99. Scott, "Indian Place Names," 35–36.

100. Cameron, "Indigenous Spectrality," 385.

101. Quoted in Francis, *Creative Subversions*, 1.

102. 2bears, "Post-Indian."

103. Derrida, *Specters of Marx*, 63.

104. LaRocque, *When the Other Is Me*, 63–64 (emphasis in original).

105. Ibid., 22.

106. Didi-Huberman, "Artistic Survival," 274.

107. LaRocque, *When the Other Is Me*, 162.

108. Francis, *Creative Subversions*, 15.

109. Bear Witness, wall text from the exhibition "Beat Nation," The Power Plant, Toronto, December 2012–May 2013.

110. See Hill, *World Upside Down*.

111. Francis, *Creative Subversions*, 145.

112. Mercer, "Maroonage," 145.

113. Marker, "Sans Soleil / Sunless."

114. Russell, *Experimental Ethnography*, 307.

115. Marker, "Sans Soleil / Sunless."

116. Russell, *Experimental Ethnography*, 269.

117. Ibid., 348.

118. The phrase "dream analysis" is taken from Russell. Ibid., 258.

119. Originally a web project curated by Tania Willard and Skeena Reece, then an exhibition at the Vancouver Art Gallery and elsewhere; see Ritter and Willard, *Beat Nation*.

120. Butler, *Unlocking*, 72.

121. Schwab, *Haunting Legacies*.

122. Freud, "Remembering."

123. Ibid., 155 (emphasis in original).

124. Laplanche and Pontalis, *Language*, 487.

125. Benjamin, *SW2*, 512.
126. For similar arguments about music and healing, see Brown, "Buzz and Rumble"; Mbembe, *Variations on the Beautiful*.
127. Nancy, *Listening*.
128. Henriques, *Sonic Bodies*, xviii (emphasis in original).
129. See Ginsburg, "Indigenous Uncanny."
130. Clover, *1989*, 70 (emphasis in original).
131. Veal, *Dub*, 253.
132. Alanis Obomsawin, in Alioff and Levine, "Interview," 13.
133. Massumi, "Autonomy," 91 (emphasis in original).
134. Ibid., 97.
135. Boon, "One Nation Under a Groove?"
136. Goodman, *Sonic Warfare*, 82.
137. K., "Why Tonto Matters."
138. Coulthard, "Beyond Recognition," 199.
139. At Toronto's Pride march in 2013, for example, a joyful cohort of two-spirit dancers in regalia were accompanied by the house beat of A Tribe Called Red's high-energy track "Sisters," which features the singers of Northern Voice.
140. Lyons, *X-Marks*; Teves, Smith, and Raheja, "Tradition."
141. Anderson, *Life Stages*, 3.
142. Simpson, *Dancing on Our Turtle's Back*, 52. Simpson draws on Geniusz, *Our Knowledge*.
143. Ibid., 49–50.
144. Ibid., 51.
145. See Coulthard, *Red Skin, White Masks*; Robinson, "Feeling Reconciliation."
146. "Idle No More."

CHAPTER 4

1. Haraway, *Companion*.
2. The event's full name was the Radical Cheese Against the Asphaltization of Small Planets Festival.
3. Katz, *Wild*, 59.
4. "Toronto Hipster Map."
5. Sharzer, *No Local*.
6. On U.S. feminism and radical cookbooks in the 1970s, see Inness, "'Boredom.'"
7. Paxson, "Post-Pasteurian Cultures."
8. Katz, *Revolution*, xiii.
9. Katz, *Wild*, 166.
10. A more accurate name for this historical epoch might be the "Capitalocene." See Moore, *Capitalism*; Haraway, "Anthropocene."

11. Latour, "Why Has Critique."
12. See Paxson, "Post-Pasteurian Cultures"; Derrida, "Hostipitality"; Morton, *Ecological*.
13. Herbst and Ulrike, "Editorial." The phrase "grassroots modernism" seems to be inspired by Esteva and Prakash's 1998 book *Grassroots Post-modernism*.
14. Ibid., 4.
15. Ibid.
16. See Relyea, *Your Everyday Art World*.
17. Wade, "Grassroots," 45.
18. Ibid., 46.
19. Ibid., 50–51.
20. Wade, "Grassroots," 47; see Kant, "An Answer"; Foucault, "What Is Enlightenment?"
21. Wade, "Grassroots," 47.
22. Ibid., 53.
23. Stengers, "Diderot's Egg," 15.
24. Wade, "Grassroots," 53.
25. Solnit, "Diary," 33.
26. See Harvey, *Condition*.
27. Pollan, *Cooked*, 406.
28. Ibid., 407.
29. Ibid., 408 (emphasis added).
30. Ibid., 414.
31. Sharzer, *No Local*, 55.
32. See Tuck and Yang, "Decolonization."
33. Sharzer, *No Local*, 3.
34. Ibid., 84.
35. Wade, "Grassroots," 46.
36. Ibid., 3.
37. Agamben, *Means*.
38. On the complicated history of the term *praxis*, see Balibar, Cassin, and Laugier, "Praxis."
39. Foucault, *Use of Pleasure*, 72.
40. Foucault, *L'usage des plaisirs*, 15.
41. See also Singh, *Unthinking Mastery*.
42. Sloterdijk, *You Must Change Your Life*, 19–105. (The book was published in English translation in 2013.)
43. Ibid., 100.
44. Ibid., 197.
45. Ibid., 190.
46. Ibid., 219.
47. Certeau, *Practice*; Certeau, Giard, and Mayol, *Practice*.
48. Sloterdijk, *You Must Change Your Life*, 444, 452.

49. See, for example, Wenger, *Communities of Practice*. Sloterdijk's emphasis on self-mastery also contradicts the call of Rilke's poem "Archaic Torso of Apollo," from which he draws his title. The poem is a hymn to the power of aesthetic brokenness and incompletion, whose final line, "You must change your life," suggests a radical contingency and insufficiency.

50. Benjamin, "Letter to Gershom Scholem," *SW3*, 326; see chapter 1 above. As Sloterdijk points out, "asceticism-based thought only becomes clearly visible when the most conspicuous standard exercises in culture, known as 'traditions,' find themselves in the difficult situation of Kafka's hunger artist—as soon as one can say that interest in them 'has markedly diminished during these last decades.'" Sloterdijk, *You Must Change Your Life*, 82.

51. Twitty, "Stinking Fish," 341.

52. Foucault, *Use of Pleasure*, 11–12.

53. Katz, *Wild*, 166.

54. Ibid., 31. I kept this in mind in my own fermenting practice when a late-summer crock of cucumber pickles was invaded by a vigorous Kahm yeast, which spread its white tendrils across the surface of the brine and down into the vegetable matter below. It competed with the *lactobacilli*, the acidifying bacteria working in the anaerobic depths. My daily practice that August was skimming off the white yeast as it broke up into clots and sank into the brine, only to regenerate into a fuzzy fractal stretching across the surface the next morning. The batch was saved, but those yeasty and somewhat soggy pickles were a rebuttal of any illusions of mastery I might have entertained.

55. Haraway, *Companion*.

56. Paxson, "Post-Pasteurian Cultures," 39.

57. Ingram, "Fermentation," 101.

58. Barad, "Posthumanist Performativity"; Barad, *Meeting*; Barad, "On Touching."

59. Margulis and Sagan, *Microcosmos*.

60. Haraway, *Companion*, 32.

61. Paxson, 38. Rimbaud's original words suggest something quite different: that the poet is "responsible for" (*chargé de*) both humans and animals. See Côté, "Filled with Animals."

62. Rimbaud, "À Georges Izambard," 370.

63. Ingram, "Fermentation," 107.

64. Paxson, "Post-Pasteurian Cultures," 36; see also Latour, *Pasteurization*.

65. Katz, *Art*, 11.

66. Ibid.

67. Barad, "Nature's Queer Performativity."

68. See Taussig, "Mastery of Non-Mastery."

69. Haraway, *Companion*, 34–36.

70. Ibid., 15.

71. Quoted in Katz, *Art*, 40.

72. Morton, *Ecological*, 78. Morton is quoting the poet George Morrison.

73. Ibid., 75, 127, 79.

74. Morton, "Queer Ecology," 280; see also Mortimer-Sandilands and Erikson, *Queer Ecologies*.

75. Derrida, *Of Hospitality*, 77 (emphasis in original).

76. Lynn Margulis observes that single-celled organisms are not mortal in the same sense as eukaryotes; a SCOBY or bacterial community can live indefinitely given the right conditions. Inevitable death is a later evolutionary development, tied to sexual differentiation. See Margulis, "Did Sex."

77. For another discussion of this ambivalent term, see Serres, *Parasite*.

78. Haraway, *Companion*, 100.

79. Derrida, "Hostipitality," 402.

80. Ibid., 360 (emphasis in original).

81. Ibid., 362.

82. Morton, *Ecological*, 9? Morton is drawing on the Lacanian language of Žižek, "Neighbors."

83. Esposito, *Immunitas*, 18.

84. Benjamin, "Theologico-Political Fragment," 313.

85. Ibid.

86. Quoted in Katz, *Wild*, 158.

87. Herring, "Secret Life."

88. Katz, *Revolution*, 316.

89. Whitman, "This Compost," ll. 42–47.

90. Ibid., l. 30.

91. Siegel, *Intoxication*, 116–117.

92. Hayden, Canuel, and Shanse, "What Was Brewing."

93. Brillat-Savarin, *Physiology*, 149–150.

94. Katz, *Revolution*, 117; Buhner, *Sacred*.

95. Quoted in Pollan, *Cooked*, 346.

96. Bakhtin, *Rabelais*, 21.

97. Ingram, "Fermentation."

98. Barthes, "Reading Brillat-Savarin," 252.

99. Katz, *Revolution*, xviii.

100. Ibid., 318.

101. Bakhtin, *Rabelais*, 94.

102. Jenkins, *Humanure*.

103. Artaud, "The Pursuit of Fecality," 559.

104. Katz, *Revolution*, 318.

105. Katz, *Art*, 392.

106. Quoted in Kirshenblatt-Gimblett, "Playing," 14 (emphases in original).

107. Quoted in Paxson, "Post-Pasteurian Cultures," 40.

108. By "humiliations," Morton is referring to the successive "revolutions in human thinking about mind and society ... that displaced human agency," which he attributes to Marx, Freud, Saussure, Derrida, and Darwin. Morton, *Ecological*, 125.

109. Ibid., 124.

110. Given the current aggressive climate of intellectual property law, this may be changing. Christopher Buccafusco writes: "If we recognize the dish as an expressive medium and the recipe as its means of fixation, there would be little or no doctrinal limit on extending copyright to dishes"—though he goes on to argue that this extension of copyright would not be necessary, appropriate, or desirable. Buccafusco, "On the Legal," 1123.

111. Katz, *Revolution*, 341.

112. Ibid., 116–117.

113. Agamben, "In Praise of Profanation" (see chapter 2 above).

114. Bürger, *Theory of the Avant-Garde*, 53.

115. See Boon and Levine, *Practice*.

116. Katz, *Revolution*, xvi.

117. Kirshenblatt-Gimblett, "Playing," 1.

118. Ibid., 22.

119. Allan Kaprow writes that George Brecht's *Events* (1959–1962) could be experienced equally as performances or as mental exercises: "Those wishing to conventionalize the brief scores (as Brecht called them) into a neo-Dada theater could and did do so. Those who wanted to project their tiny forms into daily activity, or into contemplation, were also free to follow that route." In Kaprow, "Nontheatrical Performance," 169.

120. Buck-Morss, "Aesthetics and Anaesthetics."

121. Quoted in Donovan, "Five Questions."

122. Eagleton, *Ideology of the Aesthetic*, 111. This tendency to imagine an aesthetic solution for social problems can be traced back to texts such as Schiller, *On the Aesthetic*.

123. Pollan, *Cooked*, 17.

124. Prentice, *Full Moon Feast*, 38.

125. Ibid., 39.

126. Brown, "Buzz and Rumble," 130; see chapter 3 above.

127. Fallon [Morell] and Enig, *Nourishing Traditions*, xi.

128. Ibid.

129. For a careful assessment of the innovations and the limits of Price's research, see Renner, "Conservative Nutrition."

130. See Ashbee, "Politics of Paleoconservatism."

131. Fallon [Morell] and Enig, *Nourishing Traditions*, xii.

132. Ibid.

133. Culinary historian and chef Michael Twitty's work on reclaiming historical African American foodways is a striking exception; see *Cooking Gene*.

134. Katz, *Revolution*, xviii.

135. Ibid., xix.

136. Morell even gives *Art of Fermentation* the Weston Price Foundation's imprimatur, in the form of a back-cover blurb.

137. On "the young girl following the Muses" who picks up the cast-off flowers of tradition, see Hegel, *Phenomenology*, 455; Nancy, *The Muses*.

138. Katz, *Art*, 75–76 (emphasis added).

139. See Katz, *Wild*, 50–51; *Revolution*, 153–156; *Art*, 123.

140. Green, "Tribe Called Wannabee." See also Koffman, "Playing Indian."

141. Morgensen, "Arrival at Home," 68.

142. Povinelli, *Empire of Love*, 107.

143. Herring, "Out of the Closets."

144. Morgensen, "Arrival at Home," 69.

145. Ibid., 83–84.

146. Katz, *Revolution*, 195.

147. Ibid., 197.

148. Katz, "Interview."

149. Morgan-Feir, "Artist's Ritual Bath."

150. Badger, "In and Out of Time."

151. Ibid.

152. Katz, *Wild*, 59.

153. Abbott-Barish and Murphy, "Activating."

154. Badger, "In and Out of Time."

155. Žižek, "Neighbors."

156. Schulman, *Gentrification*.

157. Srnicek and Williams, *Inventing the Future* (see my introduction to this book).

158. Bookchin, *Social Anarchism*.

159. Bourdieu, *Distinction*, 366.

160. Fournier, *Fermenting Feminism*. See also Hay and Ketchum, "Food, Feminism, and Fermentation."

161. Haraway, *Companion*, 30.

162. See Rancière, *Disagreement*.

163. Haraway, *Staying with the Trouble*; Latour, "Why Has Critique."

164. Critchley, *Infinitely*, 114.

165. Antonio Gramsci, quoted in ibid., 88.

166. These include Critchley, as well as Badiou and Rancière.

167. Schumann's broadsheet is reproduced in Katz, *Art*, plate 31.

168. For the Microcultures Collective, fermentation is all about setting up those good conditions: "The practice of fermentation, whether it be culinary fermentation or the social or artistic practices inspired by it, is the practice of creating the ideal conditions for a transformation to take place." Kruglanski, Ramujkić, and Robas, "Microcultures."

169. Katz, *Wild*, 166.

CONCLUSION

1. Butler, "Bodies."

2. Sterne, "Quebec's #casseroles."

3. Henriques, *Sonic Bodies*, 227.

4. Gratton and Sheringham, "Tracking the Art of the Project," 9.

5. Ibid., 17.

6. Weber, "Future of the Humanities" (see my introduction).

7. Bishop, *Artificial Hells*, 194 (emphasis in original).

8. Gratton and Sheringham, "Tracking the Art of the Project," 8.

9. On "the withdrawal of tradition following a surpassing disaster," see Toufic, *Forthcoming*, and my discussion in chapter 1.

10. Arendt, *Promise of Politics*, 7.

11. Brown, "Resisting," 26.

12. Dean, "Communist," 11.

13. Douzinas and Žižek, quoted in ibid., 12.

14. Benjamin, *SW2*, 425.

15. Ibid.

16. See Douzinas and Žižek, *Idea of Communism*. This tendency is especially evident in Dean's insistence on the revolutionary vanguard party. Granted, as she likes to say, "Goldman Sachs doesn't care if you raise chickens." (Quoted in Srnicek and Williams, *Inventing the Future*, 25.) But neither does it care if you join a Leninist study group.

17. Clark, "For a Left," 72.

18. Williams and Srnicek, "#ACCELERATE"; see also Srnicek and Williams, *Inventing the Future*.

19. Cuboniks, *Xenofeminism*, 93.

20. Benjamin, *Illuminations*, 264.

21. Benjamin, *SW2*, 424.

22. Benjamin, *SW1*, 260.

23. Badiou, *Communist*, 62.

24. Freud, "Mourning and Melancholia," 322.

25. Laplanche, *Essays*, 256–257.

26. As in the rapid growth of the Democratic Socialist Party in the United States following the 2016 elections.

27. Gilio-Whitaker, "Idle No More"; Taylor, *From #BlackLivesMatter*.

28. Rodenbeck, *Radical Prototypes*, 28.

29. Benjamin, *SW4*, 391.

30. Aftselakhis Spectacle Committee, "Statement."

31. Benjamin, *SW4*, 391.

32. For a thoughtful analysis, see Woloshyn, "Sounding the Halluci Nation."

33. Butler, *Parting Ways*, 12.

34. Laplanche, *Seduction*, 201.

35. Benjamin, *SW2*, 542.

36. Winnicott, *Playing and Reality*.

37. Benjamin, *SW2*, 542.

BIBLIOGRAPHY

2bears, Jackson. "My Post-Indian Technological Autobiography." In *Coded Territories: Tracing Indigenous Pathways in New Media Art*, edited by Steven Loft and Kerry Swanson, 12–29. Calgary: University of Calgary Press, 2014.

A Tribe Called Red. "NDNs from All Directions." August 18, 2011. YouTube.

———. "The Road." December 21, 2012. Soundcloud.

Abbott-Barish, Claudia, and Meghan Murphy. "Activating the Healers Infobook." rootmedicine.org, n.d. Accessed August 11, 2011.

Abrahams, Roger D. *Everyday Life: A Poetics of Vernacular Practices*. Philadelphia: University of Pennsylvania Press, 2011.

Addington, Robert, ed. *Sound Commitments: Avant-Garde Music and the Sixties*. Oxford: Oxford University Press, 2009.

Aftselakhis Spectacle Committee. "The Purim Ball: Your Hamentashen Are Killing Me!" invitation. JFREJ (Jews for Racial and Economic Justice). Accessed March 10, 2012. jfrej.org.

———. "Statement from the Aftselakhis Spectacle Committee." Aftselokhis Ladies' Auxiliary Spectacle Committee, March 13, 2014.

———. "The Aftselakhis Spectacle Committee's Purimshpil." Accessed June 21, 2019. http://spectaclecommittee.org.

———. "Your Hamentashen Are Killing Me—Program," March 3, 2012.

Agamben, Giorgio. "In Praise of Profanation." In *Profanations*, translated by Jeff Fort, 73–92. Cambridge, MA: Zone Books, 2007.

———. *Means without Ends: Notes on Politics*. Translated by Vincenzo Binetti and Cesare Casarino. Minneapolis: University of Minnesota Press, 2000.

Ahmed, Sara. *The Cultural Politics of Emotion*. New York: Routledge, 2004.

Alexander, Christopher, Sara Ishikawa, and Murray Silverstein. *A Pattern Language: Towns, Buildings, Construction*. New York: Oxford University Press, 1977.

Alfred, Taiaiake. *Wasáse: Indigenous Pathways of Action and Freedom*. Toronto: University of Toronto Press, 2009.

Alioff, Maurie, and Susan Schouten Levine. "Interview: The Long Walk of Alanis Obomsawin." *Cinema Canada* 142 (1987): 10–15.

Anderson, Kim. *Life Stages and Native Women: Memory, Teachings, and Story Medicine*. Winnipeg, MB: University of Manitoba Press, 2011.

Architekturzentrum Wien, ed. *Lessons from Bernard Rudofsky: Life as a Voyage*. Basel: Birkhäuser, 2007.

Arendt, Hannah. *The Human Condition*. Charles R. Walgreen Foundation Lectures. Chicago: University of Chicago Press, 1958.

———. *The Promise of Politics*. Edited by Jerome Kohn. New York: Schocken Books, 2005.

Artaud, Antonin. "The Pursuit of Fecality." From "To Have Done with the Judgment of God: A Radio Play (1947)." In *Selected Writings*, edited by Susan Sontag, translated by Helen Weaver, 559–562. Berkeley: University of California Press, 1989.

Ashbee, Edward. "Politics of Paleoconservatism." *Society* 37, no. 3 (March 2000): 75–84.

Ashton, Kevin. "You Didn't Make the Harlem Shake Go Viral—Corporations Did." Quartz, March 28, 2013. https://qz.com/67991/you-didnt-make -the-harlem-shake-go-viral-corporations-did/.

Badger, Gina. "In and Out of Time: An Interview with Dori Midnight." *No More Potlucks*, 2011. http://nomorepotlucks.org/site/in-out-of-time -an-interview-with-dori-midnight/.

Badiou, Alain. *The Communist Hypothesis*. Translated by David Macey and Steve Corcoran. London: Verso, 2010.

Bakhtin, M. M. *Rabelais and His World*. Translated by Hélène Iswolsky. Bloomington: Indiana University Press, 1984.

Balibar, Étienne, Barbara Cassin, and Sandra Laugier. "Praxis." In *Dictionary of Untranslatables: A Philosophical Lexicon*, edited by Barbara Cassin, Steven Rendall, and Emily S. Apter, 820–832. Princeton, NJ: Princeton University Press, 2014.

Barad, Karen. *Meeting the Universe Halfway: Quantum Physics and the Entanglement of Matter and Meaning*. Durham, NC: Duke University Press, 2007.

———. "Nature's Queer Performativity (the Authorized Version)." *Kvinder, Køn Og Forskning / Women, Gender and Research* 1–2 (2012): 25–53.

———. "On Touching: The Inhuman That Therefore I Am." *Differences: A Journal of Feminist Cultural Studies* 28, no. 3 (2012): 206–223.

———. "Posthumanist Performativity: Toward an Understanding of How Matter Comes to Matter." *Signs: Journal of Women in Culture and Society* 28, no. 3 (2003): 801–831.

Baraka, Amiri. "The Changing Same (R&B and the New Black Music)." In *The Leroi Jones / Amiri Baraka Reader*, edited by William J. Harris, 186–208. New York: Thunder's Mouth Press, 1991.

Barthes, Roland. "Reading Brillat-Savarin." In *The Rustle of Language*, translated by Richard Howard, 250–270. Berkeley: University of California Press, 1989.

Bataille, Georges. *Visions of Excess: Selected Writings, 1927–1939*. Translated by Allan Stoekl. Minneapolis: University of Minnesota Press, 1985.

Baumgarten, Jean. "Purim-Shpil." Translated by Cecilia Grayson. In *YIVO Encyclopedia of Jews in Eastern Europe*. October 13, 2010. http://www .yivoencyclopedia.org/article.aspx/Purim-shpil.

Belkin, Ahuva. "Ritual Space as Theatrical Space in Jewish Folk Theatre." In *Jewish Theatre: A Global View*, edited by Edna Nahshon, 15–24. Leiden: Brill, 2009.

Bell, John. "The End of Our Domestic Resurrection Circus: Bread and Puppet Theater and Counterculture Performance in the 1990s." *TDR: The Drama Review* 43, no. 3 (1999): 62–80.

Benjamin, Walter. *The Arcades Project*. Translated by Howard Eiland and Kevin McLaughlin. Cambridge, MA: Belknap Press, 1999.

———. *Illuminations: Essays and Reflections*. Edited by Hannah Arendt. Translated by Harry Zohn. New York: Schocken Books, 1969.

————. *Selected Writings*. Volume 1, *1913–1926*. Edited by Marcus Bullock and Michael W. Jennings. Cambridge, MA: Belknap Press of Harvard University Press, 1996.

————. *Selected Writings*. Volume 2, *1927–1934*. Edited by Michael W. Jennings, Howard Eiland, and Gary Smith. Translated by Rodney Livingstone and others. Cambridge, MA: Belknap Press of Harvard University Press, 1999.

————. *Selected Writings*. Volume 3, *1935–1938*. Edited by Howard Eiland and Michael W. Jennings. Translated by Edmund Jephcott, Howard Eiland, and others. Cambridge, MA: Belknap Press of Harvard University Press, 2002.

————. *Selected Writings*. Volume 4, *1938–1940*. Edited by Howard Eiland and Michael W. Jennings. Translated by Edmund Jephcott and others. Cambridge, MA: Belknap Press of Harvard University Press, 2003.

————. "Theologico-Political Fragment." In *Reflections: Essays, Aphorisms, Autobiographical Writings*. Edited by Peter Demetz. Translated by Edmund Jephcott, 312–313. New York: Schocken Books, 1986.

Berardi, Franco "Bifo." Introduction to *The Wretched of the Screen*, by Hito Steyerl, 9–11. Berlin: Sternberg Press, 2013.

————. *The Soul at Work: From Alienation to Autonomy*. Translated by Francesca Cadel. Los Angeles: Semiotext(e), 2009.

Berlant, Lauren. *The Queen of America Goes to Washington City: Essays on Sex and Citizenship*. Durham, NC: Duke University Press, 1997.

Berlin, Adele. *Esther: The JPS Bible Commentary*. Philadelphia: Jewish Publication Society, 2001.

Bey, Hakim [Peter Lamborn Wilson]. *T.A.Z.: The Temporary Autonomous Zone*. 2nd ed. New York: Autonomedia, 2003.

Biddle, Jennifer Loureide. *Remote Avant-Garde: Aboriginal Art under Occupation*. Durham, NC: Duke University Press, 2016.

Bishop, Claire. *Artificial Hells: Participatory Art and the Politics of Spectatorship*. London: Verso, 2012.

Bithell, Caroline, and Juniper Hill, eds. *The Oxford Handbook of Music Revival*. Oxford: Oxford University Press, 2014.

Boelstorff, Tom. "When Marriage Falls: Queer Coincidences in Straight Time." *GLQ* 13, no. 2–3 (2007): 227–248.

Bookchin, Murray. *Social Anarchism or Lifestyle Anarchism: An Unbridgeable Chasm*. Oakland, CA: AK Press, 1995.

Boon, Marcus. *In Praise of Copying*. Cambridge, MA: Harvard University Press, 2010.

———. "One Nation under a Groove?: Music, Sonic Borders, and the Politics of Vibration." *Sounding Out!* (blog), February 4, 2013. https://soundstudiesblog.com/2013/02/04/one-nation-under-a-groove-sonic-borders-and-the-politics-of-vibration/.

Boon, Marcus, and Gabriel Levine, eds. *Practice*. Cambridge, MA: Whitechapel Gallery / MIT Press, 2018.

———. "The Promise of Practice." In *Practice*, edited by Marcus Boon and Gabriel Levine, 12–23. Cambridge, MA: Whitechapel Gallery / MIT Press, 2018.

Borris, Eileen, and Rhacel Salazar Parreñas, eds. *Intimate Labors: Cultures, Technologies and the Politics of Care*. Stanford, CA: Stanford University Press, 2010.

Bourdieu, Pierre. *Distinction: A Social Critique of the Judgment of Taste*. Translated by Richard Nice. Cambridge, MA: Harvard University Press, 1984.

———. *The Logic of Practice*. Translated by Richard Nice. Stanford, CA: Stanford University Press, 1990.

Bourriaud, Nicolas. *Postproduction: Culture as Screenplay; How Art Reprograms the World*. 2nd ed. New York: Lukas & Sternberg, 2005.

Boyarin, Jonathan, and Daniel Boyarin. *Powers of Diaspora: Two Essays on the Relevance of Jewish Culture*. Minneapolis: University of Minnesota Press, 2002.

Brecht, Stefan. *Peter Schumann's Bread and Puppet Theater*. 2 vols. London: Methuen, 1988.

Brillat-Savarin, Jean Anthelme. *The Physiology of Taste; or, Meditations on Transcendental Gastronomy*. Translated by M. F. K. Fisher. New York: Knopf, 2009.

Brossat, Alain, and Sylvia Klingberg. *Revolutionary Yiddishland: A Story of Jewish Radicalism*. Translated by David Fernbach. New York: Verso, 2016.

Brown, Jayna. "Buzz and Rumble: Global Pop Music and Utopian Impulse." *Social Text* 28, no. 1 (2010): 125–146.

Brown, Wendy. "Resisting Left Melancholy." *Boundary 2* 26, no. 3 (1999): 19–27.

Browner, Tara. "An Acoustic Geography of Intertribal Pow-Wow Songs." In *Music of the First Nations: Tradition and Innovation in Native North America*, edited by Tara Browner, 131–140. Urbana: University of Illinois Press, 2009.

Buccafusco, Christopher J. "On the Legal Consequences of Sauces: Should Thomas Keller's Recipes Be Per Se Copyrightable?" *Cardozo Arts & Entertainment Law Journal* 24 (2006/2007): 1121–1156.

Buck-Morss, Susan. "Aesthetics and Anaesthetics: Walter Benjamin's Artwork Essay Reconsidered." *October* 62 (1992): 3–41.

Buhner, Stephen Harrod. *Sacred and Herbal Healing Beers: The Secrets of Ancient Fermentation*. Boulder, CO: Siris Press, 1998.

Bürger, Peter. *Theory of the Avant-Garde*. Translated by Michael Shaw. Minneapolis: University of Minnesota Press, 1984.

Butler, Judith. "Bodies in Alliance and the Politics of the Street." *Transversal Texts: European Institute for Progressive Cultural Policies*, September 2011. http://www.eipcp.net/transversal/1011/butler/en.

———. "Critically Queer." *GLQ* 1, no. 1 (1993): 17–32.

———. *Parting Ways: Jewishness and the Critique of Zionism*. New York: Columbia University Press, 2012.

———. *Precarious Life: The Powers of Mourning and Violence*. London: Verso, 2004.

Butler, Mark J. *Unlocking the Groove: Rhythm, Meter, and Musical Design in Electronic Dance Music*. Bloomington: Indiana University Press, 2006.

Caffentzis, George. "The Future of 'The Commons': Neoliberalism's 'Plan B' or the Original Disaccumulation of Capital?" *New Formations* 69 (2010): 23–41.

Cameron, Emilie. "Indigenous Spectrality and the Politics of Postcolonial Ghost Stories." *Cultural Geographies* 15, no. 3 (2008): 383–393.

Campbell, Maria. Foreword to *Life Stages and Native Women: Memory, Teachings, and Story Medicine*, by Kim Anderson, xv–xix. Winnipeg: University of Manitoba Press, 2011.

Carlsson, Chris. *Nowtopia: How Pirate Programmers, Outlaw Bicyclists, and Vacant-lot Gardeners Are Inventing the Future Today*. Oakland, CA: AK Press, 2008.

Certeau, Michel de. *The Practice of Everyday Life*. Translated by Steven Rendall. 2nd ed. Berkeley: University of California Press, 2002.

Certeau, Michel de, Luce Giard, and Pierre Mayol. *The Practice of Everyday Life*. Volume 2, *Living and Cooking*. Translated by Timothy J. Tomasik. Minneapolis: University of Minnesota Press, 1998.

Christen, Kimberley. "Gone Digital: Aboriginal Remix and the Cultural Commons." *International Journal of Cultural Property* 12, no. 3 (2005): 315–345.

Clare, Eli. *Exile and Pride: Disability, Queerness, and Liberation*. Cambridge, MA: South End Press, 1999.

Clark, T. J. "For a Left with No Future." *New Left Review* 74 (2012): 53–75.

Clayton, Jace. "The Aztec Imagery and Digital Soundworld of Mexican Producer Javier Estrada." *Frieze*, September 1, 2012. https://frieze.com /article/music-19.

Clemens, Raymond, ed. *The Voynich Manuscript*. New Haven, CT: Yale University Press, 2016.

Clifford, James. "On Ethnographic Allegory." In *Writing Culture: The Poetics and Politics of Ethnography*, edited by James Clifford and George F. Marcus, 98–121. Berkeley: University of California Press, 1986.

Clover, Joshua. *1989: Bob Dylan Didn't Have This to Sing About*. Berkeley: University of California Press, 2009.

Collins, Lisa Gail, and Margo Natalie Crawford, eds. *New Thoughts on the Black Arts Movement*. New Brunswick, NJ: Rutgers University Press, 2006.

Comaroff, John L., and Jean Comaroff. *Ethnicity, Inc.* Chicago: University of Chicago Press, 2009.

Conquergood, Dwight. "Performance Studies: Interventions and Radical Research." *TDR: The Drama Review* 46, no. 2 (2002): 145–156.

Cornellier, Bruno. "The 'Indian Thing': On Representation and Reality in the Liberal Settler Colony." *Settler Colonial Studies* 3, no. 1 (2013): 49–64.

Côté, Marcel. "Filled with Animals." *Eatbees* (blog), August 26, 2013. http:// www.eatbees.com/blog/2013/08/26/filled-with-animals/.

Coulthard, Glen Sean. "Beyond Recognition: Indigenous Self-Determination as Prefigurative Practice." In *Lighting the Eighth Fire: The Liberation, Resurgence, and Protection of Indigenous Nations*, edited by Leanne Simpson, 187–204. Winnipeg: Arbeiter Ring Publishing, 2008.

———. *Red Skin, White Masks: Rejecting the Colonial Politics of Recognition*. Minneapolis: University of Minnesota Press, 2014.

Crawley, Ashon T. *Blackpentecostal Breath: The Aesthetics of Possibility*. New York: Fordham University Press, 2017.

Crimp, Douglas. "Mourning and Militancy." *October* 51 (1989): 3–18.

Critchley, Simon. *Infinitely Demanding: Ethics of Commitment, Politics of Resistance*. London: Verso, 2013.

Cuboniks, Laboria. *Xenofeminism: A Politics for Alienation*. New York: Verso, 2018.

Dean, Jodi. "Communist Desire." In *The Ends of History: Questioning the Stakes of Historical Reason*, edited by Amy Swiffen and Joshua Nichols, 5–22. New York: Routledge, 2013.

Deloria, Philip. *Playing Indian.* New Haven: Yale University Press, 1998.

Denzin, Norman K., Yvonna S. Lincoln, and Linda Tuhiwai Smith, eds. *Handbook of Critical and Indigenous Methodologies.* Los Angeles: Sage, 2008.

Derrida, Jacques. "Hostipitality." In *Acts of Religion*, translated by Gil Anidjar, 356–420. New York: Routledge, 2002.

———. *Of Hospitality: Anne Dufourmantelle Invites Jacques Derrida to Respond.* Translated by Rachel Bowlby. Stanford, CA: Stanford University Press, 2010.

———. *Specters of Marx: The State of the Debt, the Work of Mourning and the New International.* Translated by Peggy Kamuf. New York: Routledge, 2006.

Didi-Huberman, Georges. "Artistic Survival: Panofsky vs. Warburg and the Exorcism of Impure Time." *Common Knowledge* 9, no. 2 (2003): 273–285.

Dinshaw, Carolyn, Lee Edelman, Roderick A. Ferguson, and Carla Freccero. "Theorizing Queer Temporalities: A Roundtable Discussion." *GLQ: A Journal of Lesbian and Gay Studies* 13, no. 2–3 (2007): 177–195.

Doniach, N. S. *Purim or the Feast of Esther: An Historical Study.* Philadelphia: The Jewish Publication Society of America, 1933.

Donovan, Thom. "Five Questions for Contemporary Practice with Claire Pentecost." *Art21 Magazine*, January 31, 2012. http://magazine.art21.org/2012/01/31/5-questions-for-contemporary-practice-with-claire-pentecost.

Douglas, Mary. *Purity and Danger: An Analysis of Concepts of Pollution and Taboo.* New York: Praeger, 1996.

Douzinas, Costas, and Slavoj Žižek, eds. *The Idea of Communism.* London: Verso, 2010.

Dubinsky, Karen, Catherine Krull, Susan Lord, Sean Mills, and Scott Rutherford, eds. *New World Coming: The Sixties and the Shaping of Global Consciousness.* Toronto: Between the Lines, 2009.

Duggan, Lisa. "The New Homonormativity: The Sexual Politics of Neoliberalism." In *Materializing Democracy: Toward a Revitalized Cultural Politics*, edited by Russ Castronovo and Dana D. Nelson, 175–194. Durham, NC: Duke University Press, 2002.

Durham, Jimmie. *A Certain Lack of Coherence: Writings on Art and Cultural Politics.* London: Kala Press, 1993.

Durkheim, Emile. *The Elementary Forms of Religious Life*. Translated by Karen E. Fields. New York: Free Press, 1995.

Eagleton, Terry. *The Ideology of the Aesthetic*. Oxford: Blackwell, 1990.

———. *Walter Benjamin, or Towards a Revolutionary Criticism*. London: Verso, 1981.

Eisenstadt, S. N. "Multiple Modernities." *Daedalus* 129, no. 1 (2000): 1–29.

Emerson, Caryl. *The First Hundred Years of Mikhail Bakhtin*. Princeton, NJ: Princeton University Press, 1997.

Epstein, Shifra. "The 'Drinking Banquet' *(Trink-Siyde)*: A Hasidic Event for Purim." *Poetics Today* 15, no. 1 (1994): 133–152.

Eshun, Kodwo. "Further Considerations on Afrofuturism." *CR: The New Centennial Review* 3, no. 2 (2003): 287–302.

———. *More Brilliant than the Sun: Adventures in Sonic Fiction*. London: Quartet Books, 1998.

Esposito, Roberto. *Communitas: The Origin and Destiny of Community*. Translated by Timothy Campbell. Stanford, CA: Stanford University Press, 2010.

———. *Immunitas: The Protection and Negation of Life*. Translated by Zakya Hanafi. Cambridge, UK: Polity Press, 2011.

Esteva, Gustavo, and Madhu Suri Prakash. *Grassroots Post-modernism: Remaking the Soil of Cultures*. London: Zed Books, 1998.

Evans, Jessica. "Buffy Sainte-Marie Art Exhibit at Gurevich Fine Art." Buffy Sainte-Marie Official Website, October 15, 2012. http://buffysainte-marie.com/?p=161.

Ewart, Douglas, Nicole Mitchell, Roscoe Mitchell, Famadou Don Moye, Matana Roberts, Jaribu Shahid, Wadada Leo Smith, and Corey Wilkes. "Ancient to the Future: Celebrating 40 Years of the AACM." In *People Get Ready: The Future of Jazz Is Now!*, edited by Ajay Heble and Rob Wallace, 244–264. Durham, NC: Duke University Press, 2013.

Fabian, Johannes. *Time and the Other: How Anthropology Makes Its Object*. New York: Columbia University Press, 1983.

Fallon [Morell], Sally, with Mary G. Enig. *Nourishing Traditions: The Cookbook That Challenges the Politically Correct Diet Dictocrats*. 2nd ed. Washington, DC: New Trends Publishing, 2001.

Fanon, Frantz. "On National Culture." In *The Wretched of the Earth*. Translated by Richard Philcox, 145–180. New York: Grove Press, 2004.

Farber, David. "Building the Counterculture, Creating Right Livelihoods: The Counterculture at Work." *The Sixties: A Journal of History, Politics and Culture* 6, no. 1 (2013): 1–24.

Feld, Steven. "From Schizophonia to Schismogenesis: On the Discourses and Commodification Practices of 'World Music' and 'World Beat.'" In *Music Grooves: Essays and Dialogues*, edited by Steven Feld and Charles Keil, 257–289. Chicago: University of Chicago Press, 1994.

Fielitz, Maik, and Nick Thurston. *Post-Digital Cultures of the Far Right: Online Actions and Offline Consequences in Europe and the US*. Bielefeld: transcript Verlag, 2018.

Fisch, Harold. "Reading and Carnival: On the Semiotics of Purim." *Poetics Today* 15, no. 1 (1994): 55–74.

Foucault, Michel. "The Ethics of the Concern for Self as a Practice of Freedom." Translated by P. Aranov and D. McGrawth. In *Ethics: Subjectivity and Truth*. Volume 1 of *The Essential Works of Michel Foucault*, edited by Paul Rabinow, translated by Robert Hurley and others, 281–302. New York: New Press, 1997.

———. *L'usage des plaisirs. Histoire de la sexualité, II*. Paris: Gallimard, 1984.

———. *The Use of Pleasure*. Volume 2 of *The History of Sexuality* (4 vols.), translated by Robert Hurley. New York: Vintage Books, 1990.

———. "What Is Enlightenment?" Translated by Catherine Porter. In *Ethics: Subjectivity and Truth*. Volume 1 of *The Essential Works of Michel Foucault*, edited by Paul Rabinow, translated by Robert Hurley and others, 303–320. New York: New Press, 1997.

Fournier, Lauren, ed. *Fermenting Feminism*. Laboratory for Aesthetics and Ecology, 2017. https://e-artexte.ca/id/eprint/28709/.

Francis, Daniel. *The Imaginary Indian: The Image of the Indian in Canadian Culture*. Vancouver: Arsenal Pulp Press, 1992.

Francis, Margot. *Creative Subversions: Whiteness, Indigeneity and the National Imaginary*. Vancouver: University of British Columbia Press, 2011.

Freeman, Barry. "Theatre for a Changeable World, or Making Room for a Fire." In *In Defence of Theatre: Aesthetic Practices and Social Interventions*, edited by Kathleen Gallagher and Barry Freeman, 21–34. Toronto: University of Toronto Press, 2016.

Freeman, Elizabeth. *Time Binds: Queer Temporalities, Queer Histories*. Durham, NC: Duke University Press, 2010.

Freud, Sigmund. "Mourning and Melancholia." In *The Penguin Freud Reader*, edited by Adam Phillips, 310–326. London: Penguin, 2006.

———. "Remembering, Repeating and Working-Through." In *The Standard Edition of the Complete Psychological Works of Sigmund Freud*, edited and translated by James Strachey, 12:147–156. London: Hogarth Press, 1958.

Garneau, David. "Extra-Rational Aesthetic Action and Cultural Decolonization." *FUSE Magazine* 36, no. 4 (2013): 15–16.

Geniusz, Wendy Makoons. *Our Knowledge Is Not Primitive: Decolonizing Botanical Anishinaabe Teachings*. Syracuse, NY: Syracuse University Press, 2009.

Gilio-Whitaker, Dina. "Idle No More and Fourth World Social Movements in the New Millennium." *South Atlantic Quarterly* 114, no. 4 (2015): 866–877.

Gilroy, Paul. *The Black Atlantic: Modernity and Double-Consciousness*. Cambridge, MA: Harvard University Press, 1993.

Ginsburg, Faye. "The Indigenous Uncanny: Accounting for Ghosts in Recent Indigenous Australian Experimental Media." *Visual Anthropology Review* 34, no. 1 (2018): 67–76.

———. "Screen Memories: Resignifying the Traditional in Indigenous Media." In *Media Worlds: Anthropology on New Terrain,* edited by Faye D. Ginsburg, Lila Abu-Lughod, and Brian Larkin, 39–57. Berkeley: University of California Press, 2002.

Ginsburg, Faye, and Fred Myers. "A History of Aboriginal Futures." *Critique of Anthropology* 26, no. 1 (2006): 27–45.

Girard, René. *Violence and the Sacred*. Translated by Patrick Gregory. Baltimore: Johns Hopkins University Press, 1977.

Goldie, Terrie. *Fear and Temptation: The Image of the Indigene in Canadian, Australian and New Zealand Literature*. Kingston, ON: McGill-Queen's University Press, 1989.

Goodman, Steve. *Sonic Warfare: Sound, Affect, and the Ecology of Fear*. Cambridge, MA: MIT Press, 2010.

Gordon, Avery F. *Ghostly Matters: Haunting and the Sociological Imagination*. Minneapolis: University of Minnesota Press, 2008.

Graeber, David, and Neal Rockwell. *Capitalism Is Just a Really Bad Way of Organizing Communism: Neal Rockwell in Conversation with David Graeber*. Montreal: Palimpsest/WWTWO, 2011.

Gratton, Johnnie, and Michael Sheringham. "Tracking the Art of the Project: History, Theory, Practice." In *The Art of the Project: Projects and Experiments in French Culture*, edited by Johnnie Gratton and Michael Sheringham, 1–30. New York: Bergahn Books, 2005.

Green, Rayna. "The Tribe Called Wannabee: Playing Indian in America and Europe." *Folklore* 99, no. 1 (1988): 30–55.

Halberstam, J. *In a Queer Time and Place: Transgender Bodies, Subcultural Lives*. New York: NYU Press, 2005.

Handler, Richard, and Jocelyn Linnekin. "Tradition, Genuine or Spurious." *The Journal of American Folklore* 97, no. 385 (1984): 273–290.

Haraway, Donna. "Anthropocene, Capitalocene, Plantationocene, Chthulucene: Making Kin." *Environmental Humanities* 6 (2015): 159–165.

———. *The Companion Species Manifesto: Dogs, People, and Significant Otherness*. Chicago: Prickly Paradigm Press, 2003.

———. *Staying with the Trouble: Making Kin in the Chthulucene*. Durham, NC: Duke University Press, 2016.

Hardt, Michael, and Antonio Negri. *Commonwealth*. Cambridge, MA: Belknap Press of Harvard University Press, 2009.

Harney, Stefano, and Fred Moten. "Michael Brown." *Boundary 2* 42, no. 4 (2015): 81–87.

———. *The Undercommons: Fugitive Planning and Black Study*. Wivenhoe, UK: Minor Compositions, 2013.

Harris, Cole. "How Did Colonialism Dispossess? Comments from an Edge of Empire." *Annals of the Association of American Geographers* 94, no. 1 (2004): 165–182.

Harvey, David. *A Brief History of Neoliberalism*. New York: Oxford University Press, 2005.

———. *The Condition of Postmodernity: An Enquiry into the Origins of Cultural Change*. Cambridge, UK: Blackwell, 1989.

Hayden, Brian, Neil Canuel, and Jennifer Shanse. "What Was Brewing in the Natufian? An Archaeological Assessment of Brewing Technology in the Epipaleolithic." *Journal of Archaeological Method and Theory* 20, no. 1 (2013): 102–150.

Hebdige, Dick. *Cut 'n' Mix: Culture, Identity, and Caribbean Music*. London: Methuen, 1987.

Hegel, G. W. F. *Phenomenology of Spirit*. Translated by A. V. Miller. Oxford: Oxford University Press, 1977.

Henriques, Julian. *Sonic Bodies: Reggae Sound Systems, Performance Techniques and Ways of Knowing*. New York: Continuum, 2011.

Herbst, Marc, and Christina Ulrike. "Editorial." "Grassroots Modernism." Special issue, *Journal of Aesthetics and Protest* 8 (2011): 3–12.

Herring, Peg. "The Secret Life of Soil." Oregon State University: OSU Extension Service, January 10, 2010. https://extension.oregonstate.edu /news/secret-life-soil.

Herring, Scott. "Out of the Closets, Into the Woods: *RFD*, *Country Women*, and the Post-Stonewall Emergence of Queer Anti-Urbanism." *American Quarterly* 59, no. 2 (2007): 341–372.

Hey, Maya, and Alexandra Ketchum, eds. "Food, Feminism, and Fermentation." Special issue, *Cuizine: The Journal of Canadian Food Cultures* 9, no. 2 (2018).

Hill, Richard W. *The World Upside Down / Le Monde à l'envers*. Banff, AB: Walter Phillips Gallery Editions, 2008.

Hobsbawm, E. J., and T. O. Ranger, eds. *The Invention of Tradition*. Cambridge, UK: Cambridge University Press, 1992.

hooks, bell. "Black Vernacular: Architecture as Cultural Practice." In *Art on My Mind: Visual Politics*, 145–151. New Press, 1995.

———. "Performance Practice as a Site of Opposition." In *Let's Get It On: The Politics of Black Performance*, edited by Catherine Ugwu, 210–221. Seattle: Bay Press, 1995.

Hopkins, Candice. "Making Things Our Own: The Indigenous Aesthetic in Digital Storytelling." *Leonardo* 39, no. 4 (2006): 341–344.

Horowitz, Elliott. *Reckless Rites: Purim and the Legacy of Jewish Violence*. Princeton, NJ: Princeton University Press, 2006.

———. "The Rite to Be Reckless: On the Perpetration and Interpretation of Purim Violence." *Poetics Today* 15, no. 1 (1994): 9–54.

Idel, Moshe. *Old Worlds, New Mirrors: On Jewish Mysticism and Twentieth-Century Thought*. Philadelphia: University of Pennsylvania Press, 2010.

"Idle No More, Defenders of the Land Call for Intensifying Actions through Spring, Summer." Defenders of the Land, March 18, 2013. http://www .defendersoftheland.org/story/318.

Iglioliorte, Heather, Julie Nagam, and Carla Taunton, eds. "Indigenous Art: New Media and the Digital." Special issue, *PUBLIC*, no. 54 (2016).

Ingram, Mrill. "Fermentation, Rot, and Other Human-Microbial Performances." In *Knowing Nature: Conversations at the Intersection of Political Ecology and Science Studies*, edited by Mara J. Goldman, Paul Nadasdy, and Matthew D. Turner, 99–112. Chicago: University of Chicago Press, 2011.

Inness, Sherrie A. "'Boredom Is Quite Out of the Picture': Women's Natural Foods Cookbooks and Social Change." In *Secret Ingredients: Race, Gender and Class at the Dinner Table*, 83–104. New York: Palgrave Macmillan US, 2006.

Jacobson, Eric. *Metaphysics of the Profane: The Political Theology of Walter Benjamin and Gershom Scholem*. New York: Columbia University Press, 2003.

Jenkins, Joseph C. *The Humanure Handbook: A Guide to Composting Human Manure*. 3rd ed. Grove City, PA: Jenkins Publishing, 2005.

Johnson, Gaye Theresa, and Alex Lubin, eds. *Futures of Black Radicalism*. London and New York: Verso, 2017.

Johnston, Anna, and Alan Lawson. "Settler Colonies." In *A Companion to Postcolonial Studies*, edited by Henry Schwartz and Sangeeta Ray, 360–376. Malden, MA: Blackwell, 2000.

Kant, Immanuel. "An Answer to the Question: What Is Enlightenment?" In *Perpetual Peace and Other Essays*, translated by Ted Humphrey, 41–48. Indianapolis: Hackett, 1983.

Kaprow, Allan. "Nontheatrical Performance." In *Essays on the Blurring of Art and Life*, 163–180. Berkeley: University of California Press, 2003.

Katz, Dovid. *Words on Fire: The Unfinished Story of Yiddish*. New York: Basic Books, 2004.

———. *Yiddish and Power: Ten Overhauls of a Stateless Language*. New York: Palgrave Macmillan, 2015.

Katz, Sandor. *The Art of Fermentation: An In-Depth Exploration of Essential Concepts and Processes from Around the World*. White River Junction, VT: Chelsea Green Publication Company, 2012.

———. "Interview by Sarah Schulman and Jim Hubbard." ACT UP Oral History Project, October 15, 2004. http://www.actuporalhistory.org /interviews/interviews_10.html#katz.

———. *The Revolution Will Not Be Microwaved: Inside America's Underground Food Movements*. White River Junction, VT: Chelsea Green Publication Company, 2006.

———. *Wild Fermentation: The Flavor, Nutrition, and Craft of Live-Culture Foods*. White River Junction, VT: Chelsea Green Publication Company, 2003.

Kaye/Kantrowitz, Melanie. *The Colors of Jews: Racial Politics and Radical Diasporism*. Bloomington, IN: Indiana University Press, 2007.

Keene, Adrienne. "Why Tonto Matters." *Native Appropriations* (blog), March 16, 2012. http://nativeappropriations.com/2012/03/why-tonto -matters.html.

Keil, Charles. "Participatory Discrepancies and the Power of Music." In *Music Grooves: Essays and Dialogues*, edited by Steven Feld and Charles Keil, 96–108. Chicago: University of Chicago Press, 1994.

Khatib, Sami. "Walter Benjamin and the 'Tradition of the Oppressed.'" *Anthropological Materialism* (blog), July 9, 2015. https:// anthropologicalmaterialism.hypotheses.org/2128.

Kino-nda-niimi Collective, ed. *The Winter We Danced: Voices from the Past, the Future, and the Idle No More Movement.* Winnipeg: Arbeiter Ring Publishing, 2014.

Kirk, Marshall, and Heather Madsen. *After the Ball: How America Will Conquer Its Fear and Hatred of Gays in the '90s.* New York: Doubleday, 1989.

Kirshenblatt-Gimblett, Barbara. *Destination Culture: Tourism, Museums, and Heritage.* Berkeley: University of California Press, 1998.

———. "Playing to the Senses: Food as a Performance Medium." In *Performance Research: On Cooking*, edited by Richard Gough, 1–30. London: Routledge, 1999.

Koffman, David S. "Playing Indian at Jewish Summer Camp: Lessons on Tribalism, Assimilation, and Spirituality." *Journal of Jewish Education* 84, no. 4 (2018): 413–440.

Kovach, Margaret. *Indigenous Methodologies: Characteristics, Conversations, and Contexts.* Toronto: University of Toronto Press, 2010.

Kraut, Anthea. *Choreographing the Folk: The Dance Stagings of Zora Neale Hurston.* Minneapolis: University of Minnesota Press, 2008.

Kruglanski, Aviv, Vahida Ramujkić, and Moshe Robas. "Microcultures: A Zine Designed to Generate Debate about Fermentation: Social, Economic, and Culinary." PDF File. Microcultures: A Collaboration with Micro-Organisms. Accessed January 13, 2013. http://bbva.irational.org /microcultures/microcultures_zine/microcultures_booklet.pdf.

Krystal, Matthew. *Indigenous Dance and Dancing Indian: Contested Representation in the Global Era.* Boulder: University Press of Colorado, 2012.

KuroDalaiJee. "Performance Collectives in 1960s Japan: With a Focus on the 'Ritual School.'" *Positions: East Asia Cultures Critique* 21, no. 2 (2013): 417–447.

Laplanche, Jean. *Essays on Otherness.* New York: Routledge, 1999.

———. *Seduction, Translation and the Drives.* Edited by John Fletcher and Martin Stanton. Translated by Martin Stanton. London: Institute of Contemporary Arts, 1992.

Laplanche, Jean, and J.-B. Pontalis. *The Language of Psychoanalysis.* Translated by Donald Nicholson-Smith. London: Hogarth Press and the Institute of Psycho-Analysis, 1973.

LaRocque, Emma. *When the Other Is Me: Native Resistance Discourse, 1850–1990*. Winnipeg: University of Manitoba Press, 2010.

Latour, Bruno. *The Pasteurization of France*. Translated by Alan Sheridan and John Law. Cambridge, MA: Harvard University Press, 1988.

———. *We Have Never Been Modern*. Translated by Catherine Porter. Cambridge, MA: Harvard University Press, 1993.

———. "Why Has Critique Run Out of Steam? From Matters of Fact to Matters of Concern." *Critical Inquiry* 30, no. 2 (2004): 225–248.

Lawrence, Bonita. *"Real" Indians and Others: Mixed-Blood Urban Native Peoples and Indigenous Nationhood*. Vancouver: University of British Columbia Press, 2004.

Lessig, Lawrence. *Remix: Making Art and Culture Thrive in the Hybrid Economy*. London: Bloomsbury Academic, 2008.

Lewis, George E. *A Power Stronger Than Itself: The AACM and American Experimental Music*. Chicago: University of Chicago Press, 2009.

Linebaugh, Peter. "Enclosures from the Bottom Up." *Radical History Review* 108 (2010): 11–27.

———. Introduction to *William Morris: Romantic to Revolutionary*, by E. P. Thompson. Oakland: PM Press, 2011.

———. *The Magna Carta Manifesto: Liberties and Commons for All*. Berkeley: University of California Press, 2008.

Linebaugh, Peter, and Marcus Rediker. *The Many-Headed Hydra: Sailors, Slaves, Commoners, and the Hidden History of the Revolutionary Atlantic*. Boston: Beacon Press, 2000.

Locke, John. *Second Treatise of Government*. 1689. Edited by C. B. Macpherson. Indianapolis: Hackett, 1980.

Loft, Steven, and Kerry Swanson, eds. *Coded Territories: Tracing Indigenous Pathways in New Media Art*. Calgary: University of Calgary Press, 2014.

Lyons, Scott Richard. *X-Marks: Native Signatures of Assent*. Minneapolis: University of Minnesota Press, 2010.

Margulis, Lynn. "Did Sex Emerge from Cannibalism? Sex, Death and Kefir." Originally published 1994. *Scientific American*, November 23, 2011. https://www.scientificamerican.com/article/sex-death-kefir-lynn-margulis/.

Margulis, Lynn, and Dorion Sagan. *Microcosmos: Four Billion Years of Microbial Evolution*. Berkeley: University of California Press, 1986.

Marker, Chris. "Sans Soleil / Sunless." markertext.com. Accessed June 13, 2019. http://markertext.com/sans_soleil.htm.

Marranca, Bonnie, and Gautam Dasgupta. *Theatre of the Ridiculous*. Rev. ed. Baltimore: Johns Hopkins University Press, 1988.

Martineau, Jarrett, and Eric Ritskes. "Fugitive Indigeneity: Reclaiming the Terrain of Decolonial Struggle through Indigenous Art." *Decolonization: Indigeneity, Education & Society* 3, no. 1 (2014).

Marx, Karl. *Capital: A Critique of Political Economy*. Volume 1. Translated by Ben Fowkes. Harmondsworth, UK: Penguin Books, 1990.

Massumi, Brian. "The Autonomy of Affect." *Cultural Critique* 31 (1995): 83–109.

———. *Politics of Affect*. Cambridge, UK: Polity Press, 2015.

Mattson, Rachel. "Queer Political Desire, Radical Aesthetics, and the Possible Effects of Purimshpils in an Actual Existing Democracy." Microsoft Word File. New England American Studies Association, Massachusetts Historical Society, October 1, 2010.

———. "The Rad Jew Performance Archive: A Work-in-Progress." HTML file, n.d.

Mauss, Marcel. "Techniques of the Body." *Economy and Society* 2, no. 1 (February 1, 1973): 70–88.

Mbembe, Achille. *Variations on the Beautiful in the Congolese World of Sound*. Translated by Dominique Malaquais. Vlaeberg, South Africa: Chimurenga, 2004.

McKay, Ian. *The Quest of the Folk: Antimodernism and Cultural Selection in Twentieth-Century Nova Scotia*. Montreal: McGill-Queen's University Press, 2009.

McMahon, Ryan. "The Round Dance Revolution." RPM: Revolutions Per Minute, December 20, 2012. http://rpm.fm/news/the-round-dance -revolution-idle-no-more/.

Means, Russell, and Marvin J. Wolf. *Where White Men Fear to Tread*. New York: St. Martin's Press, 1995.

Mercer, Kobena. "Maroonage of the Wandering Eye: Keith Piper." In *Appropriation*, edited by David Evans, 131–134. Cambridge, MA: Whitechapel Gallery / MIT Press, 2009.

Midnight Notes Collective. "The New Enclosures." In *Midnight Oil: Work, Energy, War, 1973–1992*, 317–333. New York: Autonomedia, 1992.

Milstein, Denise. "Revival Currents and Innovation on the Path from Protest Bossa to Tropicália." In *The Oxford Handbook of Music Revival*, edited by Caroline Bithell and Juniper Hill, 418–441. Oxford: Oxford University Press, 2014.

Moffat, Ken. "Dancing without a Floor: The Artists' Politic of Queer Club Space." *Canadian Online Journal of Queer Studies in Education* 2, no. 1 (2006).

Moore, Jason W. *Capitalism in the Web of Life: Ecology and the Accumulation of Capital*. Brooklyn, NY: Verso, 2015.

Morgan-Feir, Caoimhe. "An Artist's Ritual Bath for Trans and Queer Communities." *Canadian Art*. February 3, 2016. https://canadianart.ca /features/radiodress-queers-the-ritual-bath/.

Morgensen, Scott Lauria. "Arrival at Home: Radical Faerie Configurations of Sexuality and Place." *GLQ* 15, no. 1 (2008): 67–96.

Mortimer-Sandilands, Catriona, and Bruce Erikson, eds. *Queer Ecologies: Sex, Nature, Politics, Desire*. Bloomington: Indiana University Press, 2010.

Morton, Timothy. *The Ecological Thought*. Cambridge, MA: Harvard University Press, 2012.

———. "Guest Column: Queer Ecology." *PMLA* 125, no. 2 (2010): 273–282.

Moten, Fred. *In the Break: The Aesthetics of the Black Radical Tradition*. Minneapolis: University of Minnesota Press, 2003.

Muñoz, Jose. *Cruising Utopia: The Then and There of Queer Futurity*. New York: NYU Press, 2009.

Nancy, Jean-Luc. *Listening*. Translated by Charlotte Mandel. New York: Fordham University Press, 2007.

———. *The Muses*. Translated by Peggy Kamuf. Stanford, CA: Stanford University Press, 1996.

Nelson, Alondra. "Introduction: Future Texts." *Social Text* 20, no. 2 (2002): 1–15.

Nelson, Robin. *Practice as Research in the Arts: Principles, Protocols, Pedagogies, Resistances*. New York: Palgrave Macmillan, 2013.

Nepon, E. "Wrestling with Esther: Purim Spiels, Gender, and Political Dissidence." *Zeek: A Jewish Journal of Thought and Culture*, March 6, 2006. http://www.zeek.net/603purim/.

Niedecker, Lorine. "In the Great Snowfall before the Bomb." In *Lorine Neidecker: Collected Works*, edited by Jenny Penberthy, 142. Berkeley: University of California Press, 2002.

Noyes, Dorothy. "Tradition: Three Traditions." *Journal of Folklore Research* 46, no. 3 (2009): 233–268.

"Onaman Collective." Accessed May 15, 2018. http://onamancollective.com/.

Orenstein, Claudia. "Thinking Inside the Box: Meditations on the Miniature." *Theater* 39, no. 3 (2009): 144–155.

Paxson, Heather. "Post-Pasteurian Cultures: The Microbiopolitics of Raw-Milk Cheese in the United States." *Cultural Anthropology* 23, no. 1 (2008): 15–47.

Perchuk, Andrew, and Rani Singh, eds. *Harry Smith: The Avant-Garde in the American Vernacular*. Los Angeles: Getty Research Institute, 2010.

Pettipas, Katherine. *Severing the Ties That Bind: Government Repression of Indigenous Religious Ceremonies on the Prairies*. Winnipeg: University of Manitoba Press, 1994.

Phillips, Andrea. "Educational Aesthetics." In *Curating and the Educational Turn*, edited by Paul O'Neill and Mick Wilson, 83–96. London: Open Editions; Amsterdam: De Appel, 2010.

Pollan, Michael. *Cooked: A Natural History of Transformation*. New York: Penguin, 2013.

Pollock, Sheldon I. "Cosmopolitan and Vernacular in History." *Public Culture* 12, no. 3 (2000): 591–625.

Povinelli, Elizabeth. *The Cunning of Recognition: Indigenous Alterities and the Making of Australian Multiculturalism*. Durham, NC: Duke University Press, 2002.

———. *The Empire of Love: Toward a Theory of Intimacy, Genealogy, and Carnality*. Durham, NC: Duke University Press, 2006.

———. "Settler Modernity and the Quest for an Indigenous Tradition." *Public Culture* 11, no. 1 (1999): 19–48.

Prentice, Jessica. *Full Moon Feast: Food and the Hunger for Connection*. White River Junction, VT: Chelsea Green Publishing, 2006.

Rancière, Jacques. *Disagreement: Politics and Philosophy*. Translated by Julie Rose. Minneapolis: University of Minnesota Press, 1999.

———. *Short Voyages to the Land of the People*. Translated by James B. Swenson. Stanford, CA: Stanford University Press, 2003.

Razack, Sherene. *Race, Space, and the Law: Unmapping a White Settler Society*. Toronto: Between the Lines, 2002.

"Reclaiming: A Tradition, a Community." Reclaiming. Accessed December 29, 2018. https://reclaiming.org/.

Relyea, Lane. *Your Everyday Art World*. Cambridge, MA: MIT Press, 2013.

Renner, Martin. "Conservative Nutrition: The Industrial Food Supply and Its Critics, 1915–1985." Dissertation, University of California–Santa Cruz, 2012.

Reynolds, Simon. *Retromania: Pop Culture's Addiction to Its Own Past*. New York: Faber and Faber, 2011.

Rifkin, Mark. *Beyond Settler Time: Temporal Sovereignty and Indigenous Self-Determination*. Durham, NC: Duke University Press, 2017.

Rilke, Rainer Maria. "Archaic Torso of Apollo." In *Ahead of All Parting: The Selected Poetry and Prose of Rainer Maria Rilke*, edited and translated by Stephen Mitchell, 67. New York: Modern Library, 1995.

Rimbaud, Arthur. "À Georges Izambard," May 13, 1871. In *Rimbaud: Complete Works, Selected Letters*. Translated by Wallace Fowlie, 370–372. Chicago: University of Chicago Press, 2005.

Ritter, Kathleen, and Tania Willard, eds. *Beat Nation: Art, Hip Hop and Aboriginal Culture*. Vancouver: Vancouver Art Gallery, 2012.

Robin, Régine. "La litterature yiddish soviétique: minorité nationale et polyphonisme." *Les Temps Modernes* 458 (1984): 538–556.

Robinson, Cedric J. *Black Marxism: The Making of the Black Radical Tradition*. London: Zed Press, 1983.

Robinson, Dylan. "Feeling Reconciliation, Remaining Settled." In *Theatres of Affect*, edited by Erin Hurley, 275–306. Toronto: Playwrights Canada Press, 2014.

Rodenbeck, Judith F. *Radical Prototypes: Allan Kaprow and the Invention of Happenings*. Cambridge, MA: MIT Press, 2011.

Rolnik, Suely. "Lygia Clark and the Art/Clinic Hybrid (1996)." In *Practice*, edited by Marcus Boon and Gabriel Levine, translated by Michaela Kramer, 55–61. Cambridge, MA: Whitechapel Gallery / MIT Press, 2018.

Rubenstein, Jeffrey. "Purim, Liminality, and Communitas." *AJS Review* 17, no. 2 (1992): 247–277.

Ruivenkamp, Guido, and Andy Hilton. Introduction to *Perspectives on Commoning: Autonomist Principles and Practices*, edited by Guido Ruivenkamp and Andy Hilton, 1–24. London: Zed Books, 2017.

Russell, Catherine. *Experimental Ethnography: The Work of Film in the Age of Video*. Durham, NC: Duke University Press, 1999.

Salomonsen, Jone. *Enchanted Feminism: Ritual, Gender and Divinity among the Reclaiming Witches of San Francisco*. London and New York: Routledge, 2002.

Scales, Christopher A. *Recording Culture: Powwow Music and the Aboriginal Recording Industry on the Northern Plains*. Durham, NC: Duke University Press, 2012.

Schatzki, Theodore R., Karin Knorr-Cetina, and Eike von Savigny. *The Practice Turn in Contemporary Theory*. London: Routledge, 2000.

Schiller, Friedrich. *On the Aesthetic Education of Man in a Series of Letters*. Translated by Elizabeth M. Wilkinson and L. A. Willoughby. Oxford: Oxford University Press, 1967.

Scholem, Gershom. *The Messianic Idea in Judaism and Other Essays on Jewish Spirituality*. New York: Schocken Books, 1971.

———. *On the Kabbalah and Its Symbolism*. Translated by Ralph Manheim. New York: Schocken Books, 1969.

———. "Walter Benjamin and His Angel." In *On Jews and Judaism in Crisis: Selected Essays*, 198–236. New York: Schocken Books, 1976.

Schulman, Sarah. *The Gentrification of the Mind: Witness to a Lost Imagination*. Berkeley: University of California Press, 2012.

Schwab, Gabrielle. *Haunting Legacies: Violent Histories and Transgenerational Trauma*. New York: Columbia University Press, 2010.

Scott, David. *Conscripts of Modernity: The Tragedy of Colonial Enlightenment*. Durham, NC: Duke University Press, 2004.

Scott, Duncan Campbell. "Indian Place Names." In *New World Lyrics and Ballads*, 35–36. Toronto: Morang & Co., 1905.

Scuderi, Antonio. *Dario Fo: Framing, Festival, and the Folkloric Imagination*. Lanham, MD: Lexington Books, 2011.

Seidman, Naomi. *A Marriage Made in Heaven: The Sexual Politics of Hebrew and Yiddish*. Berkeley, CA: University of California Press, 1997.

Serres, Michel. *The Parasite*. Minneapolis, MN: University of Minnesota Press, 2007.

Shandler, Jeffrey. *Adventures in Yiddishland: Postvernacular Language and Culture*. Berkeley: University of California Press, 2006.

———. "Queer Yiddishkeit: Practice and Theory." *Shofar: An Interdisciplinary Journal of Jewish Studies* 25, no. 1 (2006): 90–113.

Shanin, Teodor. *Late Marx and the Russian Road: Marx and "the Peripheries of Capitalism."* New York: Monthly Review Press, 1983.

Sharpe, Christina. *In the Wake: On Blackness and Being*. Durham, NC: Duke University Press, 2016.

Sharzer, Greg. *No Local: Why Small-Scale Alternatives Won't Change the World*. Winchester, UK: Zero Books, 2012.

Shohat, Ella. "The Invention of the Mizrahim." *Journal of Palestine Studies* 29, no. 1 (1999): 5–20.

Sholette, Gregory. *Dark Matter: Art and Politics in the Age of Enterprise Culture.* London: Pluto Press, 2011.

Siegel, Ronald K. *Intoxication: The Universal Drive for Mind-Altering Substances.* Rochester, VT: Park Street Press, 2005.

Simpson, Audra. "Paths toward a Mohawk Nation: Narratives of Citizenship and Nationhood in Kahnawake." In *Political Theory and the Rights of Indigenous Peoples*, edited by Duncan Ivison, Paul Patton, and Will Sanders, 113–136. Cambridge, UK: Cambridge University Press, 2000.

———. "Settlement's Secret." *Cultural Anthropology* 26, no. 2 (2011): 205–217.

Simpson, Leanne Betasamosake. *As We Have Always Done: Indigenous Freedom through Radical Resistance.* Minneapolis: University of Minnesota Press, 2017.

———. *Dancing on Our Turtle's Back: Stories of Nishnaabeg Re-Creation, Resurgence and a New Emergence.* Winnipeg: Arbeiter Ring Publishing, 2011.

Singh, Julietta. *Unthinking Mastery: Dehumanism and Decolonial Entanglements.* Durham, NC: Duke University Press, 2016.

Sloterdijk, Peter. *You Must Change Your Life: On Anthropotechnics.* Translated by Wieland Hoban. Cambridge, UK: Polity Press, 2013.

Small, Christopher. *Musicking: The Meanings of Performing and Listening.* Middletown, CT: Wesleyan University Press, 1998.

Snead, James A. "Repetition as a Figure of Black Culture." In *Black Literature and Literary Theory*, edited by Henry Louis Gates, Jr., 59–80. London: Routledge, 1984.

Solnit, Rebecca. "Diary." *London Review of Books*, August 29, 2013, 32–33.

Spatz, Ben. *What a Body Can Do: Technique as Knowledge, Practice as Research.* Abingdon, Oxon: Routledge, 2015.

Srnicek, Nick, and Alex Williams. *Inventing the Future: Postcapitalism and a World without Work.* London: Verso, 2015.

Stallybrass, Peter, and Allon White. *The Politics and Poetics of Transgression.* Ithaca, NY: Cornell University Press, 1986.

Starhawk. "How We Really Shut Down the WTO." In *From ACT UP to the WTO: Urban Protest and Community Building in the Era of Globalization*, edited by Benjamin Shepard and Ronald Hayduk, 52–56. London: Verso, 2002.

Stengers, Isabelle. "Diderot's Egg: Divorcing Materialism from Eliminativism." *Radical Philosophy* 144 (2007): 7–15.

———. "Introductory Notes on an Ecology of Practices." *Cultural Studies Review* 11, no. 1 (2005): 183–196.

Stengers, Isabelle, and Philippe Pignarre. *Capitalist Sorcery: Breaking the Spell.* London: Palgrave Macmillan, 2011.

Sterne, Jonathan. "Quebec's #casseroles: On Participation, Percussion and Protest." *Sounding Out!* (blog), June 4, 2012. https://soundstudiesblog .com/2012/06/04/casseroles/.

Stewart, Kathleen. *Ordinary Affects.* Durham, NC: Duke University Press, 2007.

Storey, John. *Inventing Popular Culture: From Folklore to Globalization.* Malden, MA: Blackwell, 2003.

Svigals, Alicia. "Why We Do This Anyway: Klezmer as Jewish Youth Subculture." In *American Klezmer: Its Roots and Offshoots,* edited by Mark Slobin, 211–220. Berkeley: University of California Press, 2002.

Tancons, Claire. "The Greatest Free Show on Earth: Carnival from Trinidad to Brazil, Cape Town to New Orleans." In *Prospect.1 New Orleans,* 42–53. New Orleans: PictureBox, 2008.

———. "Occupy Wall Street: Carnival Against Capital? Carnivalesque as Protest Sensibility." *E-Flux* 30 (2011). https://www.e-flux.com/journal/30/68148 /occupy-wall-street-carnival-against-capital-carnivalesque-as-protest -sensibility/.

Taussig, Michael. "Mastery of Non-Mastery (Extracts from a Manuscript)." PDF File, October 7, 2017.

Taylor, Diana. *The Archive and the Repertoire: Performing Cultural Memory in the Americas.* Durham, NC: Duke University Press, 2003.

Taylor, Keeanga-Yamahtta. *From #BlackLivesMatter to Black Liberation.* Chicago: Haymarket Books, 2016.

Temporary Services, and Angelo. *Prisoners' Inventions.* Chicago: WhiteWalls, 2003.

Teves, Stephanie Nohelani, Andrea Smith, and Michelle H. Raheja. "Tradition." In *Native Studies Keywords,* edited by Teves, Smith, and Raheja, 233–242. Tucson: University of Arizona Press, 2015.

toksala. "Q&A with Powwowstep Pioneers A Tribe Called Red." MTV Iggy, January 31, 2011. http://www.mtviggy.com/interviews/qa-with-powwowstep -pioneers-a-tribe-called-red-keha-must-have-a-big-pair-of-balls. Accessed January 13, 2013.

"Toronto Hipster Map a Godsend for Everyone Else." Huffington Post Canada, July 4, 2013. https://www.huffingtonpost.ca/2013/07/04 /toronto-hipsters-map-yelp_n_3546704.html.

Toufic, Jalal. *Forthcoming*. Berkeley, CA: Atelos Press, 2001.

Townsend, Melanie, Dana Claxton, and Steve Loft, eds. *Transference, Tradition, Technology: Native New Media Exploring Visual and Digital Culture*. Banff: Walter Phillips Gallery Editions, 2005.

Truth and Reconciliation Committee of Canada. *Canada's Residential Schools: The Final Report of the Truth and Reconciliation Committee of Canada*. Volumes 1–3. Canada: McGill-Queens University Press, 2015.

Tsing, Anna Lowenhaupt. *The Mushroom at the End of the World: On the Possibility of Life in Capitalist Ruins*. Princeton, NJ: Princeton University Press, 2015.

Tsing, Anna Lowenhaupt, Heather Swanson, Elaine Gan, and Nils Bubandt, eds. *Arts of Living on a Damaged Planet: Ghosts and Monsters of the Anthropocene*. Minneapolis: University of Minnesota Press, 2017.

Tuck, Eve, and K. Wayne Yang. "Decolonization Is Not a Metaphor." *Decolonization: Indigeneity, Education & Society* 1, no. 1 (2012): 1–40.

Tuhiwai Smith, Linda. *Decolonizing Methodologies: Research and Indigenous Peoples*. 2nd ed. London: Zed Books, 2012.

Twitty, Michael W. *The Cooking Gene: A Journey through African-American Culinary History in the Old South*. New York: HarperCollins, 2016.

———. "Stinking Fish, Salt Fish and Smokehouse Pork: Preserved Foods, Flavour Principles and the Birth of African American Foodways." In *Cured, Smoked, and Fermented: Proceedings of the Oxford Symposium on Food and Cooking, 2010*, edited by Helen Saberi, 333–342. Devon, UK: Prospect Books, 2011.

Tylor, Edward. *Primitive Culture: Researches into the Development of Mythology, Philosophy, Religion, Language, Art, and Custom*. Volumes 1 and 2. New York: Brentano's, 1924.

Uchill, Rebecca, ed. *On Procession: Art on Parade*. Indianapolis: Indianapolis Museum of Art, 2009.

Valaskakis, Gail. *Indian Country: Essays on Contemporary Native Culture*. Waterloo, ON: Wilfrid Laurier University Press, 2005.

Vaneigem, Raoul. *The Revolution of Everyday Life*. Translated by Donald Nicholson-Smith. Oakland, CA: PM Press, 2012.

Veal, Michael. *Dub: Soundscapes and Shattered Songs in Jamaican Reggae*. Middletown, CT: Wesleyan University Press, 2007.

Veracini, Lorenzo. "Settler Collective, Founding Violence and Disavowal: The Settler Colonial Situation." *Journal of Intercultural Studies* 29, no. 4 (2008): 363–379.

Vizenor, George. *Fugitive Poses: Native American Indian Scenes of Absence and Presence.* Lincoln: University of Nebraska Press, 1998.

Wade, Meg. "Grassroots Modernism as Autonomous Ethos and Practice." *Journal of Aesthetics and Protest* 8 (2011): 45–54.

Wagamese, Richard. *Keeper'n Me.* Toronto: Anchor Canada, 2006.

Wark, Mackenzie. *The Beach Beneath the Street: The Everyday Life and Glorious Times of the Situationist International.* London: Verso, 2011.

Warner, Michael. *Publics and Counterpublics.* New York: Zone Books, 2002.

Warrior, Robert Allen. "The Sweetgrass Meaning of Solidarity: 500 Years of Resistance." *Border/Lines* 23 (1991/1992): 35–37.

Weber, Samuel. "The Future of the Humanities: Experimenting." *Culture Machine* 2 (2000). http://svr91.edns1.com/~culturem/index.php/cm /article/view/311/296.

Weheliye, Alexander G. *Phonographies: Grooves in Sonic Afro-Modernity.* Durham, NC: Duke University Press, 2005.

Weinreich, Max. *History of the Yiddish Language.* Translated by Shlomo Noble. Chicago: University of Chicago Press, 1980.

———. "Internal Bilingualism in Ashkenaz." In *Voices from the Yiddish: Essays, Memoirs, Diaries,* edited by Irving Howe and Eliezer Greenberg, 279–288. Ann Arbor: University of Michigan Press, 1972.

Wenger, Etienne. *Communities of Practice: Learning, Meaning, and Identity.* Cambridge, UK: Cambridge University Press, 1998.

Weston, Kath. *Animate Planet: Making Visceral Sense of Living in a High-Tech Ecologically Damaged World.* Durham, NC: Duke University Press, 2016.

Wex, Michael. *Born to Kvetch: Yiddish Language and Culture in All Its Moods.* New York: St. Martin's, 2005.

Whitman, Walt. "This Compost." In *The Portable Walt Whitman,* edited by Michael Warner, 129–131. New York: Penguin, 2004.

Wilder, Gary. *Freedom Time: Negritude, Decolonization, and the Future of the World.* Durham, NC: Duke University Press, 2015.

Williams, Alex, and Nick Srnicek. "#ACCELERATE MANIFESTO for an Accelerationist Politics." *Critical Legal Thinking: Law and the Political* (blog), May 14, 2013. http://criticallegalthinking.com/2013/05/14/accelerate -manifesto-for-an-accelerationist-politics/.

Williams, Raymond. *Keywords: A Vocabulary of Culture and Society*. 2nd ed. London: Fontana Paperbacks, 1983.

———. *Marxism and Literature*. Oxford: Oxford University Press, 1977.

Winnicott, D. W. *Playing and Reality*. London: Routledge, 1989.

Wolfe, Patrick. *Settler Colonialism and the Transformation of Anthropology: The Politics and Poetics of an Ethnographic Event*. London: Cassell, 1999.

Woloshyn, Alexa. "Sounding the Halluci Nation: Decolonizing Race, Masculinity, and Global Solidarities with A Tribe Called Red." In *Popular Music and the Politics of Hope: Queer and Feminist Interventions*, edited by Susan Fast and Craig Jennex, 151–171. New York: Routledge, 2019.

Wright, Michelle M. *Physics of Blackness: Beyond the Middle Passage Epistemology*. Minneapolis: University of Minnesota Press, 2015.

Wynter, Sylvia. "On How We Mistook the Map for the Territory, and Reimprisoned Ourselves in Our Unbearable Wrongness of Being, of *Desêtre*: Black Studies Toward the Human Project." In *Not Only the Master's Tools: African American Studies in Theory and Practice*, edited by Lewis R. Gordon and Jane Anna Gordon, 107–169. New York: Paradigm Press, 2006.

Žižek, Slavoj. "Neighbors and Other Monsters: A Plea for Ethical Violence." In *The Neighbor: Three Inquiries in Political Theology*, 134–190. Chicago: University of Chicago Press, 2005.

INDEX